REFLECTIONS OF A FRIENDSHIP

Reflections of a Friendship

John Ruskin's Letters to Pauline Trevelyan
1848–1866

Edited by VIRGINIA SURTEES
Foreword by RALEIGH TREVELYAN

London
GEORGE ALLEN & UNWIN LTD
Boston Sydney

First published in 1979

GEORGE ALLEN & UNWIN LTD
40 Museum Street, London WC1A 1LU

© George Allen & Unwin (Publishers) Ltd, 1979

British Library Cataloguing in Publication Data

Ruskin, John
 Reflections of a friendship.
 1. Ruskin, John – Correspondence 2. Authors,
 English – 19th century - Correspondence
 3. Trevelyan, Pauline, *Lady*
 I. Title II. Surtees, Virginia III. Trevelyan,
 Pauline, *Lady*
 828'.8'09 PR5263.A4'

 ISBN 0-04-826004-5

Typeset in 11 on 13 point Baskerville by Bedford Typesetters Ltd
and printed in Great Britain
by Unwin Brothers Limited, Old Woking, Surrey

Acknowledgements

My principal thanks are to the Trustees of the Trevelyan Estate for selecting me to edit these letters (once conserved at Wallington and now deposited at the University of Newcastle upon Tyne) and for giving me complete latitude in the use of relevant diaries and papers amongst the manuscripts belonging to the Trust. In this context one name in particular, that of Mrs John Dower, commands a major expression of gratitude. As Pauline Trevelyan, Wallington was her home, and her extensive knowledge, heightened by her affection for the grounds the house and its contents, is a repository which she has freely allowed me to plunder.

Mr Raleigh Trevelyan has helped me very considerably with his mastery of the essential features in the lives of Sir Walter and Lady Trevelyan in the period covered by these letters, and has placed at my disposal papers and photographs of his own to facilitate my work: kindnesses for which I am extremely grateful.

To Messrs George Allen & Unwin, the Ruskin Literary Trustees, I acknowledge with thanks their courtesy in allowing me to publish these letters from John Ruskin and to quote from other unpublished manuscript material from him and from his father, John James Ruskin. In particular I should like to thank Mr Rayner Unwin for the support he has given me. To Sir Ralph Millais, Bt, I am indebted for copyright permission to publish the letters from Effie Ruskin.

I am as always much beholden to Mr James Dearden, Curator of the Ruskin Galleries, Bembridge; also to Mr Alistair Eliot, Assistant Curator Special Collections, University Library, Newcastle upon Tyne, who made available to me the Trevelyan Papers.

To these I wish to record my thanks for exceptional help or advice: Dr W. A. Clark, Mr Graeme Cruickshank, Mrs A. Cullen, Miss Eileen Gainfort, Mr Evelyn Joll, Miss Mary Lutyens, Mr Jeremy Maas, Mr Kenneth Marr-Johnson, Mr Roger Norris, Mr William Payne, Miss Sophia Ryde, Mr Jeremy Williams; and to Mr M. Hogan and Mr David Mayer for elucidating the last letter in this volume. For their contribution I thank Mr F. Blyth, Professor Van

A. Burd, Mrs J. E. Chesney, Mrs Mary Davson, Mr Iain Flett, Mr Alastair Grieve, Mrs J. Hawksey, Miss G. M. Johnson, Mr Ian Lowe, Mr George Nash, Mr A. J. Piper, Professor Richard L. Purdy, Mr John Saumarez Smith, Mr D. M. Torbet, and Mr Christopher Tower.

This book has been published with financial assistance from the Arts Council of Great Britain.

The following letters are reproduced by permission of their owners: Nos 2, 51, 58, 93, 101, 106, 137, 139, 142, Pierpont Morgan Library; Nos 26, 29, Mr Raleigh Trevelyan; No. 83, Ruskin Galleries; Nos 67, 69, 114, 134, 136, 189 are printed in the *Works of John Ruskin*, Library Edition, vol. 36 (pp. 174, 243, 344, 413, 421, 478 respectively). I wish also to offer my thanks to those who have kindly allowed me to quote passages from their own manuscript sources or publications: George Allen & Unwin, Ltd, and Harvard University Press (*The Winnington Letters*, ed. V. A. Burd); Beinecke Rare Book and Manuscript Library, Yale University; University of British Columbia; Cornell University Library; Hamish Hamilton, Ltd (*England's Michelangelo*, W. Blunt); Hospitalfield Trust; Pierpont Morgan Library; John Murray, Ltd (*The Ruskins in Normandy*, J. G. Links, *Effie in Venice*, *Millais & the Ruskins*, M. Lutyens); National Gallery Library; Oxford University Press (*The Diaries of John Ruskin*, J. Evans and J. H. Whitehouse); Princeton University Library; Ruskin Galleries; John Rylands University Library of Manchester; Watts Gallery; Yale University Press (*Ruskin's Letters from Venice* 1851–1852, J. L. Bradley).

Foreword

As far back as in 1905 Sir Charles Dilke remarked, in a memoir of his wife, that Ruskin's letters to Lady Trevelyan, 'ought one day to see the light'. For Lady Dilke, as the young Mrs Pattison, had been among the many who had fallen under the spell, indeed influence, of Pauline and until the last had kept a portrait of her in a locket. A handful of letters appeared shortly afterwards in Ruskin's *Collected Works*, and others have been used, mostly in extract form, in my own book, *A Pre-Raphaelite Circle*. It has thus taken over seventy years for this almost legendary collection to be published in full, with the bonus not only of such letters from Pauline herself to Ruskin as can be traced, but of letters from Effie and Ruskin's father to Pauline among the Trevelyan manuscripts at Newcastle University Library.

Ruskin called Pauline one of his 'tutelary powers', in whom he 'wholly trusted'. She regarded him as a genius, and he was quite aware of it. This meant that she would always stand by him, in spite of any shortcomings. In the terrible days following Effie's departure in 1854 she was almost alone in remaining steadfastly true to him. Yet, even when his fame increased still further, she would never allow him to take himself too seriously. She loved teasing him, and he teased her back.

Sir George Otto Trevelyan, when an old man, told Edmund Gosse that Pauline used to have an 'ever-flowing spring of most delicious humour'. No friend of hers, man or woman, he said, 'could have enough of her company'. It was this gaiety, or brightness, that people constantly remembered. She had a reputation for frankness, and for expecting frankness in return. Enthusiasm was another of her qualities. If she believed in something, or someone, she believed in it, or him or her, fervently, just as she would take strong lines against causes, pictures, books or poems of which she did not approve. Her charm, so Dr John Brown of Edinburgh would say, lay in a quaint mixture of 'fun and pathos'.

She was born at Hawkedon in Suffolk on 25 January 1816, the daughter of an impoverished and learned parson, Dr George Bitton

Jermyn. Though she was christened Paulina, she was always known as Pauline. Her mother came from Huguenot stock. Much of her childhood was spent at Swaffham Prior near Cambridge, where her intelligence was soon noticed by dons such as Whewell, Sedgwick and Henslow, who became lifelong friends. She was not only an excellent botanist and all-round naturalist, but an outstanding linguist. Her memory was formidable. After the 1833 meeting of the British Association in Cambridge, she was able – at the age of seventeen – to transcribe from memory the whole of Sedgwick's complicated inaugural address.

It was at this same meeting that Pauline encountered Walter Calverley Trevelyan, whom she subsequently married in 1835. Although he was nineteen years her senior and decidedly eccentric, the match was a fortunate one from the Jermyns' point of view. For Calverley was not only wealthy but heir to a baronetcy and considerable estates in Northumberland and south-west England. He was also well known as a geologist and botanist. Indeed, his pursuit of every sort of knowledge, be it antiquarian, archaeological or scientific (including medical and mechanical), was relentless and erudite. In many ways he and Pauline might have seemed opposite characters. He was tall, dark, solemn, never wasting a word in his writings and not especially interested in art unless it had 'mental' qualities. After he had inherited his baronetcy in 1846, he spent large sums on improving his properties. He was one of the leading teetotallers in Britain, a strong pacifist, against capital punishment, in favour of women's suffrage, a campaigner against tobacco smoking. In his early days he was very taken up with phrenology and mesmerism. Like Pauline he was fond of travel, not only abroad but throughout the British Isles.

In due course Pauline was to find herself châtelaine of two large houses, Nettlecombe Court in Somerset and Wallington Hall in Northumberland. This gave her scope to entertain, which she always enjoyed, her guests being mostly artists, scientists, and writers. She preferred Wallington because of the bracing air and great views of crag and moor. It was a place for her to express herself, both inside the house and in the garden, and somewhere that was not overlaid with family tradition. Moreover, Edinburgh, where they had many friends and where her doctors were (an important aspect after an operation on a tumour in 1850), was not very far away. So they chose Wallington to live in.

Wallington, originally a Border castle, had been rebuilt in local grey stone at the end of the seventeenth century, with embellishments around 1740. Pauline decided to roof over the central courtyard and turn it into a hall. The decoration of this hall became a kind of pivot in her life, for she longed to make it into a Pre-Raphaelite showpiece.

Pauline and Calverley – Sir Walter, as he was by then formally known – first met Ruskin on 4 June 1847. No doubt their mutual friend Henry Acland had suggested that Pauline should call at Denmark Hill, because of her great admiration for *Modern Painters* vols I and II. It happened that Effie was staying there, before there was a question of her marrying Ruskin. Pauline showed them drawings she had done in Greece, and Ruskin gave her encouraging advice. In March 1848 the Trevelyans were in Edinburgh. By this time Effie and Ruskin were about to be married, and Effie took a great liking to Pauline, who seems to have proffered some womanly advice on how to manage her 'Master'.

Pauline became established as a book reviewer and art critic on *The Scotsman*. She also had some pictures exhibited in Edinburgh. On 3 January 1852 she published a review of Ruskin's *Pre-Raphaelitism*, which included a brilliant summary of the conditions in the British art world that had led up to the founding of the Pre-Raphaelite Brotherhood. By the late 1850s she had built up a circle of Pre-Raphaelite friends and was taking a motherly interest in Swinburne's career.

In February 1866 Ruskin was in despair over his rejection by Rose La Touche. He wanted to escape, so he told Pauline that he was thinking of taking Connie Hilliard and his young cousin Joan Severn to the Continent. He was delighted when Pauline replied that she and Calverley would like to come too. The idea was 'glorious', he said, and all the excitement of the planning began. But it was a mad idea; less than three weeks before their departure Pauline was being taken to church in a wheelchair. She died at Neuchâtel on 13 May.

Ruskin was at her bedside. As she lay dying, he told Calverley that he was grateful to be there at all. He did not think that he cared for him so much. 'Oh', replied Calverley, 'we both esteemed you above anyone else.' Pauline then said, with an effort, 'He knows that.' Those were the last conscious words that Ruskin heard her speak.

RALEIGH TREVELYAN

Contents

List of Illustrations

(1) John Ruskin, c. 1856. Photograph by Mr Jeffreys, Working Men's College

(2) Sir Walter and Lady Trevelyan, c. 1863

(3) a. Lady Trevelyan, 1857. Marble medallion by Alexander Munro

 b. Sir Walter Trevelyan, 1860

(4) a. Dr Henry Acland, 1853. Drawing by J. E. Millais, made at Glenfinlas

 b. John James Ruskin, c. 1860

(5) 'Wayside Refreshment', 1853. Drawing by J. E. Millais of himself and Effie Ruskin at Glenfinlas

(6) Wallington

(7) a. The central Hall, Wallington

 b. Ruskin's unfinished pilaster

 c. Lady Trevelyan's poppies

(8) Lady Trevelyan's grave at Neuchâtel, 1866. Drawing by John Ruskin

I should like to thank the owners of the following plates for their courtesy in allowing me to reproduce them: 1, 2, 3a, 7b, c, 8, National Trust (Wallington); 4a, b, Education Trust Ltd, Ruskin Galleries; 3b, 5, Private Collections; and *Country Life* for permission to reproduce 6, 7a.

List of Abbreviations

Bembridge – Ruskin Galleries, Bembridge School, Isle of Wight.

Bradley – *Ruskin's Letters from Venice 1851–52*, ed. J. L. Bradley (Yale University Press, 1955).

Diaries – *The Diaries of John Ruskin*, ed. J. Evans and J. H. Whitehouse (Oxford at the Clarendon Press, 1965, 1967).

JJR – John James Ruskin.

Lutyens – *Effie in Venice* (ii), *Millais and the Ruskins* (iii), M. Lutyens (John Murray, 1965, 1967).

Memorials – *Memorials of Edward Burne-Jones*, G. B-J. (London, 1904).

Millais – *Life & Letters of Sir John Everett Millais*, J. G. Millais (London, 1899), i.

R – *The Works of John Ruskin*, Library Edition, E. T. Cook and Alexander Wedderburn, 1903–12. (Arabic numbers refer to the volume number.)

Rylands – The John Rylands University Library of Manchester.

Sublime & Instructive – *Letters from John Ruskin to Louisa, Marchioness of Waterford, Anna Blunden and Ellen Heaton*, V. Surtees (Michael Joseph, 1972).

TD – Sir Walter Trevelyan's Diaries.

Winnington – *The Winnington Letters*, ed. Van A. Burd (Allen & Unwin, 1969) (copyright Harvard University Press).

Yale – The Beinecke Rare Book and Manuscript Library, Yale University Library.

Unless otherwise indicated, letters and quotations from letters and diaries are taken from the Trevelyan Papers. Original spelling and punctuation have been preserved throughout.

THE CORRESPONDENCE

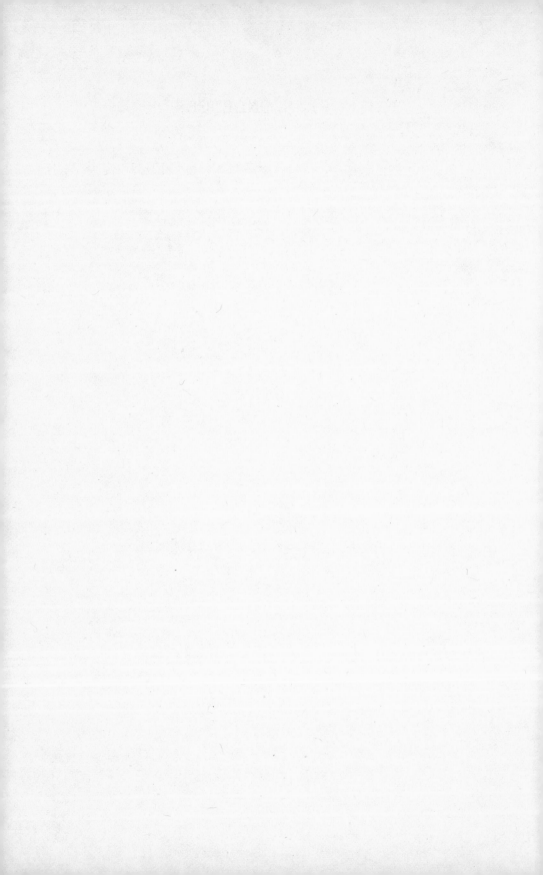

Denmark Hill, 19th January[1] [1848]

My dear lady Trevelyan

As, I think, of all whom I ever ventured to advise respecting method of study – you are the first who has yielded to me a real & faithful compliance – I should have been much grieved if you had not the sense, as well as the reality of success. I am quite sure you would not use words of depreciation, in mere form – and therefore I have been looking over the drawings to find what has discouraged – or disappointed you – But my search has been quite in vain – and really, for the sake of human nature and its capacities of contentment, I wish you would tell me what you *would have*.[2] I never saw – but once before,[3] studies so courageous – persevering and faithful – and I never knew courage or fidelity miss their reward – nor have they now. I am quite sure – however dissatisfied you may be with the actual results, that you *must* feel a great accession of power – feeling and perception – nor for my own part – would I desire to possess anything more complete or beautiful than the large studies of ivy and beech[4] – (the former especially must have cost you dear – it is so marvellously intricate) – or than the detached oak bough – or the water side grotto with its arrowy ferns. One or two subjects you have attacked of invincible difficulty – the park scene for instance, and in this – and one or two other cases, you have used your white too generally – *Glitter* of foliage is I think hardly to be expressed except in final operations – and white of course, cannot legitimately stand for green, in a pure chiaroscuro study. If tomorrow be fine, I will bring in the portfolio – and if you will tell me where you feel you have failed – we will talk over the possible causes. I will come early – about 12? With sincere regards to Sir Walter, believe me my dear lady, ever faithfully Yours

J Ruskin

My Mother begs her kind compliments.

[1] Ruskin was within three weeks of his twenty-ninth birthday and three months of his marriage to Euphemia Gray. He was living with his parents at Denmark Hill and, although plans were afoot for a house of their own when he and Effie were married, he was nevertheless intending to return daily to his rooms and his Turner water-colours at Denmark Hill, for study. The Trevelyans were in London for a short visit from Northumberland.

[2] Lady Trevelyan was a sufficiently talented artist for her work to be taken seriously and she had now submitted some of her studies for Ruskin's opinion.

[3] His cousin Mary Richardson; her laborious industry in pencil-copying when a girl had earned her 'due Honour' in *Praeterita* 'for the steady pains of her impulsive practice and unwearied attention'.

[4] Shortly before taking his degree at Oxford in 1842, Ruskin had chanced upon a tendril of ivy on the Norwood Road. Completing a light and shade study he realised that till then he had wasted years in trying to reproduce colour and beauty. Henceforward his aim was 'truth as to copy', and he expected a like response from those whom he taught, or guided, in study of art.

2

From Lady Trevelyan

26 Walker Street [Edinburgh]
Tuesday Evg [21 March 1848]

Dear Mr. Ruskin

As it appears you never mean to come & see me,[1] I must set my conscience at rest by delivering to you a message which I have for you – Mrs Alison who you know is Henry Acland's great friend, & who heard histories of you daily for some years – (greatly no doubt to her moral improvement) – is at present *very* unwell & Dr Alison[2] is too busy to make morning calls – she therefore wished you to be told that if you wd excuse such formalities & call on her, she would be truly happy to see you – she adds that you must send up yr card as she does not see many people – she says it would be a grief to her not to see Henry Acland's friend – that is her message – as for your conduct I make no remarks on it – Your friends have one melancholy consolation left – in believing that at this present time you may be supposed to be neither a free agent, nor altogether a responsible being – in which comfortable assurance

I remain
Yrs very truly
Pauline J Trevelyan

You are much better off than you deserve –

[1] Ruskin was in Scotland for a few weeks before his wedding, and with Effie was staying at her uncle Andrew Jameson's house in Newington, a southern suburb of Edinburgh. The Trevelyans, who until about 1852 when they settled permanently at Wallington spent part of each year in Scotland, were also at Edinburgh. Lady Trevelyan had met Effie Gray at Denmark Hill the previous

summer (on which occasion Effie had complacently written of her as being 'a nice little woman'), and, meeting her again now, had called upon her before Ruskin's arrival.

[2] Dr W. P. Alison, Professor of Medicine at Edinburgh. Dr Henry Acland, later Regius Professor of Medicine at Oxford; he and Ruskin had been devoted friends since Oxford days, and continued so to the end of their lives.

3

[Edinburgh] March 21st [1848]

My Dear lady Trevelyan

I think it better to trust to your forgiveness – than to my excusings – though I *have* an excuse close at hand, otherwise I might not so soon have been able to acknowledge my fault – & your merciful charging of it on my conscience – indeed I am very grateful to you – and more than rejoice that she whose happiness is now entrusted to me has been able to obtain for herself the promised friendship of one whom I so deeply respect – indeed you say true – I am far far happier than I deserve – (but I should be very miserable on any other condition).

I am grateful for Mrs Alison's kind message – and will wait on her to-morrow – DV – but first on you – With sincere regards to Sir Walter, believe me dear lady Trevelyan –

Ever faithfully & gratefully Yours

J Ruskin

I must call early tomorrow – about 12 – but if I should not find you – I shall hope to be more fortunate on Thursday. – I showed this note to Miss Gray – who thereupon looked dissatisfied & thoughtful – I asked what was wanting – or erring – and after some pause – and a renewed questioning obtained the following reply "I think you should tell her that I liked her very much".

4

From Effie Gray

10 Blacket Place Edinburgh 21st March 1848

My dear Lady Trevelyan,

Accept my very warmest thanks for your kind & beautiful gift which I hope to be able to thank you for better ere I leave Edinburgh

3

I shall have great pleasure in wearing it and I assure you that I have long ago forgiven you for punishing me at Mrs Fullerton's.[1] I did not require to send your note far, for Mr Ruskin was sitting by teaching me to draw a circle which I confess I was doing very badly notwithstanding his encouragements. I am afraid I am too old to learn drawing now. I go home on Monday but if you could be so good as to tell Mr Ruskin if you are to be at home on Thursday forenoon I shall have much pleasure in calling for you if then convenient.

And believe me with many thanks for your kindness

Yours very sincerely

Effie C. Gray

[1] Lady Trevelyan's gift came perhaps as a wedding present, or as a peace-offering for some pretended scolding at Mrs Fullerton's – who remains unidentified.

5

From Effie Gray

Bowerswell[1] [Thursday] 6th April 1848

My dear Lady Trevylian

I was very much vexed after leaving your house the day I called on you that I had not asked you how long you intended remaining in Edinburgh before going North; for I am almost afraid lest this fine weather should have tempted you from Walker Street which, if the case, may prevent these few lines in compliance with your kind wish to know our marriage day from reaching you in time, but I could not tell you the exact time as it was only fixed this morning owing to some arrangements of our mutual friends not being able to come at the same time; but we now intend that the ceremony shall take place on Monday afternoon at 4 oclock [10 April], when amongst the many kind wishes for our happiness yours will not be wanting. My dear Mother will miss me much as I have no sister older than five years, three having been taken from us at one blow by fever, who had they lived would have filled my place at this time. My Mother & I therefore have been always together since I left school.[2]

It is a sad disappointment to me Lizzie Cockburn[3] not being able to be my bridesmaid; now she is obliged to go with Lord Cockburn on the Circuit. I can say nothing as I believe it is quite her duty to

4

be his companion at that time. If Mr Ruskin was here I am sure he would either write to you himself or give me some long messages for you but he left this morning for Rossie Castle[4] and does not return till late this evening.

I have not forgotten your advice about him and I shall endeavour to follow it after we are married as it quite accords with my own ideas. I have known him now for eight years and I always thought the same although he is much changed in many respects since then, but I hope it will not be long before we meet & you will have something more to say to me.

Will you remember me most kindly to Mrs Fullerton who I hope is better, and believe me with many thanks for your kindness

Yours very sincerely

Euphemia C. Gray

[1] Effie's home in Perth.

[2] The three sisters had died in the summer of 1841, all from scarlet fever.

[3] Effie's school-friend (in Ruskin's opinion 'very nice and pretty') was the daughter of Lord Cockburn, a Scottish judge. He had been a friend of Sir Walter Scott, which would have delighted Ruskin whose own love for Scott remained constant throughout his life.

[4] Near Montrose, a property owned by Ruskin's friend William Macdonald, whom he had met at Leamington the previous summer.

6

From Effie Gray

[Bowerswell, probably 7 or 8 April 1848]

I do not know whether you wished to know our direction or not but till Monday it is

George Gray Esqr
Bowerswell
Perth

After that we go to Blair Athole and Loch Lomond & to Glasgow on Saturday morning. We reach Keswick that night and remain in Cumberland I suppose till the end of the month when we go to Denmark Hill.[1] I do not know what we shall do after that but any letters will find us if sent there.

Effie

7

From Effie Ruskin

[Ship Hotel] Dover 24th June 1848

My dear Lady Trevelyan

I do not know whether I ought to write to you or not but I want to do so, and the temptation of your giving me an address which would always find you, has strengthened my wishes. I have been wondering for a long time where you were and I did hope that during the six weeks we spent in London after our arrival from Scotland I might have seen you at some of the parties we were at, but I was unfortunate, and the dreadful fever in Westminster of which you must have heard prevented me from becoming better acquainted with Miss Buckland who doubtless could have told me some news of you.¹

We were rather early in our Highland tour and John did nothing but abuse every place one after another when he was awake, for to ride out what he calls the most melancholy country in the world he slept most of the way which I am sure you will be quite shocked at, and I had the poor advantage of having the beauties all to myself. I enjoyed London very much and the streets and shops were quite delightful and my philosopher thinks me quite a pattern wife, because I am content with the outside of the latter, but I think that no merit at all since I want for nothing. But now We are at Dover and it is such a nice place.² We have been here ten days and the weather most lovely; we are never tired of being on the beach and throwing stones into the water, and the ships riding on the waves of all kinds and sizes are perfect. The French coast is very clear and the other day through a glass we saw the church spires of Calais. Some alarm is caused today by the nonappearance of the French Mail and they are fearful that a massacre has taken place in Paris but I trust the report will be found untrue and false,

but in the present state of the world one is not now to be surprised at any thing after the extraordinary events of the last few months. You know my husband's care for the *continent* and these changes at times dishearten him very much and he is constantly longing to be on the other side of the Channel, but excepting this I may say he is truly happy and yesterday was one of the most delightful days we have spent since our marriage. We went into Canterbury early in the morning and spent the whole day in & about the Cathedral, being at service in the forenoon and in the afternoon sitting outside sketching part of St Anselms tower with the beautiful Norman decorations on it.

I have been going on steadily in learning drawing from John and I now take great pleasure in working at it, for he only lets me draw a little architecture and some of it being straight lines continually, he is afraid I will find it monotonous but I enjoy it very much and yesterday afternoon, while we were sketching, and the service was going on, I cannot tell you the perfect joy & delight the Organ and voices chanting through the walls gave me while sitting on the steps outside.

We are going from this to Folkestone for a few days next week but we shall spend the winter in London, and Denmarkhill will always find me if you should be so kind as to think of writing to me at any time. We have been looking for a house in town but they are all too large in the part where we should wish to reside and we are waiting now till the season is over when I daresay we shall easily find one. I heard lately from my friend Lizzie who is well & I had the pleasure of meeting Lady Murray at Lady Davy's one night when I heard her again play very beautifully.[3] Lord Cockburn was also in town but we missed each other. I hope Sir Walter Trevalyan is quite well. John begs me to present all the kind messages I can write that you will accept from him, but I think you know best how much he esteems you so that I will say nothing.

Excepting to ask you to believe me very sincerely yours

Effie C. Ruskin

[1] The Buckland family had known the Trevelyans and Ruskin for many years. The Rev William Buckland, a noted geologist and now Dean of Westminster, had been Canon of Christ Church, Oxford, during the time that Ruskin was gentleman-commoner at the College. Mrs Buckland was one of Lady Trevelyan's closest friends.

[2] Travel abroad was out of the question in 1848 owing to revolution and

unrest so the Ruskins had decided on a leisurely holiday at home, first at the seaside and afterwards visiting the cathedrals of southern England, Mr and Mrs Ruskin accompanying them.

[3] Effie's hopes were centred on a town house where she could enjoy the society of old and new friends; amongst these were Lady Murray, a skilled pianist and the wife of a Scottish judge, and Lady Davy (widow of Sir Humphrey Davy, Bt), a great giver of parties.

8

From Effie Ruskin

White Hart Inn Salisbury 15th July 1848

My dear Lady Trevelyan

I had the pleasure a few days ago of receiving your most kind letter while we were enjoying ourselves very much under the hospitable roof of your friends Dr & Mrs Acland whose acquaintance you were sure would give me sincere pleasure, which indeed it has, for I think they only require to be seen to know their separate worth, and I was very sorry the day before yesterday to find a disagreeable Railway which conveyed us sooner than I can write it from thence.[1]

I read your letter aloud to them and we all enjoyed it very much for they as well as ourselves had been hoping to hear where you were. I delayed answering your kind invitation, unwillingly, until we met Mr & Mrs Ruskin who would tell us their plans, for ostensibly we are travelling with them, although we went for ten days to Oxford leaving them at Folkestone, but we joined them at Winchester the night before last which place we found extremely disagreeable and noisy on account of the Assizes being there at present, and the heat was so intense that we left it and find this place very interesting and not so hot. Mr Ruskin, I am sorry to say, has had a bad cold ever since we were at Dover, which accompanied by a severe cough has cost him much annoyance. This is the only thing which prevents us from acceding to your kind request. Dr Acland told him what to do for it and I am happy to say the cough appears to be going away gradually and we think if he remains in one place and takes proper care of himself that he will lose it.[2]

We have both a great desire to come to you and if it would still be perfectly convenient for you when his cold has left him I need not say how happy we should be to come to you. Mrs Acland gave us such happy descriptions of you and your home that if possible it has made us wish to see Nettlecombe more, but I will write to you again

8

whenever John is quite better, and if then you are at home and still so good as to wish to see us we will be delighted to come. But remember we should be much vexed if you did not fulfil all your engagements and not think of us.

England is a lovely country and the wooded parts we have passed through the last two days have filled us with delight. John allows it to be beautiful in its way but grumbles about the want of hills, and goes to sleep over a book upon the Star Fish.[3] In short his heart is in Switzerland and that is all one can say. However he is happy with the Cathedrals which he is writing criticisms upon to his hearts content and cutting poor Salisbury to pieces in comparison to that of Florence, but he will tell you about it himself.[4]

How would you, Lady Trevelyan, ever suppose John & I living in a house as large and empty as a barn. When we get a house and you come to see us if we can persuade you, you will find it a small place furnished with great taste, and for a beginning to the furniture John has bought at Oxford a very grand plaster Owl which I suppose is to be the Guardian of the place.[5] John's kindest regards to you as well as mine to Sir Walter Trevelyan, and he says he is coming prepared to give his drowsiest admiration to the Taunton scenery and with this very rude speech I am afraid to add more but only to say I shall write to you again next week most probably, and believe me for the present my dear Lady Trevelyan

 Yours very sincerely

Effie C Ruskin

[1] While constructed with care and showing a proper sentiment, it is doubtful whether this phrase of Effie's would have misled Lady Trevelyan into detecting any spontaneous affection for her old and valued friends. The Ruskins had gone to Oxford for Commemoration; they had stayed a fortnight with the Aclands and Effie had been able to attend many parties.

[2] Though Effie's troubles with Mr and Mrs Ruskin were to grow in magnitude over the next six years, it was at Salisbury, and in connection with Ruskin's cough, that they had their beginnings. Her parents could remember the occasion at Oxford eight years earlier when Ruskin had spat blood and tuberculosis was feared, but now their affectionate though exaggerated fussing could not but annoy Effie. Lady Trevelyan had invited them both to Nettlecombe, near Taunton, Somerset, the beautiful sixteenth-century house standing in a great park which had been Trevelyan property for generations.

[3] History of the British Star-fishes (1842), by Edward Forbes, botanist and palaeontologist, to whom Ruskin had been introduced the previous year at an Oxford meeting of the British Association.

⁴ Later, 'under the *severe* memory of that Gothic', Ruskin would write of the 'great purity' of Salisbury spire springing like a 'foam jet', but the day following this letter an enthusiastic description of the Duomo at Florence, with its campanile 'coloured like a morning Cloud and chased like a sea shell', was entered in his *Diaries*.

⁵ A reference the Trevelyans could understand, for the Calverley crest (a Trevelyan having married a Calverley heiress from Yorkshire in the early part of the eighteenth century) was an owl, and Ruskin would have heard of the owls keeping guard at Wallington: stuffed, in the museum on an upper floor; a marble pair in the staircase Hall, carved in Athens; two in stone flanking the north door in the Great Court; another decorating the pediment of the Owl House, a garden pavilion.

9

From Effie Ruskin

Denmarkhill 3rd August [1848]

My dear Lady Trevelyan

I am sure you will think Mr Ruskin & I the most tiresome people in the world for not settling our plans about coming to you before, and now that I write we are not able to come at all to you. I do not know what you will say of us. But indeed, believe me, we are very sorry and the reason of our absence from you unfortunately cannot be helped at present so that I trust you will forgive us for keeping you so long in suspense as to our motions.

Whilst we were at Salisbury after I had sent my last letter to you and received your kind note in return, John got, I suppose from sketching too much in the Cathedral, an increase to his already bad cold which confined him to bed with considerable fever for eight days. On Monday we went to Winchester not to make the journey to London too long for him and yesterday we arrived at home. John is looking much better these last two days and his cough is nearly gone, but he thinks a few weeks in France will strengthen him very much and we propose going to Folkestone on Monday, and crossing in the afternoon to Boulogne and then going on we do'nt exactly know where. I think myself that the change of air and getting to places he has so much affection and has been pining lately so much for will do him, I hope, a great deal of good, & he requires it. Mrs Acland tells me this morning how much she regrets not being able to go to Nettlecombe and I fully sympathise with her. I feel the same myself.

You I think will like to hear that we have got a nice little house which we shall inhabit when we return, in 31 Park Street, Grosvenor Square. It will suit our little establishment very nicely.

I saw your sister's marriage in the papers. I hope it went off well, but after all it is a melancholy thing in a house.[1]

John desires his kindest regards to Sir Walter Trevelyan in which we both join to you

And Believe me

Yours very sincerely

Effie C. Ruskin

[1] Mary (Moussy) Jermyn was ten years younger than Lady Trevelyan. At twenty-two she married the Rev J. C. Hilliard, a Puseyite, later Rector of Cowley, near Uxbridge. They were married at Nettlecombe on 18 July at ten in the morning and a wedding breakfast for twenty-five guests followed. Effie, who was married at Bowerswell, probably meant to convey that a church wedding with organ, singing, church bells and a multitude of guests was a more sparkling affair than a drawing-room wedding at home.

10

From Effie Ruskin

Falaise Normandie[1] 30th August 1848

My dear Lady Trevelyan

It is quite a shame to try your eyes reading my bad writing on this thin paper, but as you kindly wished to know our movements and I shall like to write as long a letter to you as my paper will admit, I am afraid it must be on this as we have no other with us.[2]

I need hardly tell you that with beautiful warm weather, heavenly skies, & beautiful scenery we are as happy & enjoying ourselves as much as possibly can be. I have a letter from Mrs Acland yesterday perfectly delighted with Scotland which she says has made Dr Acland quite ruddy & goodnatured. I am afraid I cannot yet give France the credit of bringing roses into my husband's cheeks but he is very goodtempered and would be perfectly contented were it not for the spirit of restoration in this country which by way of improving or restoring old buildings is pulling them to pieces, not slowing but in rapid strides down they come, the black with age sides of Rouen Cathedral with all its lace-like work; statues, niches, crockets, foliated windows, which I daresay you know to be of the most exquisite workmanship, are all being demolished to make room for

staring yellow stone unrelieved which the workmen said was to be finished at some future time. The front of the Cathedral is still spared, but the whole front of St Ouen has been removed and newly built; at Lisieux the same thing is going on.

All this distresses John exceedingly and he was very busy during the week we spent in Rouen taking sketches of some of the most valuable parts and getting a number of Daguerotypes taken.[3] When we return from our tour we shall remain another week on our way back to allow him more time for sketching. The wooden houses are very interesting, but I was more struck with those of Abbeville and with the narrowness of the streets altogether new to me. We stayed a week at Abbeville (on our way from Boulogne) which John spent in draw-ing the exquisite flamboyant front of the Cathedral of St Wulfran & some of the houses in which he was very successful. We stayed in the very comfortable Hotel de L'Europe, the poor Madame was quite in despair at the want of the English this year who used to crowd her house, and excepting one lady & gentleman we have not met any of our countrymen. I wonder they are so frightened to come, for every-thing is perfectly tranquil and we have not seen any thing like bad feeling.

We went next to Rouen where, not to speak of the churches, I was very much struck with the flower market under the Cathedral. I never saw any thing so picturesque, to which the caps & other parts of dress of the women added not a little, the caps are most delicious and here in Falaise they are much more preposterous and the women much plainer in appearance. At Rouen however there is a great deal of distress amongst the workmen, and they told us that Louis Phillippe & the Duc de Nemours were so hated there that if they came they would be shot directly.[4]

We passed through most exquisite country from Rouen to Lisieux and then here where we have been a week. I had no idea France was so rich in beautiful forest country but it has not only that, but heather covered hills and low country as rich in cultivation as the South of France. The rocks stretching behind the town for more than a mile are covered with heather of the bell kind but much more luxuriant, and with many more bells. We have had charming walks, I never saw such a place for walks & with everything combined to make them perfect, trees, & fair green banks, old cottages, rocks, heather, brambles, little streams, in short every thing, and the old Chateau above all is most interesting. John drew an old Norman capital in

one of the windows of a man leading a large animal with a long snout with the man's feet in his mouth; one of John's suppositions is that it may be William the Conqueror leading the English, which the swine means, by a halter, and they not liking his guidance very much have turned restive & bitten his heels. I think John is running a race against time to try and finish before to morrow two large drawings of the castle and the principal church here. He is so anxious about finishing them that he is going to work the whole day & I am going to read aloud to him at one o'clock in the little garden under the rocks where he is drawing the castle. He has the prettiest foreground imaginable of vine with the grapes nearly ripe hanging from the rocks with Melons, Gourds, & wild flowers trailing along the ground & under the Castle or Mill with a delicious old water wheel turned by the [river] Ante. We leave this to morrow morning for Vire, Mortain, Avranches & Mont St Michel where we pass a few days then we return by Caen & Rouen. I do not think we shall be back till the end of September and we are very fortunate in not being obliged to shorten or limit our time, as at the present time it is very much at our own disposal. If you correspond with Mrs Fullerton she may have told you of Lizzie Cockburn's intended marriage[5] at Christmas with Mr Cleghorn. He is a very amiable good person & I think they will be very happy.

I hope Sir Walter Trevelyan is quite well. Will you present our kind regards to him, and believe me always

Dear Lady Trevelyan

Yours very sincerely

Effie C. Ruskin

[1] The Ruskins were in France from mid-August until October. This was Effie's first journey abroad though Ruskin knew Normandy well. JJR had accompanied them as far as Boulogne and had then returned home, but George Hobbs, Ruskin's manservant, was with them throughout.

[2] Thin, light grey-blue in colour, measuring approximately 8½in. × 6¾in., such as was commonly used by travellers in writing home to England. Later when abroad Ruskin's paper often measured 10 × 8in.

[3] Ruskin was busy all day with his pencil, sketching and making notes preparatory to writing *The Seven Lamps of Architecture* (two volumes of *Modern Painters* had already been published), and experimenting with daguerreotypes. To him Rouen was his 'ideal of Gothic proper', one of the centres of his 'life-thought', one of the 'tutoresses of all I know'; and Abbeville the 'preface and interpretation of Rouen'.

[4] King Louis-Philippe had been deposed during the revolution earlier that year;

the duc de Nemours was his eldest surviving son. At Abbeville, from where Effie wrote to her mother, 'they wanted no one but Louis Ph and it is only these villains in Paris who have caused all their misfortunes'. (For this reference, p. 14, and a further documented, diverting account of this expedition to France, see *The Ruskins in Normandy*, J. G. Links, 1968).

⁵ From Abbeville, on 12 August, Ruskin had written to congratulate her on her engagement to an Edinburgh lawyer. 'Of this I am sure – that a marriage prudently and conscientiously entered into, perfects the happiness in raising the character – however excellent – or however happy the solitary mind may render itself – there are feelings of devotion and delight which it can never comprehend. There may be disappointments – but only – I think where the expectations have been more of joy than humanity can receive – or where the *duties* of the state have been unconsidered' (Rylands).

II

From Effie Ruskin

31 Park Street 16th December [1848]

My dear Lady Trevelyan

How very good of you to write to me because I have been so naughty, for I did receive your charming letter when I returned from Normandy and I enjoyed it exceedingly, but as I had nothing to say to you at all interesting about the South of France I did not answer it immediately. The Count & Countess Bethune were also with Mr & Mrs Ruskin for three weeks during which time we lived at Denmarkhill¹ and were constantly engaged after that, not liking our servants to be so long in our house without being there, for they had been here all the time we were away, we therefore came here about a month ago and are now very happily and comfortably settled.

Our house is most conveniently situated and just large enough for us without being too small & I like London extremely.² It is very full for this season of the year and although we have been out only twice yet, in London so much is going on to interest one that I think without other more important advantages even that is not without its use.

The other day Mr Eastlake sent us to see a curious & wonderful discovery at Mr Colnaghi's,³ namely one of his young men having found out, after seven years study, a method of separating paper so as to make two sheets out of one, in a manner so neat that you cannot imagine them to have ever been joined. It is very useful in old Italian works where the letter press was on the back of the fine

prints which, shining through the faces, destroyed their value. This discovery now makes them perfectly separate even to the thinness of bank note paper. The Governor of the Bank of England was a little alarmed and sent for the young man, saying that although he separated the old works it might be by a peculiar mode of making the paper, and gave him "the Times" which he brought back in a short time entirely in two: that is each sheet printed on one side and white paper on the other.

We had Dr & Mrs Acland to dinner one day last week but they only stayed a few hours, they were very well and Mrs Acland was enquiring where you were and how you were. She returned the same night to Oxford and she was invited to meet Jenny Lind at a party. I afterwards heard she had the pleasure of showing some of the Lions of Oxford to Melle Lind with whom she was quite charmed.

I had a great treat last night in hearing the Elijah splendidly performed at Exeter Hall, Jenny Lind taking a part in English which she pronounced extremely well and sang the beautiful & sublime composition of her late friend with great feeling and correctness, not adding or deducing a single note of the original text. The concert was for the Mendelssohn Scholarships at Leipsic.[4] I hope you will get safely back to your own home and not be any worse of your Irish journey; at best being from home and going from place to place is not very comfortable at this season but you have so much spirit that I should think that with all these disadvantages you enjoyed yourself, and Sir Walter Trevelyan will be much more comfortable having you with him.[5] My husband has had a tiresome cold so that he has not been out for some days but it is going fast away and his health is remarkably good at present. He says you do not speak of your drawing and he wants to know why you send dutiful regards to him. I think he imagines he ought rather to send his to you.

It must be very painful to you to see so much distress; the number of beggars here is something quite dreadful and there are so many imposters that we have found it best to buy Mendicity tickets for the multitude and find out individual distress, but it is sometimes amusing to see how the countenances fall on presenting the ticket for they are too lazy to walk the length of Red Lion Square where they would be provided with every thing they require & work besides if they wished it.[6]

We go out next week to spend a fortnight with Mr & Mrs Ruskin for our Christmas.[7] They are both quite well. John is busy writing his

book, but presents his most *dutiful* regards together with my best ones for Sir Walter, and trusting to hear from you soon believe me my dear Lady Trevelyan

Ever yours Affectionately

Effie C. Ruskin

[1] The Ruskins reached Denmark Hill in the last days of October and remained a week. Caroline, youngest of the Domecq daughters and sister of Adèle, Ruskin's first love, had married Comte de Béthune a few years previously.

[2] The furnished house in Park Street, off Park Lane, had been made possible by the generosity of JJR. It enabled Effie to enjoy herself by going into society, and entertaining at home. Ruskin meanwhile was almost wholly engaged in writing *The Seven Lamps of Architecture*, which was published the following May.

[3] (Sir) Charles Eastlake, painter and art historian, shortly to become President of the Royal Academy (1850-65). In 1855 he was appointed Director of the National Gallery. Colnaghi owned the art-dealing premises in Pall Mall East.

[4] Jenny Lind had made her first appearance in England the previous year and had taken the country by storm. Mendelssohn had since died, and this memorial performance in the presence of the Duke and Duchess of Cambridge, the Archbishop of Canterbury, and a wildly enthusiastic audience – to which she gave her services free – was held to raise money for the Mendelssohn Foundation for Free Scholars at the Leipzig Musical Conservatory.

[5] On the day of the Ruskins' return from Normandy the previous autumn, the Trevelyans had left for Ireland having arrangements to make for the education of Alfred Trevelyan, Sir Walter's nephew, who lived at Limerick with his widowed mother.

[6] A form of charity which guaranteed food and employment on production of the ticket, but did not supply money for the pocket.

[7] This was not a success. Mrs Ruskin was critical of her daughter-in-law, and unsympathetic when she was ill.

12

Denmark Hill [Monday] 5th March [1849]

Dear lady Trevelyan

Your letter went to Scotland, where my wife is, and I received it on Saturday only: I am going into town to morrow and will bring out a little frightful memorandum of the thing you saw – a solar halo – which I will send you and then answer your letter: I am so *very* glad you are going on & liking drawing though I was sure you would by the way you began. Of course now go on to larger pieces: have you made any studies of Skies? – suppose you began with them? The Solar Halo – as far as I know – or have seen appears only on

such pale & white fleecy cloud as you describe. It ought to form a vast circle [of colour] round the sun, but can only be seen on the *light* cloud: Ruben's rainbow is in the middle of a black one and besides is much narrower and less metallic in colour than the Halo.[1] Thank you for enquiries after book. I really *am* very busy – my wife had influenza – went to Scotland for change of air – arrived only in time to watch the sick bed of a little sevenyearold brother [Robert] – whom she has just lost – she prays you therefore to forgive her not having answered your kind letter.[2]

Ever with kindest regards to Sir Walter – believe me dear lady Trevelyan

Devotedly Yours

J Ruskin

[1] Writing of the Rubens painting in 1872 (*The Rainbow Landscape;* Wallace Collection) Ruskin referred to: 'Rubens' rainbow . . . of dull blue, darker than the sky, in a scene lighted from the side of the rainbow. Rubens is not to be blamed for ignorance of optics, but for never having so much as looked at a rainbow carefully.' (R, 22, p. 212)

[2] Living at Denmark Hill he was free to finish *The Seven Lamps* without interruptions, while drawing and etching all the plates himself. The previous month Mrs Gray had come from Perth to see her daughter, and finding her in sore need of change had taken Effie back to Scotland, where she remained for the next eight months.

13

Denmark Hill, Wednesday, 7th [March 1849]

Dear lady Trevelyan

I was sorry to miss Sir Walter when he kindly called on Monday & left a sketch book which I have been looking over with very great pleasure. I am sure you must feel yourself that you are advancing in knowledge as well as power – [not] a feeling you had enough of always: you must however draw larger and carry what you do farther: You draw rocks well and will draw them perfectly as soon as you can round them: the next time you have a torrent bed to draw, get some large round masses in front of all: not *wet* and see how thoroughly you can express their curvatures: it is better for this purpose at first to take them out of the sun, as otherwise the light & shade alters before you can finish it. Do again & again until you

succeed – in light and shade: and when you have rounded the stone thoroughly put on any stains & lichens they may have, in colour, *if you like* – taking care not to interrupt the form. Painting a spotted and knotty apple is good practice: Do the same with trunks of trees, choosing smooth ones – birch – beech – & young pine. You can bring home some stones with you and paint them in your leisure realising them as far as you can.

Together with this work make memoranda from nature for chioroscuro *only*, and for *colour* only.

When you work for colour – get *that* true, though people may not know whether the red or brown thing you paint be a cow or a bunch of fern – never mind its form, but have its colour true at any cost. You cannot get both in a study from nature. You must think of one at a time. So for light and shade – make scrawls of the shapes of things, but mark *carefully* their relations of shade to the sky and to each other.[1] You will thus study form, shade, & colour on separate bits of paper: Of course if you want a likeness of a place, you must mix them as you can: but when you go out to *learn to draw*, keep them separate.

The enclosed memorandum of a gap in a thunder cloud is *not* sent as an example of success in any one of the three branches – but only as a very curious case of the solar Halo. The green under the red should be more defined. It is said to be caused by the *inflexion* of light by the borders, ridges and angles of surfaces of speculars of ice – or globules of water – but I have never read any very clear account of it.

It is connected with the colours occasioned by films upon glass, &c and I imagine as the light comes from the surface that the colours are those of the rainbow reversed. About the moon they are frequent, but colourless, forming a pale zodiacal like ring.

A curious parallel phenomenom is the double sun. I once saw an image of the sun on the edge of a cloud in the Jura – after the sun itself had set. The image was mirrored as in water and threw rays around it like the real sun.[2]

I beg your pardon for this scrawl – but it is just post time – I hope I shall be able to see some more of your sketches – by the bye – how shall I return the book I have [the sketch-book left by Sir Walter] – Ever yours most faithfully

J Ruskin

[1] In an earlier letter to Dr Acland Ruskin mentioned that he was not sure 'whether lady Trevelyan quite understood when we were talking of studies in *light & shade*, that local colour is always in such studies to be expressed with the greatest fidelity, – and not the mere incident shadow – & that whether one thing be darker than another by shadow – or be deeper tint . . . The differential amount of such depth of tint is to be expressed in the study, this will give great subtlety of perception to the eye in cases of approximately powerful colour.'

[2] In 1844, at the end of May, Ruskin entered the phenomenon in his *Diaries*: '. . . the sun's image reflected from a bank of clouds above the horizon for at least a quarter of an hour after he had set. It had all the brilliancy of a reflection in water, and if I had not seen the sun set, I should have taken it for the sun itself.' (p. 275)

14

From Effie Ruskin

Albergo Reale Milano
October 27th 1849

My dear Lady Trevelyan

I am afraid that whilst you were at Forres[1] and I going farther & farther away from you and England every day, that you often wondered why you had no letter from me, but when Mr Ruskin took me to London we only remained three days to make necessary preparations for wintering in Italy, which we determined upon doing for two reasons, namely that John has a good deal of architectural work at Venice before him, and secondly that Dr Simpson recommended his taking me to Nice or some other place for the winter months as he did not think my throat better.[2] We therefore followed his advice so far and after passing a month at Venice we intend staying the severer months at Pisa and coming home in March by way of Genoa and Nice. Our movements were so very hurried that in order to cross the Simplon we were obliged to lose no time, but we took a run to Chamouni and spent a most delightful week there. It was very amusing to witness the surprise of the people there on seeing John return, having been away only six weeks, and he is so well known there that the exclamations and holding up of hands until his return was ascertained in the valley rather took Miss Ker who is with me, and myself, by surprise. The weather was deliciously mild and the Alps a perfect beauty.

We made a very agreeable excursion to the Montanvert but coming back was not so agreeable as we got perfectly drenched with the

heaviest rain I ever saw, and as you know it is not a place where one can exactly gallop down. We were almost wet to the bones by the time we reached the Inn. We had a lovely day to cross to Martigny, but first on descending the hill at the other side, looking down the Valois, where chestnut & apple & Indian corn harvests were going on, I was so dreadfully shaken to pieces on my mule that I was too much exhausted to see or enjoy it half. The ugliness of the people all through the Valois I thought perfectly hideous, especially the women, and when we crossed the Simplon which we did very comfortably, there being no snow, and found ourselves in Italy, we were perfectly thankful to see people more like what we have been accustomed to.

We visited Isola Bella [Lake Maggiore] and to me who never saw orange & lemon trees and exquisite rare plants of various kinds before, the garden was delightful although the gardener might have it in much better order if he only took common trouble. The Count Borromeo is living there now; we saw him, he did not look particularly distressed by the fine of £20,000 he has to pay to the Austrians, but we only passed him walking. His fine Palace here is turned into an Hospital, many of the other Palaces have shared the same fate and all the nobility and gentlemen of Milan have left the town with their families. The town is still in a state of siege and 20,000 Austrians in it; we are in hopes of seeing M. Radetski as he is daily expected from Vienna.[3]

The Austrians on the whole appear to behave very well indeed and not to vex or annoy the people more than you expect, but as every weapon has been taken from the Milanese and as they feel they were entirely betrayed by Charles Albert [King of Sardinia], and had it not been for his perfidy the Austrians would never have recovered Milan. They are, as you might expect, boiling with anger at being kept in such subjection and hating their enemies from the very bottom of their souls. We hear from an English family in the Hotel that most of the Balls and shells during the blocade at Venice fell in the grand Canal, and several of the Palaces there are much destroyed. The Grimani, and the Mocenigo, Lord Byron's I think, have suffered the most severely. They are recovering slowly from the combined distresses of famine and Cholera and the common necessaries of life, such as mustard &c you cannot get, but they are doing all they can to propitiate the Emperor [Franz Joseph of Austria], and have sent to beg his pardon. Can you fancy Venice in this state.

John is glad to hear it as he thinks submission to Austria will prevent more palaces being knocked down. He is engaged in drawing nearly all day till 11 o'clock when he comes home for us to take a ramble with us to see either pictures or Churches; we are going today to see Leonardo's fresco [then at Sta Maria delle Grazie] which we have not yet had time to visit. John is now making a very nice sketch of the shields and balcony on the Visconti Palace,[4] and another from the very interesting Pulpit in St Ambroggio [repd R, 16, pl. XIV] which I think he will hardly finish in time to go to Monza tomorrow afternoon.[5]

I hope you will give us the happiness of hearing some news of you at Venice, address Poste Restante. We shall be there till the first week in December and then to Florence. Tell us what you have been drawing and how your tour in Scotland ended and where I may next write to you. I heard of you from the Cockburns in Perth; they gave me an account of your providential escape with the teapot, how thankful I was, you might have been dreadfully burned. My Father has just sent me Lord C's pamphlet on the best way of spoiling the beauties of Edinburgh, which is very amusing & sensible.

I hope Sir Walter is quite well and that you will have a happy migration to Northumberland. Kindest regards to you both from John and me and

> Believe me ever dearest Lady Trevelyan
> Your very affectionate
> Effie C Ruskin

I send this to Nettlecombe as the only address I know. I hope you found your sister & her baby quite well on your return.[6]

[1] In 1851 the Rev. Hugh Jermyn, Lady Trevelyan's brother, was appointed Dean of Moray and Ross; at present he was Vicar of St John's Episcopal Church at Forres. The town was situated on the bank of the Findhorn and its wooded hills served Lady Trevelyan for many tree studies.

[2] The eight months Effie had spent at Perth had not entirely cured what seems to have been a nervous disorder, but she had enjoyed herself and viewed her return to her husband with misgiving. Ruskin meanwhile had spent his time, mostly at Chamonix, as he loved best; his excitement at being again in the Swiss Alps ('a moment which I had looked forward to, thinking I should be almost fainting with joy, and should want to lie down on the earth and take it in my arms') was the more intense for being without his wife. On his return in September he went to Scotland, fetched Effie, thought perhaps to see the Trevelyans in Northumberland, and after a very few days at home, they were on their way to Venice with Charlotte Ker, a friend of Effie's, accompanying them.

[3] Milan and Venice in their fight for liberation were now in the hands of the Austrian army under the control of Field-Marshal Radetzky, the Civil and Military Governor. Writing to her father on the same day, though later in the afternoon, Effie was more communicative in her account of the delights of Milan, with an emphasis on the officers and men who galloped after her carriage on the Corso.

[4] Ruskin would of course have known that Lionel, Duke of Clarence (son of Edward III), had married a Visconti in 1368, and that Chaucer ('teacher of pure theological truth') had once served as page in his household.

[5] Looking back on the drive to Monza in after years, Ruskin would recollect 'going from Milan to Monza and Como, and jumping off my carriage to show Monte Rosa, and being vexed because nobody cared about it' (*Diaries*, p. 444).

[6] The Hilliards' first child, Frederick William.

15

From Effie Ruskin

Albergo Reale[1] Venice
[probably second half of] Jany [1850]

Dear Lady Trevelyan

I received your most kind letter shortly after I came here and have intended some time ere now writing to tell you about Venice. I am afraid however you will have no Pisa letter for we have lingered so long here that our stay there if we go at all, will be a very passing glance indeed. We have been now nearly three months in Venice which is the most entirely delightful place I ever was in and I look forward with the greatest possible regret to leavingn it ext month.

I do not know how it looked when you were here but excepting the tristesse which must follow recollections wherever they go, the place is, I believe, the same as it always was, and with the exception of a few of the Austrian Bombs tumbling through roofs of Houses[2] no harm has been done to any of the Palaces, at least the outsides. The insides are not of so much consequence for the original rooms have been so often changed, according to the lists of their then possessors, that a new roof or floor here and there can be easily replaced. Not so however had the outsides or windows been damaged, these could not have been mended or replaced.

Mr Ruskin is busy all day till dinner time, and from tea till bed time we hardly ever see him excepting at dinner, for he has found that the short time we are able to remain is quite insufficient for the

quantity of work before him. He sketches and writes notes, takes Daguerotypes and measures of every Palace, House, Well, or any thing else that bears on the subject in hand, so you may fancy how much he had to arrange and think about.[3] I cannot help teasing him now & then about his 60 doors and Hundreds of windows, staircases, balconies and other details he is occupied in every day. The weather has interrupted him very much lately, we have had three such snow-storms as the people have not seen here since 1829, one after the other. No sooner had the Gondoliers cleared St Mark's Place and the Riva in front than another storm began, and the Canals were quite full of snow and ice and when the thaw commenced it was hardly safe to go out for the snow fell in such masses from the Housetops. John's Gondolier one day was nearly sunk (so he says) and was only saved from receiving a complete avalanche into it by a dexterous stroke of the Gondolier's oar.

Although I have before mentioned that Venice, at least the stone work of it, has not suffered from the revolution, the effects are very sad, everything is dull and spiritless and the Italian nobility seem to be behaving with such a want of moral courage and at the same time so entirely against their own interests, that one can hardly under-stand what kind of argument they can have for such conduct. Since we have been in Italy we have become acquainted with several Austrians and also with some Italian families of rank so that we hear plenty of politics and both sides of the question, and one cannot help getting much interested in questions of so much importance to Italy as they are constantly discussing.

Most of the Venetian families have remained at their country houses or have gone into other countries instead of coming back to their Palaces here which Radetski has entreated them to do to pro-mote a spirit of industry amongst the trades people, but they are so afraid of what the Republican party here who still exist will say that they think it looks better to remain away. They are in fact much more afraid of their own townspeople than the Austrians from whom in fact they have nothing to fear. The first night the Fenice [theatre] opened for the Carnival about a month ago the Republicans set men to watch at the doors all the Italians who entered; a number had come in from the country to go but on hearing this, as we were witnesses, not one person came excepting the Countess Mocenigo, who however is a German.[4]

Even the Church is out of fashion and nobody goes during all the

23

Christmas solemnities, at all of which I made a point of being present, excepting a number of the very lowest people who rushed with paper-bags after the candle bearers to gather the wax. There was never any one to be seen there but Austrians and musicians. I asked an Italian one day the reason of this. Oh! he said, it is not respectable to go to Church, nobody ever goes, and the Priests teach a false doctrine. I have asked many since and they all answer the same that the present religion is not the thing at all and that their pastors show them no example, and as for the Pope, he betrayed them and they have the greatest contempt for him. In short they say Venice is dead and all Italy is dead, and when you ask if they expect things soon to be different, they shrug their shoulders like the French and do not answer. From the way the Italians take all Radetski's offers of kindness (for he is mildness itself and not one of the fines which were levied on the different families have been paid or ever will be) one cannot help being angry with them. Radetski said the other day that he would give dinners and balls at Verona and if the Ladies did not go his officers should waltz together. He gave one ball last week and I asked Madame Minischalchi[5] if she went. Of course not! she assured me, all had colds!, and now she & the Count are en route for London and intend returning in June to see how things are getting on. We have seen Marshal Radetski many times; he is truly astonishing, his figure is very upright and he walks very firmly. His hair is grey and his eyes very much inflamed which detracts from his personal appearance. Everyone says he is very good, and those attached to his person have a great affection for him. He sent for his Countess the other day to come and stay with him at Verona. She came and is a thin little woman with a flaxen wig, no teeth and a cap. They had not met for *thirty* years before but had always corresponded and been on amicable terms, and now I suppose they will continue to live together.

Radetski was here the other day on business. The governor of the Arsenal and one of his officers had been murdered by an Italian who immediately afterwards killed himself and an enquiry was held by Radetski. The second day there was a Parade of the Austrian troops in St Mark's Square where the Marshal decorated two young Croat soldiers with Medals. The troops here behave extremely well and one never hears of or see them doing the least wrong. They all buy and pay for their own food and the people in the shops seem quite satisfied with their honesty.

John begs his kindest regards, he was rather indignant at your thinking he would be required to be teased before he would visit you, and he begs me to tell you that so far from this being the case, he certainly intends seeing you this year DV. at Wallington, which I hope you are now comfortably settled in and your household cares becoming lighter every day. The coming spring will enable you to get your flower garden begun. When I first came here I felt much better but lately I have been very poorly, and our friend Mr Rawdon Brown who is the only English resident here now, brought a Friar, one of the Fate-bene-Fratelli to see me who has made me much better, he is so kind and so humble and quiet that it is a great treat to see him.[6] He brings me a bottle of new milk across the Lagoon every morning from the Cows in the Monastery, and every day he thinks me better. I hope Sir Walter is quite well. Give him my very best regards. We shall be here till the 9th February and then to Verona for ten days & I might beg a letter Poste Restante either here or there will find me and as I am forbid to write letters excuse this short one and believe me Ever most affect

<div align="right">Effie Ruskin</div>

[1] A slip for Hotel Danieli, where the Ruskins had arrived in the second week of November 1849. It is possible that Lady Trevelyan's letter, to which this is a belated reply, was directed to the Reale in Milan (see Letter 13) and Effie, with the letter under her eye while writing, would have inadvertently made the slip. This letter is probably a week or two earlier than Ruskin's (Letter 16) in which he is concerned by news of Lady Trevelyan's ill health and begins his letter by seeking reassurance, while Effie here ignores it altogether.

[2] In July of the previous year.

[3] Ruskin was working at full stretch, collecting material for *The Stones of Venice*; his diary entries are wholly concerned with notes on Venetian architecture for which he said he filled six hundred quarto pages.

[4] She was Austrian; Effie often confused the two.

[5] A wealthy Veronese family.

[6] Rawdon Brown became one of the best known Englishmen in Venice, his researches and calendaring of Venetian state papers occupying him for many years. He was inclined to be irritable and quarrelsome, but delighted to be 'thought of – in little things or great', as when Effie gathered him three wild strawberries and gave them to him on a piece of Venetian glass (Bradley, p. 276). The Friar brought milk from his small island monastery in the lagoon.

Venice 27th January [1850]

Dear lady Trevelyan

I have been three months intending to thank you for your delight-
ful letter to Effie – of which I had my proper share and now my letter
of thanks becomes one of inquiry – touching the illness of which you
say only enough to make us anxious, in your note to Mrs. Gray.
I think it must be serious illness indeed which could make any one
stay in Edinburgh at this time – and I am very honestly and very
thoroughly sorry for it, and I pray you to send us literally a *line*
when you have time – to tell us you are better – if as I hope you may
already send us so good news.[1]

Meantime again and again thank you for your kind invitation. I
shall not call your county hideous – or if I should – it will be hideous
in a noble sense – like the "Frightful there to see" of Coleridges lovely
lady.[2] There *is* a wildness about those Northumbrian hills which might
seem to deserve the ill name, if they were set beside the blue ranges
I see every evening here against the sunset: but I love that dreary
northern look with all my heart – ever since at seven years old, I was
shut up – to my very hearts delight – by a foot and a half fall of snow
in Alnwick.[3] Nor indeed have we any right – even here, to speak dis-
paragingly of Northumberland – or any place else – we have had
some five weeks of continual frost; and a week of snow – a fall of
some nine inches, with an after fall of three or four more. The Italians
did not trouble themselves to sweep it off their house roofs – and,
after passing the whole summer in as close neighbourhood to Mont
Rose and Mont Blanc as my best climbing could obtain for me, with-
out so much as a snowflake coming in my face – I was within a
half gondola's breadth of being *sunk by an avalanche* – in Venice!
Half the roof of a house cleared itself at once; and the sheet of snow
came crash into the canal just missing the boat. St Marks place was a
new and most strange scene – one white field like a mountain lake
frozen over – (for the people only swept the arcades, and left the
centre untouched) – the domes of St Marks as white as the Dôme
du Gouter: and the traceries of the Doge's palace drawn in sugar –
and looking like the Gothic on a Twelfth Cake. Nor was the Grand
Canal less strange. The rich balconies were all laden with snow –
and draped with it so [sketch] – instead of white silks and satins
as they used to be – the sky was dark leaden colour above – and the

sea water was thrown out in its own pure but gloomy green – looking strangely dark under the white frost-work of the houses – and the sea gulls – driven by the cold up to the Rialto – were drifting about everywhere *slowly* like great snowflakes themselves – with the deep green of the water reflected in a pale aquamarine from their breasts.[4] Well – this was all satisfactory enough – a thaw came at last – and after being dripped upon for a week by all the tiles and spouts in Venice, I thought the thing was at an end – when one morning, drawing out of my boat as I usually do, (just under the Bridge of sighs) – I found something unusual the matter with my colours. Water wouldn't melt them – and on my poking at them, I found my brush had become a bit of stick. It – and they – were fast frozen.

I don't usually go out in this kind of weather to draw elsewhere – but I *have* worked in winter time many a day – and such a thing never happened to me before. I dropped the pencil & took the oar – and entering the lagoon towards Murano, I found it one sheet of ice as far as the eye could reach. I fully expected – if the thing held, to be able to *walk* to Torcello in another day or two – but it relaxed gradually – and I hope the worst is now over; and that the move as the chief object of my bringing Effie to Italy – to obtain a milder air for her – has been thus entirely missed. You will say – why did you stay in Venice – but from all I hear – things are as bad at Naples – and of course at Pisa as they are here. Effie is – if that be possible – fonder of Venice than I am – and I think it *is* possible – for she has perhaps some two thirds or three quarters of my pleasure in St Marks and the Doge's palace – without suffering my pain from the sight of restorations or ruins.

While I mourn over cannonshot, & quarrel with Carpenters, She is making friends with Austrian officers – and projecting improvements in saloons – while I mutter and growl at the people, she is chatting to them and laughing at them – and – if she were not still ill, poor thing – would have decidedly the best of it. Ill however she is – yet better for every breath of Sirocco she can catch – and much bettered lately by the care and advice of a monk – no – not a monk – but a Frate of one of their benevolent societies – one of those who have the care of the Lazaretto. He pets her and encourages her – and gives her milk, as fresh as if it were out of her Bowers Well pail[5] – and has a nice quiet watchful way which makes her trust him – as I do – far more than most physicians: I hope to be able to write to you that she is ready for Northumberland one of these days. So –

Effie being thus content in Venice, and I finding the work I proposed to myself not to be accomplished without various hunts over the shelves of St Marks library, we have lingered from week to week - and Pisa and Florence are to be visited only because we *must* go round by the Maritime Alps at any rate – but we shall not stay ten days at either place. I have not been able to *draw* much – owing to the weather – but I have got some architectural facts together – and kept records of things which must soon be swept away: I have been working hard – but the subject is intricate beyond all imagination – and three months vanish in making even the approaches to its elucidation.

Can you conceive that it should be an open question with Italian antiquarians whether the Ducal palace dates from 1350 or 1423?[6] Yet so it is – and among the private palaces the dates are about as fixed as those of the Pyramids.

However – I must not lose myself in this Venetian mist – to which Scotch mist is transparent – nor weary you with our letters as we have done with our silence – I hope however you have by this time received Effies letter. She writes little at present – your letter – long as its answer was delayed – was I think the first she did answer – except those from home, since she came here.

I long to see some of the studies made on the banks of the Findhorn among the pools and pines.[7] You know I have a sketchbook of yours at home – I hope to be able to restore that – and borrow another – this coming spring. Those brown Scotch rivers *are* delightful – and the more so, because one can paint anything: the Swiss greens and blues are very well as long as one can look at the real thing – but they will not dry in portfolios. I have something too to show you in the way of glaciers – though I was fearfully beaten in Switzerland. Our sincere regards to Sir Walter –

> Ever dear Lady Trevelyan
> Most faithfully Yours
> J Ruskin

[1] It would be a long time before such news would be forthcoming for Lady Trevelyan's health was never completely restored, but she was so courageous and showed so gallant a spirit that few were aware that she was rarely out of pain. In February of this year there were indications of peritonitis.

[2] *Christabel*, pt ii.

[3] Presumably in the autumn of 1826 on the Ruskin family's homeward journey from Perth, but no reference to Alnwick has been found.

⁴ Though Ruskin never repeats himself it is interesting to note that the beauty of this passage is echoed in his *Diaries* on 9 January: 'Sea Gulls. It was lovely to see them in the grey darkness of the snowy sky, with the deep local green of the sea – the dark canal – reflected in their white under bodies in a dim chrysoprase, opposed to the purply grey of their backs. Their wings are edged with white in front and they were pausing continually at one or two feet above the water, flapping their wings slowly like moths.' (p. 457)

⁵ Effie was delighted to find the milk 'as good as any Scotch milk I ever tasted'. (Lutyens, ii. p. 113).

⁶ The great gothic palace was finished in 1423, but it had taken over a hundred years to build. To Ruskin its completion represented 'the central struggle of Venetian life' during Venice's entire gothic period.

⁷ See Letter 14, note 1.

17

From Effie Ruskin

Montélimart 1st April 1850

My dear Lady Trevelyan

I was sorry to hear from Lizzie Cleghorn yesterday that you were still in Edinburgh and confined to your sofa. She did not say that you were ill so that I hope it is only your extreme patience and obedience to Dr Simpson, who wishes to make you quite strong before you leave his care that keeps you a prisoner and not personal sufferings, but I did not know what to judge from your long and kind letter to me at Venice because you write in such excellent spirits that one could not learn from your letters you were an invalid, but one may be very ill for all that, and I am afraid you were more indisposed than you liked to allow from the fact of your still being in Edinburgh.¹ If you have any leisure second in your conversations with Dr Simpson, who I think one of the good and talented of the earth and as you say persuasive to the last degree, pray remember me most kindly to him for I think he cannot have forgotten us, especially as I have consulted him since I was in Venice; say to him I am much better but not well and that the Italian winter from its severity was particularly unfortunate for me. Sometimes I think I am quite well and then again my throat hurts me, and sometimes I think I am as ill as ever. The summer weather that is coming will I hope do us both good. Your illness cannot have interfered with your beloved occupation, drawing, for my brother & Lizzie tell me you have some beautiful drawings in the Exhibition² which I assure you rejoices the

heart of your *Master*, as you modestly call him extremely and he was particularly glad to hear of a certain [illegible] beech tree & water lilies which I think he said he knew.

I am sure he will be delighted to lend you any book of sketches that will be of the slightest use to you, only please come and get them in person, for I should like above all things to take a lesson from you in seeing you take one from him, and I am sure if you are in London this season that you will succeed in getting a good many lessons and in seeing him which he declares nobody shall, and all the way home up to this point he has been declaring that when he returns to Park St he is to shut himself up from the naked eye to write his book, which he thinks will do better service to mankind if he continues in a good humour with them all the time he is working.

We left Venice with extreme regret and you will hardly believe it, that I was the most sorry. John I think got to love it less as he stayed, and I think the utter degradation of the Italians had principally to do with it, for he had no where to walk & their dirty habits and continually interested mottoes were ever before him, and as he was much brought in contact with them he was proportionally disgusted and he was quite disheartened in his hopes of any betterment in the higher classes, for they too are sinking their country still lower by their sulkiness and indolence; and after he had carried away all his work from Venice I think he felt almost relieved to be away from a place which gave him so much distress, but I think he will go back again for he has still other portions of his subject unexplored, and I am so very fond of the place that I shall urge him to return. I found some kind friends there who did every thing in their power to make me comfortable & happy in which they easily succeeded for I was very happy before but [?not] as to creature comforts which are not to be despised in Italy. One sent me bread, a second milk, and a third flowers every day nearly, the first two being regular.[3] I saw something of society too, both Italian & German. I did not approve of either, but the former most; separately the Austrians are worth knowing and I improved my German, which I am particularly fond of, as much as I desired, that is to say little did I speak, for with foreigners I found it was not at all necessary and I wonder half of them don't die of the talking disease for they all seem to try in any discussion however trifling who can talk most in the shortest space of time and all together.

We spent a pleasant week at Verona and the Scaliger Monument

underwent a thorough examination, and John had me at the top of a long ladder to see the features of Can'Grande which he pronounced to be vulgar and commonplace. I did not think much about going up a ladder as I was to see something I had not seen before at the top of it, but when I reached the ground I was rather annoyed and covered with blushes by seeing that the Veronese had collected to a considerable number and gave me a sufficiency of staring as if I had done something quite out of the ordinary coarse of things. We have been travelling every day since we left Verona and only rested on Good Friday at Brignolles and yesterday at Avignon, the architecture of whose churches struck me as being very barbarous after wintering amongst the Italian Gothic. The coast of Genoa I found inexpressibly lovely and each succeeding place seems more rich and beautiful than another, but I think Mentone is the culminating point. The oranges & lemons were without number, and the fields quite Republican with blue & red and white jonquils. We reach Paris on Monday, stay a day or two, and then if I may hope for a letter one will find me at my old address 31 Park St, Grosvenor Sqr.

I hope Sir Walter is quite well, give him our best regards and tell him from me that I hope some of his onorous duties as High Sherriff[4] will bring him to London although I can't tell you at present why they have any connection. John's kindest remembrance and my best love & believe me Ever Yours Affetly

<div align="center">Effie Ruskin</div>

[1] Lady Trevelyan was indeed very ill and suffering great pain. Simpson had diagnosed a tumour, but was hopeful as to its progress.

[2] At an Edinburgh exhibition.

[3] The bread had come from Rawdon Brown, the milk from the friar, and the flowers most probably from Paulizza, an officer in the Austrian army who was Effie's great admirer in Venice.

[4] Sir Walter Trevelyan had recently been appointed High Sheriff of Northumberland.

<div align="center">**18**</div>

From Effie Ruskin

<div align="right">31 Park Street Nov 1850[1]</div>

My dear Lady Trevelyan

Although you rather insinuate that I wish to cut my acquaintance

I assure you I have never thought of such a thing and only last week in Edinburgh I was making numerous enquiries all about your health and general wellbeing from Lizzie Cleghorn who I went to call upon for half an hour in passing through to return home.

I wrote you a letter to Abbeythune[2] which I suppose from your not mentioning you never received, and whilst I was in Scotland I was so much occupied attending Mama who was confined of a fine little boy about a month ago, that playing with the children, taking care of the house and enjoying myself and getting strong with country walks, I had no time at all for writing as John insisted on a letter every day and I was away from him two months; before that we paid two visits in Shropshire and afterwards John took me a little excursion into Wales where we had rainy weather & the country and people looked very boglike and Irish, so we left them and went to Perth where John left me.

I think we shall be here till next summer and hope you may soon come our way for I fear we shall not be in yours.[3] How I wish I had only one room more that I may lay it at your feet as the Mexicans say, but my little house is quite full and an extra bedroom is all I want to make it very comfortable for us. John is deep in his Stones and occupied with Printers people who do mezzo-tints and litho-graphs, spoil some and make more work, and John is so delighted with his work and so happy that I assure you it is a great blessing to live with a man who is never cross nor worried but always kind and good. He was at Oxford last Saturday with the Aclands, standing Godfather to their last baby who is about three weeks old.[4] He says they are very well but Dr Acland has too much to do and he would not lead the life he does for the world. I am much better than I was and quite gay and merry. John sees the greatest difference in me since I was in Scotland but I had been improving in strength ever since I was in Venice which is the most exhausting place in the world and where I hope to go next year DV.

Whilst I was at Perth I had a visit from a nutual friend of ours Sir James Murray who talked to me a great deal about you and praised you to a degree, which I am afraid would almost make Sir Walter jealous only he must have got accustomed to that sort of thing by this time. By the bye, coming from Somersetshire do you know anything of a Mr & Mrs George Dennistoun of East Brent Cross.[5] He I think is much occupied about the present state of the Church; if you could tell me something of them I should be very much obliged to you,

but if they are intimate friends of yours you will easily tell me some-
thing of them. John sends his most kind regards to you & Sir Walter
and hopes you will tell me in your next what you are busy about
just [now], he was so much delighted with your domestic troubles
although believe me, we sympathised, and I remain Ever yrs

 Most Affetly

 Effie Ruskin

[1] The Ruskins had reached home at the beginning of the London season. Effie
had found it gay and exhilarating and had enjoyed herself. In August, after some
country visits they had gone to Perth, where Ruskin left Effie with her family for
two months. Her brother Albert was born shortly before her return to London.

[2] A house in Lunan Bay, twenty-five miles north of Arbroath.

[3] Back in the London house Effie entered upon a round of activities while Ruskin
spent the daytime at Denmark Hill working at *The Stones of Venice*, avoiding all
social engagements so far as possible, though finding to his great vexation that he
was obliged to attend more evening parties than he cared for. Adding up the time
spent in London in the last two years, he later could only remember 'ten or
twelve pleasant evenings passed in society' (Bradley, p. 85). The Trevelyans were
in the north, Lady Trevelyan rather better for her sea-bathing at Abbeythune
during the summer, and Sir Walter had been in London and was taken by Ruskin
to call on G. F. Watts at his studio. At about this time Ruskin had bought Watts's
painting *Archangel Michael*, which he hung in the Park Street house. In the early
part of the following year Effie sat to Watts for her portrait (National Trust,
Wightwick Manor) and it was probably of this drawing that Ruskin wrote in
1873 to Watts: 'You drew [illegible, possibly 'my Wife'] for instance – trying to
make an angel of her – she was not an angel, by any means.' (Watts Gallery)

[4] The Aclands' second son, Harry, was born on 14 October and christened
Henry Dyke on Saturday 2 November. A slip in Ruskin's *Diaries* gives this date as
2 October.

[5] Sir James Murray, physician and discoverer of fluid magnesia. George
Denistoun was the son of a Glasgow merchant and the younger brother of James
Denistoun, friend of the Trevelyans and author of *Memoirs of the Duke of Urbino*,
which book Lady Trevelyan reviewed on publication (1851).

19

From Effie Ruskin

 31 Park St 1st March [1851]

My dear Lady Trevelyan

 Your friend Miss Mackenzie has just been here and has told me
how very ill you have been since you began yr note to her. I am so
disappointed to learn that you are still subject to these attacks of

illness from which you suffered so much last year, but I hope you will soon give us better accounts of yrself, and do Dr Simpson credit by getting strong.[1]

Miss Mackenzie I have seen several times lately and was promising myself the pleasure of taking her to Denmark Hill some of these days to see the Turners, but I hear that the Pictures are not at Home for a fortnight as the walls on which they hang are being cleaned. What a fine noble creature Miss Mackenzie is, there is such a repose & power & depth about her at the same time.[2] The other night at Sir G. Clerk's Concert Lady Eastlake[3] and I were admiring her fine head & calm expression through some hundreds of uninteresting ones. I think this year we shall see more of each other, and I shall deem myself happy if she likes me half as much as I am sure I shall her.

John is very busy now with his second volume of the Stones, his first comes out today as well as a Pamphlet upon some ideas of Church Government which he calls "Notes on the construction of Sheep-folds".[4] I am afraid you will not like it but be sure and read it and tell us exactly what you think of it. The large plates of the Stones for the Portfolio which is to be separate from the Book are very fine I think and I hope John will receive sufficient encouragement to enable him to engrave as many as he wishes to because each plate costing £50 is too expensive an undertaking for him to make without some public aid I believe.[5] I hope Edinburgh will not treat you to East winds while you remain & prevent you getting out of doors & fresh air which is so valuable to health. I find when I do not walk with John early in the morning it makes the greatest difference to me. London is, I think, very gay notwithstanding all the important subjects which are agitating mens' minds now about the government. John & I have quantities of Invitations but I limit myself to twice a week. I am better but not strong and require to take care of myself. I hope Sir Walter is quite well and give him my best regards & with dearest love to yrself Ever Believe me

 Yr most Affect

 Effie Ruskin

[1] Lady Trevelyan was seriously ill again; on 21 March she underwent an operation and did not recover strength until September. Louisa Stewart-Mackenzie (Loo), later the second wife of the 2nd Lord Ashburton, was a vivacious and strong-minded woman of twenty-four, of handsome appearance. At the age of fourteen she had met the Trevelyans when her father was High Commissioner of Corfu. She became one of Lady Trevelyan's closest friends and was often at

Wallington. Ruskin's impression was of a 'romantic young lady – just on the edge of the turn down hill' (Yale). Probably too forceful a type, it was not an acquaintanceship he did anything to foster.

[2] Meanwhile Lady Trevelyan was writing to Louisa about Effie. 'She is so honest and truehearted and loving, her manner at first does her injustice.' (R. Trevelyan)

[3] In 1849, at the age of forty, Elizabeth Rigby had married Eastlake. She was an able and regular contributor to the *Quarterly Review*. Writing to his father from Venice the following year, Ruskin asked that a basket of 'anything fresh or nice in flowers be sent her now and then'. JJR must have moved with dispatch and Sir Charles wrote directly to acknowledge the '*beautiful* flowers and cucumbers' (Bradley, pp. 269, 279). Lady Eastlake was ill disposed towards Ruskin and encouraged Effie to leave him.

[4] This is an exposé of the Church Visible and Invisible; on discipline and divine doctrine; and an attack on High Church practice. Lady Trevelyan was a professed Puseyite and found the work distasteful. 'I think it is weak (besides of course not agreeing with its principles),' she wrote to Loo. 'I don't think it is in any way worthy of him . . . It is a thousand pities he should go out of his own line, unless he has something better to say.' But her admiration for *The Stones of Venice* was unqualified. 'It is full of beautiful things . . . I doubt it wont be a popular book, common readers find it difficult . . . and professional people of course will find fault with it. I still hope there are a great, great many who will read and profit by it.' She ended her letter by conjecturing that Ruskin would be happier leading a 'quiet country life, but I agree with you that she [Effie] would find it a trial at first' (R. Trevelyan).

[5] *The Stones of Venice* ii and iii were published in 1853, but the drawings, in atlas folio size entitled *Examples of Venetian Architecture* and issued in three parts, failed to pay and were discontinued after volume i, Ruskin referring to them at the end of this same year as 'my unfortunate folio publication'. These are now incorporated, reduced in size, in R, 11.

20

8th March [1851]

Dear Sir Walter

I heard last night of Lady Trevelyans dreadful illness, if you can send us any good news I should be most thankful. Pray write to us – if possible.

Ever faithfully Yours

J Ruskin

Sir Walter Trevelyan Bart.

[Casa Wetzlar] Venice, 22nd September [1851]

Dear lady Trevelyan

Your letter was sent to me into Switzerland – missed me – and lay for a fortnight in a sulky portmanteau – it found me at last here – and made me very happy – first by telling me that you were getting well and then by all its various kindness.[1] We have been able to hear nothing positive about you for some time so that its good report was doubly welcome – only it seems so cheerful and hopeful that I am afraid you let yourself be too much stirred by that strange sense of recovery to daily interests of which you speak. I trust you will be cautious – and not trouble yourself to write notes of thanks for six-penny pamphlets[2] – whatever else of kind or good you may do. And don't *let* the world be noisy about you – shut it all out. I am sure it is a very healthy sensation – not a sick one by any means, to feel it turbulent & wearisome. Poor Henry Acland – of whom you ask me, staid in it too long and when I last saw him was grieviously ill[3] – at last he yielded to the threatenings of physicians & prayers of friends, and just before I left England he had gone to rest himself in a place certainly – but for the sea waves, quiet enough, the island of Sark in the Guernsey group. I hope he is there still. I had a little too much of London myself and was very feeble when I left it, and am never going to let my quiet habits be broken through again. – by the bye I hope you have guessed by this time that I am there no longer. I do not suppose you would think me capable of leaving your kind letter unacknowledged all this time, had I received it sooner.

We are in lodgings here – so comfortable that I feel for the first time in my life as if I were really in my own house – I always con-sidered Park St as lodgings of the most disagreeable kind – and did not even trouble myself to arrange my books there. But here all my possessions are in order – down to my inkstand with One pen in it! – no more – & my pencil case with three pencils in it & two brushes. And I am beginning to consider myself an exemplary person. As for Effie, I have no doubt she is a very examplary mistress of a household also – for she is scolding from morning till night; and is always discovering something wrong. Certainly there is a good deal of that to *be* discovered; and I begin to see that the Italians are complete animals – mixtures of dog & cat (without the fidelity of the one or cleanliness of the other) – but still manageable by watchfulness &

plenty of Stick. They must be made to "eat stick"[4] on all occasions; and appear, when well abused, to get rather fond of you – and capable of a good deal of steadiness in affection: I have not as yet been able to perceive a *ray* of *gratitude* in any of them; if you are kind to them they consider you a fool, and treat you accordingly: Several persons who know them well tell me that if you jest with them, you may do anything with them – and this I believe – but cannot jest with them: so must get on as well as I can in an atmosphere of Scolding; for the present. I hope the scolding will die away as our people get to do what we would have them, by habit. Effie is very fond of them all the while – I let them get the better of me, and dislike them very heartily therefore: and yet I can see that under all that is bad in them, there is the making of very noble people – but for their unhappy religion.

So I am to fight out my quarrel with the Pope – am I – without saying anything about any body else.[5] Well, but then, are you Tractarians going to be quiet? You say you are down – I had no idea of that – I thought you were in great strength and that there was a Tractarian curate – *or* rector in at least three parishes out of seven over the whole country: I know that all my Oxford friends – with one exception,[6] are divided between Tractarianism & liberalism – and are determined to let the Catholics have it all their own way, either because they love them – or because they don't care about religion at all. Such members of parliament as they make! the men whom I used to have hot suppers with. They will give all England a hot supper, one of these days – if they don't take care.

Meantime I am rejoiced that you like anything I have said about your preRaphaelites[7] – and that you are again drawing yourself – When you are *quite* well again – please tell me what you are doing – something very noble ought to come of those studies of trees. I have lately much delight in studying Albert Durers illustration of the Revelation [the *Apocalypse*] – if you have them not – get them – woodcuts – worth about 2 to 3 pounds the whole set – don't be disgusted with their coarseness – but examine them well, reading them with the text. I cannot keep this letter or I should give you more to read than would be right. Best regards to Sir Walter. Effies love to you. Ever most faithfully yours

J Ruskin

We shall be here, I trust till April. Direct Casa Wetzlar: Campo Sta Maria Zobenigo.

The way Albert Durer has read the Bible is so interesting. Thus you will see he interprets the Seal of God to be the Cross – the angel ascending from the east has it & the seated [kneeling] multitudes are receiving it on their foreheads.[8]

[1] The Ruskins had left England in August for a second winter in Venice, staying ten days in Switzerland on the way, and were now settled in their new lodgings on the Grand Canal. Ruskin addressed this letter to Wallington, but sent it first to JJR with directions to read, seal, and dispatch; to it he added his letter from Lady Trevelyan – to which this is a reply. 'Her letter is enclosed also', he wrote to his father, 'which I am sure you will like – You will see she is clever if you knew how good and useful she was also you would be flattered by her signature to me – "your ever dutiful and affectionate Scholar".' (Bradley, p. 18) Effie writing home the same day announced that on moral grounds she had refused the theatre box offered her by Ruskin to see *Phèdre* played by the great Rachel, who 'they say is such a very bad person', drinking herself to death with gin.

[2] *Notes on the Construction of Sheepfolds* was priced at a shilling a copy.

[3] This was not the first breakdown from overwork. The Trevelyans had known Dr Acland in Rome in 1838, when he was recovering from nervous prostration.

[4] A phrase used by Lady Trevelyan to her dogs.

[5] Presumably Lady Trevelyan had resented Ruskin's reference in the *Sheepfolds* to 'Romanist heresy . . .' (the 'priest's power to absolve from sin: – with all the other endless and miserable falsehoods of the Papal hierarchy') being coupled however indirectly with Tractarianism, for which Ruskin had an underlying, and occasionally overt, antagonism.

[6] Probably the Rev. Osborne Gordon, Ruskin's Oxford tutor and friend.

[7] On 13 May *The Times* had published a letter from Ruskin defending the Pre-Raphaelite artists and their paintings then showing at the Royal Academy; pressed by Millais, Coventry Patmore had approached Ruskin to write in their defence. Ruskin followed this up by a further letter at the end of the month, and in the middle of August his pamphlet on *PreRaphaelitism* was published. Lady Trevelyan needed no converting; she was already an enthusiastic admirer of the P.R.B., and earlier may well have added her word in support. She reviewed Ruskin's pamphlet for *The Scotsman* in the new year.

[8] The woodcut of *The Four Angels Holding the Winds* (Revelations 7, vv 1–3).

22

From Effie Ruskin

Herne Hill,[1] Dulwich 25th July [1852]

My dear Lady Trevelyan

I have been a fortnight nearly in England but what with moving into a new house, want of servants and quantities of workmen and other troubles, I have not been able till now to answer your kind

note. That we left Venice after a year's residence there with much regret, you will easily believe. We passed the St Gothard in the finest weather and saw Lucerne and other places to great advantage, and are settled here for some time to come I believe. Mr Ruskin found so many interruptions in London to his work & quiet habits that wishing to be nearer his Turners he has rented a house in which we are now residing about ten minutes walk from his Father's house. He now intends to finish his second Vol of the Stones and 3rd Vol of Modern Painters at his leisure. Much of his time is at present spent in Mr Turner's house[2] where he finds boxes and drawers *full* of most wonderful drawings of untold value which he is glad to look at now as they will probably be sold afterwards, as determined in his will, but John is anxious to get rid of the executorship as it might cause him a great deal of trouble if the case remains in Chancery where, if all Mr Dickens says is true concerning that establishment, it is likely to remain some time.[3]

Thank you very much for wishing us to come to Wallington. You must really think us the most ungrateful of our species, but you know we have been such wanderers that we must stay a little at home when we are in England – and I suspect this Autumn that we shall not move again, and if I go to Scotland to see my family I do not think I shall trouble John to go with me as I know how much he has to do, but he thanks you very much for remembering him, and wishes to see you again very much so that you may depend on my taking advantage of the first symptoms that I see of a desire to go into the country to see you; but you are *so* very far north, I wish you were nearer and we could see more of you. I am delighted however to hear how well & strong you are, and I am sure your garden must benefit much by your being able to go about by yourself and care for the flowers. I have a little garden too which I suppose is about the size of your drawing room but contains a little of everything and is one of my principal pleasures, for I must confess that every thing else (but nature) about here looks hideously ugly after Venice, and the extreme cleanliness, squareness & precision of everything perfectly painful after living in tumble down Palaces with Tintorettos and Veroneses for furniture.

I have only been in London once and was distressed to hear of Miss L Mackenzie's loss which you anticipated. I tried to find out where she lived in order to ask for her Mother and herself, but in vain. If you write pray give her my best love and sympathy, for I really

love her very much and I always was so happy to have a quiet talk with her when I could. My friend Mrs. Cleghorn was here, very ill with the same disease in the neck, and has gone to Germany for further advice.[4] I was very sorry but not surprised to hear of Miss Fullerton's perversion. We travelled homewards with Ld & Ldy Fielding who seem quite happy in their new faith and bent upon trying to convert as many as they can. They are so ardent that if they fail it won't be for want of zeal.[5] But now goodbye. Do let us hear of you for we are both so fond of you and very thankful to hear of your good health. Our kindest regards to Sir Walter and

<div style="text-align:center">Believe me Ever yr affect
Effie Ruskin</div>

[1] No. 30, the house JJR had taken and furnished for his son and daughter-in-law, and which they both despised.

[2] Turner had died in December 1851 appointing Ruskin an executor of his will. This charge Ruskin successfully combated on hearing that the will was to be contested. Lady Trevelyan could well picture the accumulation of treasure in the Queen Anne Street house, having paid a call there on Turner in 1841. (See Appendix I)

[3] Dickens's novel *Bleak House* had been appearing in monthly instalments since November 1851. Ruskin would have noted the resemblance between the case in the Court of Chancery in the novel, where the length of proceedings and the costs absorbed the disputed estate, and the litigation over Turner's will which would swallow up money and of which the outcome would be equally unsatisfactory.

[4] Loo's elder brother had died on 15 July at the age of twenty-eight. He was an army officer and had been married under two years. Lizzie Cleghorn's disease has not been determined, perhaps a severe goitre took her to Germany where treatment was known to be particularly successful.

[5] Viscount Feilding and his wife had been but recently converted to Roman Catholicism. They did their very best to induce the Ruskins to embrace the faith and spared no effort on the journey home. Miss Fullerton's 'perversion' was, of course, conversion to Rome.

<div style="text-align:center">23</div>

<div style="text-align:right">Friday [probably April 1853]</div>

Dear lady Trevelyan

I could not write to thank you yesterday[1] – and to day, with my thanks – I must be imprudent enough to propose some further requests. The magnolia is too much divided to form the type of capital[2] – and I must find something of this form [sketch] whether renuncular

– rose – or water lily – or very *open* tulip – I must take these from some botanical book as well as I can – if there are none out.

The Nymphaea [white water lily], and T [ulipa] Sylvestris [wild] tulip are very nice forms indeed – the latter excellent – the former a little too straightened – The printers go on very slowly – if within the next fortnight you happen to see any forms more accurately corresponding with these beneath [sketch] – whatever the shape of the lip – please send them to me. The Nymphaea profile is

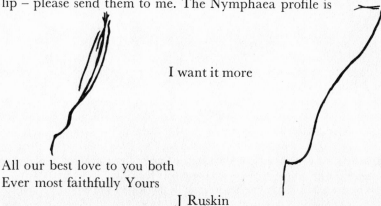

I want it more

All our best love to you both
Ever most faithfully Yours

J Ruskin

– I don't always write quite so ill – but am rather tired.

[1] The Trevelyans had been in London staying at Porchester Terrace, Bayswater, since early February. On the 15th Sir Walter commented in his diary: 'Dined with Ruskins. Interesting drawings and etchings of Turner. Casts from Venice and Verona of mediaeval work.' The following day Lady Trevelyan described the same event to Loo. 'I am so thankful to find that I can worship him so entirely as ever – and also that he is as kind and loving as ever – what a blessing *that* is, when one has been several years without seeing ones idol.' On this same occasion she took him some of her drawings to look at: 'Oh what a fright I was in – for he said he expected great things of me – & I was afraid when he saw what I had done he would think I was a shocking bad scholar . . . He was not the least disgusted – but quite the contrary – and said he was very proud of his scholar & in fact I came to such glory that . . . I shall stand upon my head for the rest of my days.' Effie's dress, though 'picturesque', was reported to have been 'quiet, and in good taste. After all . . . if she is a little too fond of fine people & fine ways there is a deal of truthfulness & true heartedness in her.' The following week, the Trevelyans were again at Herne Hill, and on the last day of the month Lady Trevelyan stayed a few nights, Sir Walter going later in the week to join her. He walked out to Herne Hill and accompanied his wife and the Ruskins to Dr Munro, of Novar, the picture collector, whom he judged 'a vulgar goodnatured man'. Returning to Bayswater, presumably to fetch his night clothes, he was back at Herne Hill to dine and sleep, and was shown a 'number of beautiful daguerreotypes of parts of St. Marks'. They were not let off 'some interesting Italian sketches of Mr. R's' before leaving the

next day. (In all, Lady Trevelyan's expenses during her stay amounted to ten shillings.) While in London, the Trevelyans frequently attended the high church services at St Andrew's, Wells Street, though Sir Walter found the 'whining mode of reading called intoning' most disagreeable, nor could he think it devotional. Lady Trevelyan was again staying at Herne Hill in early April, and on the 3rd when Sir Walter went to join them he met his wife and Effie taking a walk together. Ruskin took him indoors to show him a collection of Turner plates in *Liber Studiorum*, indicating the different stages and alterations. On Ruskin's recommendation Lady Trevelyan applied to W. H. Hunt, the water-colour artist, for some drawing lessons (see letter following) and these cost Sir Walter three guineas. They paid Hunt a visit on 6 April, and went from there to Frederick Goodall (genre painter) where they found 'beautiful studies of weeds'.

In the middle of April the Trevelyans called on John Millais at his studio in Gower Street. This seems to have been their first encounter, though as a champion of the P.R.B. Lady Trevelyan knew his work well, and had written eloquently on its merits in *The Scotsman* the previous year. 'Principal picture a highland prisoner released, and delivered to his wife [wrote Sir Walter in his diary]. A fine one and deep sentiment. In another picture a cavalier lady giving food to a knight in concealment [*The Proscribed Royalist*]'. Lady Trevelyan had been extremely interested to see the portrait of Effie in the first of these pictures, the *Order of Release*, having heard speak of it from the model herself.

The next week Lady Trevelyan went with the Ruskins to a concert, and the following day she took Loo and Effie to 'Claudet's where Pauline wanted them to sit for daguerreotype stereoscopic portraits – they made a beautiful group after several unsuccessful portraits – taking a long time, though the actual sitting only a few seconds' (T.D. See also Lutyens, iii, p. 44). Later in the afternoon, no doubt with Ruskin's blessing, Lady Trevelyan went to Leech's studio and Sir Walter records that 'he looked at and admired Pauline's drawings – & shewed us beautiful sketches of his own'. During that same month of April when the Trevelyans and the Ruskins seem to have been constantly together, there was an evening concert at Exeter Hall to which the Trevelyans took Loo and Effie. Luncheon at Herne Hill, to which Loo was also invited, presented the Trevelyans with a further opportunity of meeting Millais. Ruskin again showed his guests some Turner drawings, 'one drawing on the board as he left it – Margate – explained his rough way of sketching – finishing at home' (T.D.) On 27 April the Trevelyans 'dined at Mr. Ruskin's (father) Denmark Hill – met JR[uskin] – Millais'. This must have been an exciting occasion for the Private View of the Royal Academy Exhibition was to open in two days time, when Millais's *Order of Release* would have its first showing. Coventry Patmore was to dislike in it the portrait of Effie 'beyond speech', but as few people had yet seen the painting the suspense and gaiety, enhanced by Lady Trevelyan's lively wit, must have made the gathering a memorable one.

[2] Ruskin was completing *The Stones of Venice*, and it seems likely that while Lady Trevelyan was staying with him Ruskin asked her help in obtaining specimens of flowers for illustration in the book. In describing specified capitals of St Mark's he needed to demonstrate how 'the most subtle pieces of composition on broad contour' relied on the outline of types of flowers. Whether the magnolia was Lady

Trevelyan's own suggestion is not clear (Ruskin having perhaps made a rough outline sketch of what he needed), though it is possible, as her knowledge of botany was extensive. On 12 April the Trevelyans probably went on foot down the Broad Walk in Kensington Gardens as they had business with John and Charles Lee, Nursery and Seedsman in Kensington Road, on the north side, close to Holland House. Here they got 'blossoms of Magnolia conspicua for Pauline to draw for Mr. Ruskin'. One of Ruskin's reasons for rejecting this specimen may have been the anachronism of this type of magnolia, which had not been known in Europe till brought from China in the late eighteenth century, whereas the capitals of St Mark's dated from the fourteenth. The Trevelyans were up early on the morning of 5 May: '8 a.m. to Academy Exhibition [noted Sir Walter], pleasant. Millais large picture [word illegible] & the better from being unfinished, has not had time to labor on the brick & mortar.' This seems to have been a figure of speech: *The Order of Release* ('the big picture') displays nothing approximating to brick and mortar. Sir Walter disliked great attention to detail in a picture and perhaps this was his general way of expressing it (but see Letter 38, note 1). Later in the morning, being Ascension Day, the Trevelyans attended St Stephen's, Shepherds Bush.

24

[April 1853]

Dear lady Trevelyan

It is very shocking of me not to have written to thank you for all your trouble or to tell you – how nicely the last flowers did – but you will see the plate soon, I hope[1] – in the meantime would you kindly tell me the botanical name of the flower called Po [illegible] I think on your paper – or is it merely this?

I enclose a line of Hunt's – by which you will see that we have all three been obliging each other.[2]

With best regards to Sir Walter

Yours most faithfully

J Ruskin

[1] Ruskin finally adopted not only the magnolia (R, 10, pl. X, figs 3 and 4, facing p. 164) but the *Nymphaea*, and a variety of the *Tulip sylvestris* also. In his own shortened account (R, 11, p. 271) Ruskin writes of Lady Trevelyan sending to Nettlecombe, her home in Somerset (he gives the county as Devonshire), for a magnolia blossom, and having copied it helped him prepare the drawing for engraving; so her second effort found its reward. Ruskin added that the plate was prepared in the early spring when no other suitable examples were obtainable, or else he would have preferred two different species.

[2] 'Park Gate, Bramley, near Basingstoke, Hants. April 28th [1853]:

Dear Sir, I must beg you to accept my best thanks for having induced me to give Lady Trevelyan a few lessons as it is a great pleasure to meet with a person who admired nature equal to her Ladyship and very flattering to me to have given a lesson to one who draws so well.

With best Respects to Mrs. Ruskin, I remain yours

Obliged W Hunt'

William Henry 'Bird's Nest' Hunt (he owed his appellation to his successful drawings from hedgerows) was known for his genre pictures and nature drawings. Ruskin greatly admired his work. Hunt was now sixty-three years old, and though a Londoner, had acquired a cottage in Hampshire in 1851 where he spent much of the spring and summer. He was on the point of leaving for the country when Lady Trevelyan came to his London address, 62 Stanhope Street, off the Hampstead Road, for instruction in drawing. On 21 April she went for her first lesson to learn 'his method of painting, and came back delighted' (TD). His technique of colouring with pure colour on opaque white body-colour, then hatching and stippling, was what interested her most. On the 25th she paid another visit to Hunt 'to see him draw'; the next day 'drawing lessons', and then, quite unconsciously, Sir Walter invests the scene for us with a flash of recognition: 'Birds nests and eggs on mossy banks.'

25

Jedburgh, Wednesday evening [June 29th 1853][1]

Dear Sir Walter,

You will be glad to hear that we got here most comfortably[2] – after some little difficulties about horses ending in a substantial lunch four miles beyond Otterburn and *four glasses of whiskey* on Carterfell[3] (I suppose you will never send anybody that way any more). But we had a noble view – the sun came out just as we reached the top – and Millais who had been somewhat disgusted by the desolate moors, was very happy & enthusiastic – and when we got down into the valley near Jedburgh, they both declared they must *stop there* and paint *that*, it had never been painted at all – This is just what I want them to feel – and Millais pounced just as I expected on the beautiful modelling of the sandstone rocks among the trees.

But I am a little anxious to hear that you did not suffer by your cold drive with us. I thought you were looking a little pale with the cold wind – please send me a line to Callander to say how you are – and how the house is going on. I will write again to say how Dr Brown likes the pieces of natural history.[4] I cannot tell you how happy we were at Wallington – but all of us beg you to believe that we love you very much and think that there are no other such people in the world.

With our sincere regards to lady Trevelyan – and Miss Mackenzie –
believe me affectionately Yours

<div style="text-align:center">

J Ruskin

</div>

[1] It was probably while Lady Trevelyan had been at Herne Hill in the spring
that the plan was hatched for the Ruskins to stay at Wallington in the summer,
on their way to Scotland. John Everett Millais accompanied them, also his
brother William though he joined them two days later. The visit which had just
now ended had lasted a week and had been a success. What had previously been
to Ruskin a relationship based on respect and friendliness now blossomed into an
affectionate and abiding intimacy. Of all his friends there were few in the years
ahead on whose loyalty he would place greater trust, while on her side Lady
Trevelyan, sympathising and teasing, would yet stand up to him and, despite his
intransigence, never failed him. This deep and harmonious friendship, quickened
at Wallington but born of shared tastes, knowledge, and interests, became one of
the most stable elements in Ruskin's life. 'She and Sir Walter are two of the most
perfect people I have ever met,' he told his father, 'and Sir Walter opens out as one
knows him, every day more brightly.' And again, writing to Denmark Hill: 'The
pleasantness of these people consists in very different qualities. In Lady Trevelyan
in her wit & playfulness – together with very profound feeling; in Sir Walter, in
general kindness – accurate information on almost every subject – and the tone of
mind resulting from a steady effort to do as much good as he can to the people on a
large estate' (Yale). The day after their arrival Sir Walter took the Ruskins and
Millais over the moors 'to a little tarn where the sea-gulls come to breed'. 'J.M.
had never been so far north or seen any scenery like our moorland,' Sir Walter
noted, 'and it was pleasant to see his delight – especially pleased with our rocky
streams &c.' Less pleasing, and the prelude to weeks of bad weather, was a heavy
thunderstorm which sent them hurrying home. The impression made by Sir
Walter on this occasion is worth recording as Ruskin referred to it a year later
(Letter 50). His was a dignified figure with well defined features and an impressive
brow, and 'with his bare head . . . his hair driving back from his fine forehead as
it would be torn away . . . leading Lady Trevelyan's pony on the moor against
the wind and the rain', and Lady Trevelyan herself, small, vital, laughing, with
'restless bright eyes that nothing in heaven or earth escaped', is as vivid a portrait
as if composed today.

Sir Walter's museum at the top of the house contained (as it still does) a very
valuable collection of minerals, birds, and shells, which were of considerable
interest to Ruskin. In particular, Peter the Skye terrier, the 'droll doggie with his
hair over his eyes – who when he is asked if he is poorly lies down and puts out
his paw to have his pulse felt' (Yale) conquered Ruskin's heart. There are
references to Peter in later letters. From his appearance he might have claimed
distant cousinship with the group of dogs represented by Wooton in the mid-
seventeenth-century picture painted for the dining-room at Wallington, and now
hanging on the half-landing of the graceful staircase. Though Ruskin was
attracted to Wallington for its '*Northumberlandishness*', it is astonishing to find no
mention in these letters – or in subsequent letters from brother artists – of the over-

<div style="text-align:center">

45

</div>

whelmingly beautiful rococo plaster-work, particularly in the saloon, in the dining-room, and in the staircase hall. That Ruskin would not have approved of rococo decoration is certain, but to make no reference in writing to his father of the most striking feature of the interior of the house – if only to abuse it – seems so unlikely that one can but conjecture that on this first visit meals were taken in what is now the study, or in the writing-room, and that the saloon, which was in need of attention (and was repainted in 1858 at a cost of £72 12s 6d) was not in use. There are grounds for supposing that the Trevelyans paid scarce attention to comfort and their mode of life seems to have been not a little eccentric. Augustus Hare, arriving at Wallington for luncheon in 1861, found nothing for the guests beyond artichokes and cauliflower. Sir Walter was a strict teetotaller. The rooms were bare of furniture, and only by good management could one make oneself tolerably comfortable, while Augustus Hare observed that 'Lady Trevelyan always sits upon the rug by preference'. Ruskin's perpetual teasing about the cold in Northumberland no doubt sprang from intimate knowledge.

On the Sunday of their stay at Wallington, after attending chapel at Cambo (the neighbouring village), where Sir Walter was apt to read the lesson from his pew, Millais 'made sketches in Water-colour of Mr. Ruskin & myself – drawings very beautiful, rapidly done – & good likenesses' (TD); while on the next day the 27th, a party was formed including Loo, also a guest, to go over to Capheaton, the Swinburnes' house three miles away, of see Sir John Swinburne's water-colours by Turner. (Algernon, his sixteen-year-old grandson, would not yet have returned from Eton for the summer.) Effie and the Millais brothers remained behind, 'Millais drawing Mrs. Ruskin' (TD). At Capheaton the drawings, unframed and in a portfolio, were 'revelled over & admired, Mr R considers them some of the finest he has seen & so well selected' (TD). The collection consisted of *Lake of Thun*; *Castle of Chillon*; *Tancarville*; *Bonneville*; *Palace of Biberich*; *Marksburg and Bruberg* (*Braubach*) (British Museum, R. W. Lloyd Bequest).

[2] The Ruskin party left Wallington on 29 June and, with Carterfell and the Cheviots behind them, the first night was spent at Jedburgh, just over the border. Sir Walter had gone with them in a dog-cart for a little way but had found the drive unpleasant, a very high wind having given him a headache, and returning by an easier way he avoided having to get down to unlatch field gates. He and Lady Trevelyan had now to prepare for the arrival of workmen to roof in the central hall at Wallington, their own temporary removal being made to the smaller Garden House on the estate.

[3] Sir Walter was unflagging in the cause of total abstinence.

[4] Sir Walter had entrusted these specimens to Ruskin's safe keeping for Dr John Brown, 'Lady Trevelyan's particular friends [Ruskin wrote later] – the Doctor at least – the lady I don't like nor I think does Lady T. Wary. Black eyed. Vicious expression like a biting horse' (Yale). For, although they had corresponded since 1846, when on the publication of *Modern Painters* ii Dr Brown had written the author a congratulatory letter, they had not yet met. Their shared love of Turner had once led the doctor to think of Ruskin as 'very nearly a god'; later a more sober judgement made him revise his opinion: 'I find we must cross the River before we get at our gods.' Nine years older than Ruskin, a Fellow of the Royal College of Physicians, he had practised at Edinburgh for twenty years where his

reputation stood high in the medical world. On occasion he turned his pen to art criticism, but it was as the author of *Horae Subsecivae* (in particular *Rab and his Friends*) in which he demonstrated his devotion to dogs, that he gained a great popular following. As understanding and affection deepened on both sides, Dr Brown came to speak of Ruskin as 'an amazing genius . . . I am sure he has wings under his flannel jacket; he is not a man, but a stray angel, who has singed his wings a little and tumbled into our sphere. He has all the arrogance, insight, unreasonableness, and spiritual sheen of the celestial.' To Ruskin he was simply 'the best and truest friend of all my life'.

26

From Effie Ruskin

[Edinburgh 1 July 1853]

Dear Lady Trevelyan

I write you a few lines now, because although I have not yet heard of or seen Simpson, still I will have so very few moments before [I] go to Stirling that I think you will like to hear what we are all about.[1] How often we talk of you all and how very much we enjoyed our visit to you. John has just been putting in a little note about you in his appendix, thanking you for sending him drawings of flowers for his plates,[2] and I doubt not you shall have a note full of delight from Dr John Brown who I shall present your gift to this evening at my Uncle's [Andrew Jameson] who has invited a number of artists, Noel Paton, Harvey[3] & others with the above Doctor & Dr Simpson to meet John & Mr Millais. Of course John is awfully bored & would be thankful for an express train to carry him to Callander.

The PRBs have behaved very properly, tell that Darling Lulu [Mackenzie] about Scotland. They admire it in their different ways. William Millais is always sketching or bursting into enthusiastic fits abusing all the rest of the world and keeping us extremely merry, for as his Brother says, he thinks if he were dying "that Boy" would make him laugh. The three went up to the Calton Hill at ten last night and came back immensely delighted,[4] the Millais' say it was the only lovely city they had seen. Today they are going to look over the town and I shall remain in all day in hopes of a visit from Dr Simpson. We all voted Melrose a decided take in,[5] but Jedburgh is very striking and I should have been very glad as we waited four hours at Melrose to have paid Dryburgh a visit, but I could get no one to give me encouragement and the gentlemen ate so much

Gooseberry tart and cream that they were extremely sleepy after it. John was going to write to Sir Walter to tell him that he does not quite understand how he could have for nothing the wear and tear of Mr ——'s carriage from Otterburn to Jedburgh and back, and that if there is anything to be paid thereupon John will pay when made aware of it.

The two Pr.bs are not down yet but I am sure I may send their sincerest regards. Mr J Millais says that the three men who have made the greatest impression on him for beauty of feature or grandeur of head are Lockhart, Manning & Sir Walter.[6] Are you not very busy now. I shall write again & to Lulu.

Ever Yrs Effie

[1] From Edinburgh, where they spent two nights, the party moved on towards the Highlands, reaching Bridge o'Turk in Glenfinlas (near Callander) the next evening. Sir Walter Scott's ballad of *Glenfinlas, The Glen of the Green Women*, written in 1798 and based on an old Highland legend, would have made the choice of neighbourhood, once familiar to Scott, particularly felicitous to Ruskin. The tale was of a siren who lured a young Highland huntsman into the woods to be torn to pieces and devoured by the temptress, so that only his bones were found the next day. If Ruskin ever looked back, perhaps he allowed his mind to dwell on the theme of the ballad, equating the enchantment and destruction of the young Highlander by the siren in whose toils he had fallen, with the bewitchment exercised over Millais by the pretty Scots girl, leading eventually to the deterioration of the painter's artistic genius.

[2] *The Stones of Venice*, final Appendix 10 (R, 11, p. 271. See also Letter 24, note 1).

[3] (Sir) Noel Paton who became a successful painter had been a friend of Millais since their days together at the Academy School; nevertheless, Ruskin and he remained on good terms for many years and, though acknowledging him 'the Genius of Edinburgh', Ruskin reckoned him 'more of a thinking and feeling man than a painter'. (Sir) George Harvey was later President of the Royal Scottish Academy. At about this time Ruskin jotted down an impression of his work: '*Theory*. Wilkie's touch and Religious Sentiment. Result 0000000000', and though thinking him a second-rate artist, found him a 'most amiable man'.

[4] While still young Ruskin had written of 'Calton, though commanding a glorious group of city, mountain, and ocean, is suspended over the very jaws of perpetually active chimneys' (R, 1, p. 258). Nevertheless, it was enhanced for him by Turner's early water-colour of *Edinburgh from Carlton-Hill* and he would not have missed an opportunity of surveying the view through the eyes of his master.

[5] Writing the same day to Rawdon Brown in Venice, Effie voted Melrose Abbey 'a commonplace ruin' (Lutyens, iii, p. 56).

[6] John Gibson Lockhart, son-in-law and biographer of Sir Walter Scott, was strikingly handsome; his thick black hair and dark eyes were often commented upon, though in his last years his appearance was thin and careworn. He had been

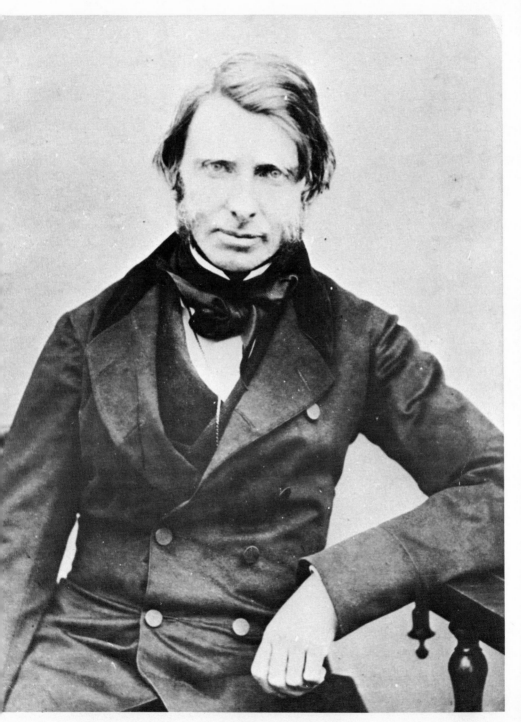

1 John Ruskin, c.1856

2 Sir Walter and Lady Trevelyan, c.1863

editor of the *Quarterly Review* since 1825 and retired this year. It was to his daughter that Ruskin made some kind of an offer of marriage in 1846. Henry Manning (he had already taken the path to Rome) was a man of commanding height; finely carved features and a high forehead marked an austere countenance relieved by the expressiveness of the eyes. Sir Walter Trevelyan's appearance has already been noted (Letter 25 note 1).

27

From Effie Ruskin

[Glenfinlas, probably 7 July 1853]

Dearest Pauline

I thought to have sent you an answer to your letter by return of Post but I have been in bed all day with my customary troubles rendered however as far as pain is concerned much lighter by some Chloroform Pills Dr Simpson gave me which however make me feel so sick and fainting like that I fear my note will be a stupid one. I cannot thank you sufficiently for procuring me two visits [at Edinburgh] from the little Genius which without your aid I never should have managed and I am so much better already that John Millais declares I do nothing but laugh & eat & grow fat besides which my drawing goes on *he says* splendidly. I get a lesson of an hour and a half every morning – he sits by and watches my feeble efforts to draw poor William who sits to me & is a perfect martyr. He gets so wearied & yawns & fidgets upon which his Brother gets up and administering a box on the ear & a scold at the same time gets him to sit still a little longer and really his temper is so good and his delight in every thing so unceasing that he is quite invaluable, he fishes a great deal on Loch Achray and often tells us some myth about a salmon which he was just on the point of catching but didnt, and certainly facts and the plates at breakfast are in favour of Perch very well fried of which he devours much the larger share. They are all out & have been so all day looking for a habitation for us, as we find this so expensive and I think they will find some difficulty in finding any place near.[1] John is quite well & very happy, they have all found a waterfall they like and are to begin sketching tomorrow.[2] Till now the weather has been rather bad & of course I am responsible for every shower that falls & get it accordingly. They are much delighted with the way the people speak *English* but John Millais says he has found out they never give a direct

answer but are very honest notwithstanding. I hope we shall soon get settled and rough it a little. The gentlemen are most anxious to live upon the Perch they catch and they say they never wish for more but if you only saw the Whisky, Beer, Sherry, Honey, Lamb & Chickens that they regale themselves with I think it remains to be seen how they will relish living on their swill.

I must tell you what Simpson said to me, he thought me very thin and found the throat mucuous membrane more diseased than formerly, the heart irritable and internal arrangements disordered. He said as I could not bear nourishment within he would recommend my rubbing myself all over every night with olive oil and give me some pills besides which I find great benefit from already. I sleep better & have had no headaches, he told me for the rest to enjoy myself as much as I could and be much in the open air and when I returned to Edinburgh to see him again. I should like to hear how you are and you will perhaps kindly address a letter to me to New Trossachs Inn, Bridge of Turk, by Callander.

I think the sea will do you much good, Dr Simpson says you should be quite strong.[3] My coiffure is nearly finished and will be lovely. You make me quite proud by carrying my droll little face down to the cottage.[4] You shall see me carrying off yours some fine day when I am a P.R.B. Millais' great delight in teaching me is how I am to astonish Lady Trevelyan and Mr Ruskin. When I lose confidence and say that drawing is not my forte I get such a dreadful reprimand that I go on again & make about ten dots per hour, but I like it and I can think of nothing else since I am at work which to a restless little animal like me is a blessing.

Very best regards to Sir Walter and a shake of my paw to Peter

Ever yrs Effie.

[1] They moved immediately from the inn to a small neighbouring cottage belonging to the schoolmaster, whitewashed and thatched, nestling below Ben Ledi with, as Ruskin informed his friend Furnivall, 'a bog in front'. To his parents he wrote wishing they would join him. William Millais remained at the inn. (For a detailed account of these next weeks, see Lutyens, iii.)

[2] This was the spot chosen for Millais's well-known portrait. 'A lovely piece of worn rock with foaming water,' Ruskin wrote to his parents on the same day as this letter of Effie's, 'and I am standing looking quietly down the stream; just the sort of thing I used to do for hours together.' (R, 12, p. xxiv)

[3] Effie's concern for Lady Trevelyan's health, though short and fleeting, is reflected in this rather complacent statement. The Trevelyans had taken lodgings

for a few days at Roker, a small village in Whitburn Bay on the north-east coast of Co. Durham. (Their joint bill came to £3 16s.)

⁴ The portrait Effie refers to is one of the two studies Millais made of her on 27 June at Wallington (see Letter 25, note 1). He kept the first (repr. *Millais*, p. 286) and gave Lady Trevelyan the second (Lutyens, iii, p. 54), which she took with her when she moved temporarily from the big house to the smaller one in the garden. Might the 'coiffure' to which Effie refers be the foxgloves she is wearing in her hair when Millais painted his portrait of her at Glenfinlas? That a 'coiffure' was begun, or at least debated upon, at Wallington is implicit in its needing no explanation, and Effie's comment is made in a reply to a question regarding it in Lady Trevelyan's letter. As can be seen in the portrait (Lutyens, iii, facing p. 34) she is wearing a piece of cloth, or velvet, across the crown of her head, the foxgloves forming a border. These might have been cut out in velvet, an example having been drawn from nature at Wallington.

28

From Effie Ruskin

[*c.* 10 August 1853]

[Letter incomplete at beginning and end]

. . . he wishes the people here to build pretty houses with heather & fern windows & Everett is drawing such lovely illustrations as examples of said windows with huge Herons & hares & swallows & mice, corn, & every thing else that the land produces.¹ His large picture of John with a Torrent-bed goes on perfectly and very slowly as he is doing it all like a miniature and about two inches a day is as much as he can do.² William, the happiest being I ever knew, is also getting on very well with his oil picture³ but leaves us next week to spend a couple of days at Bowerswell enroute to London. By the way a friend of his, a great Musician, a German of the name of Warburg has left London as he is never well there & gone to try Edin: & William says he was a great friend & pupil of Mendellssohns & possesses some of his unpublished works.⁴ He, Mr W, is a very first rate composer & has done some very fine Quartettes but William says he is so shy & modest that he is likely to remain unknown in Edin from want of pushing himself. W. describes his playing as so exquisite that as he has written saying he would be grateful for some [? introductions] . . .

¹ Ruskin was to deliver four lectures at Edinburgh in November called collectively 'Architecture and Painting'. The first was to be on architecture and its ornamentation. To his delight he had discovered Millais's aptitude for archi-

tectural design and was obliging him to draw church windows, cloisters, and porches (Lutyens, iii, p. 81), and Millais (or Everett as they called him) taking his tone from Ruskin, considered it 'immensely necessary that something new and good should be done in the place of the old ornamentations'. But now, for variation, Millais was expending his boundless imagination on inventive ornamentation for domestic uses: 'Figures, flowers, and animals are all grouped in every conceivable way.' This new enthusiasm, which must have given the party plenty to laugh over, prompted Millais to make rapid sketches of Effie adorned on head, neck, breast and arm with a varied assortment of vegetation and animal life. (See Lutyens, iii, p. 76, and *Millais Royal Academy Exhibition Catalogue*, 1967, pl. 16).

[2] Ruskin's *Diaries* tell the same tale. It was begun at the end of July and immediately roughed in while Henry Acland, who had joined them, held the canvas; a few inches were laid in that very afternoon. There follows an outline of a timetable recording the days and hours of work achieved on the painting, the second week marking the greatest output: five days showed twenty-four hours of work. It seemed unlikely that it would be finished before November, and it was in fact not completed until the end of the following year.

[3] Now in a private collection. Sir Walter Trevelyan saw some of William Millais's work in progress at Wallington and 'did not like his colouring – his green too intense – his drawings of weeds beautiful' (TD).

[4] Warburg remained unknown. It may have been Mendelssohn's name, tarnished with recollections of accompanying Effie to *Elijah* in 1848, which later led Ruskin to suspect him of being 'the same pinchbeck article as Overbeck'. To his friend Mrs John Simon he admitted 'having been much tormented with him between the year 1848 & –53 – by a person of whose sensibilities I have no very high opinion' (Cornell University Library).

29

Glenfinlas 30th August [1853]

Dear lady Trevelyan

I am getting anxious to know how the finished studies are going on, as you have not said anything in your letters to Effie about sketches in Cumberland or elsewhere:[1] and I want you to do some complete things now, for my old ideas have been sadly overthrown – touching the necessity of many studies in light and shade, by my saucy little wife's taking it into her head to try and paint in oil: just like a monkey, after seeing Everett doing it – but the jest is – that she did it, too, and has painted some flowers and leaves very nearly as well as I could do them myself – to say no more. So you must really finish all your work completely – or she will be crowing so when we come again to Wallington that there will be no enduring her.

I am making some studies of plants for architectural purposes[2] in

which I again want some help from you – for I have no one of whom I can ask the name of the *commonest* plant – or rather, I am ashamed to ask their names because they are so common – and go on in total ignorance from day to day. Now, whenever I draw a plant, I am going to send a leaf & flower to you – in a *dated* envelope – I shall date my drawings as I do the envelope so that you [need] never trouble yourself to answer at the time – so long as the plant is kept in its envelope, and I hope you will be so good as to send me the botanical name of the plant – and if you know anything about its being good for this or that – or having odd properties, to tell me that also: but in general if you merely answer my envelopes with another – always naming the *date* attached to my plant – and giving the name after it thus:

September 2nd
Smithia Browniensis

It will be all I want. I daresay some day I shall send you a dandelion – or something as common – but pray don't think I do so in jest – as I really don't know the right name of anything that grows.

I have not given up my idea of a Botanical-reference-book founded on colours.[3] Both Everett and I agree that heather has a way of being purple which would justify its being put among purple flowers – and we decidedly consider that bluebells are generally known by being blue, and not by having any number of stamens. I am certain I could put such a book in a useful form.

I wish you had come here, instead of to Cumberland. I should have liked so much to have taken you to the Scotch church wherein it requires all my obstinacy to retain my presbyterian principles after the first line of the first psalm.[4]

I have not seen Effie's letters to you lately but suppose she has told you what we are all about. At all events I shall leave her to do so – for the history is too important to be crowded into this next page. We are very happy but often think of Wallington with regret. And it is very curious, Everett has never seemed so much delighted with anything he has seen here, as with the little dingle on the road to the Gullery[5] I don't understand it – but fancy it is a little too much for him and he is choked with it.

He says he begins to enter into it more, now.

With all our sincerest regards both to Sir Walter & Yourself

Ever most faithfully Yours
J Ruskin

53

[1] The Trevelyans had spent four weeks in the Lakes travelling from Ullswater to the Salutation Inn at Ambleside, and to Coniston Water, staying at the Water Head Inn, which many years later Ruskin described as 'much my home as Brantwood'. They were at home at Wallington by the middle of August.

[2] For his first two Edinburgh lectures.

[3] Unfinished and set in a different form, *Proserpine* (R, 25) was published in parts over a period of eleven years (1875–86) and carried the sub-title: *Studies of Wayside Flowers, while the air was yet pure among the Alps, and in the Scotland and England which my Father knew*. Its aim was to teach children one botanical Latin name for each flower with its English equivalent, but since the most current names were 'apt to be founded on some unclean or debasing associations', Ruskin 'boldly' substituted other generic names for plants, 'thus faultfully hitherto titled' (R, 25, p. 201).

[4] The small wheezing precentor at the little Free Kirk sang the first line of each verse, his shaggy terrier joining in with a pitiable wail. The remaining lines were sung by the congregation, a few sheep-dogs adding their voices. Millais found the service as unlike an Oxford one as 'an oyster is unlike a crow' (*Millais*, p. 209).

[5] See Letter 25, note 1, where Sir Walter's diary told of Millais's enthusiasm for the countryside.

30

[Glenfinlas 1 September 1853]

Dear lady Trevelyan

I enclose flower no. 1. *1st September*. In looking over your letter about Sir Peregrine Aclands drawings,[1] I find this sentence "Such trees, some of them are – such exquisite drawing!" Now my third Edinburgh lecture is to be on Turner,[2] and I want to give *one* illustration of his power in drawing nature. I intended at first to take a stone, but I don't think people would see or understand this so well as a bit of tree – and I should like a tree – because I hear that Blackwood in their last article on Turner & me, say that "Turner never drew a tree in his life".[3] Now the Liber Studiorums – though noble, are not refined enough to *magnify*; and I want to copy a branch of Turner's trees so large that people can see it at the end of the lecture room. I have only one first rate tree drawing – Bolton Abbey, – and I would not risk that to travel for 200 pounds, besides that, it depends on the entire group of trees and has no part separately magnifiable.[4] From what you say of the small estimate the Acland drawings are held in, I think it possible that if I were to ask Henry Acland, he might get one of them lent to me, if you could tell me which to ask for. I don't want *distant* trees – or even middle-

sized ones – is there any one of them with *complicated* near branches?
We have your nice letter. I am so glad you enjoyed Cumberland.
Best love to Sir Walter – Ever affectionately Yours
J Ruskin

By the bye – do you think you could without fatiguing yourself,
copy for me the head of the tree in Sir J Swinburne's Bacharach[5] – or
would he allow this? I really think it would not be wasted time for
you and it would be a great favour to me – I know you could do it,
if you have time. You know it must not be in colour unless you like.

At any rate give my remembrances to Sir J Swinburne & Miss
Swinburne when you see them.

[1] Sir Peregrine Acland, 2nd Bart, now in his mid-sixties, was the head of a
younger branch of the family, whose baronetcy became extinct with his death in
1871. His fourteen Turner water-colours were *Vale of Ashburnham; Vale of Heath-
field; Hurstmonceaux Castle; Battle: The spot where Harold fell; Pevensey Bay from
Crowhurst Park; Rosehill Park; Bodiam Castle; Pevensey Castle; Vale of Ashburnham;
Beauport, near Bexhill; Battle Abbey; Vale of Pevensey from Rosehill Park; Rosehill;
Beach at Hastings.* Of these the first six were engraved in *Views in Sussex* (1819).
These drawings had come to Sir Peregrine through his maternal uncle, J. R.
Fuller, for whom they had been made by Turner. They were now 'perishing of
damp' in the passages of Fairfield, his house in Somerset. Later, when writing to
Henry Acland, Ruskin lamented their deplorable condition. 'I have little power of
conceiving any wickedness greater than his treatment of those Sussex drawings of
Turner . . . Killing men is bad work; killing great men's work is worse. There may
be an excuse for the one – there can be none for the other.' (R, 36, p. 431)

[2] *Turner and his Works.* Ruskin had already written to the Secretary of the
Philosophical Institution at Edinburgh, under whose auspices the lectures were to
be given, inquiring the 'size and shape of the lecture-room, and position of seats
in it'.

[3] Ruskin was accustomed to jibes from *Blackwood's Magazine.* In October 1836
he had first sprung to Turner's defence when it had spoken ill of the artist's three
pictures at the Royal Academy. 'I never read such a magazine, it never touches
on art without doing mischief' (Bradley, p. 218). On this occasion (July issue) the
writer in a long article, 'The Fine Arts and Public Taste in 1853', addressed him-
self to an imaginary 'Post-Raphaelite', denigrating much of Turner's work and
dwelling on his 'absolute poverty of detail as to foliage' and his being 'rather
deficient' in the representation of trees as opposed to Claude. He mocked at the
Pre-Raphaelites, singling out Millais's *Order of Release* and *Proscribed Royalist,* and
abused Ruskin, the 'Graduate', with considerable venom.

[4] The trees on the far shore of Bolton Abbey are described in *Modern Painters* iv
(R, 6, pp. 303–8). This was a water-colour which Ruskin particularly valued and
hung above his heavy mahogany bedhead at Brantwood.

[5] At no time did the Swinburne collection include Turner's *Bacharach.* This is a

slip on Ruskin's part, or an intentional misuse of the name. *Marksburg* (*Braubach*) is the drawing to which he is referring. (See Letters 25, note 1; 34, note 2. I am grateful to Mr Evelyn Joll for having guided me to this interpretation.)

31

[Glenfinlas
probably first part of September 1853]

Dear lady Trevelyan

It is indeed most kind of Miss Swinburne to allow the drawing to be copied, & not less kind of you to be so pleased to do it: but I hope you will get quite strong at the sea first – and if the thing is very troublesome to you, give it up – as I *can* manage with liber studiorum: but if you are able to do it for me I shall be most grateful.[1] You can do it either in colour or shade, as you like – but I should think you would enjoy doing it in colour: only you will of course remember that the main thing I want is the perfect form and curvature of each spray, and therefore don't torment yourself to get this or that colour – above all – don't miss a form, or spoil a neatly drawn bit, in order to get the colour more accurate.

You must do the thing exactly the same size, and do as much of the group of trees as you can, *perfectly*.

Best thanks for the nice little slip of paper about the Scabious. I had another plant to send you to night but there has been some setting in order in our cottage – and I can't find anything. I suppose it has gone out of the window but I will get another to morrow.

Everett is getting on beautifully with his picture just now – it is half done in appearance – and more than half in reality as the leafage is all done, and only the rocks are to come, which though full of drawing are easier in colour. I am very sorry to hear of the cholera in Newcastle[2] – I have fancied there was something unwholesome in the air all the summer – but we all feel more ourselves within these few days – as if there had been a change about the beginning of the month. Our best love to Sir Walter.
Ever affectionately Yours

J Ruskin

[1] Lady Trevelyan made a skilful copy (Letter 34) but Ruskin made use of his own copies from Claude and Turner to illustrate his lecture. Miss Julia Swinburne constituted herself the guardian of her father's water-colours and at his death the drawings passed to her.

[2] Its outbreak was severe, exacting a heavy toll of life.

Glenfiinlas, 6 September [1853]

My dear Lady Trevelyan

Best thanks for your kind letter and nice account of Cumberland
and Corby. I thought you would enjoy Cumberland if the weather
were at all tolerable. I hope you saw the pass from Wast Water into
Borrowdale well, for there is really something sublime about it.
Did you ride up any of the mountains? the view from all the three
chief ones – Skiddaw – Helvellyn & Scawfell is interesting – but it
is too late to tell you that – so I will rather tell you as you desire me
something about our very simple "doings" Neither Everett nor I am
quite as well as we ought to be; he had headaches very often, and I am
somehow or another, wonderfully lazy, I don't care about these hills,[1]
and the long extents of morass make me as dull as their own peat
holes – and I don't find the climate in the least bracing – as I expec-
ted – on the contrary, soft and damp – or blighting when it is dry:
and the upshot of it all is that I never am up & out in the morning
as I am in Switzerland but all of us are as late at breakfast as if we
were in London – never before nine oclock. – Then I generally
have some letters to write or, till lately, some bits of index to correct
and Everett makes sketches in pen and ink of our wet days adven-
tures[2] – or idles over a bit of paper somehow or another – until about
12 oclock when the sun is right for his picture – and then we all go out
to the place where he is painting – a beautiful piece of Torrent bed
overhung by honeysuckle & mountain ash – and he sets to work on
one jutting bit of rock – and I go on with mine, a study for modern
painters vol III, on another just above him,[3] within speaking dis-
tance, and Effie sometimes reads to us & sometimes holds the um-
brella over one of us – and sometimes potters about the rocks and
draws a strawberry leaf on her own account. At two oclock, comes
Crawley [Ruskin's servant] with our dinner in a basket – and there is
a little rock table just above us on which it is laid out: after the
discussion of which Everett goes on with his work in an impatient
manner – always gobbling his dinner at a rate which is partly the
cause of his headaches; but I lie on my back on the rocks & listen to
the water above my head until I find myself going to sleep & then I
wake up & go to work again. At about ½ past four we give up, and
set out for our walk or scramble which generally furnishes Everett
with a subject for next days sketch – and come home to tea when it

gets dark, which I am sorry to say – it does, now, a great deal too soon. On wet days we have battledore and shuttlecock in the barn – and work at architectural designs which Everett is helping me with for Edinburgh, and which I hope will do their work very well. I am to give four lectures between 1st and 11th November – can you get back from Ireland so soon? – I am not quite sure whether I want you or not – I should feel, if you were there, that you were anxious for me – and if I got confused – or did not interest the people, I should be more put out by having friends there than by being among strangers;[4] but I think I shall do pretty well, if I have only voice enough, so if you really would like to come I will bear the risk of being torn to bits as well as I can.

I am heartily glad you like the second volume of Stones: I am nearly sure you will be pleased with the third – which is more general in its subjects – & perhaps Cardinal Wiseman will like it too – as there is plenty of abuse of the reformation in it – It will soon be sent you now – as the last page of the index is in press – the Index being 100 pages in *Appendix print* took me some time to arrange.[5]

I intended to have sent you another flower – but forgot to gather it so it will come to morrow.[6]

I will reconsider my plan about the flowers but I am not at all put out of conceit of it. Under every colour I would places notices of the flowers which occasionally assumed it, with references to the colour under which they really came. No flower is more variable than the rose itself – but I could easily put under the white & yellow heads "Often the Rose See the Red division" and I should unhesitatingly class the rose in that division – in spite of all Yorkshire – as this world assuredly does – else why speak of rose-colour – and Violet-colour and Primrose-colour.

I find flowers always arrange themselves in my mind first by their colours: there is a blue division where the gentians – forget me nots – and bluebells go – and a red division where the roses and poppies & peonies and multitudes more go – and a great violet division for heaths and violets – and a vigorous yellow division for buttercups – sunflowers, & dandelions – and finally a white division for lilies & daisies – & when I see the great glaring orange lilies I immediately look upon them as having lost character. Still I should be terribly puzzled by the patchwork creatures – tulips & suchlike, and I will look at what you call the natural system. Effie sends her love – and desires me to say that the collars delighted Mrs Pritchard in-

tensely and to enclose the post office order to you – it is in the name of Pauline Trevelyan – Mrs Pritchard could hardly believe the collars were so cheap.[7] Best love to Sir Walter.

Ever affectionately Yours J Ruskin

I am *very* glad to have so nice an account of your drawing and especially that you see things melting into pretty colours: it is just the best way to see them.

[1] He compared them with Switzerland and found them wanting. 'Scotland is immeasurably inferior to Switzerland in her sponginess . . . it is always squash, splash, plash'; but he came to change his opinion in a few weeks, and left Glenfinlas with regret.

[2] Some of these are reproduced in *Millais*, and Lutyens, iii.

[3] Probably the *Gneiss* study (repd R, 12, pl. I), which was not included in *Modern Painters*.

[4] Ruskin's parents were displeased at his course of lectures, fearing that this would delay his return and the completion of *Modern Painters*; there was also some urking uneasiness that to be a public lecturer was lowering. 'I don't care to see you allied with the platform – though the pulpit would be our delight,' wrote JJR (Bembridge).

[5] Volume ii was published on 28 July at two guineas; the third volume at one and a half guineas would follow on 2 October. Ruskin had been making his Venetian Index containing pictorial and architectural notes during the first weeks at Glenfinlas. Three years earlier Wiseman had been appointed Archbishop of Westminster and a day later nominated Cardinal. In the summer of 1852 he had convened a Synod to establish a new form of ecclesiastical government for Roman Catholics in England, and was now in Rome to have the decrees ratified. The Trevelyans had known him in Rome in 1836, where he had had more than a passing influence on Lady Trevelyan, and whose return there in 1842 had been partly in order to see him. At that time she may have had serious thoughts of turning to Roman Catholicism. Had Ruskin written this letter a few weeks later, after Wiseman had delivered himself of the 'Flaminian Gate Pastoral' (now too well known to require explanation), he might have felt in sympathy with the public protest against 'Papal Aggression'. Feeling ran very high at this time; Queen Victoria, on reading the Cardinal's Pastoral in which he planned to 'govern, and shall continue to govern, the counties of Middlesex, Hertford and Essex as ordinary thereof', was led to exclaim: 'Am I Queen of England or am I not?' The Tractarians too came in for violent abuse, Dr Arnold going so far as to assert that he looked upon such a one 'as the enemy disguised as a spy'. In his third volume of *The Stones of Venice* Ruskin wrote of the 'struggle between Romanism and Protestantism' at the time of the Reformation, emphasising how the Reformed Church, masking her 'pride, malice, wrath, love of change, under the thirst for truth', was as injurious to itself as the Roman Church, which, 'in the fact cf its refusing correction, it stood confessed as the Church of the unholy'.

[6] See following letter, note 1.

33

[Glenfinlas] 28th September [1853]

Dear lady Trevelyan

I was truly glad to have your letter – being a little anxious about you – and very glad also to know you are at work upon and enjoying the Turner, and very particularly happy in my two plants Sept 7th, 8th having such nice names & stories. I never saw such pretty things as they are. I wonder why that lovely little cinqfoil was dedicated to the Virgin?[1] When the drawing is done – and pray believe that I have not a shadow of doubt either of your care – or industry – or skill, (as far as any human skill can go, in copying Turner) – when, I say, the work is done, please seal it up with a nice sheet of smooth paper over the face – doubled over the edges and sealed together on the back so as not to slip, and then get two smooth boards, the exact size of the cardboard and each about $\frac{1}{4}$ of an inch thick, and putting the drawing between them, tie both firmly: wrap up all well in brown paper, and so despatch as a railway parcel, it will come quite safe. In case either of the plants now sent should come out of their envelopes the geranium like leaf is Sept. 27.[2]

What an awful account you give of Newcastle. I never recollect any such horrors of the cholera before – most assuredly there ought to be commissioners.

All my ideas of government are very arbitrary not centralising as we do in these days – but establishing a sort of nervous system through the whole body of the state & leaving nothing to self government. I am glad you are going to Ireland.

What are the things which you are so angry with me for in the Stones? What I said about religious people not loving art?[3] I hope I am wrong. I believe, that you yourself are an instance of my error, but I did not know enough of you when I wrote the passage – a

good while ago – to make you an exception. I thought you were just going to become a Roman Catholic.

Effies love – and Everett's best regards to you both

Ever affectionately Yours

J Ruskin

[1] Six small packets exist among the Trevelyan papers enclosing pressed leaves and endorsed with the dates in Ruskin's hand. On that of 8 September he added 'I could not find a flower.' The cinquefoil was probably the wild strawberry plant: 'The fruit of the Virgin Mary' (*The Englishman's Flora*, G. Grigson, 1955, p. 152). The plant also appears in a fifteenth-century German painting of the Virgin; a further picture, *The Madonna with the Strawberry Plant*, is of the same period. (My authority for this information is Dr A. W. Clark, lately of the Plant Biology Department, University of Newcastle upon Tyne.)

[2] In this letter Ruskin enclosed two further packets each marked with a date: 'Sept. 27'; 'Sept. 28'. On that of the 27th Lady Trevelyan has written 'pratense'.

[3] The second volume contains the following passage: 'I cannot answer for the experience of others, but I never yet met with a Christian whose heart was thoroughly set upon the world to come, and, so far as human judgment could pronounce, perfect and right before God, who cared about art at all.' (R, 10, p. 124)

34

[Glenfinlas] 6th October [1853]

Dear lady Trevelyan

I got your kind letter and the drawing together this morning – and am so sorry I did not know sooner you were going by Glasgow,[1] for it would really have been worth your while to come up to loch Katrine to see this place with its brown ferns, and to see Millais subject: however it is too late now – unless you were coming back in less than three weeks – we stay here – DV. till Wednesday the 26th.

You have indeed taken great pains with the drawing – it is far more finished than I hoped, and yet in one respect it disappoints me – I had forgotten that the trees were cut at the top by the margin[2] – and now that I see the group separate, it is another proof to me how curiously subtle Turners composition is. The trees are not *themselves* when they are separated from the other lines of the picture. I can hardly tell you whether I shall use this group or not. I must compare it with what materials there are in the liber in order to see which will be most striking in black & white, but even if I do not use it, I trust you will not regret your labour for indeed I am very grate-

ful to you, and you cannot have copied these trees so carefully without doing yourself a great deal of good.[3] I told you I should be sending you a buttercup or dandelion some day: but I really did not think I should have sent you the sweet woodruff – having scented many a book with it when I was a boy, but I thought the leaf I sent you had no smell, and therefore must be something else. Has the Geranium pratense [Meadow crane's-bill] a purple flower? both Millais and I have been drawing hundreds of leaves – but not a flower occurred with them.[4]

All my friends, nearly, are upon me about that sentence touching love of art I can't help it. I know that art is a terrible stumbling block to myself – making me dislike everything that is not pretty – and every occupation that is not so pleasant as drawing. all the best ministers that I know are Gloriously ignorant of everything of the kind – Then there were Cromwell & Knox on the one side & Leo the tenth and the Medici on the other.[5] I am afraid the Knights of the Hammer have the better of Knights of the brush. I am quite sure that none but good men ever produce good art – but I am not at all sure that good art produces good men, or that the love of it is of much use. I never said anything of this kind about nature – no one can love *her* too much.

I am much gratified by an old man's being so much interested in my book as Sir J. Swinburne. I can easily get *young* people to feel with me, but I think much more of making any impression on the settled mind of an old man.[6]

I forget if I told you Everetts plans when he first came he meant to paint two pictures, one of rocks, the other of Doune castle, but he has been obliged to give up the Doune altogether[7] – and there was a moment of doubt respecting the possibility of finishing even the other, but I think he will work through it. The weather has been dreadful.

Can you tell me the plants which you see in Ireland? Do you stay all the time at Dublin.

Effie is much better than she was when she came here – but I fear will lose again when she leaves. I wish you could come & see us here.

Effie with a natural & feminine love of the enigmatical must needs write *across* my letter though I told her I must stop, myself, and she might have the bottom of it. Our best love to Sir Walter.

Ever affectionately Yours,

J Ruskin

[In Effie's hand] Dearest Pauline I don't write now because I have much to do & John & you carry on so steady a correspondence. I am well & hope to see you the same at Edin.

[1] The Trevelyans were on their way to Ireland.

[2] In the Turner drawing so diligently copied by Lady Trevelyan the two trees occupying the foreground are indeed cut by the upper margin.

[3] Ruskin made use of his own copy of Turner trees taken from the *Liber Studiorum* No. 83, *Stork and Aqueduct*; and while making no reference to the *Blackwood* article (the magazine being printed in Edinburgh where he lectured) he may have found a grain of pleasure in refuting the reviewer by referring to Claude's trees as 'presenting a deceptive appearance of truth to nature'. These too he illustrated from his own copy taken from Claude's *Liber Veritatis* vol. ii, No. 140, *Angel comforting Hagar* (repr. R, 12, pl. 127).

[4] In his second Edinburgh lecture on 'Architecture and Painting' Ruskin referred to the geranium *pratense* by name. It flowers (purple-blue) in June and July, so that only its leaves are to be found in the month of October.

[5] Knox and Cromwell were single-minded in their rigid faith; Pope Leo X, a son of Lorenzo de' Medici (the Magnificent) was a patron of learning and the arts, but an immoral pontiff.

[6] At the age of ninety-one Sir John Swinburne was reading and enjoying *The Stones of Venice*. A few years later, when writing to Mrs Patmore, Thomas Woolner, the P.R.B. sculptor, thought him 'as fine a picture as any drawing, rather more so, the old boy is 96 and as cheerful as a man half that age'. *Thomas Woolner R.A., His Life in Letters*, A. Woolner, 1917, p. 119) He lived until 1860.

[7] There had been very few fine days nor did time allow for the projected painting of Effie framed in a window-opening at Doune Castle, as a companion portrait to that of Ruskin.

35

[Glenfinlas October 1853]

Dear lady Trevelyan

I have double confession to make – first, that my father wrote to me a month ago desiring me to return Sir Walter his best thanks for the superb haunch which afforded much enjoyment not only to him – but to a "literary" friend who has worked hard in seeing the Stones of Venice[1] through the press and was much refreshed after his fatigues by a slice of your venison – & the second confession – that I was so taken up about my Turner & flower work as not to remember Sir Walter's query.[2]

Our best love to him & you.
Ever affectionately Yours
J Ruskin

¹ W. H. Harrison, Ruskin's 'literary master' for thirty years, had dined at Denmark Hill on 2 September. He had been editor of *Friendship's Offering*, which had published Ruskin's first poems, and thereafter undertook to see Ruskin's work through the press, often complaining of his punctuation and observations.

² Whether or not the venison had reached Denmark Hill.

36

[Glenfinlas] 19th October [1853]

Dear lady Trevelyan

I don't at all like the thought of going to Greenland, even with you.¹ It is getting very sufficiently frosty on these hills, and I don't like glaciers *at home*. It is only delightful to see them in strange countries, astonished and astonishing.

You are setting Effie a worse example than usual in being ill so often – pray don't. I wish you could have come round this way, but any time when you are in Scotland you will be able to find Millais subject (it is drawn so like) and if seeing the doctor will really do you any good, I will be content – but I don't think Manchester air will,² and the air here – though as I said, frosty enough, is yet so delicate & pure, and the autumn so different from autumn any where else, that I ever saw, that I should have thought coming this way might have been the best for you after all. If I can help it I never will be out of a hill country in autumn again – The colours of the ash (mountain) and fern, among the purple rocks are beyond conception or hope – and it is so delightful to have something that does *not* change. The rocks and lichens in their everlasting strength & delicate glory – and the dead leaves instead of being trampled into sodden heaps, sinking like flaky sponge under the foot – lying upon the rocks like spots of gold until the rain washes them down and the torrents take them away, & the harvest is yet standing in heaps in the level fields – the air clear and for the most part calm – the birds in fuller song than in summer, & the bell heather coming out now bell by bell – but *still* coming out in the little sheltered crannies – and the withered russet of the past blossoms mingling with it in perfect harmony – I never saw anything so beautiful. I enclose two flowers – I am ashamed to send the common yellow thing³ – but I don't know it – and have drawn its *green* leaves a great many times – and Everett and I have quite quarrelled about its flower for just in the corner of my picture – in a lovely place – just finished – *out* came one of the nasty

things one sunny day – and he must needs paint it in immediately &
there it is – a bright yellow spot looking like a splash of gamboge.
As if it couldn't have come out somewhere else!

Our best love to Sir Walter.

Ever affectionately Yours

J Ruskin

[1] The reference to Greenland was a well-tried joke. The Trevelyans were
enthusiastic in putting up money for an expedition to be sent to the Arctic regions
in search of Sir John Franklin and his two ships, *Erebus* and *Terror*. Occasionally
they spoke of joining the expedition themselves. Franklin had made two voyages
of discovery before setting out again in 1845 to discover the north-west passage.
This he achieved but he was fated never to return. Sir Walter Trevelyan was
keenly interested in the recovery of any scientific papers.

[2] From Ireland the Trevelyans were travelling to Manchester, where Sir Walter
was attending a meeting on teetotalism.

[3] The small packet (see Letter 33, note 1) marked 'Oct 17th' contains the yellow
flower, its colour as undimmed as on the day Ruskin picked it at Glenfinlas and
enclosed it two days later in this letter to Northumberland. The flower can be
distinguished in the upper left side of the portrait. It is one of the Hawkweeds (a
member of *Hieracium* L. Euvulgate) but without a basal leaf it is impossible to
identify the species. (Again I am grateful to Dr Clark for the identification.)
Ruskin continued in his dislike, mentioning it again in writing to Millais about
the portrait a year later: 'On the whole the thing is right and what can one say
more – always excepting the yellow flower.' (Lutyens, iii, p. 247)

37

[Edinburgh 1 November 1853][1]

Dear lady Trevelyan –

I forgot one thing I wanted – & my servant is out & I don't know
what to do – can you help me – by putting the bearer in any way of
getting the outer bough of a tree – ash if possible, 5 or six feet long,
with its sprays all about it, so? [sketch]

I don't know who has a garden or would let their trees be cut.[2]

Ever most truly Yours

J Ruskin

[1] So dated because the Trevelyans, who had come for the four lectures, had
only reached Edinburgh today. Ruskin required the branch of a tree for his first
lecture that evening.

Sir Walter considered the lecture 'well attended – much good and beautiful – & some absurd. Too sweeping in denunciation of what he does not like' (TD). The next evening the Trevelyans dined with the Ruskins and Millais. Two other guests completed the party: Effie's uncle Andrew Jameson, and Dr Thomas Guthrie, minister of St John's Free Church, Edinburgh, and a total abstainer whom Sir Walter found 'A most interesting person'. To Ruskin he was 'as delightful out of the pulpit as in it', which seems to indicate that he had heard him preach the previous Sunday, 30 October, two days after their arrival from Glenfinlas. His enthusiasm was tempered on the next occasion however: 'Eloquent and delightful as usual, but wonderfully like a Romanist priest.' The subject of the sermon 'displeased and amazed' him (*Diaries*, pp. 484–5).

38

[Edinburgh 7 November 1853]

Dear lady Trevelyan

I can't get quite rid of the roughness in my throat and I want to see a good physician to ask if anything can be done to get me right for tomorrow – Can you recommend me one? I have sent to Dr Brown, and only ordered this note to be given to you in case he should be out of town.¹

Ever affectionately Yours

J Ruskin

In case you should not know one I have given the servt a letter to Mr Hill to ask about one whom Noel Paton wanted me to see, so don't put yourself about.²

¹ The third lecture, on Turner, was to have been given on the 8th, but a bad throat obliged Ruskin to postpone it until the 15th. As is apparent, Dr Brown was not available. Sir Walter meanwhile went to London for a brief visit, staying at Burton Crescent, equidistant from King's Cross Station and the British Museum. His diary records a visit to an exhibition on Sunday 6 November where he saw Millais, who 'sat some time near his Huguenot & heard 1 praise the figure for 10 who praised the wall. Convinces me as I have always thought that he is wrong in bestowing so much labor on details which would not attract the attention in nature – the same fault but in less degree in imitating texture of clothes.' The *Huguenot* had been shown at the 1852 Royal Academy Exhibition and had been bought by Windus. It seems likely (and I am grateful to Mr Jeremy Maas for the possible explanation of this conundrum) that the present exhibition was the first Winter English Exhibition held by the dealer Gambart, at his premises, 121 Pall Mall. Although no catalogue is extant it is known that his exhibition this year was

in the autumn (in December the following years) and that the doors were open on Sundays. The *Huguenot* may well have been shown for a few weeks, possibly before being sent for engraving. It is also conceivable that Sir Walter was writing of a reduced water-colour replica which Millais executed 'shortly after the original picture', but it seems unlikely that within the space of a year in which he had been fully occupied with the painting of his two important pictures, *The Order of Release* and *The Proscribed Royalist*, he would have found time for a water-colour replica; nor among the participants of the Glenfinlas episode is there any reference to his working upon it either there or at Wallington.

Sir Walter had also called upon W. H. Hunt while in London with a view to making a purchase. The following letter was addressed to Scotland. 'Mr. Hunt presents his compliments to Lady Trevelyan and begs to say that he is extremely sorry to have been from home when Sir Walter called and not to have returned in time to wait upon him at Burton Crescent. Mr H has reserved a drawing and hopes to have others for her Ladyship to choose from when next in town. Nov 10th, 62 Stanhope St, Hampstead Road.'

[2] David Octavius Hill, Secretary of the Scottish Academy and, according to Ruskin, as a 'landscape painter, amiable and unobtrusive', was also a fine photographer, though this work was not yet known. The doctor whom Paton recommended cannot have been Mr Beveridge (Lutyens, iii, p. 106), for by 6 November Ruskin had already consulted him (and discussed with him the Book of Revelations) and had been given the advice which he afterwards followed, to apply friction to the neck. Lady Trevelyan no doubt recommended a physician, but Ruskin's throat continued troublesome.

39

5 Albyn place, [Edinburgh]
Sunday [13 November 1853]

Dear lady Trevelyan

We were very much in confusion last night in leaving our Inn.[1] I thought you would like an answer to your kind note to-day just as well. Effie is better and is gone to your dreaded Guthries. I am steadily better – still a little hoarse but hope to be audible enough on Tuesday, when I shall certainly *try* to lecture, D.V.[2]

Keep this book as long as you like. I have no use for it[3] – Your own will soon be at Wallington. The booksellers declare your name was not on the list of those to whom the *first* volume was sent, which was of course kept by them for the second & third. You had the first alright, had you not? Best love to Sir Walter. Ever affectionately Yours

J Ruskin

[1] The Ruskins had spent the first fortnight at the Royal Hotel in Princes Street, but finding it beyond their means had moved to this cheaper establishment.

[2] Sir Walter had tea with Ruskin on the 15th and then went 'to his lecture on Turner, much of it very interesting and beautiful . . . interesting anecdotes of Turner – altogether this was a much better lecture than his previous ones. It is a subject that he understands better & has studied longer & has not such eccentric theories about as architecture' (TD). Two days later Ruskin noted that he had got into a religious discussion with Lady Trevelyan and that 'she got very angry, and declared that when she read me and heard me at a distance, she thought me so wise that anybody might make an idol of me, and worship me to any extent, but when she got to talk to me, I turned out only a *rag doll* after all' (R, 12, p. xxxiv). On the 18th the Trevelyans again took tea with Ruskin and 'then to lecture (on Pre-Raphaelitism) which I did not like so well as last. R does not agree with me in thinking talent a labor thrown away by good artists in minutely finishing parts of pictures which in nature would not be observed – as backgrounds by Millais in Huguenots – & foregrounds in others' (TD).

[3] His own copy of *The Stones of Venice* iii. Whilst at Edinburgh Ruskin was reading Thackeray's *The Newcomes*, of which the first part had come out in October.

40

Herne Hill 9th January 1854

Dear lady Trevelyan

Many, many thanks for your long and delightful letter – and many – many happy years to Sir Walter and you. I cannot I fear – send you such a nice long letter in answer – but I will tell you what you ask – first about Hunt. He is at Hastings at present,[1] but as soon as he comes up to town I will call upon him and will choose a drawing for you – provided either of the reserved one's are such as I think you would like; and if not – should there be any other one which I can recommend with all my heart, I will secure it for you as you direct. Meantime I write to him to know when he will be in town and what he is likely to have.

After I saw you at Perth[2] I had a somewhat disagreeable round of confused visitations to pay at Glasgow – always having to arrange something & go somewhere – and as I can't bear arranging, and like to stop everywhere and go nowhere, I was'nt comfortable, in spite of the kindest efforts on the part of the kindest friends to make me so – except for some half day or so at Mrs Blackburns, when I enjoyed myself particularly – but even then under a species of horror from the sense of neighbouring steam engines and forges and other distur-

bances. But Glasgow cathedral is very noble[3] – and I saw some valuable M.SS. in the Glasgow library; and had a grand field-day at Hamilton – not unmixed with some vexation at seeing such magnificent M.S.S squeezed together on the shelves as if there were no room for them in the palace.[4] But the Duke has a good deal of regard for them nevertheless, and they might be much worse off – poor things; I suppose very few M.S.S. are petted like mine: I was in great distress for them at Durham, where we stopped on Xmas day – and where Mr Raine was so good as to give up his whole afternoon to me and take us all – Effie, & Sophie and me, home to his own Christmas dinner – and to take a choice manuscript out of the great library to entertain me after tea! And I was very happy at Durham altogether – for the place and the Inn – and the people, were all oldfashioned and faraway-like – and the very scrapers at the doors of the houses had trefoils over them so [sketch] – and in summer it must be a divine place – and I must go back to it – for I have seen no such manuscripts anywhere – They are quite glorious, and I like Mr Raine exceedingly – if he would not only crush their leaves as if they were Scotch one-pound notes.[5] Indeed he has done them an infinite deal of good and has a profound respect for them – and they are most fortunate in having such a keeper – but if he could but understand that body-colour cracks when sheets are crumpled, he would be quite perfect.

We got home quite comfortably just a fortnight ago. Effie is I think better – but is never happy here, which makes her ill,[6] and I *must* be here; for I am hard at work on Modern painters, (& so delighted to get back to my Turners after those stupid stones.) I shall have something to show you, I hope, when you come up, in the interval between Northumbrian spring & summer – no – by the bye, I forgot – Spring in Northumberland – is at the end of June; the hawthorns were just out – I don't know when the summer can be – having nothing but a confused recollection of having been very cold last year all July & August: but I suppose in August. And if you do not come to town till July, we shall be in Switzerland – (D V) But I hope you will be in town by the end of April, and then – if you will kindly come to stay with us a little I hope I shall have more to show you & talk to you about than last time.

Ever, dear lady Trevelyan affectionately Yours

J Ruskin

[1] For many years he visited Hastings regularly; a number of his best landscapes were painted in his cottage by the beach in the old part of the town.

[2] After the last lecture on 18 November Ruskin remained three weeks alone in Edinburgh and then joined Effie at Perth for a few days. The Trevelyans were there on 14 December arriving 'too late for dinner but went to T at Mrs Grays where met Ruskin' (TD).

[3] Ruskin went alone to Glasgow to stay with his old friend Mrs Blackburn, a gifted artist whom he had known before her marriage to the Professor of Mathematics at Glasgow University. St Mungo's, built in the early fifteenth century as a parish church, had only recently become a cathedral.

[4] The 11th Duke of Hamilton had succeeded his father eighteen months previously, and like him was so fully aware of his high descent that Lord Brougham, an old friend of the father, referred to the son as 'Very Duke of Very Duke'. The rare collection of books and illuminated manuscripts to which he found himself heir had principally come to Hamilton Palace from William Beckford, his grandfather, and were considered family heirlooms. 'These precious manuscripts of the earlier Christian age', as Ruskin called them, were dispersed at Sotheby's in the great library sales of the 1880s, owing to family debts and extravagance. The Duchess of Hamilton (once Princess Marie of Baden) scarcely appeared on this occasion for, as Sir Walter wrote in his diary after having seen Effie's mother who conveyed the information, there had been a row over 'plate and relics abstracted from the Duke's stores for Papist Chapel, by the Dutchess'. She joined the Roman Church in 1855. Ruskin had his own illuminated manuscript of the Book of Hours (Use of Rheims), North French of the thirteenth century, which he had bought a year or two earlier. In the next years he acquired further rare examples of medieval manuscripts.

[5] On the way south the Ruskins had stayed at the County Hotel, Durham, for Christmas; accompanying them was Sophie Gray, Effie's ten-year-old sister, who was coming to live with them in London for a few months. Though the trefoil scrapers have vanished from the front doors in the narrow winding streets where the wind whistled and caught one at corners unawares, in many places the grooves still remain. The Rev. James Raine, of Crook Hall, then on the outskirts of the city, was Librarian to the Dean and Chapter for more than forty years and is still remembered for the care he exercised over the books and manuscripts in his charge. At the death of Robert Surtees (1834), whose literary executor he was, he completed the fourth volume of Surtees's *History of the County Palatine* (see Letter 51). The Cathedral Library is rich in illuminated manuscripts and Ruskin would have seen the *Cassidorus in Psalmos*, the eighth-century fragment of St Mark; also decorated pages of eighth-century fragmentary gospels.

[6] We have Ruskin's word for it (letter to Mrs Gray, Lutyens, iii, p. 126) that Effie passed her days in 'sullen melancholy', and his statement for his lawyer after Effie had left him told how she had said to him in Edinburgh that 'if she were to suffer the pains of eternal torment, they could not be worse than going home to live at Herne Hill' (*Vindication of Ruskin*, J. H. Whitehouse, 1950, p. 12).

30th January [1854]

Dear lady Trevelyan

I am really ashamed of myself about the Bishop's floors.[1] Would you please send me his proper address. The furs? feathers? arrived all safe – I never saw anything so exquisite – don't know which I like best – I hope these things will be worn. They unite the beauty of ermine, and silk, and velvet – and armour.[2] Would you kindly tell your friend the Roman Catholic priest that he need never suspect me of dishonesty – towards any of my adversaries – he may of ignorance wherever he sees ground – but if he likes, at my next Edinburgh lecture I will allude to the German revival – and state my own impressions about it – the fact being that I would not give sixpence the dozen for Overbecks works – nay – would not give them houseroom. They are mere spurious mushroomy parasites on the old religious school – just what our present Greek buildings are to the old Greek school.[3]

By way of exchange – in order that he may see the sort of letters I get on the other side, I send you one from an ultra Protestant – which may amuse you both.

I am very happy to be undeceived about Northumberland spring and will take care to see Hunts drawings as soon as possible.

Ever affectionately Yours

J Ruskin

[1] As a young man at Oxford Alexander Forbes (now Bishop of Brechin) had come under the influence of the Oxford Movement, but an aptitude for oriental languages had advanced him in the East India Company and he had gone out to Madras as assistant to the local magistrate. Ill health forced his resignation and brought him back to England where he took holy orders. After a three-year curacy, and now a friend of Dr Pusey, he was appointed to St Saviour's, Leeds. The next year (1848) Bishop Wilberforce, on the suggestion of Gladstone, nominated Forbes to the see of Brechin. His *Short Explanation of the Nicene Creed* (1852) ran into two editions; this was followed by *A Commentary on the Canticles*. A powerful theologian, he was tried in 1860 and formally censured for instruction in the false doctrine of the true presence. Soon after his appointment as Bishop he determined to transfer the episcopate to Dundee, and the building of St Paul's Cathedral, Scottish Episcopal Church, was put in hand under the direction of (Sir) Gilbert Scott, the first stone being laid in 1853. Two years later the church was opened, though not consecrated until 1865. During its building (1853–5) the Bishop must have discussed its decoration with the Trevelyans, and in November 1853 Sir Walter had driven from Edinburgh to Dundee to see the plans for the

church, which were Gothic in style. There was a scheme on foot (later abandoned) to decorate the walls with frescoes, and it appears that a tiled floor had also been considered. A latent renewal of interest in encaustic tiles had probably occasioned this enterprise. Lady Trevelyan would have turned to Ruskin for suggestions and had probably discussed it with him in Scotland.

[2] A possible explanation is that Lady Trevelyan had sent Ruskin a collection of birds' feathers. There is an echo of this passage in his *Elementary Organic Structure* (1877–8); when taking a goose feather as an example he found it 'just like satin to the finger'. Of the plume of a sea-mew he wrote: 'We must think of all feathers first as exactly intermediate between the fur of animals and scales of fish. They are fur made strong . . . partly defensive armour.' (R, 15, p. 404)

[3] This may refer to a passage in Ruskin's Edinburgh lecture on Pre-Raphaelitism in which he stigmatised those painters of the Modernist movement who took beauty for their first object, and truth only for their second. On these grounds Ruskin's denunciation of the modern German school was inexhaustible. Overbeck, whose work was mostly of a religious order, was the leader of the Nazarene group of artists living in Italy. Ruskin considered him a man of little intellect who degraded 'the subjects he intended to honour' by his hypocrisy and want of imagination.

42

From Effie Ruskin

[Herne Hill 18 February 1854][1]

Dear Pauline

You are a dear good lady to be so kind as to write me two letters and also to be pleased with the cloak which I think quite suited for *you*, and hope you mean to hire a carriage on purpose to pay little visits and be told that green & brown become you vastly, and that you look so comfortable and warm in this wild cold weather. I am shrivelled to a mummy and am hardly able to bear the keen air. I have just been giving myself a dose of it by breaking a piece of glass at my back & getting Crawley, who is the comfort of my life, to patch brown paper over the place to keep Sophie & I in the Body.

John has gone to Den Hill with his friend Newton[2] who has come over from the Greek Isles wearing a beard and quite the old man, talking Philosophy and Phidias, intermingled with remarks I suppose for my benefit how all the women in Rhodes spin & make their husbands clothes, and how shocking it is to be waited on by a Greek lady in a satin gown & Parisian corsets who eats scraps after her Lord, occasionally gets a beating, and hands coffee to the guests.

I was in town yesterday lunching with Lady Lewis, Grafton Street, & perhaps you know her. Loo was there and looked well. She was going to Lady Palmerston's in the evening. Mr Watts was there & one of the Duff Gordons, a young lady with crisp hair who talks fast, but a good creature.[3] John dined at Sir Robt Inglis's[4] which he considered a great bore, and I understand quarelled with his host over the Oyster Rates about the 13th Century – when I am sure they had few things better as entremets if they patronised anything so unwholesome.

I am going to Ella's first annotated evening on Thursday, I sit beside Lady Eastlake, which is very pleasant. She is just finishing her translations of Waagen's & is very glad.[5]

One violet has appeared but nothing else, but snow is seen in the garden at present.

Would Sir Walter kindly send the money now. I enclose the address & will rather pay you the £5–10 when you come.[6]

Ever yrs Effie

Tell the dear Doctor I rub with oil but am wofully thin but aloes makes me comfortable [probably as a purgative] & I think at last I have faith in oil too.

[1] A reference to Newton (below) in JJR's diary provides the date.

[2] (Sir) Charles Newton, the distinguished archaeologist, had relinquished the Rhodes Consulate the previous month. His father having recently died, he had returned to England before embarking on further excavations which were to lead to the discovery of the remains of the Hellicarnassus mausoleum. He and Ruskin had been together at Christ Church, Oxford.

[3] Lady Lewis was the second wife of Sir Frankland Lewis, Bt. His first wife had been the aunt of the two Miss Duff Gordons, Georgy and Alice, whom Watts had known well in Florence in 1846. Probably Alice, the younger of the sisters, was at the party, for her hair was wavy 'like the tendrils of a vine'; and, though Georgy was known to be 'very clever . . . saying whatever comes into her head' (*England's Michelangelo*, W. Blunt, 1975, p. 41), she would already have been thirty-six, while Alice, only a year or two older than Effie, was perhaps still sufficiently a 'young lady' to earn Effie's patronising assessment.

[4] Sir Robert Inglis, Bt, was an Antiquary of the Royal Academy, a keen Churchman, and had been for many years Member of Parliament for Oxford. More praiseworthy still, in 1815 he had not only taken on Battersea Rise, the 34 bedroom Clapham house, at the death of its owner, Henry Thornton of the Clapham Sect, but also the guardianship of all nine of his children; these included the formidable Marianne (*The Parting of Friends*, D. Newsome, 1966, p. 22). His courteous manner and pleasant countenance were remarked upon by Ruskin.

[5] John Ella, violinist and conductor, held an annual series of 'Musical Winter Evening Concerts' of a high standard, forerunners of the popular concert. The committee was drawn from the aristocracy and membership could only be obtained by personal introduction. Owing to the initiation of programmes consisting of a few pages of simple analysis, these soirées were known as 'annotated evenings'. Lady Eastlake completed her translation of Dr Waagen's *Treasures of Art in Britain* in February of this year.

[6] Probably for some charity.

43

8th March [1854]

Dear lady Trevelyan

Just after receiving your last letter I discovered that a large collection of Chamouni rock specimens, on which I much depended for my present work, had got all *misnumbered*. Sir Walter, at any rate – if not you – will be able to conceive my discomfiture. I cannot account for the thing either, but by supposing they must have been unpacked at the Custom house [in 1848], & rolled up in wrong papers. But at any rate, I had to set to work on the instant to repair the mischief as I best could, and tiles and every thing had to be laid aside till I got my collection into order, & when that was done I wanted to go to a tile makers – to know what could be done – and a convenient day never came for that – and at last I must ask the Bishop to find out the possibilities of the thing among his employed people – I have blotted down some forms of colour on the two bits of paper enclosed – and I want to know whether the Bishop can go to the cost of having tiles made with as much work as there is on the letter B. – also – whether Gold can be introduced in tiles so protected as to bear the wear & tear of the foot – and at what cost – as inscriptions might be introduced glittering among the quieter hues of the pavement – on the other piece of paper is a suggestion of what might be done cheap – the forms of disposition and patterns of tile might of course be varied in every square fathom of pavement. If the Bishop can go to the expense of having tiles made like this, I can furnish him with endless varieties of patterns from my M.S.S. – but a set of twenty or thirty tiles would pretty well puzzle the eye. But will you ask the Bishop 1. What cost he can go to – 2. What the making of such tiles will cost. 3. Whether he likes this kind of thing – no, No 3. ought to come first & then No 2. and then No 1.[1]

And please tell me *how* to address a Bishop – I never had occasion to write to one, and must buy a "complete letter writer" if you don't tell me.[2]

With best love to Sir Walter ever affectionately Yours

J Ruskin

N.B. Of course the chequer pattern 3 sets of tiles would be wanted – long blues, – purples, and small white squares. I think the pattern of a tile pavement never should go over the edges of the tiles, but I could give millions of patterns, for sets of three sizes.

[1] Lady Trevelyan forwarded to the Bishop the colour samples enclosed in this letter. He was slow in reacting owing to his Lenten services having occupied his time and consumed his energies, but in his letter of 15 April 1854 to Lady Trevelyan he acknowledged 'the receipt of Mr. Ruskin's beautiful tiles', and begged her to convey 'to Mr Ruskin all that I do feel and ought to say on such an occasion. I have written to Mr Scott about them.'

[2] Ruskin must have known perfectly well how to address a bishop. Perhaps he did not wish to start a correspondence on a matter which did not greatly interest him. He seems to have had no difficulty in addressing the Bishop of Natal in 1862 (*Winnington*, p.386), or else by then he had taken soundings.

44

9th April [1854]

Dear lady Trevelyan

I am getting a little anxious at not hearing from you. I sincerely trust you are not ill – please send me the least line possible to say you are not. I have seen Hunts drawings – did not like the one he had kept for you – told him to sell it – I hope to see another soon.

Ever yours affectionately

JR.

45

[Easter] Saturday Evening 15th April [1854]

Dear lady Trevelyan

I was delighted to have your letter and more delighted by the reading thereof.

I don't know when I have had so refreshing a laugh, and then I

was so glad to hear of your being well, and able to go and see machines dig: I was with John Millais to day, and informed him of Sir Walter's changes in his former subject – on which he said – "When he is about it, he ought to wear chain-mail at once; I never saw the man who would look the thing so well."[1] So I am afraid there is no help for you in this quarter – we all think Sir Walter quite right.

I have been doing nothing since I wrote to you – and yet have been always busy – To be sure, – in the springtime I pass a good many hours in the garden looking at the buds, and throwing stones for my dogs to play with[2] – and I have been drawing leaves, finding that I have advanced in power, and can do them better than I used to do – by the bye – if that bit of brown beech-leaf is all Sir Walter has got to send me, you may tell him I don't know it from a dead leaf – In *our* spring we have *Green* things. I have also been working a good deal at a black & white finished copy of a Turner drawing to show how they should be engraved, and I am making a catalogue of the manuscripts at the British museum – and taking some lessons again from Hunt and trying to paint a stone, to my very great discomfiture. I have also been adding a good deal in the form of notes to my lectures – as they have been going through the press, and writing a little notice of Giottos chapel at Padua for the Arundel Society,[3] besides doing some of Modern Painters whenever I get time, and I was several days standing on one leg to please John Millais – till I got such cramp and pain in the side that I had to give over, since which break down I have merely had to sit for hours a day without moving my head, and to look all the time out of the window at a particular brick in an opposite chimney without winking: in order to secure the expression.[4] I have also had to hunt through some books on painted glass to find 13th century squares of design without any popery in them – which might be glazed in the face of a protestant congregation – at the bottom of the hill. They are nevertheless very restive; and have nearly protested both their clergymen & architect into fevers. I advise a little orthodox white-wash and plain lattice, but the clergyman has a chromatic weakness, and I fear, may paint himself out of the pulpit.[5]

What Effie has been about, all this time, I cannot exactly tell you, she has had a friend with her, a Miss Boswell – elderly rather – and stout, and they went about town together seeing sights.[6] Effie has been drawing a little – but I believe the drawing fit will die off,[7] like the woodcarving one. What do you mean by saying I shall think

your new drawing stupid? But I am very sorry to hear of Dr John Browns illness – as I know it is very inconvenient to him to leave Edinburgh – however necessary. I wanted much to have asked both him and his wife to stay here, but I cannot do everything I want to do – or perhaps everything I *should* do. Effie has an unfortunate prejudice against Dr Brown, owing to some (she calls it) concealment, about the behaviour of a young man – a Mr Harvey – left in his charge – years ago. She infected me with the same feeling, for some time; but I find it is better to trust to one's own eyes & thoughts than to anyone else's. But I could not ask him here.[8]

And now – comes the worst business of all. We – that is to say my father and mother and I, leave London for Switzerland, God Willing – on May 9th. Effie will probably leave us for Scotland some days previously[9] – so that if you and Sir Walter do not come before the beginning of May, you may miss *her* altogether – and perhaps find me – (unless for the first time in my life I fulfil my present intention of being ready with all things before-hand) in a mere puzzlement of pack up. Pray come sooner if you can at all manage it. With best love to Sir Walter.

> Ever affectionately Yours
>
> J Ruskin

[1] Sir Walter had now turned his attention to some new contrivance used in one of his fields to his great satisfaction: a digger, which 'thoroughly cleaned the weeds out of the ground', and a clod crusher, another 'very perfect' implement of the same order (TD). It is just possible that to Millais's imagination these two instruments conveyed the impression of some relic of the Middle Ages to which Sir Walter would contribute an appearance in chain-mail; more likely it had some reference to a joke known to them all.

[2] He could scarcely remember the time when there were no dogs in the family. Dash, the spaniel; Lion the black Newfoundland, who had bitten him on the lip when he was a child of five (Was this much-loved dog called after Byron's Newfoundland, Lion, who had amused him at the end of his life at Missolonghi?); The terrier Twig; Tug, Mungo, Wisie given to Effie in Venice but remaining for years at Denmark Hill; bulldogs, St Bernards, collies.

[3] This was Part II of *Giotto and his Works at Padua*, for which Ruskin wrote an explanatory text. Part I had been issued the previous year and in 1860 Part III followed.

[4] Ruskin was still sitting for his portrait. Gower Street, where Millais had his studio on the ground-floor back of his parents' house, was a street Ruskin found immensely ugly. Already in *The Stones of Venice* he had complained of its type of architecture, and now again in *Modern Painters* iii: 'a desert of Ugliness'. Perhaps this passage was written during these fateful weeks.

[5] A Byzantine chancel was added to the unexceptional late eighteenth-century Camden Church in the Peckham Road, Camberwell. The Rev. Daniel Moore was the incumbent and Gilbert Scott, the architect for the new work, in which Ruskin was greatly interested, and in the main his suggestions were adopted. Several stained-glass windows adorned the new chancel. The church was damaged in the Second World War and has since been pulled down.

[6] Effie had been busying herself with her escape. Her parents had arrived secretly in London the evening before, and ten days later Mrs Gray and her daughter were on their way to Scotland. Miss Jane Boswell from Ayr, an old friend of the Grays, was on a visit in return for one paid her by Effie. At their first meeting in 1853 Ruskin had thought her 'very clever, witty, not troublesome' but by now this opinion had probably suffered a reverse; she was making plenty of trouble for she cordially disliked all the Ruskins.

[7] A drawing exists, *Woman in Church watching her Former Lover Married*, which was partly executed by Effie at this period. Apparently begun by Millais in 1853, it bears his initials, also 'EGR 1854'. (See *Millais Royal Academy Exhibition Catalogue*, 1967, No. 335.)

[8] Dr Brown was abroad for his health; during April he was in Spain. Mr Harvey is unidentified.

[9] Since neither Ruskin nor his parents wished for Effie's company during the summer in Switzerland she was returning home – supposedly for a few months.

46

Dover, 8th May [1854]

Dear lady Trevelyan

I received your little line with deep gratitude – fearing that even *you* might for a little while have been something altered to me by what has happened.[1] I do not know what Effie has written of me. I am thankful that neither by word nor look of mine, at least voluntarily, any evil was ever spoken of *her* – She has now put it out of my power to shelter or save her from the consequences of the indulgence of her unchastised will. For *me* you need not be in pain. All the worst to me – has been long past. I have had no wife for several years – only a shadow – and a duty.

I will write you a long letter soon – at least to Sir Walter. There are only two people beside my parents whom I mean to acquaint with the whole circumstances of this matter – those are Dr Acland, and your husband. The world must talk as it will. I cannot give it the edifying spectacle of a husband and wife challenging each others truth. Happily I have long been accustomed to do without the world – and am as able to do so as I ever was. But I will not give my two best friends the pain of having to trust me in ignorance.

I am very very sorry you have been ill – but it was no wonder. I am sure you loved Effie – it must have been a cruel shock to you to receive her letter – whatever it said.[2]

I hope to be in France to morrow – in Switzerland in a fortnight – my father & mother are with me – I will write again speedily. Be assured all is for the best: and take my earnest thanks for your steady trust in me at a time when I most need it. For indeed Effie has said such things to me that sometimes I could almost have begun to doubt of myself – and what then might my friends do.

I hope Hunt's picture will make you quite well again. It might comfort any grief, I think – I mean the "light of the World".[3] I cannot write more this evening – but I hope I have said enough to put you out of fear for me –

<div style="text-align: center;">Ever affectionately Yours
J Ruskin</div>

Best love to Sir Walter.

[1] Effie had left her husband on 25 April and was seeking an annulment on grounds of non-consummation of the marriage. Ruskin was now on his way to Switzerland with his parents, almost in sight of Calais – 'the port of entry to his paradise' (R, 5, p. xxxi), carrying out calmly and with deliberation those plans which had been made some months ago. The Trevelyans had reached London from Northumberland on May 5th and had taken rooms at 4 Holles Street, Cavendish Square. There is no mention of the Ruskin break-up in Sir Walter's diary though it must have been much talked of in their circle of friends. On 14 May the Trevelyans attended St Andrews, Wells Street, where 'Service well done – met John Millais' (TD).

[2] Lady Trevelyan had been very fond of Effie but she remained entirely staunch, being in a better position than most (see Letter 47, note 1) to gauge the nature of the falsehoods being circulated by those indisposed towards Ruskin. The friendship between the two women ceased, though Effie attempted to prolong it.

[3] The Trevelyans had been to the Royal Academy and had admired Holman Hunt's *Light of the World*. 'A wonderful work', Sir Walter thought it, but the artist's second canvas was less to his taste. '*The Awakened Conscience*, tho' a striking picture I don't like – nor is it so well painted.' They left London for Nettlecombe by train, 'the new Paddington Station now open is splendid in general & in detail in exceeding good taste' (TD).

Rouen, 17th May – 1854

My dear Sir Walter

I got lady Trevelyan's kind little line as I was leaving town – just at the Railway station. I put it in a wrong pocketbook & could not find it at Dover – so that I was obliged to send my answer to Wallington instead of Holles St – I hope she got it soon – it was very kind of her to write to me. I have too long delayed giving you further information on this unhappy subject. I have written a long letter to Henry Acland about it, and in order to avoid the pain of writing such another, I have asked him to forward it to you for your reading. In order that it may be quite safe, I told him to send it to Wallington – in case you might have left Holles St. I send this to Holles St merely to tell you & lady Trevelyan that I am quite well, and working very happily on Rouen Cathedral. Tell lady Trevelyan whatever you think fit – out of the long letter. It will be very painful to her – you will best know how much she can bear to know at present.[1]

I did not forget the Bishop of Brechins work – but could not attend to it before leaving London. If he can still wait for three months, I can give him working drawings of tiles as soon as I return, but I can only furnish some pretty & available patterns out of my books, I could not design the floor. I cannot design in the least.[2]

With sincerest regards to you both,
Faithfully Yours

J Ruskin

Sir Walter Trevelyan Bart.

Please send me a line, directed 7 Billiter St,[3] (whence it will be forwarded) to tell me how lady Trevelyan is.

[1] For this most important letter, probably read by both Trevelyans and returned to Dr Acland, see Appendix II.

[2] Nothing further is heard of the Bishop's tiles.

[3] The city office of Ruskin, Telford & Domecq.

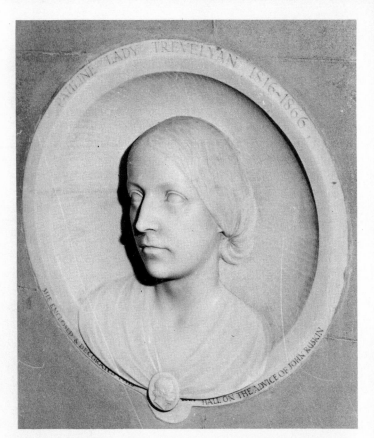

3 a. Lady Trevelyan, 1857

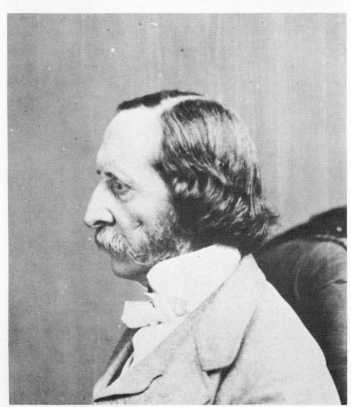

b. Sir Walter Trevelyan, 1860

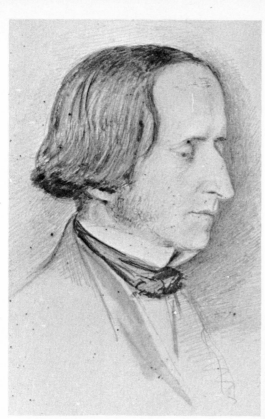

4 a. Dr Henry Acland, 1853

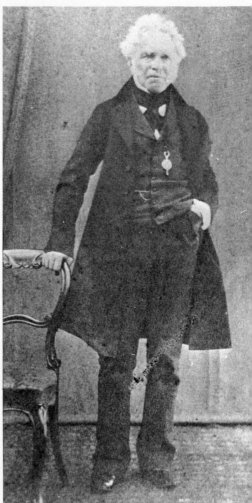

b. John James Ruskin, c.1860

Geneva, 5th June [1854]

Dear lady Trevelyan

Your kind letter – received last night – was one of great comfort to my father & mother as well as to myself. So far from drawing back from sympathy – and distrusting my friends – I never felt the need of them so much. I am only afraid of *their* distrusting me. For indeed that a young wife – in Effies position, should leave her husband in this desperate way, might well make the world inclined to believe that the husband had treated her most cruelly. It is impossible for people not to think so – who do not know me, and though I am as independent of the world as most people, I am not used to be looked upon as Effie will make some people look upon me – and am very grateful to my unshaken friends.

Indeed I am most ready to admit I may have been wrong in several ways – about Effie – but assuredly, I did all I could for her to the best of my judgement – except where I must have sacrificed not only my own but my parents entire happiness if I had yielded to her. As for controlling her – I never felt myself a judge of what was right for her to do or not to do – and I had so much steady resistance to make to her in one or two great things that I could not bear to thwart her in less ones – I used to express my wishes to her very often – that she would be less with certain people, and more with others: but, except only with you and Miss Fortescue – it was generally sure that Effie would take a dislike to the people whom I liked best.[1] I had no *capacity* for watching flirtations – I might as well have set myself to learn a new science, as to guess at peoples characters and meanings. I should never have had any peace of mind, if I had been always thinking how far Effie was going – with this person or that. I knew her to be clever – and for a long time believed she loved me – I thought her both too clever – & too affectionate – to pass the bounds of what was either prudent for herself or kind to me. I also was induced to believe that her influence over several young men whom she got about her was very useful to them[2] – I used to hear her giving good advice like an old lady – which I thought it possible – from the *young* lady – might be listened to – In the last instance (which indeed at present gives me the most anxiety of all things connected with this calamity) I trusted as much to the sense – honour – & principle of my friend [Millais] as to Effie's. The honour

& principle failed not. But the sense did – to my infinite astonishment – (for I supposed he must have passed through all kinds of temptations: – and fancied, besides, his ideal quite of another kind).[3] But he lost his sense – and this is the worst of the whole matter at this moment. He never has seen Effie since November, but I don't know what thoughts may come into his head when he hears of this.[4]

The whole matter is strange – complicated – full of difficulty and doubt. I cannot in Effie distinguish art from blindness when she said what was not true I never could tell how far she herself believed it. She never – during the whole course of our married life – once admitted having been wrong in anything. I believe she truly thinks herself conscientous – unselfish and upright – It was in this she was so like Miss Edgeworths lady Olivia.[5] I do not know what she might have been – had she been married to a person more of her own disposition. She is such a mass of contradiction that I pass continually from pity to indignation – & back again – But there was so much that was base and false in her last conduct that I cannot trust to anything she ever said or did. How did she make you believe she was so fond of me? and how, by the bye–came you to think that I was *not* fond of her?[6] I am not demonstrative in my affections – – but I loved her dearly. Much however of the show and gloss of the affection was taken off by hard wear. Effie never did anything for me. No gratitude was ever mingled with my love. She never praised me nor sympathized in my work – but always laughed at me – I can *bear* being laughed at as well as most people – but it is not the way in which a wife is likely to increase her husbands regard for her. Finally she drew from my affection all she could – and was perpetually demanding more – and trying to shake me in my settled purposes & principles. No wonder that a cord – so hardly strained, should seem to hang loose sometimes. But it was not broken – nay – is not even yet *so* broken – in spite of much contempt being added to anger – and wounded pride – all contending with the ancient affection – but that I earnestly desire her happiness and should rejoice to hear that she had found some "way of peace". That I ever should receive her again as my wife is impossible, because I could never be certain that her repentance was sincere – or if sincere, likely to be permanent, and I believe I have that to do in the world which must not be impeded by indulgences to one who – however much to be pitied now, would in all probability remain pitiable, whatever I sacrificed for her.[7]

I am much grieved to hear of Sir Walter's illness – how kind of him to write to me when he was just recovering from his attack – and how *like* him to say nothing about it.[8]

I have been made excessively uncomfortable for the last fortnight by finding *restorations* going on at Chartres – Rouen – & Amiens – the three best Gothic cathedrals, I believe in the world – I was like to have got quite ill – and was obliged to come away. The sight of the Alps has put me to rights again. I never thought them so beautiful. I am drawing vignettes, which I am rather proud of and which I think you will like, and writing – at present only dismissing arrears of letters – but I shall soon get to my third volume. I will write again in a fortnight or so – to tell you more about our doings – but this letter must go to night – little as there is in it.

I am so glad you like your Hunt. But literally all that I said to him was that I did'nt think he was painting up to his own mark, and that I saw a good deal in a withered leaf which he had missed out of it. He is so modest that he never knows whether what he does is his own doing, I believe. I think he has a vague idea that it comes on the paper by accident.

Best love to Sir Walter.

Ever affectionately Yours

J Ruskin

I forgot this was to be addressed to you at Henry Aclands – my love to them both.[9]

[1] Harriet Fortescue admired Ruskin's work; her brother, later Lord Carlingford, was in turn an admirer of Effie. Besides Dr Brown, whom Effie is known to have disliked, those others of Ruskin's friends for whom she had an aversion are not recorded, though the odds on her liking Dr Acland are small. Perhaps Anne Strachan, Ruskin's old nurse and much loved by him, F. J. Furnivall, Osborne Gordon, W. H. Harrison, and Richard Fall were amongst those she did not care for. These were very early friends of the Ruskins, and possibly, particularly in these last years, she preferred to avoid anyone connected closely with Denmark Hill. Coventry Patmore seems to have disliked her, and this may have been reciprocal.

[2] Her influence over Clare Ford in 1851 had been entirely beneficial. (See Lutyens, iii, p. 14.)

[3] Nothing surprised Ruskin more for he admired Millais enormously and could not conceive him so losing his common sense as to fall in love with 'my commonplace Scotch wife' (Yale. Letter to Dr Brown).

[4] When Ruskin wrote this present letter he may already have received Furni-

vall's, telling him that Millais was returning to Brig o' Turk to complete the land-scape in the Ruskin portrait. To this Ruskin replied on June 9 asking to know Millais's attitude and other people's to Millais's going, or abstaining from going, to Scotland. 'I have no personal reason for asking this, but I wish to know for Millais' own sake, poor fellow, and you need not fear surprising me by telling me. I know the *facts*, but I want to know the *sayings*!' (R, 36, p. 169)

[5] *Leonora* (1833), in which Lady Olivia is always able to justify, with great felicity to herself, her entirely selfish conduct.

[6] Lady Trevelyan seems to have detected only half the truth. She was probably referring to her visits to Herne Hill in the early part of 1853, since when she and Effie had scarcely been alone together. Effie would have put up a good front, knowing that she could not expect sympathy from Lady Trevelyan. (This was very much the reverse of her relationship with Lady Eastlake.)

[7] The artlessness of this passage seems to convey complete truth. Now, with his intellectual powers undimmed and with a vision of the tasks he felt compelled to undertake ('I have that to do in the world . . .'), unfettered by domestic ties and once again in Switzerland with his parents, he was free to write to this loyal friend precisely as he felt about Effie and their marriage and the 'ancient affection', without pretence and without bitterness.

[8] Sir Walter had been suffering from a form of whooping cough.

[9] The letter is addressed to Lady Trevelyan, 'care of Henry Acland, Esq, M.D., Broad Street, Oxford'. Lady Trevelyan has added the notation: 'About his broken marriage.'

49

Chamouni, 17th July 1854

Dear lady Trevelyan

I wish I could let you see the aiguilles this morning[1] – pale and serene – intense in their strength and silence, in the morning light, and in the sky – I see – more and more lately, that I have never enough insisted on the great fact that the sky is not blue *colour* – but blue *light*. One ought to think of it as a great lambent vault of blue flame, when one is drawing – else one never rightly comprehends its relation to the mud of this earth. I think I could do something now, if I were only 15 instead of 35, but I must be content with telling other people how to do something.

I think the Alps are growing. They seem larger every time I come to them, and more infinite. Every landscape among them is to my eye, made up of a thousand vignettes; I don't mean a thousand hyperbolically, but gravely – ten hundred – twenty times fifty, a hundred times ten – vignettes – each containing about as much, in

itself, as that one with the stag drinking, in Jacqueline, in Rogers' Poems.[2] So, you may imagine how comfortable I feel in sitting down to do anything. Also I have discovered that pines cannot be symbolized. They can be drawn – so [sketch] – one by one – and no other way.[3] So, before beginning a sketch among the Alps, you see, the first thing to be done is to count the pines, on both sides of the valley – then you consider how long it will take you to draw them – say at the rate of a pine a minute (that is rather fast, if they are to be done with any refinement – allowing an average, for near ones take much longer). Then you know how long your sketch will take you before you get to the rocks; and this is very convenient:

It is very fine, truly, of Acland, to turn rebellious now – after being himself at the bottom of all the mischief.[4] Sixteen years ago – he and I went together to draw the tower of Christchurch Cathedral. He made rather a mess of it – drawing it – if I recollect right – in this kind of way [sketch] & getting particularly embrouillé in the cornice. So – by way of doing great things, I drew it this kind of way [sketch] considering myself to have particularly distinguished myself in the said cornice. Presently Henry came to look at what I was about; and after pretending for a long time, in his wicked way, to be very humble, what does he do but deliberately set himself to *count* the arches in said cornice, first in the cathedral & then in the drawing; – points out that I am three short, on both sides – and conceals his malicious triumph under the appearance of profound sorrow and disappointment. And that was the first lesson I ever had in PreRaphaelitism: If I don't count the tentacula of his starfish and "dabby things" for him – he may think himself better off than he deserves.

I was very glad to have your letter for my friends are all aghast – one way or another – and don't know what to say, or whether to write to me or not: – and decide not, at last. I was very glad to know that Acland had really begun *his* – and I have written to him to say that that will do, for the present, for I am sure he will not know what to say.[5] I shall write and thank Mrs Buckland also, directly – but the less I write, the less I like writing, at present, for it puts me into painful trains of thought – and when I am at my pines and aiguilles, I am all right –

I have got a wonderful subject at Fribourg which I hope to draw as I get back[6] –

Modern painters – last vol – is going on fast, and I have written

something about crystal palace, a little pamphlet which I shall tell Smith & Elder to send you as many of as you like to have – as I should be grateful if you would give one away here & there, when you see good.[7]

I hope to be home about 25th August – as to what is to be done next year – I know not yet at all – but it is very likely I may come and see you a little in this October – or about the fall of the leaf – (by the bye when *do* those brown things you call leaves, fall, in Northumberland? –) for I have to go to Whitby some time or other this winter to study Turners boats, & see a storm, if I can.[8]

I am very sorry to hear Sir Walter coughs still – my mother has had cough for nine months – it is a strange time for diseases of the throat – but my throat is much better – thanks to Beveridge[9] – I should like intensely of course – to be with you when you have the Aclands next year – but it is really nothing now to come *here* – suppose we could all come here together? You have some rocks at Wallington certainly – but this is better for PreRaphaelite purposes – owing to the above noticed facts about the pines!

I must send you this shabby line to day for I am going to sleep at the Montanvert and don't know how long I should put it off again if it did not go now.

> With most sincere regards to Sir Walter
> Ever gratefully Yours

> J Ruskin

You shall have drawing as soon as I get home.

[1] He had reached Chamonix a week earlier. 'Thank God, here once more; and feeling it more deeply than ever' (*Diaries*, p. 498). Ruskin made many drawings of his favourite Aiguille de Blaitière. A sketch (pen and ink wash) inscribed lower left: 'Aiguille de Blaitière near its base J Ruskin 1854' hangs at Wallington. (See Letter 53, note 1).

[2] Turner's vignette illustrating Roger's *Jacqueline* (*Poems*, 1834) presents a deep ravine banked by woods on either side, two waterfalls, a turretted castle, snow-capped mountains in the distance, and in the immediate foreground a stag at the water's edge. (See R, 21, p. 214.)

[3] A sketch at Wallington inscribed: 'JR 1854 Slope of the Alps with fir trees' may have been made this day. (See Letter 53, note 1).

[4] While the Trevelyans were staying with Acland had he perhaps shown hesitation in the 'Battle of the Styles' for the new Oxford Museum? (See Letter following, note 8.) Till now he had been firmly Gothic in his preference, but perhaps the required precision of detail had left him undecided.

[5] 'September 1st. A letter from Acland relieves me from the anxiety which I

have so long laboured under; letter received as I was drawing on the slope of the hill, in the very flank of Mont Blanc. Deo Gratias. Gloria' (*Diaries*, p. 503). At first glance this seems to refer to Acland's reception and reaction to Ruskin's letter of early May concerning the break-up of his marriage. Or, and this was of singular importance to Ruskin, might it in part refer to Acland's now unwavering support of Gothic revival for the new museum?

⁶ Several of Ruskin's views of Fribourg exist, made at various dates. Pasted into an album preserved at Wallington, a small rough pen and sepia sketch, 'Fribourg 1854', carries a pencil notation in Ruskin's hand: 'a finest white, steeple brighter than town or walls'.

⁷ Amongst his other activities in the Alps that summer Ruskin had commemorated *The Opening of the Crystal Palace* which had taken place at Sydenham in June. Issued on 24 July at the price of one shilling, the pamphlet opened by praising the scale and environment of a museum 'where contemplation may be consistent with rest, and instruction with enjoyment'. He could dream of 'intellects once dormant, roused into activity within the crystal walls', but these hopes were concomitant with 'melancholy thoughts', for after three hundred years of study and investigation into the art of architecture, its principles discussed 'with all earnestness and acuteness' and a search made after 'lofty ideals', the 'great result, the long-expected conclusion' had led but to a 'magnificent conservatory'. This was followed by a resounding denunciation of 'restoration', at Rouen in particular.

⁸ In preparation for *The Harbours of England*, for which Ruskin wrote the text to illustrate twelve drawings by Turner.

⁹ See Letter 38, note 2.

50

Paris, 24th September [18]54

Dear Lady Trevelyan

I received your letter two days ago at Sens, and we are all most truly sorry for Sir Walter, and for you.¹ Poor Sir Walter has indeed had much to suffer – first in his anxiety about your health – and then when you were getting better these bitter sorrows striking him again and again – like the Northumberland rain beating on his bare forehead as we crossed the moor.² You are both of you good people, and I think that must be the reason you have so much to suffer – you would have been *too* happy, but for such things as these. Men *must* have sorrow in this world; and it takes hard blows to make them sorrowful when they are good.

I should think you must often have read the verses for the twentieth Sunday after Trinity in the Christian Year as you were wandering among the Scotch Hills. I had some times of painful

feeling myself when I came abroad first, and I found that book very useful to me. I did not understand it before.³ But I have got over my darkness now, thank God; and I am very full of plans, and promises, & hopes, and shall have much to talk to you about when I see you – though I do not think I shall be able to come north this autumn now. I have stayed so much longer than I intended in Switzerland, and I have been sadly idle, and want to do something. Not exactly idle neither, for I have been learning a good many things, and have convinced myself of some things which I had long suspected: for instance that most Raphaels are not worth ten pounds apiece – I settled that matter only yesterday in the Louvre:⁴ And you may tell Sir Walter I have great misgivings that the science of geology is good for very little. It never tells me anything I want to know.

I think that seems to be one of the wants of this age – people that will tell one what one wants to know – as you do about my flowers. (I have a whole parcel for you – dried – to find out – from Source of Arveron and front of the Cathedral at Sion [in the Valais],)⁵ and I am going to set myself up to tell people anything *in any way* that they want to know, as soon as I get home. I am rolling projects over and over in my head: I want to give short lectures to about 200 at once in turn, of the Sign painters – and shop decorators – and writing masters – and upholsterers – and masons – and brickmakers, and glassblowers, and pottery people – and young artists – and young men in general, and school-masters – and young ladies in general – and schoolmistresses – and I want to teach Illumination to the sign painters and the young ladies; and to have prayer books all *written* again; (only the Liturgy altered first, as I told you) – and I want to explode printing; and gunpowder – the two great curses of the age – I begin to think that abominable art of printing is the root of all the mischief – it makes people used to have everything the same shape. And I mean to lend out Liber Studiorum & Albert Durers to everybody who wants them; and to make copies of all fine 13th century manuscripts, and lend *them* out – all for nothing, of course, – and have a room where anybody can go in all day and always see *nothing* in it but what is *good*: and I want to have a black hole, where they shall see nothing but what is bad: filled with Claudes, & Sir Charles Barry's architecture⁶ – and so on – and I want to have a little Academy of my own in all the manufacturing towns – and to get the young artists – preRaphaelite always, to help me – and I want to have an Academy exhibition – an opposition shop – where all the

pictures shall be hung on the line; in nice little rooms, decorated in a Giottesque manner; and no bad pictures let in – and none good turned out and very few altogether – and only a certain number of people let in each day – by ticket – so as to have no elbowing. And as all this is merely by the way, while I go on with my usual work about Turner and collect materials for a great work I mean to write on politics – founded on the Thirteenth Century – I shall have plenty to do when I get home.

We stayed in the Alpine air, thinking it healthier than London air just now – my father & mother waited for me at Geneva, and I went to the Montanvert and into the Valais, for a month. I have got rather beaten again by those big Alps – it is very ungenerous of them to take such advantage of their size. But I will take the conceit out of them yet, some day. Meantime I am enjoying a little of the Louvre. Nothing is more curious than the effect of perfect art upon ones own mind, after being a long time among wild nature. I always go straight to Paul Veronese if I can – after leaving Chamouni; this time I had very nearly cried; the great painting[7] seemed so inexpressibly sublime – more sublime even than the mountains – owing to the greater comprehensibiiity of the power. The mountains are part of the daily, but far-off, mystery of the universe – but Veronese's painting always makes me feel as if an archangel had come down into the room – and were working before my eyes. I don't mean in the *piety* of the painting, but in its power. I would go to Tintoret if I could – but there are no Tintorets in the Louvre – except one – hung sixty feet from the floor – and after Tintoret there is nothing within a hundred miles of Veronese. The Titians and Giorgiones are all very well – but quite *human*. Veronese is *super*human.

I find Angelico's and Perugino's rather thin and poor work – after Alps. Or perhaps I am getting every day more fond of matter of fact, and don't care to make the effort of the fancy they ask of one. As I said, I have made up my mind that Raphael is a take-in; I must be a little cautious however before I communicate the discovery to the public.

I am going to take three more days here, & then we go leisurely homewards by Amiens – we hope to be at Denmark Hill by the 2nd or 3rd August [a slip for October]. Then I must run to Oxford on the 14th about Aclands museum[8] – and stay two or three days – but shall, after that I hope, settle at D. Hill for the winter. Please

write & tell me all about the drawing you have done – I shall want you to help me a great deal, when I get my plans organized – and with my flowers, directly; – I have got a book by Lindley on Botany – which tells me larkspur & buttercups are the same thing[9] – I don't believe it; and won't – and of course – it doesn't tell me the name of any of *my* flowers. I have got such a pretty blue one – for mosaic – I suppose *you* will say it isn't blue – but red, or yellow, or any colour *but* blue – at all events it appears to me Blue, and I mean to call it a blue flower.

Please tell me how you liked Dunblane Abbey – & Doune – if you were there – but I suppose you have seen them often. Mr Hill showed me some sketches of grand subjects about the Bridge of Allan.[10]

My father & mother join in sincere regards to Sir Walter & you: Believe me always affectionately Yours

<div align="center">J Ruskin</div>

[1] A younger brother of Sir Walter's had committed suicide.

[2] See Letter 25, note 1.

[3] Hoping to gain comfort in the healing powers of the countryside, the Trevelyans had gone to Scotland. There, with the book of sacred poems by Keble, the originator of Tractarianism, Lady Trevelyan perhaps found some relief in the lines specified by Ruskin.

> Where is thy Favour'd haunt, eternal Voice . . .
> 'Tis on the mountain's summit dark and high,
> When storms are hurrying by . . .
> No sounds of worldly toil, ascending there,
> Mar the full burst of prayer;
> . . . the fitful sweep
> The wheeling kite's wild solitary cry . . .
> Such sounds as make deep silence in the heart
> For Thought to do her part . . .
> There lies thy cross, beneath it meekly bow . . .

Meanwhile on 10 July Ruskin himself had had recourse to the same book. 'It is curious that the first book that I took up here, after my new testament, was the *Christian Year*, and it opened at the poem for the 20th Sunday after Trinity, which I have never read before.' (*Diaries*, p. 498)

[4] Ruskin's view of Raphael was ambivalent for, though he recognised him as 'one of the three great masters of the cinquecento', yet his art marked the turning-point from 'art employed for the display of religious facts' to 'religious facts employed for the display of art'. Ruskin would have been looking at *La Belle Jardinière* and *Holy Family of Francis I* at the Louvre.

[5] Where he found 'one mass of weeds' (*Diaries*, p. 508). (See Letter 53.)

[6] Sir Charles Barry R.A., architect of buildings in the Italianate manner, could

move also from the Tudor to the Jacobean style, to Ruskin's profound disgust. There was much to criticise in Claude's work, though it is more likely to have been the comparison with Turner which Ruskin most resented.

[7] *Marriage in Cana.*

[8] Ever since 1847 Acland had urged an Oxford museum of Natural History. Ruskin was enthusiastic and envisaged a Gothic building decorated by the Pre-Raphaelites.

[9] In the *Ladies' Botany* (1834) J. Lindley had observed that both flowers were of the *Ranunculaceae* genus.

[10] While in Scotland the Trevelyans had gone to Bridge of Allan for the waters. It is tempting to suppose that they also visited Glenfinlas close by, curious to see the stage upon which so profound a human drama had been enacted, but no such expedition is recorded in Sir Walter's diary. Perhaps D. O. Hill had shown Ruskin his sketches at Edinburgh in the autumn of 1853.

<div align="center">

51

</div>

From Lady Trevelyan

<div align="right">

Wallington
Decr 11 [1854]

</div>

My dear Mr Ruskin

It is such a very long time since I have heard from you.[1] I suppose you know I wrote last? and if you are busy with lectures & workmen, I am busy with lectures & work women, soap & scrubbing brushes and brooms and mops are my subjects, which are quite as necessary as letters with scriggly tails, for we have been for three weeks trying to make the big house habitably clean,[2] & the more it is cleaned the dirtier it seems to get, and though there may be an end to most earthly things, there is no end to dusting, but perhaps by the time you have reformed the outsides of the houses, I shall have tidied up the inside of ours – and as I have found time to write I hope you'll please do the same, & tell us how you are, and what you are about besides the lectures, and whether you have got any workingmen learning to draw[3]. A labouring man near Nettlecombe once got a friend to ask me to help him because he wanted to draw, and I was a good deal set up at the idea of a pupil, & a future genius, but the drawings he had done & shown to his clergy, turned out to be tracings against the windows & my scholar afterwards took to drink, and I think all he wanted of me was shillings. I wish you better luck, don't give your class shillings.

Many thanks for "the Builder",[4] Mrs Loudon was so delighted

<div align="center">

91

</div>

with that lecture she wrote & told us how pleased she had been.

Do you think any body can *acquire* the power of ornamental painting? I should be afraid it was a very rare talent, judging by the way people habitually jumble colours & forms of the most detestable incongruity together, in their houses & in their clothes, even when they have perfect things given them, like flowers, not one person in 20 makes a decent nosegay.[5]

Talking of flowers, when are you going to send me some more dried ones? I am making another garden for spring flowers. I hope it is to be very pretty. Have you been to Oxford yet? please to tell me all about it. I am going to send you two or three drawings when anybody goes south that you may, if you will be so good, just tell me what is the matter with them. Shall I have them left at the Athenaeum?[6] or where?

I hope you are insane about the Crimean war, you are perverse enough to say you don't care about it just out of malicious wickedness, pray don't. It is such a wonderful thing, and will do everybody such a quantity of good and shake up the lazy luxurious youth of England out of conventionalism & affectation into manhood and nobleness. Oh what a comfort it is to find that people have not degenerated after all, and that no one has yet succeeded in 'laughing England's chivalry away'. Whatever comes of it we may be thankful for ever, for Alma & Balaclava.[7]

Calverley wants you to get hold of the last volume of the Surtees society's publication, & see what a fine specimen there is of a *northumbrian* illuminated letter of Saxon times.[8] I have great sympathy with the man in the Builder having made desperate efforts to find out what letter it is – quite in vain.[9]

Please remember me very kindly to Mr & Mrs Ruskin. Peter sends his love, I wish you could see my bullfinches, you'd want to have them, they are so tame.

 Yrs affectly

 P. J. Trevelyan

[1] There appears to have been no letter from Ruskin since Paris. He had been to Oxford in the middle of October, and Sir Walter had seen him at the Athenaeum later in the month looking 'tolerably well', and what information he could give his wife she passed on to Louisa Mackenzie. 'He has no time to give way to sorrow, he says the worst time is over – & that now he can give his full mind to other things.' Of Effie all she knew was that Dr Brown believed her still at Perth and 'thinks her conduct shocking!' Ruskin had his final sittings at Millais's studio,

when the hands were completed. Patmore's poem *The Angel in the House* had been published, and Ruskin was enthusiastic. 'The circumstances of my own life unhappily render it impossible for me to venture to write a critique', he wrote to Patmore, but he knew it would 'do good wherever read' (R, 36, pp. 182, 180).

[2] Preparatory to returning after the workmen had been in possession for nearly eighteen months. The central hall had now been roofed in and rebuilt, and the balustrade on the upper landing copied from a plate in *The Stones of Venice* ii, (R, 10, pl. XIII, fig. 4) which had been taken from a balustrade between the pillars of the apse in the Cathedral at Murano.

[3] For five years from 2 November he taught and lectured on Thursdays at the Working Men's College, 31 Red Lion Square, which F. D. Maurice had founded in October. Within the first weeks of its opening students numbered over one hundred. None were admitted without a preliminary examination in reading, writing, and the first four rules of arithmetic.

[4] Probably the issue of 18 November (see below, note 9). Mrs Loudon was the author of *Flower Garden of Bulbous Plants* and the widow of J. C. Loudon, publisher of Ruskin's first article, which appeared in *Loudon's Magazine of Natural History* (1834).

[5] In the lecture Ruskin had delivered on 'Decorative Colour' (note 9) he had suggested that, though it required talent of the highest order to be a painter 'hundreds of persons' possessed the gift of laying on simple colour with skill. 'Amongst dressmakers', he continued, 'there were many who instinctively evinced an aptitude at arranging flowers and putting in colour . . . and the instinct to arrange bouquets of flowers, so as to combine in harmony the various hues, was common.' (R, 12, p. 482)

[6] Ruskin had been elected a member of the Athenaeum in 1849 under Rule II.

[7] The battle of the Alma had been fought and won in September; the next month had seen the Charge of the Light Brigade at Balaclava. Lady Trevelyan was here (mis)quoting Lord Byron: 'Cervantes smiled Spain's chivalry away' (*Don Juan*, C. xiii, xi).

[8] The Surtees Society had been founded in 1834 to commemorate the late Robert Surtees of Mainsforth (see Letter 40, note 5), 'the mighty shade of Surtees, that most learned of antiquarians, most elegant of scholars' (*Durham*, Sir Timothy Eden, i, 1952, p. xvi). Its object then as now was to publish annually unedited manuscripts dealing with conditions religious – intellectual and social – arising in the British Isles between the Humber and the Firth of Forth on the east and the Mersey and Clyde on the west. Volume xxviii to which Lady Trevelyan drew Ruskin's attention deals with the first division of the Rushworth Codex (St Matthew's Gospel) written in the late ninth century by Faerman of the West Riding, at that time still constituting part of the ancient kingdom of Northumbria. A coloured plate of the illuminated letter is included in the volume. Ruskin was not a member of the Society while Sir Walter was Vice-President from its inception until his death in 1879.

[9] Signing himself 'Illuminator', the 'man in the Builder' (18 November 1854, p. 593) had been to the Architectural Museum in Canon Row, Westminster, on 11 November for the purpose of hearing Ruskin speak on 'Decorative Colouring: The Distinction between Illumination and Painting', the first lecture in a series of

93

three. He complained that the first illustration consisted of an initial letter of the seventh century of a single line so 'singularly involved and twisted and twirled about' that he could not recognise it. Further specimens were 'indistinct, with difficulty legible, so much were they surrounded and mixed with ornaments and forms which seemed to battle with initials striving for mastery'. Ruskin in his next lecture (25 November; the *Builder*, 2 December, p. 614) remarked in reference to the above complaint that when a person 'became accustomed to illuminated lettering, it would be read with facility'.

52

Thursday
[probably 13 or 14 December 1854]

Dear lady Trevelyan

I only got your letter last night – if I don't answer to day (though I can't tell you half I want to tell you) – there is no saying when I may – but it can be but a line of echoed cheer to your noble piece of passion about the war – this glorious woe – my own deepest feeling about it is not so much in that it has shown what is in us yet – for I never doubted that – but in it binding us for ever – as I trust – to our French brothers – surely after thus pouring out our blood together, we cannot turn against each other any more in unholy wrath – surely the two countries will gradually lock each other into steadfast embrace – and the world cannot hurt us – For all the feelings that the war has brought out among ourselves I am also deeply thankful – but the intense folly – jobbery – wrongheaded wretchedness of insuperable – inpenetrable Donkeyism – Moleism – Gooseism – Slothism – and if there be any animal that has no eyes – nor feet – nor brain – nor ears – that animal-ism – of all our managers & heads in every possible department hitherto – is nearly as depressing as all else is touching & heavenly – I have not mind nor heart to enter into the agony of the poor friends, & lovers & mothers of the men who have been sacrificed to misunderstood orders – misdirected movements – forgettings of necessities – ill chosen anchorages – unexamined anchors – To die for a cause – worthy the name of a cause – yes, but to die because the Birmingham contractor made the cable link not to play – and the official head of the department had quarrelled with his clerk – this is to need pity indeed.[1]

I have a great deal to tell you about my workmen – but I really can't to day. The main thing is – Acland has got his museum –

94

Gothic – the architect is a friend of mine – I can do whatever I like with it – and if we don't have capitals & archivolts! – & expect the architect here to day –

I shall get all the preRaphaelites to design me – each an archivolt and some capitals[2] – & we will have all the plants in England and all the monsters in the museum –

But of all this when I can write

Ever affectionately Yours

J Ruskin

I am doing a drawing for you

Best regards to you & Sir Walter

from us all.

[1] Mismanagement at home, sickness, mortality, the confusion and starvation of the expeditionary force to the Crimea are too well known to need repetition.

[2] On 12 December Ruskin had received a 'telegraphic message' from Oxford. Permission to build a museum had been granted, and a design by Benjamin Woodward accepted. 'Veronese Gothic of the best and manliest type' had won the day. Plans (by the Pre-Raphaelites and others) were immediately entered into for ornamental decoration of all kinds, inside and out, but if these were ever committed to paper they have not been traced.

53

1st January [18]55

Dear lady Trevelyan

I trust this year will be happy to you & yours – As far as any year can be happy – to good people, which must still bring much sorrow to so many others. May it bring also victory, & peace.

I send you two little drawings & a largish one[1] – to make up by quantity for want of quality – Perhaps some day you will give me back two for one good one for I *can* do good drawings now, when I have time – but I have not a good one that I – or rather my father – can spare – my Chamouni studies being all necessary to me. I have been writing a great many notes today – else I had much to tell you. I have got an order to build a bank![2] The banker says it must look like a bank. I return answer I am very sorry – but it will look a great deal more like a church – If he provokes me – I *will* make it look like a bank, of flowers.

Please send me names of enclosed creatures. They all grew behind

the Bishops house at Sion[3] and had a remarkably vicious & Romanizing look in consequence, which made me gather them all – carefully.

With sincerest regards to Sir Walter

Always affectionately Yours

J Ruskin

[1] The 'largish' drawing is that of Letter 49, note 3; (the two smaller ones are framed together: 'Mont Blanc from Geneva (Morning) J Ruskin 1849' and the 'Aiguille Blaitière' of the same Letter, note 1.

[2] No record exists of Ruskin having ever designed a bank. But see Letter 56.

[3] The plants of Letter 50.

54

[Probably about 18 January 1855]

Dear lady Trevelyan

I shall indeed be glad to see you & thank you for all your kindness only I wish you had told me *how* ill you had been – instead of saying in your quiet way "I have been ill", for I don't know what that means, and it makes me anxious. I will keep Monday, Tuesday, Wednesday, entirely open for you, and will if I can – run into town on Saturday [20th] to see you & know which day will be best – if you will tell me which inn you go to.[1] Perhaps Sir Walter can come out too and dine with us quietly one of these days – Best thanks for the names of the plants – I want to work out a bit of uncomfortable description of Sion[2] – & I am so glad they all are *waste* plants.

Will Peter come with you? I should like to show him to my good little Wisie[3] – as an example of what Sulky dogs are like.

With sincerest regards to Sir Walter

Ever gratefully Yours

J R

It is very good of you to be pleased with those drawings.

[1] The Trevelyans were in lodgings at 4 Holles Street.

[2] In *Modern Painters* iv Ruskin named the flowers Lady Trevelyan identified for him as dwarf mallow, wild succory, wall-rocket, goose-foot, milfoil, and borage (R, 6, p. 413). 'A network of grey weeds [he wrote] quite wonderful in their various expressions of thorny discontent and savageness.'

[3] The white spitz of Letter 45, note 2.

55

Dear lady Trevelyan

My Father is so jealous of me for asking you to come when he can't see you that I want you to come so as to be able to stay till ½ past 3 or four when he will get home to shake hands.

– please come to lunch at one to morrow [Tuesday] or Friday – at your pleasure instead of 12, if you can – I think I can hold you in play then till my Father gets home.[1]

 With kindest regards to Sir Walter

 Affectionately Yours

J Ruskin

[1] Tuesday 23 January was chosen and the Trevelyans 'drove to Denmark Hill to lunch. JR shewed Turner drawings bought of Mr Windus [*Devonport; Buckfastleigh Abbey; Richmond, Yorkshire*].' The finished portrait by Millais was also shown and neither of the Trevelyans cared for it as a likeness. 'Millais' portrait of him very unpleasing expression though beautifully painted – tho' I do not like the subject of the background, a dark coloured rock with nearly invisible vegetation' (TD). On her side Lady Trevelyan found it unsatisfactory in many ways though admitting to its being 'beautifully painted'. 'The portrait is detestable', she wrote to Loo, '(that is the face). The figure is admirable.' Ruskin considered the painting a fine one but 'whatever there is of good and strength in me, comes visibly, as far as I know myself, only sometimes into the grey of my eyes which Millais ought to have got, but didn't' (R, 36, p. 219). A few days later the Trevelyans were on their way home for the great move back into Wallington, the house free from workmen at last. Lady Trevelyan was soon writing to Loo: 'Effie is at home – & I *ought* to tell you that I had a very nice account of her from some friends of ours . . . They say she is quiet and good, devotes herself to the teachings of her little sisters: dines early with them like a governess, & is kind to poor people – and neighbours. I am so glad. I hope she will keep good – I shall always have a regard for her. With all her faults – which are horrid – she has some noble qualities.' (R. Trevelyan)

56

Dear lady Trevelyan

I don't feel ashamed of myself at all: – and am not going to make the slightest excuse. It seems to me that the proper view of the subject

is that you, being in Dull Northumberland – snowed up – cannot possibly have anything else to do than to write me a letter every other day or so, to amuse me, and that I being in busy London – and rather smoked *out* than snowed up by March & other winds coming down the chimney – cannot be expected to write anything more than a Quarterly review of things in general.

First then – Having found out (did I tell you this before? – I hope not) a Quaker – particularly interested in gold & colours – and lent him Theophilus on middle-age art,[1] he has found out for me – I believe, the right way of putting in the gold – and the art of printing will soon be no more –

What shall I publish first in the new style?

Secondly. Rossetti is helping me gloriously with the working college[2] – and the men are all so happy and getting on so wonderfully that I really don't know what they are likely to do next. Of the bank – no news yet.[3] The working drawings are being made and Rossetti is considering what mythological information will be best for the minds of the Clerks. Of the Oxford museum – no news yet. The "Quantities are being taken out" as they say. It is not *certain* yet that Woodward has it – depends still on confirmation by convocation Till it is sure – I do not trouble my head much about the matter – as soon as it is secure to Woodward I will set to work upon various monstrosities for his advantage.[4]

Modern Painters will be, I hope much astonished some day before the end of the year – and by no means pleasantly. I continue to labour under that painful feeling which you were so kind as to try to relieve me from, that I can't speak quite strongly enough – and that there is an oppressive atmosphere of mawkish amiability in all I write – it plagues me more than I can tell you, in spite of all that you said. Perhaps if you come to town you might succeed in irritating me a little and something might come of it. When are you coming. It is snowing here to-day so I suppose in Northumberland you have still to dig your way about – but when you can get out, please come as soon as may be – and if you would bring Peter with you he might give me a few lessons in snarling & showing teeth. My best compliments to him – with humble congratulations on the powers I envy.

Luca Signorelli is actually under examination at present by Arundel people – but we really don't know how to get anything nicely engraved of that kind. I am entrusted with experiments on photography which I am sorry to say are but very unsatisfactory.[5]

I have not heard from the Aclands except through Woodward for some time, but Mrs Acland was better when I last heard.[6]

All our sincerest regards to you and Sir Walter

Ever affectionately Yours

J Ruskin

[1] *On Various Arts*, a twelfth century treatise by Theophilus, on the preparation and composition of oils for painting. Its translation by Hendrie (1847) had been noticed by Ruskin in 1848 in the *Quarterly* when reviewing a pamphlet by Sir Charles Eastlake on the *History of Oil-Painting*. The translation itself – 'the Latin monkish though it be' – bore traces of unsound scholarship, but the medieval process of procuring gold by means of mineral acids seems to have found a ready enthusiast in the Quaker, whose name is not known but who may possibly have been J. J. Laing, an art student and skilled copyist whom Ruskin employed to draw from illuminated manuscripts. He later enlarged *Manual of Illumination* by adding notes and further illustrations from illuminated manuscripts. Nevertheless it is not known whether he was a Quaker.

[2] Rossetti had taken his first figure class on 22 January. 'Quite a separate thing from Ruskin's who teaches foliage [and later elementary landscape]. His class has progressed astonishingly, and I must try to keep pace with him' (*Letters of D. G. Rossetti*, ed. O. Doughty and J. Wahl, 1965, p. 239). There is scarcely a mention of Rossetti or of Elizabeth Siddal in Ruskin's letters to Lady Trevelyan, yet the year 1855 saw the foundation and growth of their friendship. Ruskin commissioned several of Rossetti's finest water-colours and influenced others to buy, while to Elizabeth Siddal he gave £150 a year, taking in exchange any work she had to offer, thus providing her with some kind of independence. Lady Trevelyan must have heard something of this talented, listless creature from the Aclands, who on Ruskin's behalf had had her to stay at Oxford in order that Dr Acland might diagnose the cause of her precarious health.

[3] Ruskin had showed her the plans when they had last met in January. 'Some architects are building a bank under his direction, it will be a lovely thing, I wish it was not to be in a narrow London street,' she wrote to Loo. It seems possible that the 'bank' was the Crown Life Insurance Co. in New Bridge Street, built by Woodward in 1855. Holman Hunt referred to Ruskin's influence on the façade of this building, which was destroyed in 1865.

[4] Ruskin designed a Gothic balcony for the museum, also an elaborate window in the Decorated style with slender columns, capitals, tracery, and on the adjacent wall slithered a large lizard (repr. R, 16, pls xi, xii) reminiscent of Millais's triumphant sketch of an over-adorned Effie at Glenfinlas. (See Letter 28, note 1).

[5] He was interested in photography as a means of studying works of art and as an aid to their conservation.

[6] Mrs Acland, already the mother of four, and with another four to follow, was expecting the birth of a child in May.

Calverley Hotel Tunbridge Wells
3rd June [1855]

Dear lady Trevelyan

Indeed I have been treating you very ill – but then the Spring
has treated *me* very ill, so I could hardly help it. I managed to lay
myself up with a cough some seven or eight weeks ago; – chiefly
the empress Eugenie's fault – as I stayed out in an east wind to look
at her over the garden palings;[1] then I went out again one day
expecting to find it was spring, and found it was January, (or a
Northumberland June) – and got ill again: had to come down here
at last and give all up for a little while, I am now quite well again,
and hope soon to be back in London – but my mother has taken up
the carpets and covered up all the pictures and I have nowhere to
go. I never felt so utterly homeless in my life: I would come out and
play hermit crab with you & Miss Mackenzie if I could – but I am
like a dog turned out of the drawingroom and tied to the doorscraper
– for my classes are still going on at the college and I have to direct
them & many other matters by speedy return of post – Besides – it
is quite cold enough here, for a person just shaking off a seven weeks
cough – and I have bleak recollections of that Berwick coast. The
last day I was at Dunbar,[2] the wind was blowing round pebbles
about, of the size of eggs – in curious little billiard-ball evolutions
in and out, round the church door – and was grazing and rasping
the sea in the wildest way – raising no waves – but fairly *taking the
skin* off it, wherever it touched it – in white swirls of spray, as a
carpenters plane does off light wood.

Nevertheless I highly approve of the Squashery[3] – not by the bye
– that any such word can be applicable to proceedings for the
preservation of Seaweed, if at all successful. *My* disgust has been
always ineffable and hopeless, at seeing what in the basin of clear
salt water, was a feathery fringe – divided into as many rose crests
and silken films as there were ripples on the sea it came out of –
collapse – as it was drawn out of its supporting & dividing element –
into a shapeless cord or lump of inextricable pulp, eminently dis-
agreeable to sight & touch. In fact – I have never done much in
pickling or preserving. By the bye – I hope considerably to flatter –
and pin down – some peoples filmy honours, before the year is out –
I have told Smith & Elder to send you a few sheets I have been

putting in order – lately – with a view to future operations on a larger scale – touching the Academy.[4]

As for my classes, there is much more to be told you than I can in a letter: you must come & see. I will only say the men all like the work – and I like the men. I am hampered for room – but hope to get more space next year – and carry out the plan in other places, and for other classes. I have already found one among the pupils[5] who seems quite able to fulfil my ancient hopes as to the proper engraving of Turner, and I am working hard with him, I hope very soon to bring out something.

But I am not going to talk any more of hopes or plans. Only wait till Newyears day: provided I am able to carry on till then without another break down.

I am sorry I was not in town when Sir Walter came up. I was a good deal surprised at his thinking it possible to introduce that Maine law among us:[6] I have no opinions or judgment on such matters myself – having no knowledge – all I feel about it is that there is a certain poetry in Beer – and a peculiar, racy, Shakespearean odour of non-sanctity in a Tavern which I should be sorry to lose, for my *own share* – which consists in grave contemplation of said taverns from the opposite sides of roads – I have still a certain Sir Tobyish sympathy with the Cakes & Ale, which makes me believe in their Perpetuity.[7] I may as well send you this as keep you another week wondering what I am doing – though *this* does not very clearly tell you – however it will that I am always affectionately Yours

J Ruskin

My father & mother beg their sincere regards to you both. Sincere regards to Sir Walter, and Miss Mackenzie. You must bring her out to see us at D.Hill

[1] The state visit of the Emperor and Empress of the French had begun on 17 April. Disembarking at Dover, they had driven 'at foot pace through the great southern metropolis', the Empress wearing a straw bonnet and a tartan dress of 'quite unobtrusive pattern' under a grey mantle. The day was fine but the fresh breeze, recorded by the Royal Humane Society's Receiving House at Hyde Park Corner, was in fact a north-easterly wind. When suffering from minor ailments the Ruskin family frequently placed themselves under the care of Dr William Richardson, Mrs Ruskin's nephew, who practised at Tunbridge Wells.

[2] In August 1847.

[3] Probably a joking name given by Ruskin to some method of Sir Walter's for preserving seaweed.

[4] *Academy Notes* (1855) issued on June 1 in which for the first time Ruskin reviewed pictures at the Royal Academy Exhibition. 'I have been feeling my teeth for a snarl at the Academy,' he had told Rossetti.

[5] For fifty years George Allen gave devoted service. Originally a carpenter, he ended as Ruskin's publisher. As an engraver Ruskin considered him very fine indeed and had him taught 'by my friend, Turner's fellow-worker, Thomas Lupton'.

[6] A law to prohibit the sale of drink, exercised in the state of Maine in 1851. Sir Walter had come to London on 29 May for two nights, staying at the Portland Hotel. (When his wife accompanied him they were more apt to take lodgings as only certain hotels were considered suitable for ladies.) The next evening at Exeter Hall he presided at the United Kingdom Alliance 'for the Total and Immediate legislative suppression of the Traffic in all Intoxicating Beverages'.

[7] 'Dost thou think, because thou art virtuous, there shall be no more cakes and ale?' (*Twlefth Night*, II, iii)

58

From Lady Trevelyan

Wallington July 5 [1855]

My dear Mr Ruskin,

I hope you are better than when you wrote last & that you have left Tunbridge wells, such an odious place – how can you go there?[1] This is to let you know that we are home again & I long to hear when you will keep faith with me about coming. I don't think we are going away again, and if you will come before the end of August, it will do very nicely. I assure you the snow is quite gone from Northumberland now, & the Hawthorns are in blossom, so it is spring. If you had come to the coast when we were there, you would latterly have found it quite warm & delightful & the braes quite covered with wild flowers.

Poor Miss Mackenzie lost her sister suddenly while she was with us and went home in sad distress. Sir Walter has just been to London again about a railway bill & is only now come home – that's the way wives are treated – and what was worse he carried off the key of my store room & we were reduced to great distress for food, but fortunately I found an opportunity of stealing some tea & sugar which in these Border counties is the natural way of supplying ones household wants.

Now if you are at Denmark Hill, I want you to do me a little kindness, if you can without inconvenience, show your Turners to our friend Mr Scott, the director of the Newcastle School of Design

who is going to be in London for a few days & wishes very much to see you & them. He is a very nice person & I am sure you would like him. Calverley is very fond of him. He will be at 45 Albany street Regents Park on Monday 9th July for three or four days.[2] Perhaps the shortest way would be (if you are at home) if you would send him a note & tell him when he may come out and see you. Now please don't think me a great nuisance. I think you will find it interesting to talk to him about the working mens drawings. He has been long engaged with classes of that kind – and has thought a great deal on the matter. He is very amiable, so don't ill treat him.

The country is very delicious at present, the lovely weather and the quantities of flowers are most enjoyable – so do come before it sets to work to rain.

Did you go to the Stonelaying of the Oxford Museum?[3] We hope to see Henry Acland here soon in his way either to or from Scotland.

I am in great trouble at losing my Doctor, he is going off to the Crimea.[4] He will be a great loss to us but he is quite right to go so we do not dissuade him.

Now please write & tell me you are coming very soon to see us. It is such a long time since we really saw anything of you. Could you not settle to come with Henry Acland. Mrs Acland cannot come with him this year. Calverley sends his kindest regards & with Peter's love.

 I remain
 Yrs Affectly P. J. Trevelyan

Pray remember us very kindly to Mr & Mrs Ruskin

[1] Ruskin seems not to have cared greatly for it himself, for writing home from Venice in 1851 he recommended that 'whatever likenesses she [his mother] may find at Tunbridge to France or Switzerland, she will be so kind as, when she is next in Switzerland, to discover none to Tunbridge'. (Bradley, p. 66)

[2] William Bell Scott, painter and verse-writer, was staying with the Rossetti family in London. Through her artistic interests Lady Trevelyan had become acquainted with him in Newcastle and she soon turned to him for suggestions for the decoration of the central hall at Wallington. Scott was inclined to exaggerate his importance as an artist and with a jealous nature was on the look-out for slights. After their deaths he wrote disparagingly of Ruskin and Rossetti, though claiming their friendship during their lifetime.

[3] On 20 June, the day of the stone-laying, Ruskin was returning to Denmark Hill from Dover where cured of his cough he had gone to complete his text for *Harbours of England* after leaving Tunbridge Wells.

[4] Dr Howison, her doctor at Cambo.

[9 July 1855]

Dear lady Trevelyan

Why do you make speeches in your letters, you know I haven't anything else to do than to see people who have got anything to say to me. I write to Mr Scott forthwith[1] – I am quite well, thank God.
Ever yours

J R (going to town)

[1] 'Denmark Hill, Camberwell Saturday July 9th [1855].
Mr Ruskin presents his compliments to Mr Scott and, hearing from Lady Trevelyan that Mr Scott wished to speak to Mr Ruskin about the working men's college, will remain at home on Wednesday or Thursday afternoon if it would suit Mr Scott to come out to us either of these days (at one o'clock – or any hour between that and five): perhaps Mr Scott would favour Mr Ruskin with a line saying if he can come. It will give Mr Ruskin much pleasure if Mr Scott can accompany him to the college on Thursday evening. Perhaps the most convenient way would be for Mr Scott to dine with Mr Ruskin on Thursday at 5, and so go on to the college.' (Bembridge)

60

[July 1855]

Dear lady Trevelyan

I have just received your kind letter, and I answer it before I do anything else. My father is very unwell, and has had to go down to Tunbridge Wells for a change – and would like much to have me with him there, but I have not gone, being resolved to let nothing that I *can* prevent interference with the finishing of this old book of mine [*Modern Painters*].

I send my father a certain quantity, finished & ready for press and copied legibly by Crawley, every morning; and it is becoming his Newspaper. I cannot run away to my pleasures when I have not gone to his sickness. Acland will soon be better, when he has made omelettes enough by way of classical pictures, and I am sure you will enjoy yourselves as much without me, nearly, as with me – because – if I came just now, you might be taking fancies that I

was not comfortable, (though I should be, – quite,) – and not be
so easy as you are by yourselves. But that is not the point of the
matter. I really have as much to do as I can before the long days
are gone – or rather I must just use every hour of them – as there is
no chance of my getting all done which I want.

It may give you and Henry a laugh to hear the titles of the finished
chapters – so I – No – I won't – either – you would laugh so much.[1]

Henry will come again to you for the mere sake of rebelling with
you against me, when I do come, so that you will have *him* again,
and me too –

I have nothing to tell you – literally nothing – or I would have
sent more than that scrap the other day – I like Scott very much –
but he is languid, and not to be got out – in a single hasty chat. You
never told me that he was David Scott's brother – I came out with
something – (luckily not so bad as it might have been) – about
David Scott in the middle of Dinner – and was very sorry.[2]

I have got two new Turners. Schaffhausen (fall) – and *Salisbury*.
I consider Salisbury now half classic ground on account of Patmore's
poem[3] – which I hope will really be one of the things the 19th
Century has produced, worth producing – But my Turner Salisbury
is on its own account one of the most precious drawings I have – all
full of sheep – wet grass – & summer rain, and the fall of the Rhine
is an old favourite too – so I am very happy with them, and I am
reading Saussures Voyage dans les Alpes one of my very old books –
with intense pleasure again – I find him worth all the modern
geologists put together: and he takes me so quietly to the places I
like best.[4] Every morning at breakfast I have shut the house against
every body and live as I do at Chamouni and Sion – by the bye – I
trust poor Chamouni is not burned – as it was said to be[5] – or they
will rebuild the principal street in the new Swiss style [sketch]. One
of the plates I am getting ready is to be of Geneva as it was and is.

I am sorry to send you so stupid a note – but I have nothing to
tell you – and really am sorry I cannot come – which makes me
duller even than usual.

What is "Epic Pastoral" – I ought to have a chapter on it I
suppose – but I don't know what it is – a fortnight ago Mr & Mrs
Carlyle came here to tea on the lawn. Milk fresh from Cow – Mrs
Carlyle brought her little dog – a worse dog even than Peter. Dog
runs between cow's legs; Cow disapproves & means to say so – but
preliminarily upsets the gardener – milking pail and all. The

Gardener lay on his back on the grass among the milk – full a quarter of a minute before he could understand what was the matter, looking hopelessly into Mrs Carlyle's face[6] –

Is *that* Epic Pastoral?

How is Miss Mackenzie?

 With best love to Sir Walter & Henry

 Ever yours affectionately

J Ruskin

My father's illness is merely a tedious bilious attack. He is now getting better.

[1] Under the heading 'Of Many Things' the chapter titles include: 'O Realization'; 'Of the False, and True, Ideal, Religious, Profane, Purist, Naturalist, Grotesque'; 'Of the Pathetic Fallacy'. The 'Moral of Landscape' had perhaps not yet been written.

[2] When Ruskin wrote to the *Pall Mall Gazette* on the subject of reviewing (R, 15, pp. 491–2), he vented his true opinion of W. B. Scott. If in 1855 he found him 'languid', 'not to be got out', by 1875 he referred to him as 'one of the more limited, and particularly unfortunate class of artists who suppose themselves to have great native genius . . .' Ruskin's criticism at dinner of David Scott, the artist, may well have been on the lines of his *Diary* entry at Edinburgh for 91 November 1853: 'Glanced to-day through the life and diary of David Scott... a poor bravura creature . . . a most base judgment calling Titian's frescoes at Padua "puerile" . . . His *Wedding Guest stopped by the Ancient Mariner* a miserable commonplace with vast muscles in legs under trowsers. Really these roaring high art men are wretched nuisances. They should be flogged and set to plough and porridge' (p. 482). Since Bell Scott was himself the author of the memoir in question of his dead brother, it can scarcely be wondered at if he took exception. 'I have found he had a prejudice against my brother David [Scott wrote later] as one of those wilful epical giants whom he recognizes as struggling with Jupiter' (University of British Columbia). After dinner at Denmark Hill they had gone to the Working Men's College. Already chafing at an imagined hint that he might learn something from Ruskin's method of teaching, he came away fulminating at the want of conventional instruction as practised at Government schools, which he found 'in a high degree criminal'. It was the beginning of Scott's antipathy to Ruskin, though the real cause probably lay in a jealous awareness that Ruskin's influence with Lady Trevelyan was far stronger than his own. She passed on to him Ruskin's spontaneous opinion of him, while in his reply Scott was circumlocutory and guarded. No doubt the reactions on both sides were just as Lady Trevelyan had foreseen.

[3] The close of Salisbury Cathedral was the setting for Patmore's *Angel in the House*.

[4] Published in 1786. Ruskin had been given this book for his fifteenth birthday.

De Saussure, a distinguished Swiss physicist, was the first to explore the ice and snow regions of the Alps.

[5] Fire had broken out at dawn on the morning of 20 July. Half the town was in ruins and the Hotel de l'Union, where the Ruskins had always stayed, was rendered uninhabitable by an inundation of water.

[6] Carlyle had been introduced to Ruskin by George Richmond in 1851, and though Ruskin wrote of Mrs Carlyle as a clever shrew with a rasping voice he came to respect her and after her death (within a few weeks of Lady Trevelyan's) he wrote to Rawdon Brown that 'the deaths of Mrs Carlyle and Lady Trevelyan take from me my two best women friends of older power' (R, 36, p. 509). For Carlyle he had nothing but affection and high respect. At the time of his marriage annulment, Mrs Carlyle, who knew well what it was like to suffer from a husband's neglect, 'pitied Mrs Ruskin while people generally blame her – for love of dress and company and flirtation – she was too young and pretty to be so left on her own devices as she was by her husband who seemed to wish nothing more of her but the credit of having a pretty well-dressed wife' (*Necessary Evil*, L & E Hanson, 1952, p. 431). The little dog Nero had been owned by Mrs Carlyle for ten years.

61

25th Sept [1855]

Dear lady Trevelyan

I have been too long without hearing about you, and want just to know how you are. I thought perhaps also you might have heard discouraging reports of Acland – I hope he will soon be all right again: but rest was absolutely necessary, and at last he has been wise enough to take it. I did not see him owing to the mistake about a letter, before he left for the Rhine. Funny his going to Bonn, of all places: merely to spite me, because I hate the Germans so. I have not lost a single chance of a fling at them, (I hope) throughout this book of mine [*Modern Painters*, iii] – Such a lively place as it is too – with its muddy river – and plain of potatoes – But there is really no telling what people will like – only one grows old before one can learn the great necessity of letting every body choose for himself – Are *you* going to stay at Wallington all the Winter? I have a great piece of Plant work which I want you to do for me – I have arranged my Plants on my new colour System – and I want you to tell me if it is all right – I found the colour would not do quite – so I took in form as well – and patched up a classification between the two – I found it was still necessary at last, however, to have a large class called "Tiresomes", which were plants who didn't know their own minds about anything – but I am sure people will learn botany a great deal

faster on my plan. My book goes on delightfully – as far as text is concerned – Plates a little slower – Still I am ahead of what I expected to be at this time.

Best regards to Sir Walter,
Ever affectionately Yours

J Ruskin

62

Christmas, 1855

Dear lady Trevelyan

I was very glad of your kind little note this morning – I did not know you were going to stay so long with the Aclands – but thought you were in town again – you are much better there.[1]

Our sincerest regards to you both – and all good wishes. I am so glad you and my mother are beginning to understand each other. My mother said when you went away last time – Lady Trevelyan seemed different – "kinder" to her. I am much vexed about my boy's book; he will at all events understand better – hereafter – the meaning of Proverbs XXV.14.[2] I went down to "Our Village" [Camberwell] yesterday to choose a book for him myself thinking that among all our mighty inventions for the education of youth – & cheap art – science – & literature, I might get a fruitful holly-sprig for him – But not so – Either dull – dead – unexhilirating science and piety – or – by way of amusement – the latest & foolishest refuse of fiction. I bought three books & took them home to examine – Could not send one – Talk of Irreverence indeed – I found angels and the Virgin Mary mixed up with every kind of monster and German nightmare – and half the books I opened began with love stories and had Ballet Frontispieces – full of Cupids.

So Harry must wait till New Year's day – but I will take care to have the book fairly down to Oxford as soon as may be – so as to be safe – meantime – if Angie[3] would send me a Catalogue of their books, it might be easier for us, she & I, to manage the matter nicely.

I did as I was bid – about Humboldt but here – by your Agency & Acland, is the world deprived of an important fact. That *was* the

108

fact Kosmos did verily so appear to me – at that period of my life – I may have been wrong or right – but so it was, and now there is this Absolute Fact for ever lost & extinguished under a Phrase, and so few facts as one can ever get at! too![4]

I am just getting my Plant system ready for you to look over carefully.[5] When it is – to morrow or next day – may I send it to you at Oxford?

I have to go out to make a loving call or two – My best love to Sir Walter, Henry & Mrs Acland – Angie & Harry –

Ever affectionately Yours

J Ruskin

Do you know anything of Mr Donkin? – I want to hear of him – & my regards to Mrs Donkin – & the Butlers. My mother has not forgotten Mr Melville's sermons. They will come with the book.[6]

[1] The Trevelyans had been in lodgings in Bryanston Square in October on their way to Paris. By the end of November they were again in London, at 'Mr Thompson's hotel, Holles Street, very comfortable' (TD), but shortly afterwards had removed to Mrs Wilcox further down the street where they had lodged several times before. During this London visit Lady Trevelyan took three drawing lessons from the artist John Leech. On 5 December there had been a dinner-party at Denmark Hill when the Trevelyans were shown 'some recent acquisitions from Mr Windus' (Turner's *Salisbury* and *Falls of Schaffhausen*). The next day they had called on George Richmond, but found him from home. Shortly afterwards they had gone to the Aclands at Oxford; here they remained five weeks as Lady Trevelyan became severely ill.

[2] Ruskin had evidently sent a message through Lady Trevelyan to his godson Harry Acland, promising him a book for Christmas. This was not yet forthcoming, and the quotation from the Old Testament was most apt: 'Whoso boasteth himself of a false gift is like clouds and wind without rain.'

[3] The Aclands' six-year-old daughter.

[4] This paragraph is unexplained. In 1847 Ruskin had read an English translation of *Kosmos*, the life-work of Humboldt, the German naturalist.

[5] He had recently written to Mrs Carlyle that he was 'dissatisfied with the Linnaean, Jussieuan, and Everybody-elsian arrangement of plants, and have accordingly arranged a sytem of my own . . . and am now printing my new arrangement in a legible manner, on interleaved foolscap. I consider this arrangement one of my great achievements of the year.' (R, 5, p. 1)

[6] W. F. Donkin was Professor of Astronomy at Oxford. Mrs (Josephine) Butler, the social reformer, was married to an Oxford tutor. The Rev. Henry Melvill, later a canon of St Paul's, was an Evangelical preacher of repute and had acquired a great following. At an earlier date Ruskin had admired his sermons and when an old man he could still remember Mr Melvill's eloquence.

[Second half of January 1856]

Dear lady Trevelyan

What I want you to do, for me is to look over list of plants sent, & tell me if any of them had better go into any other of *my* classes. I believe I have put some water plants among land ones, & so on.

You can't mend my *system* – so you need not try[1] – I only want you to help me in carrying it out.

I have Angies and Tiny's[2] list – all quite legible & nice I hope the book – whatever it may be – will be there on Saturday morning.

Ever most faithfully Yours

J Ruskin

[1] As threatened in his previous letter Ruskin sent his scheme to Lady Trevelyan. On 14 January Sir Walter 'Sent back to Ruskin his proposed system of plants with notes shewing its unscientific and illogical nature' (TD).

[2] Lady Trevelyan's dog.

5th Feb. [1856]

Dear lady Trevelyan

Are you still at Oxford – I hope you are better – I have been down a bit myself: sorethroat & feverishness, but all right now[1] – only I couldn't write before to ask about you: my best love to Henry & Mrs Acland[2] if you are still at Oxford & always to Sir Walter

Ever affectionately Yours

J Ruskin

[1] JJR's diary records: 'John down to drawingroom. Not so well' (29 January). On 7 February he was better but not yet able to take his class at the Working Men's College; by the 14th he was teaching again.

[2] In April Ruskin stayed with Acland and alarmed him with his theories of political economy. Home at Denmark Hill he attempted to pacify Acland with a long letter (R, 36, pp. 237–40) expounding his qualifications for 'a doctrine of Innovation'. Meanwhile Acland, not in the least reassured, wrote to Lady Trevelyan: 'I only said Ruskin was cracked because he will go on with his politics . . . and the only result will be his losing general confidence. Indeed this is the saddening thing about him, that his little eccentricities as it were – I know no other name – certainly divert him from the regions where he is preeminent to questionable regions of style, taste and matter. But barring these things I love him more and more.

20th Feb [1856]

Dear lady Trevelyan

I am quite well again. It was only cold such as one must have once a year or so, needing to be taken measures with, but leaving one all the better – but I can't write a letter for I have a heap of unanswered ones – foot deep – only just to ask you, in *your* turn, what you mean by getting thin again – and whether you have really conquered the illness – I don't like it staying so long – at Oxford & Wallington too – so please send me one line to say when you are quite well – I think there is nothing in this next volume of any worse character than usual – perhaps on the whole it may be considered within the mark. It is chiefly geological – containing a general confession of my entire ignorance of that science, and an expression of my conviction that nobody else knows much more – so what Sir Walter will say to it, I don't know: it is rather Anti Protestant also – so I hope you will like it.[1]

I am very sorry to hear of the Rat incursion, but have never the less, some sympathy with the beasts. They must have enjoyed the chocolate and apricot jam so much more than any body else would – and the notion of perfect comfort and plenty is delightful – even when one hears it only of Rats.

Do you think Dr Brown is getting really better? – well? I should be sincerely glad to hear of his quite recovered health[2] –

This fourth volume has been detained – of course – always something – but I am taking more pains about plates – Enclosed bit of etching begun will show you – one can't do much in a forenoon, it hurts ones eyes.

Always with best regards to Sir Walter and my fathers & mothers to you both affectionately Yours

J Ruskin

[1] There is little of such a character in *Modern Painters* iv, which was published in April of this year. Referring to the mind of the Protestant as 'waspish and bitter enough', Ruskin nevertheless, and to a greater extent, struck also at Romanism. Many years later the President of the Geological Society instanced this volume as a work that 'might be read with advantage by many geologists'.

[2] This inquiry was probably occasioned by the message from Dr Brown (below) which Lady Trevelyan had transmitted to Ruskin in her letter, and to which Ruskin's present letter is a reply. '[Edinburgh 4 February 1856] Dear Lady

Trevelyan . . . Do you hear from Mr Ruskin? and do you write to him? If you do, tell him I wrote him a huge letter, in my brain, after reading that glorious 3rd Volume [*Modern Painters*]. (It, the letter, has now gone beyond all fetching.) Tell him how delighted I was with it, especially the chapters on the Pathetic Fallacy, on Finish, and on Scott's poetry.' (*Letters of Dr John Brown*, ed. by his son, 1907, p. 109)

66

[Hotel de France] Amiens 17th May [1856][1]

Dear lady Trevelyan

Would you kindly put enclosed in envelope & send it to Mr Scott. I am quite tired – but if I were not – I believe I should say no more – but I like the plan much.[2]

I am going to do nothing for ever so long – I have had my say, pretty well, till next year, and I succeeded in passing 12 hours of summer daylight yesterday – without, as far as I know – having a single Idea on any subject whatsoever. I have nothing to say to you – nor to anybody else – and I don't know where I am going.

If you have anything to say to *me* – I daresay a letter might find me at Post Office Geneva but I don't know – best love to Sir Walter. Always affectionately Yours

J Ruskin

[1] Ruskin and his parents had reached Amiens on the 16th, the day after leaving England. He had walked about the town before dinner and found the purple iris and periwinkle in flower. Today he had been over the Cathedral with Couttet, his old friend and mountain guide, and had made a drawing of part of the west front (repr. R, 33, pl. xi). Meanwhile the Trevelyans had arrived in London and had gone to the Royal Academy. Sir Walter found Ruskin's *Academy Notes* (1856) 'most flippant & in great part untrue'. Lady Trevelyan took lessons from W. L. Leitch, the artist. 'A simple interesting person,' Sir Walter thought him, and paid him £5 for the lessons.

[2] This was the plan for the decoration of the central hall at Wallington. Lady Trevelyan had commissioned Bell Scott to prepare a scheme and to send the details to Ruskin. (See Appendix III for Scott's letter and Ruskin's reply, which he here transmitted through Lady Trevelyan; also her covering letter to Scott.)

Dover 26th September[1] [1865]

Dear lady Trevelyan

I have been reproaching myself many a day for not writing, but, somehow, I have got into quite a stupid state of indolence for these three or four months, and the sight of a pen and ink has frightened me so that I hadn't a word to say: nor have I now, only I know you will be glad to hear that we are on this side the water again, and all well.

We have been dividing our time between Interlachen, Thun, Friburg – Chamouni and Geneva:[2] and I have done nothing but ramble in sun and eat breakfasts and dinners – and sleep: I am not so much the better for it as I ought to be – because I don't like it: I get sulky when I can't do anything – and getting sulky puts one out of order – and I don't feel refreshed or up to my work again – nor do I intend to do anything much for some time yet, perhaps not all winter – I am going to read – for I have been using my own brains too much and other peoples not enough lately: – and to see manufacturies, and take long walks in the snow. I expect to get on better so for in Switzerland I am tormented by the beauty of the things, when I can't draw them – or by the people building hotels on my picturesquest places and so on – I have begun my readings by a large course of French Novels; but I am not sure that *those* are very good for me, for I have fallen in love with three of George Sand's heroines, one after the other, – no – with four – and am quite vexed because I can't see them. .[3] seriously vexed I mean; made uncomfortable – I was also thrown into a great relapse at Paris by finding the whole of the apse of Notre dame and the most of the rest of it – *utterly* restored – fairly knocked down and built again[4] New, so that Notredame now exists no more for *me*, and every day of my life I regret Turner's death more – and – which will perhaps surprise you – *Prout's* [1852] – there are so many things turning up, now, that I want to ask Prout about – and there is nobody to take his place – or feel with me as he did – and altogether I am a good deal put out at present, not to speak of the disagreeableness of finding oneself nearly forty; while one is busy one does not think how old one is getting but one finds it out, in idleness. I calculate that – if I am spared for so long, it is only some 11,780 days till I shall be seventy; and I give away every day with a grudge – if it happened to be a wet – or an idle one – and a great many have been wet & idle lately

Out of four months on the continent, I have taken only ten days of whole work – and ten days half work, those were to make some drawings of old bits of Thun and Fribourg, likely to be destroyed before I get back to them again, for I have a plan for etching views of seven Swiss towns, and bequeathing them to foolish posterity, that it may mourn and gnash its teeth in its Hotels[5]

I mean to draw – if I can – Basle – Schaffhausen, Lucerne, – Thun – Fribourg – Sion – & Bellinzona; the 1.2.3.4. elaborately to illustrate Turner's multitudinous sketches of them – there are at least 16 of Fribourg – 7 or 8 of Lucerne – 30 of Bellinzona & four or five of Schaffhausen among the sketches left to the nation, and I can realise these a little with detail so as to explain them – and the other three I shall do one view of each: Thun & Sion because I am fond of the places, and Basle in compliment to Holbein;[6] and I hope that Berne and Geneva will be properly humiliated at being left out of the list – as too much spoiled to be worth notice.

I made myself of some use in Chamouni also I think – not by working – but by setting others to work. Sir Walter may perhaps have noticed that there is a great dispute among the geologists whether Studer & Favre are right in saying that the limestone goes under the gneiss at Chamouni – poor Mr Sharpe who was killed last summer by a fall from his horse, having said it was only cleavage, not bedding. So I had a hole dug under Mont Blanc: and I got fifteen feet down between the limestone & gneiss; and found it all as Studer & Favre & I myself had supposed[7] – only the gneiss was so rotten that I couldn't go on underneath it without regular mining apparatus wooden shield & so on – so I stopped till next year, and if the geolgists aren't satisfied, I will dig as deep as they like.

Among other minor matters for grumbling the weather worried me – always wet or burning hot – and we made a nice finish of it yesterday afternoon – The steamboat – a small packet – waiting off the pier of Calais three hours for train from Paris. Train arrives with 80 passengers – 170 altogether on board the boat. We got away about six oclock – squally afternoon, and sea rather high from wind before. The 170 passengers soon presented the appearance of a series of heaps of some sort of awkwardly made brown fish – being sold by Dutch auction[8] and kicked about with no buyers – it got pretty dark, with clouds over what moon there was – long swells of sea racing by with crashing light – and half way over, really a very violent squall with rain in pailfuls – and large pailfuls too. My

father and mother had to sit it out all on deck – we are none of us ever ill – and the cabins were unenterable except by creeping on all fours over the fisheaps – my mother instead of being the worse – is the better for it this morning – it seems to have been a kind of water cure for her – she was terribly frightened, and perhaps that kept her from taking cold.

On the whole we are all very much the better of our journey & perhaps we shall find the good of it more when we get home, and so I think – I have given you enough of ourselves. You are never explicit enough about *yourself* – I am afraid you are not so well as you ought to be. I am very sorry for poor Miss Mackenzie – I should like to see her again. I daresay I might come down Wallington way next spring – but I have no notion clearly – what I shall do – it depends on many things – most of all on what is done about the Turner bequest, which I mean now to make as much noise about as I have voice for.[9] My love to poor Peter – & condolences & congratulations, but I cannot but attribute his recovery to his having such a *very* bad temper. Good natured dogs always die when anything happens to them – the sulky ones have a kind of – 'I shall live to bite somebody, yet' spirit in them, which is better than medicine. I have a good deal of that feeling myself – always when I am unwell.

We hope to be at home next Wednesday, and then you have only to tell me when you are likely to come south – and I will take care to have plenty leisure days, and we will have some nice chats – and I shall convince you of the beauty and necessity of my new botanical system, and make a botanist of you at last, as well as an artist. I am heartily glad to hear that colour does so well at Wallington. I am quite clear for colour now – every where – and my mother was converted from certain predelictions for white work by the inside of the Sainte Chapelle, last week.[10] She & my father beg their sincere regards to you both.

Love to Sir Walter – and kind remembrances to Mr Scott

Ever dear lady Trevelyan, affectionately & gratefully Yours

J Ruskin

[1] In his *Diaries* Ruskin dates this letter '27th. Saturday Dover . . . Heavy storm all day. Wrote . . . to Lady Trevelyan.'

[2] It was on the Lake of Geneva this summer that Ruskin and Charles Eliot Norton met for a second time; this was the beginning of a lasting friendship.

[3] Ruskin read to his mother *La Dame aux Cheveux Gris* by Henriette de Cabrières in July; later, *François le Champi* by George Sand, whose novels, though 'immoral

but elegant', captivated him. His favourite heroines were la petite Fadette and Consuelo in the novels of those names, la petite Marie (*La Mare au diable*), and perhaps Gilberte in *Le Péché de Monsieur Antoine*, which he read while in Paris.

[4] 'Sept 14th. Paris. After dinner to Notredame, which exists no more, being entirely restored, except a bit here and there; now quite valueless. A painful day.' (*Diaries*, p. 521)

[5] He proposed to engrave his drawings and add historical notes to form a book on Swiss history, but the plan evaporated principally because his father was fretting over the uncompleted *Modern Painters*. Also Switzerland was being spoilt for him by its influx of foreigners; Lucerne would soon consist of a row of symmetrical hotels at the foot of the lake; railways were projected round the head of the Lake of Geneva; Chamonix was rapidly being turned into 'a kind of Cremorne Gardens'. Ten years later he wrote to C. E. Norton: 'Every beautiful street in my favourite cities has been destroyed – Geneva – Lucerne – Zurich – Schaffhausen – Berne, – might just as well have been swallowed up by earthquake as to be what they are now.' (R, 36, p. 501)

[6] Holbein went to Basle at an early age and lived and worked there.

[7] Ruskin had employed workmen to investigate. Daniel Sharpe had been President of the Geological Society. Favre, a Swiss geologist. Gottlieb Studer, also Swiss, a noted Bernese climber.

[8] A sale in which the price of the object is repeatedly reduced until a buyer is found.

[9] While abroad he had heard that the Turner Bequest of paintings and drawings had been handed over to the National Gallery. The next month he wrote to *The Times*, following this up with a letter to Lord Palmerston, then Prime Minister, offering to sort and arrange the drawings and sketches himself.

[10] Mrs Ruskin would have been dazzled by the colour, the gilding, mosaic work, the richly coloured stonework and statues, and the ceiling sprinkled with stars on a blue ground. Perhaps most of all by the beauty of the stained-glass windows.

68

[Denmark Hill November 1856]

Dear lady Trevelyan

Can Sir Walter and you dine with us on Thursday at 6 – the Simons are coming who are nice, rather.[1] If you cannot, I'll come and see you on Wednesday about two – send me a line to morrow to say, please[2]

Ever affectionately Yours

J Ruskin

[1] The invitation seems to have been refused. Dr (later Sir John) Simon and his Irish wife, although only encountered in the summer of this year, had already become particular friends and so remained, Mrs Ruskin finding in Mrs Simon a sympathetic companion. Dr Simon, well known for his work as a sanitary reformer,

was the first Medical Officer of Health to the City of London and later became President of the Royal College of Surgeons.

² The Trevelyans had been established in London since the middle of October at Thompson's Hotel, Holles Street, where, except for a seaside visit to Brighton, they remained into the new year. Wasting no time, they had begun their round of studio-visiting. First to Madox Brown at Fortess Terrace, Kentish Town, where Sir Walter recorded that they did not 'see much, his best picture is at Liverpool'. (*Jesus Washing Peter's Feet* had won a £50 prize at the Liverpool Academy Exhibition a month earlier.) 'He had a well-coloured tho' uninteresting picture – a view near Hampstead – roofs & garden with autumnal tints to the trees very well rendered. [*An English Autumn Afternoon.* Both works now in the Tate Gallery.] Then to Rossetti, in colouring & feeling he outshines most others of the artists – he shewed us some beautiful bits but few finished.' Amongst the works at Blackfriars the Trevelyans saw Rossetti's sketches for *Mary in the House of St John.* The work was to be assigned to Miss Ellen Heaton, of Leeds, but in 1858 the beautiful water-colour by then completed became the property of Lady Trevelyan (it is now in the Bancroft Collection, Wilmington), while Miss Heaton had to content herself with an inferior replica. Woolner had accompanied the Trevelyans to call on Robert Browning, where they saw Rossetti's early water-colour version of *Dante's Dream,* the colour and expression of which Sir Walter thought very fine. Writing to Scotland from 63 Marine Parade, Brighton, where she had gone for recuperative sea-breezes, Lady Trevelyan told the architect, Patrick Allan-Fraser, that she had seen 'some wonderful & splendid pictures (water colour) by Rossetti one of the Pre Raffaelites whom I dare say you have heard of. He is a person not only of genius but of that lofty "mediaeval" sort of mind that seems to live above the world. He is quite young.' (Hospitalfield House.) It was probably during this visit to London that the Trevelyans met William Michael Rossetti, brother of Dante Gabriel, who recorded his impression of them in a letter to W. Bell Scott in early January 1857: 'Of Lady Trevelyan I saw but very little the single time I met her . . . but that little was all of the right sort. She seems particularly frank, unaffected, & goodhumouredly willing to be pleased – as the eminent sparkler (do you read "Little Dorrit"?) phrases it, a woman "with no nonsense about her egad." I had *rather* more conversation with Sir Walter whom I should judge to be a fine-minded man of both natural & acquired dignity. He would do very well for Don Quixote.' (Troxell Collection Princeton University)

69

Tuesday Evening [November 1856,
the day following the previous letter]

Dear lady Trevelyan

Tomorrow – about ½ past one – or two – I shall hope to find you – well, I trust.

Yours affectly

J Ruskin

[November 1856]

Dear lady Trevelyan

Could – and would, you and Sir Walter dine with us on Monday next? 18th [crossed out] 17th. George Richmond and his brother are coming – at least I hope Tom – (the elder Mr Richmond[1] – you know them both do you not) did not catch cold yesterday in being martyrized by me at Marlborough house,[2] but George I hope is sure –

Always affectionately Yours

J Ruskin

[1] Thomas Richmond, like his younger brother George, was an artist and had known Ruskin since 1840, when they had been introduced in Rome. He made three oil portraits of Ruskin and in 1851 had painted a full-length of Effie Ruskin. (See also *Sublime & Instructive*, p. 143.)

[2] In this same month the Trustees of the Turner Bequest had hung thirty-four oil-paintings at Marlborough House (used by the Science and Art Department until 1859); Ruskin had written the catalogue, a copy of which he gave Lady Trevelyan. (This is now at the Ruskin Galleries, Bembridge, bound up with a catalogue of a later Turner exhibition and inscribed in Lady Trevelyan's hand on the fly-leaf: 'Pauline Trevelyan From the Author Jany 1857'.)

[November 1856]

Dear Sir Walter

I'm *very* sorry; I hope this illness is not serious: any day will do for me – Thursday Friday or Saturday. If on Thursday, please note that I shall be at the national gallery – if on Friday or Saturday at Marlborough house – and at, or after, one oclock – on each day.[1]

Most truly Yours

J Ruskin

[1] Lady Trevelyan was ill. Ruskin was inviting Sir Walter to join him to look at the Turners.

[November 1856]

Dear Sir Walter

I will call at three this afternoon – & wait till $\frac{1}{2}$ past – in the *little* library on left hand at top of stairs. I know you have a great deal to do: so I shall not expect you – only if you can come in at that time I will be there[1]

Faithfully Yours

J Ruskin

[1] Presumably at Marlborough House.

73

[Denmark Hill Friday 5th December 1856]

Dear lady Trevelyan

Are you able at all to come out again? – we have pleasant people. Mr & Mrs Simon, coming to dinner to day.[1] Mr & Mrs Hullah to morrow[2] – it would give us very great pleasure if you & Sir Walter *could* come – If not I will come & see you to morrow about two – unless you say no by bearer.

We dine at six.

Affectionately Yours

J Ruskin

Just say yes – by bearer, for either day – or sorrowful no for both – sorrowful to us doubly as it will show us how ill you are.

[1] The Trevelyans accepted dinner for that very evening; besides the Simons the other guests were Lady Colquhoun and Dr Grant, JJR's devoted doctor (JJR diaries, Bembridge). There was much discussion of *Aurora Leigh*, the newly published blank verse narrative of modern life by Elizabeth Barrett Browning, of which Ruskin was excessively enthusiastic. 'I think *Aurora Leigh* the greatest *poem* in the English language [he wrote] unsurpassed by anything but Shakespeare.' He had known the Brownings for some years and had taken Effie to call in 1852. 'Mr Ruskin has been to see us', Mrs Browning had written to Miss Mitford, '. . . and brought his pretty, natural, sprightly wife with him . . "whose single naughtiness", said he, "is the love of continental life and discontent with England". Why should we affect to believe anything in the world? Gossip is as bad as history. Sundry affidavits have been made to me that Mrs Ruskin was victimised by the Graduate's continental tasks, and had been breaking her heart at Venice while her

husband was about the "stones". All which is to be read exactly backwards. She teazes me, he tells you, to buy a house at Venice. Pretty she is, and exquisitely dressed . . that struck me . . but extraordinary beauty she has none at all, neither of feature nor expression. Have you seen her? and what is your thought? She loves art, she says.' (Typescript British Museum, partly quoted in *The Letters of E. B. Browning*, ed. F. G. Kenyon, 1897, ii, p. 87.) That Mrs Browning listened to a modicum of gossip is evident from her letter to a friend written at about the time of the Ruskins' marriage annulment: 'As to the Ruskin mystery if I understand at all, and it was an awful whisper which came to me, the woman must be what shall I say? A *beast* . . . to speak mildly. This, at least, according to my own views of what human nature & bestial nature are severally.' (Sotheby sale, 29 November 1971, Lot 168)

[2] John Hullah was Professor of Singing at King's College, London. (Until late in life Ruskin continued at intervals to take singing lessons. *The Professor*, J. Dearden, 1967, p. 101)

74

[Denmark Hill Saturday 6 December 1856]

Dear lady Trevelyan

It is so ugly an afternoon that I do not come into town as I intended: one of my main objects being to ask you if you and Sir Walter could again be so kind as to dine with us on Friday next [12th] when the Richmonds have promised to come: and also to say that after Thursday I will stay at home always until one o'clock, in hope of your coming out early for a chat.[1]

Would you be at home if I were to come on Monday afternoon? and have you anything to show me at Holles St? My father & Mother were very happy to have you last night – they beg their best regards. I was so very happy to see you well and cheerful again:

With sincere regards to Sir Walter

affectionately Yours

J Ruskin

[1] Lady Trevelyan went 'early for a chat' on the 10th, and with Sir Walter dined at Denmark Hill on the 12th. The other guests were William Morris, Edward [Burne] Jones, and George Richmond and his wife. This must have been a particularly agreeable party. 'Just come back from being with our hero for four hours – so happy we've been: he is so kind to us, calls us his dear boys and makes us feel like such old friends . . . think of knowing Ruskin like an equal and being called his dear boys.' (*Memorials*, i, p. 147)

Monday [8 December 1856]

Dear lady Trevelyan

I am so sorry I must wait here till after tomorrow – but hope to be with you late on Wednesday.

Ever gratefully & affectionately Yours – with kind love to Sir Walter.

J Ruskin

76

Mond[1] [Tuesday] Morning [30 December 1856]

Dear lady Trevelyan

The enclosed note received this morning will tell you why I cannot come this afternoon – the "old hour" being two oclock.[2] So I must be content with waiting for you here after Tuesday.

We have just seen Sir Walter's rescue in the Times: It could not on the whole have been more satisfactory. Sir W. having no part whatever in getting the man into trouble, but having him so neatly taken off his hands.[3]

– Our best thanks for coming on Friday, to you both.

– Ever affectionately Yours

J Ruskin

[1] A slip for Tuesday, see below, note 3.

[2] This passage seems to indicate the visit from someone whom Ruskin could not countermand, and who had been in the habit of coming immediately after luncheon – the Ruskins' luncheon hour being at half-past one.

[3] The Trevelyans had dined at Denmark Hill on Friday 26 December, when they would have discussed the recent murder of a farm labourer from Sir Walter's estate in Somerset. The victim, and the murderer who had been caught, had been much the worse for drink, having spent the hours before the crime at a public house. (Perhaps the farm hand was the man of Letter 51 who had taken to drink. Ruskin's letter seems to imply that Sir Walter had already had cause for complaint against one or other of the men.) *The Times* of Tuesday 30 December carried a long account of the murder and inquest, followed by a letter written from the Athenaeum on 29 December by Sir Walter, asking whether no moral responsibility rested with a government that did not seek to remedy the evil of houses 'licenced for the sale of intoxicating drink'.

[Probably early January 1857]

Dear lady Trevelyan

I was very sorry to find you ill to day – not only for your sake, nor for mine, but for Turners: for I wanted to beg you – on my knees – if necessary – to write to Sir J Swinburne or Miss Swinburne & use all your influence with them to keep them from sending anything of Turners – above all – that Bonneville or Bacharach – to that confounded Manchester exhibition. The whole freshness & power of those drawings would be destroyed by a single season's exposure to strong light – & nothing could replace them – there are not such another two – of the period – in existence.[1]

Please send me a line, first to say you are better 2ndly to say you have done this

Best regards to Sir Walter –
most truly Yours

J Ruskin

[1] The important Art Treasures Exhibition was to open in Manchester in June, and the organisers had begun to enlist the help of owners of potential exhibits. (See also *Sublime & Instructive*, p. 200.)

[? January 1857]

Dear lady Trevelyan

It is too late to make appointments for to morrow – and on Monday I have an engagement already – but on Tuesday or Wednesday if you would come down to the National gallery any time between one & four, I would show you something there and then go to Marlborough house with you unless you were tired or preferred waiting till Friday next which is a Student's quiet day. I have plenty to show you at N.G.

Yours affectionately

JR

[? January 1857]

Dear lady Trevelyan

I send a note from Miss Mackenzie to Sir Walter which is in a great hurry – to the Uxbridge address.[1] I am not sure of the name of your Somersetshire place.

I was just in time the day before yesterday to see Miss Swinburne[2] & hope to see *you* soon – but as for writing or running about just now it has become as impossible to me as any other sort of good behaviour –

Ever yours affectionately

J Ruskin

[1] Cowley, near Uxbridge, where Lady Trevelyan's sister lived with her husband, the Rector of Cowley, (see Letter 9, note 1).

[2] To urge her not to send the Swinburne's Turners to Manchester. They were not sent.

80

[Probably end of February or early March 1857]

Dear lady Trevelyan

We are all quite well – & very grateful for your letter[1] – but I am very busy – for the National gallery people have fraternized at last, and I am framing my hundred sketches, & want to do it prettily & practically & properly – and it isn't easy – besides that Turner's scraps of paper are all sizes.[2]

Overtures – through Mr Wornum, even from Sir C.E! – Wornum declaring lady Eastlake never wrote quarterly review![3] I behaved in as conciliatory a way as I can – it don't do anybody good to quarrel – and if Sir C. wants me in future to look at him as an opaque instead of a transparent body – I will – only I won't say he can paint – so he needn't take any trouble about it.

But I can't write you a letter, having many & many now in arrear – only I really mean to come and see you – & my father and mother beg their sincere regards to you both – & with love to Sir Walter I am affectionately Yours

J Ruskin

[1] In which Lady Trevelyan had most probably told Ruskin of her attendance, with Sir Walter, at Thackeray's lectures at Newcastle (published 1860 as *The Four Georges*). On 23 February they heard the lecture on George II, 'very amusing & clever it was – but I think he might have chosen a more elevating subject – & allow what is neither edifying nor worth remembering to be forgotten.' On the 25th the lecture was on George III, and this was 'much finer than his last I think, in better taste' (TD).

[2] In February R. N. Wornum, Keeper of the National Gallery and art critic on the *Art Journal*, had given Ruskin 'free access to all the sketches in the National Gallery – to . . . do what I liked in arrangement of the hundred I am to frame' (*Sublime & Instructive*, p. 208). In this same month just over one hundred drawings from the Turner Bequest were exhibited on screens at Marlborough House. Ruskin strongly disapproved of the manner in which they were shown on grounds of exposure to light, and with the permission of the National Gallery he now selected a hundred drawings and designed for them sliding frames in cabinets, by way of protection.

[3] In his *Academy Notes* (1855) Ruskin had written disparagingly of Sir Charles Eastlake's painting of *Beatrice* (No. 120). The next year (March 1856) his wife, in an unsigned article in the *Quarterly Review*, had launched an attack on Ruskin and his moral character as well as on the *Academy Notes* and the three volumes of *Modern Painters*.

81

Easter Monday [13th April 1857]

Dear lady Trevelyan

When are you coming to town, and when might I come to Wallington? I have to make arrangements now with Manchester people[1] – & can't come *before* June, in fact I shiver to think of coming at all except on the hottest day of the summer – if I only knew which it would be –

I have been very busy, & have done hardly anything this spring. I am rather in a state of mess than otherwise – & don't well see my way out of it, but we are all pretty well.[2]

Our loves to Sir Walter and you.

Always affectionately Yours

J Ruskin

[1] Ruskin had been invited to deliver two lectures at the Manchester exhibition.

[2] He was overworking in the sorting and arranging of the thousands of Turner drawings; he was writing the *Elements of Drawing* (published June 1857) and the previous week he had given evidence at the National Gallery Site Commission. On 8 April he had risen 'after four days and nights of toothache. Shaky'.

[April 1857]

Dear lady Trevelyan

Middle of June will do nicely: I am so glad that you are to be at home and that I may come.

I am just in an abyss of exhibition work: a difficult address to be given; & seeing painters who come up from country, & looking at pictures for hours together to see if I can find *any* good in them[1] – and so on.

Why do you never send any regards to my father as well as my mother. Don't you like him? – He is very good.[2]

Love to Sir Walter. Yours affectionately

J R

[1] For his *Academy Notes*. The difficult address was to be given on 6 May at the Society of Arts to commemorate the work of Thomas Seddon, the artist who had died in Egypt the previous year.

[2] A. J. Froude wrote of him as being 'so true a man – true in word and in deed' (R, 18, p. xxviii). Most probably Lady Trevelyan simply forgot to send messages to JJR. The fact of his being in trade would not have influenced her since both Trevelyans dined frequently at Denmark Hill. Nor could it have been established custom to ignore a married man, for JJR, a stickler for etiquette, would have been the first to acknowledge it. Before long he and Lady Trevelyan were exchanging letters, she no doubt amused by his circumlocutory style and expression. So well did they come to hit it off that Ruskin reminded his father: 'You have cut me out with half my friends . . . you have run me very hard with Lady Trevelyan.' (R, 13, p. 436)

83

18 May [1857]

Dear lady Trevelyan

It cannot be yet for at least a month – that I get to Manchester – most probably. I have an architectural bit of pamphlet to do first on houses of Parliament designs.[1] I hope to get to Manchester about the end of June & to you directly afterwards, but will write again before that. I have sent you some Academy "notes" to day – but are not you coming to town?

Ever affectionately Yours with sincere regards to Sir Walter

J Ruskin

¹ Another 'Battle of the Styles' was being waged throughout 1857–9 for new government buildings. Ruskin was in favour of Gothic designs. Among his manuscripts found after his death were some odd sheets of rough notes for a paper on the subject; the reference in this present letter is one of the very few to exist.

84

[Probably beginning of June 1857]

Dear lady Trevelyan

My Manchester work is fixed – if all goes well, for 10th & 13th July. Might I come to you on the 14th [Tuesday] & stay till the Monday following – If not, I will come, if you are at home then, as I return from Scotland, when I can give you more troublesome criticism[Letter incomplete]

¹ Ruskin planned to join his parents in Scotland after a visit to Wallington, and hoped to return to the Trevelyans on the homeward journey, when he would again praise or criticise the decoration of the central hall. This cube-shaped room in the middle of the house rose to the roof; the bedrooms on the first floor opened on to the gallery running round the four sides; its balustrade, a suggestion of Ruskin's (see Letter 51, note 2), was already in position. The decoration of the hall offered great scope and Lady Trevelyan was determined to make it a thing of artistic beauty; she and her friends were to embellish the pilasters with large-scale groups of massed flowers ('we paint with oil and varnish on the stone', she told Allan-Fraser), and W. Bell Scott would paint eight large canvases illustrating Northumbrian historical scenes. These were to be executed in oils and fixed to panels allowing for an air passage. At the time of Ruskin's arrival (on St Swithin's day, a day later than originally intended) the second picture, *Building the Roman Wall*, had been barely set up in time for his inspection. The first, *Sir Cuthbert on the Farne Islands*, was already on display and had cost Sir Walter £100.

85

[June 1857]

Dear lady Trevelyan

I will come, if all is well, both as I go north and return: first on the 14th July, to stay to Monday & then, I suppose, about the beginning of October, if I can at all get at you through the snow – But I shall know better about the time of our return when I come first. . . . [Letter incomplete]

[Edinburgh 24 July 1857][1]

Dear lady Trevelyan

I do'nt mean this for a letter – only to tell you that I got here quite comfortably and that we go to Stirling tomorrow, I hope: and that I enjoyed myself intensely – and believe in Peter and love Sir Walter & you, & am always yours,

J Ruskin

Kindest regards to Miss Mackenzie & Mr Scott, & Mr Trevelyan, and Mr Worcester[2]

[1] The visit to Wallington was over. Ruskin had reached Edinburgh and joined his parents for their two months' travelling. Dr Acland was to be with them at Blair Atholl. Ruskin's impression of the completed work executed in the hall at Wallington survives in a letter of 18 August 1863 from Lady Trevelyan to Bell Scott: 'I will tell you exactly what he tells me about [the paintings] . . . He thinks they are in the highest sense of the word great works, and he thoroughly admires them, and he says that he does not believe that we could have got them so well done, take them all by all, by any other living man . . . But he does not *enjoy* them, because the colour is not pleasant, and one colour is left quite uninfluenced by another, and the unnecessary bits of ugliness and vulgarity annoy him as cruelly as they annoy me – (perhaps worse, though I doubt it)' Troxell Collection, Princeton University). Ruskin's own experiment in mural painting was delayed until his return visit in September. But he had been to Capheaton, and he had searched for fossils at the iron works with Sir Walter. He had also given a drawing lesson to Loo, an occasion Bell Scott commemorated by a charming portrayal of the pupil and master seated at a table by lamplight.

[2] David Wooster had been engaged in 1855 by Sir Walter to help put his geological collection to rights in the museum at Wallington. 'He is very clever and full of knowledge,' Lady Trevelyan wrote to Loo. 'He will make our museum very nice . . . He did the Ipswich one which was the most provincial I ever saw' (R. Trevelyan). The engagement, which was for a short period only, extended to twenty-two years.

87

Durham, Sunday [20 September 1857][1]

Dear lady Trevelyan

I thought you would be glad to know we got in great comfort and good time to Morpeth, and in like manner to Newcastle – and in like manner here – where I found my father & mother well – and

where to day it is very fine; and where I have just heard a sermon which makes me think that a nation among which such things are possible wants a great deal of bayoneting of its women and children; and that nothing short of that would ever make it feel or think any more; Where also we have had a cindery walk by the riverside, with other rural enjoyments, such as are possible in a coal-field, including an examination of a rusty boiler.

Please tell Sir Walter we are going to sleep to morrow at Staindrop, and next day at the Hotel at Tees fall;[2] and *don't* tell him that I don't like the spandrils, but I positively don't, and think you must entirely alter them, ground, leaves, & all. [See Appendix III, note.] I will send you my revolutionary project in detail when I reach London. Can you tell me where a letter would find Alice Donkin if you can, just send me a line to post office Penrith. Love to Sir Walter – best regards to Miss Lloyd[3] – I have a very grateful recollection of her kind little help when I was suffering under your persecution – and the sandstone. Tell Mr Wooster with kind regards, I will send him something about illumination when I reach town.[4]

Ever affectionately Yours

J Ruskin

Could you also tell me, when you write, if Sir John Swinburne is better?[5]

[1] Ruskin (with Crawley his manservant) was on his way home. He had stopped at Wallington for two nights (17 and 18 September) before rejoining his parents at Durham. On this occasion Lady Trevelyan had wished him to decorate one of the two south-west piers of the hall, herself painting the other. A lily of the Annunciation was suggested, but Ruskin preferred a humbler flower, and to the delight of Bell Scott who was present, drew what he thought to be corn-cockles, but were in fact cornflowers and corn. Being assured he was mistaken he lost patience and the pilaster remained unfinished.

[2] Staindrop and its early fifteenth-century church lie on the main road from Durham to Barnard Castle. The Ruskins would have put up at the Queen's Head, on the north side of the village green, a posting inn of some consequence boasting sixteen rooms and accommodation for fresh relays of horses. But Ruskin did not care for what he called that 'strange Staindrop look – black – deserted – depressed – and stern'. He was perhaps glad to move on through the wooded banks of Teesdale, thick with autumn crocus, to the old High Force hotel where the eighty-foot-high waterfall of the river Tees crashes over the rocks.

[3] Laura Capel Lofft (not Lloyd) was a close friend of the Trevelyans and became Sir Walter's second wife in 1867. She was perhaps the only one of the party at Wallington who had sympathised and not teased Ruskin over his painting, and she may have found difficulties of her own in painting her large design of hollyhocks

and wild flowers. Writing later of this episode, Ruskin considered that he had 'said all the good I truly could of the frescoes, and no harm; painted a corn-cockle on the walls myself, in reverent subordination to them; got out of the house as soon afterwards as I could' (R, 15, p. 491). Alice Emily Donkin was the daughier of Professor Donkin (see Letter 62). Ruskin seems to have helped her with her drawing. She had a cousin, Alice Jane Donkin, who later married one of Lewis Carroll's brothers, but it is probably the first of these two to whom Ruskin is referring.

[4] Ruskin appears to have been dilatory in forwarding the information for Mr Wooster, but from now until the following May he was entirely occupied with his work at the National Gallery. 'In seven tin boxes [he wrote in his Preface to *Modern Painters* v] I found upwards of nineteen thousand pieces of paper, drawn upon by Turner . . . Many on both sides; some with four, five, or six subjects on each side . . . some in chalk which the touch of the finger would sweep away; others in ink rotted into holes; others . . . long eaten away by damp and mildew . . . others worm-eaten, some mouse-eaten, many torn . . . numbers doubled up into four . . . being Turner's favourite mode of packing for travelling . . . With two assistants [George Allen and W. Ward] I was at work all the autumn and winter of 1857, every day, all day long, and often far into the night' (R, 7, pp. 4–5). However, he found time at the end of October to go to Oxford to inspect the frescoes which Rossetti and his friends were painting on the upper walls of the Debating Hall of the new Union building, and pronounced Rossetti's picture to be 'the finest piece of colour in the world' (*Memorials*, i, p. 168). One of the few accounts still existing, written while the painting of the frescoes was in progress, was sent by Lady Trevelyan to Bell Scott in November. (See Appendix IV.) Shortly after this visit, when writing to Loo, he was able to tell her that he had seen Lady Trevelyan at Oxford 'looking very well & going to lectures & all sorts of things – and very peremptory, and insisting on one's eating chicken pie when one did'nt want it'. While eating the Common Room breakfast at Christ Church on 27 October Lewis Carroll had his first meeting with Ruskin, whose 'feebleness of expression' he noted in his diary, marking the day nevertheless: '*Dies notabilis*' (*The Diaries of Lewis Carroll*, ed. R. Lancelyn Green, 1953, i, p. 129).

[5] He had strained his Achilles tendon but was soon walking again.

<div align="center">

88

</div>

[Probably November 1857]

Dear lady Trevelyan

Thank you for wanting to know what I am about, I wish I knew myself. I am in a state of great puzzlement about those precious books. I don't know whether to divide or lock them up – I should like to lock up for some time at least – but if I tumbled over any place in Switzerland or fell ill – they might all become mere thumbed curiosities – destroyed in a years wear & tear – I am in a sad puzzle about it however. –[1]

I should like you very much to have a drawing of Inchbolds:[2] but I hardly know how to get at him at present, he's at Florence. But I'll try to find out and let you know what he has been doing. It will be helpful to him, as he is often hard pushed.

With sincere regards to Sir Walter ever affectionately

J Ruskin

Remember me to Mr Wooster. I've forgotten neither spandrils nor illuminations – but found the book I thought of so much less likely to be useful than I expected that I have been quite unwilling to send it – I send one now which he may find some curious things in – but I fear – not much to his purpose. Theophilus on the arts of the middle ages.[3]

[1] Probably Turner's small, oblong pocket-books, of which there were a very great number, consisting usually of ninety-two leaves, with sketches on both sides and on the end-boards. Ruskin described how he paged them himself, unbound them, and 'laid every leaf separately in a clean sheet of smooth writing-paper', and sealed each book in a separate packet (R, 7, pp. 4–5).

[2] J. W. Inchbold, landscape painter, whose work Ruskin was inclined to praise.

[3] See Letter 56. The Trevelyans came to London soon after the dispatch of the book. On 23 December they were guests at 34 Onslow Square, the house of Marochetti, the sculptor, to which Millais and Effie, his wife, had also been invited. Over three years had elapsed since the Ruskins' marriage annulment and Lady Trevelyan, with a spontaneous gesture, put out her hand in reconciliation. Effie Millais refused to take it (Lutyens, iii, pp. 212–13). At the beginning of January 1858 the Trevelyans were at Oxford, where they went 'To Union to see paintings on wall, prae raff' (TD).

89

[Probably 22 or 23 December 1857][1]

Dear lady Trevelyan

After all the mischief you have ever known of me, can you imagine such a thing as my not coming with this spring? But the Glasgow people don't want me – and say that in April they could not get an audience, and therefore I've not written any lectures – & can't therefore read them at Newcastle. I did not know the Glasgow people had altered their minds till lately – a day or two ago, but I thought it very likely they might & so wrote no lectures. Even with this additional time I shall not get all done that I wanted to do at the

National gallery, before the London season fairly sets in.[2] Its no use
making any excuses. I know you'll call me all manner of names – so
I must leave you to select them. I'm going to write to Mr Scott:
Love to Sir Walter.

My father & mother unite in sincere regards.

Ever affectionately Yours

J Ruskin

[1] A letter exists from Lady Trevelyan to Bell Scott dated 'Xmas Eve' 1857, in
which she told him that Ruskin 'has just put off' his lecture.

[2] He completed his work in May, but the excitement of 'seeing unfolded the
whole career of Turner's mind' had been so overwhelming that never in his life
had he 'felt so much exhausted as when I locked the last box, and gave the keys to
Mr Wornum' (R, 7, p. 5). Among the great number of drawings which he sorted
he was shocked to come upon many sketches which to his mind were obscene and
unworthy of the great artist. In May 1862 he wrote a statement which bore witness
to his having been present when Wornum burned them in 'the month of December
1858', since no one in authority had seen fit to give directions about them. 'I am
satisfied', he wrote to Wornum, 'that you had no other course than to burn them,
both for the sake of Turner's reputation (they having been assuredly drawn under
a certain condition of insanity) and for your own peace . . . I hereby declare that
the parcel of them was undone by me, and all the obscene drawings it contained
burnt in my presence.' (National Gallery Archives)

90

D.Hill 27th September [1858]

Dear lady Trevelyan

I think for once in my life I am a little penitent – I am not quite
sure about it – for I believe penitence makes people uncomfortable,
and I feel quite comfortable.

I've been enjoying my journey very nicely.[1] I got out of every-
body's way and answered no letters. I had great satisfaction in
looking at the great heap of letters in my box, and thinking how
much tiresome work I hadn't done. I went first to Basel: then to
Rheinfelden which is a little Swiss village compound of one street
and one church tower and some old walls and an old bridge, which
Turner has drawn five or six times, making the village always about
as large as Strasburg. Having sketched bridge,[2] &c I proceeded to
Lautenbourg: – then to Brugg – to see and sketch Hapsburg[3] – which
I did – then to Bremgarten – then to Zug: – trotting along the bye
roads with such cart or carriage as could be got – walking up the

131

hills – and thinking how wretched the people were on the railroads and in the big inns: – Having thus dodged everybody in the north of Switzerland, I went in for the Alps at Morgarten – which is too ugly to sketch – so over St Gothard to Bellinzona – where I settled myself in the second inn – that I might be quieter – and stayed a month.[4] I found I couldn't draw as well as Turner: and got disgusted thereupon – and determined to do nothing at all but to live luxuriously and take my pleasure. So I went to Turin[5] – and got nice rooms – and stayed all the rest of my time there – much tickled every morning when I woke at the notion of my romantic friends hunting for me among those squashy glaciers in Switzerland. I spent my time in Turin very pleasantly. E.G.

Morning. 7 oclock get up: –

Military band while dressing – cavalry crossing grand square to exercise – (8 oclock) Breakfast-room, four windowed, two windows to fine street – two to great square – sunny weather – Fresco ceiling – red damask silk walls – coffee – and Galignani.

9 oclock. Saunter over into picture gallery in my slippers – obsequious attendant. Three large Paul Veroneses – Chair & table ready – I sit down and draw – if I like – or don't if I don't like

11 oclock. Military band under gallery Windows – I lie back in my chair – & listen – looking drowsily at Paul Veronese.[6]

½ past eleven. Military band stops. I take a saunter through the rooms – make disagreeable remarks to a few artists, and otherwise enjoy myself critically

12. I think it is time to be idle. Put up my work – and proceed to see what is going on on the shady side of the Piazzas. Study Italian character – Proceed finally to the Fruit market – and buy a melon for fourpence.

2. P.M. Dine	Soup
	Fish from Genoa
3 P.M. Return to gallery –	Two entre-mets
(doing as little there	N.B. Mushrooms at Turin
as possible)	wonderful.
	Roti
5 P.M. Gallery shuts. Take	Larks, or Thrushes, stewed in
afternoon walk in	Silver –
garden of Villa	Ice.
della Regina. Statues	Peaches – Figs. Grapes,
– fountains &c.	and the Fourpenny Melon –

Alps in distance (from St Gothard to Col de Tende.) Sunset – &c.

7½ P.M. Coffee.

8½ P.M. Opera Comique

10½ P.M. Little walk in square by moonlight.

11. Bed.

The varieties on this were only that at 5 – if the afternoon were sultry & not nice for walking, I merely stayed and heard military band again in palace court: – and that one night in the week besides Sunday, I couldn't go to the opera – because it was the "Riposo" night of the actors: so I used to read French novels instead.

On Sunday there were plenty of military masses: and military band in King's gardens with promenade of pretty Turinoises: many very pretty ones also driving in carriages in evening round champ de Mars – with Alps – sunset – &c at the same time.

I stayed in Turin about seven weeks, and then came over the Cenis as fast as I could (finding the Alps very dull and disagreeable)

– I saw your drawing in progress the other day – It isn't at all like Paul Veronese. When I've seen more of it, I'll tell you more:

– No – I'm not coming north – nor going any where, and I don't feel much inclined to *do* anything.

– Writing letters is really so tiresome that I can't write any more –

Love to Sir Walter – and I'm sure you must see by my having taken the trouble to write all this – that I am always – affectionately Yours

<div align="center">J Ruskin</div>

My fathers & mothers entirest regards to you both.

[1] Ruskin had left England in May and was away four months.

[2] In a letter to Mrs Simon the following year he admitted that Turner's 'audacious fictions are really unpardonable' (Bodleian typescript), and on his birthday (8 February) also the next year, he had convinced Sir Walter of the same fact. 'Dined with Ruskins, Denmark Hill. JR jnr birthday – showed a number of Turner drawings – some sketches with his own accurate drawings of some scenes – showing how Turner altered and was anything but truthful' (TD). Ruskin reached Rheinfelden on 20 May and made at least eight sketches; three of these are of the bridge, of which two are repr. R, 7, pl. B and 83.

[3] Near Brugg. (Repr. R, 16, pl. 4.)

[4] 'I am not at the Angelo [he told his father] . . . but at the Aquila d'Oro . . . the comfort is here & the view: – as good roast chicken as at Denmark Hill – and trout every day, & always good. Urn & silver teapot for tea.' (Yale. For further glimpses of Ruskin at Zug and Bellinzona see *Sublime & Instructive*, pp. 18, note 6; and 100, note 2.)

⁵ It was at Turin that Ruskin underwent a violent revulsion from his religious faith; this was to have a deep effect on him for many years.

⁶ *The Queen of Sheba before Solomon*, by Veronese. Ruskin made at least two finished drawings of parts of the painting as well as many studies.

91

[Probably *c.*20 December 1858]

Dear lady Trevelyan

Can you & Sir Walter dine with us on Tuesday – Thursday – Friday – or Saturday next week?¹

– We are all pretty well and shall be so glad to see you again.

I won't give you my Venetian windows. I've done with architecture and won't be answerable for any more of it. I can't get the architects to understand its first principles & I'm sick of them. I've got into the clouds again. Thats the country to live in.²

Yours affectionately JR.

¹ Ruskin called on the Trevelyans on Christmas Day; they chose Tuesday 28 December for dining at Denmark Hill. JJR noted in his diary the names of the other guests: the Rev. Daniel Moore (of Camden Church) and Mrs Moore, and Miss Eliza Fall, sister of Richard Fall, Ruskin's boyhood friend. Though Ruskin wrote of her as 'typically an old maid', yet she was 'brilliant at a Christmas party', so perhaps on this occasion she shone in a seasonable light. On the day of this dinner-party Ruskin wrote to C. E. Norton enumerating the many things he could not get 'said or done'; among them: 'I want Turner's pictures not to fade. I want to be able to draw clouds', and, perhaps a reference to Lady Trevelyan, 'I want to make a dear High Church friend of mine sit under Mr Spurgeon', the popular Baptist preacher. Previous to this evening of revelry, Ruskin had dined with the Trevelyans in the middle of November and they would have talked of *Mary in the House of St John*, the water-colour which Rossetti was now completing. The next day the Trevelyans were at Rossetti's studio at Chatham Place, Blackfriars, 'to see the drawing he is doing for P[auline]. There is much feeling in some of his work but great extravaganza in many' (TD). At the end of the year it was shown at the Hogarth Club exhibition; Simeon Solomon the painter found. it 'most impressive', while Lady Trevelyan herself thought it 'a very *fine* thing – as grand and deep in feeling as anything he has done'. On 30 December the Trevelyans called on Christina Rossetti.

² Ruskin was engaged in completing *Modern Painters*; volume v carries a section on 'Cloud Beauty'. He was disheartened by the progress in the building of the Oxford museum, which was suffering from lack of funds. Money had been insufficient for the main façade where he had hoped to see a richly ornamented porch and doorway.

[December 1858]

Dear lady Trevelyan

I expected a terrible scold;[1] you are really very good. I've written to Hughes & expect his answer forthwith but as he usually paints with a very beautiful young wife sitting to hold his brushes – and a sort of Cherubic frame, (as far as I could see before it disappeared nurseryways last time I went into his room) about his picture in a curiously Louis-quatorze style for a P.R.B. I think it very doubtful if he can come.[2]

All our loves to you & Sir Walter

Yours affectionately

J Ruskin

[1] For not having obliged her by giving her his design for Venetian windows.

[2] Lady Trevelyan had enlisted Arthur Hughes in her scheme for the decoration of the hall, and when he had been at Wallington during the summer they had together painted the north-west piers. It seems likely that when accepting Ruskin's dinner invitation Lady Trevelyan had suggested that Hughes might be able to join them. But he was living at Maidstone (Buckland Terrace) and probably found it impracticable to dine at Denmark Hill.

<p style="text-align:center">93</p>

From Lady Trevelyan

Wallington May 2 [1859]

My dear Mr Ruskin

If you are not off to Switzerland, pray write & tell me how you all are & when you are going.[1] You never answered my last note when I wrote & offered to come to Denmark Hill, which was not pretty of you. But I have long lamented the mistaken economy of your parents in not paying the extra 2d a week for 'manners' when they sent you to school.

We got home about a fortnight ago and the only snow I have seen is on the top of Cheviot. We have a moderate allowance of East wind to be sure, but I have no doubt it is much worse at Dk Hill.

When do you mean to come home from Switzerland, and are you going to draw there? or to behave as you did at Turin? I hope they have hung Mr Brett's picture well at the R. Academy?[2]

They have got lots of the "Oxford Museum" in the Booksellers shops here. I suppose on account of the beauty of the cover – which is a credit to any shop.[3]

Please give my best love to Mrs Ruskin and Your Father, Peter sends his love to you and so do we.

Ys affecly P J Trevelyan

Mr. Wooster is very well – his 'Ed has not been like to split' once since we got home. Mr. Scott has got a violent cold painting in a damp old church & has been really ill, but is better.[4] I am wonderfully well for me.

[1] Ruskin had seen Lady Trevelyan at the beginning of April, on which occasion he had given her advice on the method of writing a novel (Appendix V). He and his parents were leaving England on 20 May. This year they were going to Germany. Having admitted to the Commission on the National Gallery Site in 1857 that he had never been to the German art galleries, it was time for him to repair the omission.

[2] *Val d'Aosta*, painted by John Brett the previous summer near Villeneuve, mostly under Ruskin's direction (repr. R, 14, frontispiece). When reviewing it in *Academy Notes*, 1859 (No. 908), Ruskin praised the picture highly, finding it 'precious, in its patient way; and as a wonder of toil and delicate handling, unimpeachable'. Millais, who had both his Academy pictures abused by Ruskin in the same *Notes* (*The Vale of Rest* and *Apple Blossoms*) was quick to comment on the 'wretched work like a photograph of some place in Switzerland, evidently painted under his [Ruskin's] guidance, for he seems to have lauded it up sky-high and that is *just where it is* in the miniature room!' (*Millais*, i, p. 342). In 1860 Ruskin bought the picture himself and kept it all his life. (For Ruskin's admonishment to a would-be purchaser, see *Sublime & Instructive*, p. 115 note 2.)

[3] Newcastle booksellers had an eye to business in carrying copies of the new book for the city was developing fast, and, though still mostly in the classical tradition, Victorian gothic was beginning to gain ground. *The Oxford Museum*, published on 4 April, was bound in mauve cloth boards, lettered 'The Oxford Museum Acland and Ruskin' on the front; the title only on the spine. It led off with a Preface by Dr Acland and was followed by his lecture delivered in 1858 concerning the museum. This in turn was followed by two long addresses in letter form from Ruskin, three illustrations, and three Appendices.

[4] At Rothbury Church, situated between Morpeth and Alnwick.

94

Dover 18th May [1859]

Dear lady Trevelyan

I did not answer your kind note having been unable – with all the

time I could get – to finish my drawings for engraver, or other things needed for next year – before exhibition and disturbance time.[1]

I am not going to write even now – being jaded & in need of fresh air & idleness: but please when you write, put P.J.T. on outside of letter, for I have given orders that *no* letters shall be forwarded – except indorsed ones, of which I have left a list.

Nice notion I shall give people in general of the "manners" – shan't I.

We hope to get over water to morrow and to Dresden or Nuremberg or somewhere out of the immediate row, but we cannot count on any where of course. All our love to you both –

Ever affectionately Yours J Ruskin
I was so glad to see that you were better in health.

[1] He had, however, found time to arrange for an early copy of *Two Paths* (a collection of his lectures on various aspects of art delivered between 1858 and March 1859) to be sent to Wallington. Inscribed in Lady Trevelyan's hand: 'Pauline Trevelyan From the Author May 9 '59' (Sotheby Catalogue 5 October 1970, Lot 144).

95

Hanover 3rd June [1859]

Dear lady Trevelyan

I forget if I answered your funny little note – but if I did – which the state of my "manners" renders improbable – still you will be glad to hear that we are getting on very nicely and happily through this flat Germany – and I find the architecture interesting though barbarous. The people are semi-barbarous too – their main character it seems to me – is a quiet egotism – of a Depth unexampled in any other human Nature. All other Nation's invent Idols. A German Stands – or Walks – His Own Idol. Self contained. His Morality, Sentiment – Intellect – all Going upon Himself – to Himself – In Himself – By Himself – For Himself – and if there are any other Prepositions of an exclusive character – put them in.

Cologne cathedral is an absurd failure – No good whatsoever in any part of it.[1] The German paintings are indescribably Funny in their intense resolve to be Fine. Overbecks Assumption in the cathedral of Cologne is out and out the most execrable picture I ever

137

saw in my life[2] – Corbould's Fair Women are actually better. There is some good stippling in them.[3]

I believe you might have tied that fellow Overbeck to a Mill wheel on the Rhine – & let him go round upon it for a thousand years, without washing the least particle of his conceit out of him.

If I don't send this to day it probably won't come tomorrow. I'm sending a parcel of notes & want you just to know we are all well – If you want any abuse of any particular picture at Dresden – and will let me know by a note there – I think I am in tolerable humour to do it for you –

Kindest regards to you both from us all – Love to Peter –

Ever affectionately Yours

J Ruskin

[1] He found the 'German Gothic abominable', and the Cathedral 'a miserable humbug'.

[2] 'Execrable beyond all contempt', and he condemned it also for plagiarism 'cunningly concealed . . . as real base plagiarism is always'.

[3] E. H. Corbould had exhibited his drawing, *A Dream of Fair Women* (No 212), at the New Water-Colour Society that summer.

96

Denmark Hill 11th November [1859]

Dear lady Trevelyan

I was very glad to have your little note. I had heard of you however from Acland, who is much the better of Northumberland as I am sure Munro will be also.[1] – We got home a month ago – and after some visitings and visit receivings – chiefly of a sick friend who needed some quiet[2] – I am getting settled to my winter's work. Not having yet recovered however from the calamitous impression of Germany and feeling somewhat languid at all points – but pretty well.

I made some studies from Titian & Veronese, at Dresden and Munich; but did no landscape work this summer. I hope to get free of all bonds this next spring and take up my painting quietly.[3]

The Aclands, whom I left yesterday, are all looking well. Angie is like a crimson daisy,[4] in spite of all illness. The museum is by no means so satisfactory in the way of colour, and Henry is in an excited state about it. Mrs. Acland wants him to let it alone.[5] – So do I, rather.

I am sorry to hear of the Ashburtons going to Egypt again[6] – but

I should not have seen much of them even had they been in town for I must keep close to type, now

– I am half thinking of getting a mediaevil Wicket gate instead of ours and never letting the bell be answered – Unless in prospect of Muffins and such campanularly announced luxuries.[7] I often pine for Turin – That was the way to live –

Meantime – I sympathize with you in your glacial habitation, and wish you well out of it, in time for Christmas

Sincerest regards to Sir Walter My father & mother join in all very heartily, & believe me dear lady Trevelyan

 Affectionately Yours

J Ruskin

[1] Alexander Munro, the sculptor, was a frequent visitor to Wallington, where his plaster model, *Paolo and Francesca*, from the Great Exhibition of 1851, was already in place as well as medallions of the Trevelyans.

[2] Mrs Hewitt had been a guest at Denmark Hill from 11 to 30 October. By now a friend of the family, she had corresponded with Ruskin since 1857 and was receiving instruction in drawing from him.

[3] At Dresden it was chiefly from Titian's *Lady in a Red Dress* and Veronese's *Cuccina Family* (repr, R, 7, pl. F) that he made studies. At about this time he wrote to C. E. Norton: 'I am finishing 5th vol. [*Modern Painters*], and find it is only to be done *at all* by working at it to the exclusion of *everything* else. But – that way – I heartily trust in getting it done in the spring and having my hands and soul so far free.' And to the Brownings: 'I earnestly hope to get my book done, and all literary work with it, this winter, and to be able to take a few years of quiet copying, either nature or Turner – Or Titian or Veronese or Tintoret – engraving as I copy. It seems to me the most useful thing I can do. I am tired of talking.' (R, 36, pp. 329, 331)

[4] He may have been remembering the child he had seen at Calais early that summer: 'a little girl munching a slice of very nice white bread and butter. She had put a little deal stool in front of her, covered with buttercups and red daisies . . . ' (*Diaries*, p. 539)

[5] In *The Oxford Museum* Ruskin had pleaded for experiment and thought before introducing colour decoration into the interior of the museum.

[6] As a restorative for Lord Ashburton's poor health. His first wife (Carlyle's brilliant Lady Harriet Baring) had died, and in November 1858 he had married Loo. This was a match viewed with some apprehension by his friends for fear it would bring him 'many slightly insipid new connections' (*The Flight of Youth*, James Pope-Hennessy, 1951, p. 103).

[7] As the muffin man walked through the streets in the late afternoon he announced himself and his wares by ringing his handbell. The muffins were carried on a tray balanced on his head and covered with baize to retain the heat. He was still carrying on business until after the First World War.

[Probably early January 1860]

I'm trying to etch some distant pines, and in a state of torment which pines only could speak = moaningly. But I think the bit of the book is coming out rather nice, and I'm cutting out all the wisest parts, which are too good for this generation – so I hope nobody will find themselves particularly aggrieved –

Ever yours affectionately

JR

98

[Probably early January 1860]

Dear lady Trevelyan

Paper got, & forwarded all right I never could make out what you were doing down at Uxbridge. Thought there was a chapel building and something strong coming out in clerical *lace*.

– I'm very glad it's your sister – Is she as nice as you – and less saucy? My father says he's *so* glad there are *two*.

Ever affectionately Yours

JR

Can't do the pines – not time enough. Gave them up on Saturday. I'll do them quietly – as well as I can after book's done.

99

[Probably end of February or early March 1860]

Dear lady Trevelyan

My mother says she thinks you really were a little displeased with me for not having written to you for so long.[1] It is no wonder if you were, but the fact is I never care much at present to talk to any of my friends – not thinking that I shall give any pleasure – I have been in bad humour with most things and see no use in complaining. I do what I can, and feel more and more inclined to cease talking. I have no changes of purpose or prospect to report – and one day is just like another.[2]

My work is more than is good for me, and in still greater propor-

tion it is, just now – more than I expected; for many new and difficult questions were opened to me by the knowledge of Turner's character which my work at the Gallery enabled me to obtain – and by the examination of Venetian painting which I had to complete before I could close Modern Painters. I have had more difficulty also than I expected in obtaining as much clue to simple matters in botany, as was required for my account of vegetation forms, and in investigating such things as I wanted, for myself – I was led continually further into detail than was of any use, before I knew it.

In many respects I am entirely foiled – finding things on which I supposed scientific men were entirely agreed – still in dispute. The fundamental subject of all, the origin of wood,and the operation of cambium – seems still far from anything like clear interpretation – while in clouds and water, I have to give up many parts of my plan entirely – the mathematicians actually cannot tell me the curves of waves on sand! – I mean – what the general law of wave curvature is, which forms bays or minorities – and in addition to all these difficulties my engravers can't do what I want, and *I* can't do what I want – and the end of it all is that every evening I am quite stupid and spiritless – I hope in three months it will be all done. And then I will write you as often as you like to let me – After all – one main, unconscious reason of my not writing is that I do not quite understand your feelings about many things – and about many serious things do not care to tell you always what I am thinking – I am much changed in many things since you first put up with me [3] and I am a little afraid sometimes of not being put up with much longer –

Kindest regards to Sir Walter Ever affectionately Yours

J Ruskin

[1] The Trevelyans had come to London in the early part of February, staying first at the Collonade Hotel on the corner of Charles Street, St James's Square, and the Opera Arcade, and moving on to Morley's Hotel in Trafalgar Square. On the 18th they went to the exhibition at the Hogarth Club, where Sir Walter found 'extravagant drawings by Rossetti'. Rossetti had two oil-paintings on show: *Bocca Baciata*, generally condemned as 'coarse' and 'sensual' and which marked a turning-point in his career, and *The Salutation of Beatrice*, two panels depicting Dante and Beatrice in Florence and in Paradise. His only water-colour drawing was of *Lucrezia Borgia* washing her hands having administered a lethal dose of poison to her husband. On the 22nd they dined at Denmark Hill; Mr Warnum was also there and Lady Trevelyan probably teased Ruskin for being so poor a correspondent.

141

² There were many matters to vex him, and exhausted from overwork (his *Elements of Perspective* had been written and published the previous autumn) he still drove himself relentlessly to complete *Modern Painters*.

³ Principally, where Lady Trevelyan was concerned, in the religious crisis he had undergone.

Easter Sunday [8th April 1860]

Dear lady Trevelyan

I never believed that buds were such provoking creatures: I can't finish one of my woodcuts because I want a horsechestnut bud for it,¹ and the stupid things keep holding themselves all prim so [sketch] instead of spreading: – A fine green country Northumberland must look, this spring, I should think.

I've been enjoying the spiral & opposite sections of trees exceedingly – only its impossible to explain them without being tedious: so I have let it alone. There will be thirty chapters I find, and I'm inventing names for them to prevent people from guessing what they're about.²

I've been busy on an etching of the "English particular Devil", which I hope people will like. It is a pity that in the old George & Dragon story, the Saint turns out a Myth, and the Dragon – by no means³ –

My father is in a troubled state of mind because a pamphlet on China – announced as sent by Sir Walter – has not arrived. Perhaps I've got it – but I don't really think so –

Ever affectionately Yours

J Ruskin

¹ In *Modern Painters* v, Chapter III, Ruskin presents a woodcut of a section of a horse-chestnut bud. The passage on the spiral is illustrated by diagrams.

² The thirty chapters include such titles as 'The Angel of the Sea', 'The Law of Help', 'The Task of the Least', 'The Rule of the Greatest', 'The Dark Mirror'.

³ The etching is of the Dragon (repr. R, 7, pl. 78) from Turner's painting, *The Garden of the Hesperides*. Ruskin saw the Dragon as the demon of covetousness and a destroyer. 'In each city and country of past time, the master-minds had to declare the chief worship which lay at the nation's heart; to define it; adorn it . . . here in England is our great spiritual fact for ever interpreted to us – the Assumption of the Dragon. No St George any more to be heard of . . .' (R, 7, p. 408)

[Probably 12th April 1860]

Dear lady Trevelyan

To think of people getting into such scrapes – at your age too – ten years older than your sister. However I must see if I cant find something for this precious bazaar. I'll send it tomorrow if I can find anything.

Ever affectionately yours

JR

Chinese pamphlet arrived & delivered. It didn't look amusing enough to keep.

102

13th [April 1860]

Dear lady Trevelyan

I've been looking out some things Here are a few things of mine, & a pretty copy of Hunt by one of my pupils;[1] and I've written to some of my *girl* pupils[2] to day to ask if they can send you anything, if you get a parcel marked "from Winnington", therefore, its for you, if there's anything in it.

– mine have to be mounted to look like drawings at all – but will come to morrow

– There's a pretty little chalk sketch of Harding's among them[3]

Ever affectionately Yours

JR

I've told the girls it will do in three days – will it?

[1] The copy of Hunt's pear (see Letter 103) may have been made by George Allen, who remembered how Ruskin would bring drawings of his own by various artists to the Working Men's College for practice in copying, and 'for the purpose of showing how certain effects were got, e.g. the rounding of a pear by Hunt' (R, 5, p. xxxix).

[2] These were the pupils at Winnington School Hall, near Crewe, Cheshire, in whom Ruskin had taken more than a common interest since his first meeting with Miss Bell, the headmistress, early in 1859. She was an enlightened teacher but of an ambitious turn and realised it would add to the school's reputation to have Ruskin as a visiting lecturer and as adviser and patron. By now he had stayed twice at the school, where his own rooms were set aside for him. He taught the girls and entered into their games, and when absent wrote them long weekly

letters setting them exercises on the reading of the Bible. He now wrote to 'the Birds' (his collective name for them) to ask: 'Have you anything by you in the way of sketch or work, that would be available at one of those fine pieces of charity called ladies' Bazaars. A really very nice friend of mine has got herself into the scrape of promising to keep a stall at Newcastle – and she hasn't got enough, she says – if you *have* anything that you wouldn't mind giving her please send it to

<div style="text-align:center">

Lady Trevelyan
Wallington
Newcastle-on-Tyne

</div>

Writing "from Winnington" on parcel. In two or three days would do.' (*Winnington*, p. 216, undated but assigned to 'probably January 1860'.) Sir Walter's accounts disclose £1 5s spent on 'Bazaar Raffles &c'.

³ J. D. Harding, water-colourist and lithographer from whom Ruskin received his early drawing lessons. ('Delightful for what they were worth.')

<div style="text-align:center">

103

</div>

<div style="text-align:right">

[Probably 20 April 1860]¹

</div>

Dear lady Trevelyan

It appears by the enclosed that what *can* be done, will be – by the young Winnington ladies.² I suppose Saturday *is* the last day you can give them – in case any thing occurs to you that you could suggest to them to please you better a line to Miss Bell – Winnington Hall

<div style="text-align:center">

Northwich

</div>

would reach them sooner than by coming round here –

I've been hindered from making up my parcel till to day, – but it will truly come by a fast train to morrow. The copy from Hunt's pear is really very good.

I'm so glad you like my dragon I'm etching him all myself and won't do him brown³ – but leave him nice and scratchy.

I would'nt be so spiteful, if I were you, even though I *had* to dig every body and everything out of the snow

Send me back my birds' letter please – It's a handy name to write to them all by – and saves much trouble –

<div style="text-align:center">

Ever affectionately Yours

J Ruskin

</div>

¹ So dated since it is natural to suppose that Ruskin wrote this letter on the same day as he wrote to Winnington (see below, note 2).

² Drawings appear to have been forwarded to Wallington as indicated in a further letter from Ruskin to the Birds: 'I am sure Lady T. will like the drawings

5 'Wayside Refreshment', 1853

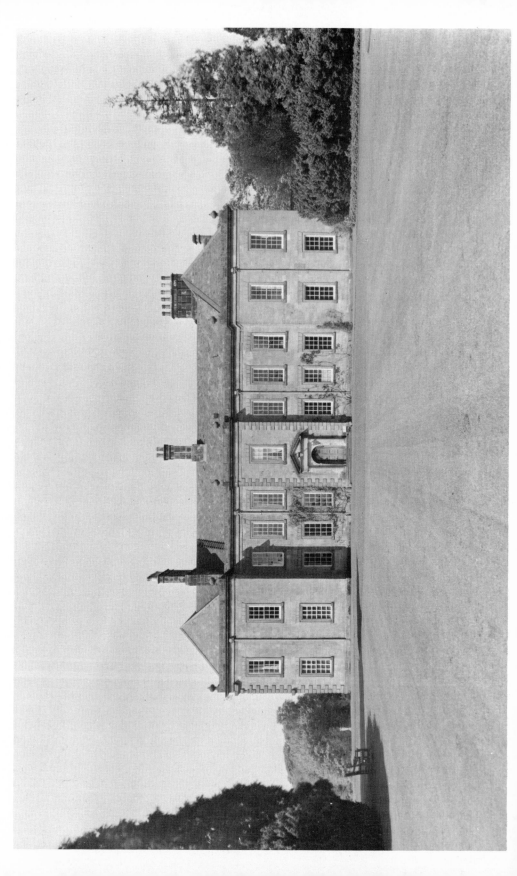

so much – and be very grateful to you all, as I am.' (Undated, but postmark 20 April; see *Winnington*, p. 217 and note 1.)

³ Perhaps some reference to Ruskin's known dislike of Turner's 'old conventional principle of . . . brown foreground' (*Sublime & Instructive*, p. 159).

104

[Probably early May 1860]¹

Dear lady Trevelyan

The way you pious people reconcile it to your consciences to take everybody else in – is to me utterly incomprehensible – A thousand pounds! and Seven pounds of it for a pencil scratch of the top of a steeple² – Where do you expect to go to? There's certainly something in that Northumberland air which gives a natural taste for foraging – thats the only excuse I can find for you – but [illegible] riding & reiving was nothing to this.

By the way, theres a beautiful picture of your county in spring in the exhibition³ – It's all white – except the sky – which is black, and – Stop – I think I can draw it [sketch]

A B. Sky
C D. An amusing road
F G. A snow-drift
T. A tree, growing.

Theres not much else very veracious in the Academy this year – They painted so much apple blossom last year that now there's none⁴ – They're just like people knocking their heads together in a door way and then standing bowing – to let each other go in first. All the blossoms came at once – This year there are none – & NO Fruit – neither – I have'nt done my book but I've written the end of it – and have only a little bit to fill in – Printers going on – I hope the end will come some day soon. I am trying to make it as unpleasant to everybody as I can – Ever with love to Sir Walter affectionately Yours

JR.

¹ From internal evidence the letter was written at about the time of the opening of the Royal Academy Exhibition.

² Passage unexplained. At Seaton, where they went for sea-bathing and owned property, the Treleyans were erecting a village school with a little pointed turret, as well as other buildings. Perhaps the reference is to one of these, or else to the purchase of a picture.

[3] Ruskin was always teasing Lady Trevelyan about the cold and the barrenness of Northumberland. The painting in question may have been *A Rustic Path – Winter*, by A. MacCullum in which the boughs and twigs of the trees are leafless.

[4] In his *Academy Notes* 1858, Ruskin had shown himself amazed that 'among all this painting of delicate detail there is not a true one of English spring . . . no Pre-Raphaelite has painted a cherry-tree in blossom, dark-white against the twilight of April; nor an almond-tree rosy on the blue sky; nor the flush of apple-blossom.' In consequence the Academy walls were rich in blossom the following year and a reviewer observed that 'Ruskin has much to answer for . . . From Millais . . . down to the sorriest scrub . . . all appear to have taken the apple-blossom fever, and to have painted the blossoms when at the height of their delirium' (R, 14, p. xxiv).

105

From JJR to Sir Walter Trevelyan

Dover 5 June 1860

Dear Sir

I have too long delayed thanking you as I do most sincerely for sending me a Pamphlet on Chinese affairs which seemed in small space to embrace a very wide subject. I no doubt liked the Book the better that it expressed entirely my own opinions.

I am seldom uneasy about public affairs but I cannot help being anxious about our proceedings in China.[1] Of the French I never think for a moment.[2] If they come they will come like Sacrifices in their Train & we shall have our Blood roused without the previous trouble of going abroad for that purpose, but for this Chinese War I have a perfect horror & dread – such a sneaking Housebreaking sort of Warfare at the Instigation of a set of Manchester Warehousemen or by the advice of such men as Bowring & Bruce – you have only to look at the Portrait of the first on the Academy Walls to see he is a fool & to read the Dispatches of the last to see he is totally incapable as a negotiator.[3] The Chinese are not so sorely distressed or alarmed as yet, to be likely to grant requests so stupidly & insolently put as in Mr Bruce's first ultimatum.[4] I hope somebody possessed of common sense & common courtesy will make another effort to save us from the enormous waste of Life & Money the attempt to get to Pekin will cost us. Our risk is fearful – Success will procure for us a Treaty worth exactly nothing & failure might lead to a Rupture with France & endanger India.

I was afraid you had the trouble of ordering two copies of the

Pamphlet the first most likely being in some of my Son's study drawers – & for which we have to apologise.

We came here with my Son who left us 24 May & telegraphed from Geneva 26 May at 1 o'clock letting us know at 4 of his being there well. His 5th volume M.P. will be out 12 or 15 June & I have told publishers to forward one for Lady Trevelyan's acceptance. I feel pretty well assured the contents will give you both pleasure. Mrs. Ruskin joins in presenting Kindest Regards to you & Lady Trevelyan I am

 Dear Sir

 Yours very truly

 John James Ruskin

Sir Walter Trevelyan Bart.

[1] Sir Walter, a pacifist, was outraged by the China War. Hostilities had broken out in 1857 as the result of the seizure of a British vessel trading in opium. In the view of many at home (Sir) John Bowring, the British representative, was thought to have acted contrary to instructions. After his recall the Earl of Elgin was sent out as special envoy but continued to carry out the policy of his predecessor. With the Treaty of Tientsin peace was patched up, but in 1860 when Elgin's younger brother, the Hon. Frederick Bruce, now British Envoy, attempted to reach Peking to ratify the treaty, there was further trouble. An expeditionary force was sent from England, and Lord Elgin went out to China for a second time. 'I can just remember our wars since 1797 [JJR wrote to a friend], and anything more thoroughly stupid or painfully disastrous and humiliating than the China Affair I recollect not.' (R, 36, p. 319)

[2] England was in fear of invasion by the French.

[3] In the House of Lords in March Lord Ellenborough traced the origins of the misunderstandings and wars with China to our own merchants. No doubt JJR had in mind the case for Free Trade which had been launched by Manchester merchants. The portrait of Bowring by H. W. Pickersgill R.A. was No. 11 at the Royal Academy Summer Exhibition.

[4] This was a demand for apology, indemnity, and restitution for acts committed by Chinese troops. These the Emperor of China rejected, whereupon the British army in China advanced on Peking, sacking and burning the Summer Palace. Peking surrendered in October.

106

From Lady Trevelyan to JJR

 [9 June 1860][1]

(Letter incomplete at beginning)

I wish I could get you to take some interest in the enterprise of which

I enclose a prospectus.² *do* read it when you have a vacant half hour. It would be such a miserable thing after spending two millions on this matter to leave the thing incomplete for want of £3500! and now we know exactly where to go to, there would be no great risk of life. Besides I *should* like our old flag to be the first to go round the world of the Arctic Route, and not the Stars & the Stripes – which will be before us if we don't mind.

I hope Mrs. Ruskin is well & that you continue to have good accounts from Switzerland. With our united best regards to you and love to Mrs Ruskin

> Ys very sincerely
>
> P.J. Trevelyan

¹ See opening paragraph of Letter 107.

² This was a search expedition to the Arctic, on which subject Lady Trevelyan was writing at the same time to W. Bell Scott: 'I sent you a paper about Captain Snow's Arctic search. Now I conjure you . . . do puff, do ventilate the subject and make others take an interest in it. If they dont care for the records and Journal, there is always some chance of finding the crew alive, if they dont care for those they may be moved by our old flag going first round the world by the Arctic route . . . I have set my whole heart on this search' (*Autobiographical Notes of William Bell Scott*, ed. W. Minto, 1892, ii, p. 54). In urging Scott to 'puff' the venture she may have been coupling a reference to his smoking habits with a current colloquialism. The Trevelyans contributed £100 towards the expedition.

107

From JJR

Denmark Hill 14 June 1860

Dear Lady Trevelyan

I beg to thank you for your kind Letter of 9 June, received only last night. Smith Elder & Co. assure me that Vol. 5th shall go to you today.

If it at all relieves you we will take back the Illumi. M.S. but if you would have travelled with these Books, believing yourself to be immediately under the protection of the Virgin they should go where you went or where you chose to take them – but if you are to be under such dread apprehension let them come to Denmark Hill & welcome if they bring you with them.¹

Regarding the Arctic Regions I am sorry to be obliged to confess some Indifference. I would give £10 at any time as the measure of

my interest in them or because I see others with warmer hearts taking an Interest in them. I would myself rather give a £100 for anything connected with the other world than £10 towards a Discovery of a passage upon this. The State these Arctic Regions are kept in seems to me a declaration from Heaven that we are not wanted there. To other Lands we are invited both by God & Mammon & I regret to see that as a Lender the latter is generally preferred. Witness the Diggings.[2]

John writes from Bonneville & is quite well. I have contrived to get very unwell since he went which has happened before.[3]

Mrs R is well & will be most days except Tuesday at home. I hope to be able, if you will kindly come, to get the Richmonds & some person to meet you at six O'clock Dinner. With our kindest Regards to you & Sir Wr Trevelyan

I am Dear Lady Trevelyan yours sincerely

John James Ruskin

[1] The Trevelyans had come to London in the early part of the month; Lady Trevelyan wished to return books and manuscripts lent her by Ruskin. As always their time was spent chiefly in making the rounds of studios and exhibitions. They had admired Watts's new fresco in Lincoln's Inn Hall, no doubt contrasting its quality with that of their own murals at home. A visit to the Olympic Theatre followed, where Sir Walter was compelled to record that 'Donkeyness is disgusting on or off the stage.' Later in the month at Oxford Sir Walter entered up a visit to the Union building in his diary and also to Exeter College Chapel, recently rebuilt by Sir Gilbert Scott in Gothic revival style. This he found 'very beautiful. Union paintings those by the PRB extravagant – by no means do [ditto].'

[2] Presumably the diggings in Australian mines which since 1853 had continued to yield gold. In 1863 he again referred to the diggings, questioning his son on the matter (R, 17, p. 488).

[3] Ruskin was travelling slowly, taking the road from Geneva to Chamonix. He returned to Bonneville the following month. JJR's health was affected not only by his son's absence but also by the alarming direction in which his thought was now taking him.

108

From JJR to Sir Walter Trevelyan

Denmark Hill 26 July 186c

Dear Sir

I have desired Smith & Co to send you by Book post the August

No. of Cornhill Magazine containing an Article by my Son – "Unto this Last" which though political Economy is dry enough, I am sure you and Lady Trevelyan will like.[1]

The Editor, albeit eager to have anything from John, rather shrunk from appearing to sanction the Sentiments – so to relieve him from the Opprobrium of seeming to approve of anything kind liberal or just towards the Working Classes I let my Sons initials go to the end of the article. The Times some time ago expressed surprise that Dr Guthrie & Mr Ruskin whom they allowed to be both men of Genius should be such perfect Innocents in Political Economy – so I presume we shall have the Slaughter of the Innocents.

My son sent me the papers from Chamouni saying not to publish if I did not like it. I was charmed with the article though little complimentary to my Vocation but he does well to drag the Merchant Princes from their Pedestal, & place them on a lower & more appropriate Shelf. They have themselves gone down into an abyss from which they will have some difficulty in ever again emerging.

I was not favoured with a sight of you when in Town. I had been too unwell for a Dinner Table but I do not know you would have come had I been well. John took us by surprise by writing that he intended being home so soon as 2 Sept for his Mother's Birthday. This Letter has acted miraculously on my Illness & we are going to Tunbridge Wells to spend the Interim.

Mrs Ruskin joins in kind Regards to Lady Trevelyan & you and I am

My dear Sir

Yrs truly

John James Ruskin

Sir Wr Trevelyan Bart.

[1] Ruskin was at Chamonix in sombre mood. Many things combined to impair a mind already overtaxed by work. The necessity for living away from his parents' devoted care was becoming essential; loss of faith had shaken him deeply, and his growing obsession for the child Rose La Touche was driving hin to 'a new epoch of life and death'. With his books on art and architecture behind him he was free to turn his mind to social economics, which now became his own main preoccupation. His four papers on Political Economy were published in the *Cornhill Magazine* (under Thackeray's editorship) in consecutive months beginning in August. JJR was uneasy with regard to their reception, and indeed they were so strongly criticised that Thackeray was obliged to bring the series to a close. The essays were collected into one volume in 1862 and appeared under the title *Unto this Last*.

From JJR

Denmark Hill 27 July 1860

Dear Lady Trevelyan

I had only yesterday written to Sir Wr Trevelyan to Wallington sending a Cornhill Magazine with an article of John's in it.

I hope the 5th Vol. came to your hand.[1] This morning I have the great pleasure of your letter from Seaton & I send the enclosed Letter to John at Bonneville
 now Faucigny
 France.[2]

I have said to Sir Walter I continued too unwell to try to get the favour of a Dinner Visit from him when in London not knowing at any rate if you would or could have come. I am mending gradually as John's absence shortens. May I address a Letter with a Cheque for £10 to Wallington.

I see we may expect the very acceptable present of some Venison.[3] It is indeed very kind of Sir Walter to think of us in this way. The weather is miserable but fields & gardens bear it better than we could expect. We have fires every Evening. I remember some small Critic of Rokeby 40 years ago or nearly so – thinking he had caught Sir Walter Scott in a great mistake, alluding to Fires in that Region in July.[4] He would find them much further south in July 1860.

Mrs Ruskin is very very happy in your affectionate Remembrances – & with united kind Regards to Sir Walter & you I am Dear Lady Trevelyan
 Yrs very truly John James Ruskin
Mrs R is pretty well
John is very well
Dr Acland's Fortune is made[5]

[1] *Modern Painters*, published on 14 June.

[2] In Italy's fight for liberation she had been obliged to cede Savoy (and Nice) to France.

[3] JJR's contribution towards the Arctic expedition must have reached Wallington at about the time he was noting in his diary under the date 31 July: 'Sir W. T. vn [venison].'

[4] Situated on the river bank at the meeting point of the Greta and the Tees, Rokeby Castle was the background to events following the Battle of Marston Moor, as recounted by Sir Walter Scott. The incident referred to by JJR occurs in the 'sultry summer' of July when the participants 'closed beside the chimney's

blaze', and 'bade them light the evening flame' (*Rokeby*, Canto V, v & vi).

[5] Perhaps a pleasantry in reference to *The Oxford Museum*, which had recently gone into a second edition.

110

Bonneville 30th July [1860]

Dear lady Trevelyan

The weather has been nearly as bad at Chamouni – *so* bad – in fact, that I was thinking of Northumberland every day: and once wrote you a long letter – a fortnight ago, finding when it was written there was nothing in it, I did not send it. No improvement in weather, even now, and hay very effectually spoiled: but I don't hear complaints of harvest, & the look of the harvest is good, and pretty. a tall sheef at the head of a battalion – with a cross of red roses in the uppermost swathe, looked lovely in the fields of St Martin's this morning. We have had a month among the Alpine roses; nearly in vain – they fade more quickly even than our real roses; and get so rusty and wretched that it is of no use to try and paint them.[1] In fact I find it of little use to try to paint anything: but am endeavouring to bring myself into a mechanical habit of work, so as not to care what I do – or what comes of it – or what any one thinks of it. I shall probably work all the better. I don't know what you will think, by the way, of this letter – for I perceive myself to be half asleep – the hand running off the lines – I have really succeeded in doing a great deal of nothing this summer; – having an American friend with me who helps me. A great "medium" he![2] – and tells people's character by touching their letters – I gave him one of your's the other day: he crushed it a little in his hand – and looked very much pleased, & said "Lady T's a very nice body" He proceeded to give a better account of you than of any other of my friends, which shook my faith in his powers, not a little – I was quite going in for Spiritualism before That is very nice about lady Ashburton – Mary Florence – Santa Maria del Fiore – I hope she'll be nice and pretty.[3] By the way, I counted the gentians (deep large blue bell –) in spaces of six feet square on the pastures of the Aiguille de Varens this year. I measured a square with my pole: Put stones at the corners: then pulled all the gentians, counting as I gathered. There were 132 in one square; 176 in another: The average would be 120, to the square of six feet – over about twenty acres of the aiguille side:

it was curious to hear the crisp rattling sound of the edges of their strong bells as the foot struck over them in walking. Also, I never before this year noticed the richly clustered white lily; small in blossom but as thick on the stalk as campanula bells.[4] Such a bouquet of them as I had, one day – (to my sorrow) instead of the person they were intended for – a pretty English girl who came down from Chamouni early one morning & we thought she was going to stay the evening; & did'nt know how to get at her or her people: so what must we do but go up the Varens & gather as many lilies as we could hold, each; and then we cut all the buds off all the rose bushes* all the way down, and cut the thorns off with our penknives in the patientest way – and put the rose buds all round the lilies, and you never saw such a bouquet – and the girl had gone away to Geneva when we came down – was there ever such a shame.[5] There had one good come of railroads, I see, however. Young ladies schools travel as well as boy's school now – which makes the glaciers not quite so freezing as they used to be. I've had enough of them – (of the glaciers I mean) for the present however – and am going into low land Switzerland to try and paint some cottages – I have promised to be home, or at least to do all that in me lies, to *get* home – by 1st September: and I hope to finish my work at Wallington before coming abroad again – but make a point now of planning and promising nothing either to myself or any one else – and just doing any thing that comes to hand.

I'm very glad you like the book – *My* book I mean of course – by *The*: I hope clergymen will enjoy it particularly – They have built such a beautiful orthodox English chapel at Chamouni, with lancet windows: – as dark as pitch – & a little tin belfry[6] – They have built it for the most part out of a great stone of old glacier moraine, which impudent calves used to slip off and break their legs – the Chamouni people used to call it the Pierre aux Veaux – absit omen Best regards to Sir Walter – I hope all the amphoras he finds in his Roman villa will be empty:[7] – please tell him I've had a great satisfaction out of some engineering operations on the streams at Chamouni – having the magistrates to interrupt me – Thanks for returning the missals – Of course I never expected you to do any thing of the kind – and I'm vexed at your conscience having troubled you. If *I* had a conscience I would keep it in better order –

Ever affectionately Yours J. Ruskin

* Real wild rose – pale red – sweetest in scent I ever found.

¹ Roses, of whatever species, were symbolic of the child Rosie and now formed the subject of many of his drawings.

² W. J. Stillman, American journalist and editor of *The Crayon*, was greatly influenced by Ruskin, though on this occasion of their spending two months together they managed to make each other 'reciprocally miserable to an amazing extent'. Ruskin was exasperated by Stillman's slipshod drawing, while Stillman was irritated by the subjects Ruskin expected him to draw. Great interest in spiritualism had been aroused in the last two years but Lady Trevelyan disliked such phenomena.

³ Loo's child was born in June and named Mary Florence (the latter name after Florence Nightingale). She sat twice to Rossetti in the 1870s and he thought her 'handsome and winning to a very unusual degree', and 'of the sweetest look and temper' (*Letters of D. G. Rossetti*, ed. Doughty and Wahl, 1967, iii, pp. 1320, 1321).

⁴ This was the wild dwarf branched white lily.

⁵ Ruskin gives an account of this incident in *Proserpina* (R, 25, p. 204).

⁶ The granite building erected at a cost of nearly £1,400 held two hundred people and was built with money chiefly subscribed by the English. It was opened in this year by C. R. Sumner, Bishop of Winchester.

⁷ A jest which the teetotal Sir Walter would not have appreciated. The foundations of a Roman villa had been recently discovered on one of his farms above Seaton.

III

From JJR to Sir Walter Trevelyan

Calverley Hotel

Tunbridge Wells 2 Augt 1860

Dear Sir

I waited till I saw on the Table in all its perfection the Haunch of Venison you so kindly directed to be sent to us before expressing the ardour of our admiration & thanks – I had not been at a public Dinner these thirty years nor sat at great private Boards so the appearance of your magnificent present at once told me why a Haunch of Venison was a much prized Dish. Mrs Ruskin & myself thank you particularly for so goodly a Gift – nothing equal to it had ever before entered our House or graced our Table.¹

Mr Newman's Essay also kindly sent by you followed me here.² I have read great part of it but get bewildered by the vastness of the subject. Many of the views presented by Mr Newman are very painful. The Ethics of War I fear are very small – might too often making right. The great hope now is that the peace of the World may be promoted by the increased horrors of modern warfare. The true soldier like the Duke of Wellington seems to shrink from them

& the present Emperor of the French though acquiescing in the necessity of a Street Slaughter returned from Italy with his Hair turned Grey by one Campaign.[3] War as we now have it will become as distasteful to the true Soldier as the Battue is to the true Sportsman.

I had sent the Cornhill Mag to Wallington but as Mr Smith[4] is a *liberal* & gave me a dozen I sent one to Seaton as you seem to be staying longer there. I ought to write to Lady Trevelyan to thank her for her letter but am late for Post. The Comet I have not seen for my Illness kept me chiefly gazing at the Drawing Room Fire.[5]

It is as dark here as in London. Mrs Ruskin joins in kindest Regards to you & Lady Trevelyan – my Son has had some Bilious attack which sends him down from the Glaciers. I hope it has left him.

I am
> My dear Sir
> Yours very truly
>> John James Ruskin

Sir Walter C. Trevelyan Bt.

[1] Anyone as precise as JJR could hardly have forgotten the previous gift of venison. Presumably he meant exactly what he said and that the haunch far surpassed earlier gifts in size.

[2] Perhaps the essay 'On Consulting the Faithful in Matters of Doctrine', which appeared in the *Rambler* towards the end of 1859.

[3] At the time of Louis Napoleon's *coup d'état* in December 1851 the army had fired on civilians in the streets of Paris; and now, although victorious, Napoleon's army suffered appalling loss at the Battle of Solferino in June. These two events remained a haunting recollection to the Emperor to the end of his life.

[4] George Smith, of Messrs Smith Elder & Co., was Ruskin's publisher.

[5] Though visible to the naked eye in central and southern England during the latter part of June and first week of July, the New Comet was so distant and the weather so unfavourable for viewing that it did not become 'a popular object and soon disappeared'.

112

From JJR

Calverley Hotel, Tunbridge Wells
3 August 1860

Dear Lady Trevelyan
I said I was not writing to you but I have found an excuse in

forwarding a Letter from John & in a Letter this morning dropped in from Dr J. Brown to me with a P.S. that will interest you. It is this 2 Aug "I know you will rejoice with me when I tell you that on Monday I took my dear Wife to a pleasant upland farmhouse which I have rented between Dunkeld & Blair Gowrie & she is there with her son & immensely better .in Body & in mind – a Relief – & happiness to me quite unspeakable"[1] Dr Brown to my amazement is sorely vexed at an Article in Scotsman of 2 Aug. on John's Political Economy. After the Articles in Blackwood I cannot imagine how a mere spurt like this should vex the Soul of Dr Brown. He says "They show you the way in which the unlucky paper will be set upon – I am so jealous of his greatness & his unapproachableness, that I get quite unhappy at such a bye stroke as this & yet why should you & I vex ourselves?" but in truth I do not at all vex myself & look for twenty such flings all beginning as this does with the very novel Ne sutor ultra crepidam [judicaret].[2]

The Blackwood articles did at times annoy me because they mutilated his paragraphs in quoting & even that gaunt personage Lady Eastlake with her article in Quarterly[3] does at times haunt me but this Scotsman critic though because so – I daresay clever enough, is of no higher notions in Political Economy than those distinguished members of the mercantile Community in my country Scotland, who deal exclusively in Red Herrings & penny Candles. In place of being vexed I am obliged to the Scotsman for a column of large print always a mark of consideration whether for praise or abuse & obliged moreover to him for differing with my Son.

The Missals were put in John's study – Mrs R does not always tell me what is said of Vol. 5 [Modern Painters] I suppose to prevent my thinking too much of John

I am Dear Lady Trevelyan

Yrs very truly

John James Ruskin

[1] Mrs Brown had been seriously ill with general weakening of the mind. On hearing of this (temporary) improvement, Ruskin wrote immediately to Dr Brown: 'Lausanne, 6th Aug. Among the things that have given me chiefest pleasure in my news from home was the late account of the decided improvement in Mrs Brown's health.' (R, 36, p. 340)

[2] 'Let the cobbler stick to his last' (Pliny).

[3] See Letter 80.

From JJR Calverley Hotel
 Tunbridge Wells 21 Aug 1860

Dear Lady Trevelyan

 I have the great pleasure of your Letter of 17 Aug & today Mrs Ruskin has received the Lace & your kind Letter. I now enclose

Tickets of Laces kept	Collar & Sleeves	1. 3. 6.
	Collar & Sleeves	2. 4. -
	Veil	1. 8.
		£4.15. 6.

These Mrs R takes – for my grand niece & I have fallen in love with a Collar & Cuff 23/Ticket which the young Lady's Mama can hardly refuse so I enclose small Cheque for £5.18.6[1] & return the other things which I hope will come safely & if there be any mistake you will kindly tell us.

 We thank you for Reports of the Aclands & hope your nephew will find Marlborough College of which I hear very little – a School worth going to. Best Thanks for newspaper. I have desired a Cornhill Magazine Sept to go to Sir Walter. I am rather proud of these papers though there is some danger of my forgetting associates with Louis Blanc & Mr Owen of Lanark[2] – & I don't like vexing Dr Brown. John seems to have been really unwell among the Glaciers & is himself again at Basle coming home Saturday week.

 In all you say in your first Letter of Capitalists Workmen I entirely concur. I never kept a Traveller & my Business led me once a year to Sheffield where I found the men sober & industrious on 20/ to 25/. Drunken & riotous & half the week idle on 50/. The police office I have visited with my Correspondent a Magistrate & found it armed like a Town besieged & mutinous workmen pouring Vitriol on those who were willing to work on moderate Wages. There are doubtless hard masters like Moses & Sons & I suppose the Song of the Shirt is founded on Truth,[3] but there is much room for amendment in both men & masters.

 John's papers may do some good in respect to adulteration & in his plain language *Cheating* for much of Trade is neither more nor less than Cheating & Swindling.

 Mrs Ruskin joins me in kindest Regards
 I am my dear Lady Trevelyan Yrs very truly
 John James Ruskin

¹ His great niece Maria was the daughter of Dr William Richardson of Tunbridge Wells. JJR's account book records £5 18s 6d paid for lace on 21 August.

² Louis Blanc, French politician and socialist. Robert Owen, the reformer and socialist, owned cotton mills at New Lanark.

³ *The Song of the Shirt* (1843) by Thomas Hood, has as its subject a young seamstress toiling for a meagre wage in miserable conditions. This was a favourite theme for moralist, reformer, and artist.

114

[Mid-October 1860]

Dear lady Trevelyan

I've just got my last incendiary [*Cornhill*] production (for November) finally revised – and am in for a rest, I believe, which your letter begins pleasantly – My rest at home began badly – six weeks ago¹ – my mother falling down the stairs in her dressing room & breaking the thigh-bone – all has gone on since as well as could be; and I did not write to tell you, because it was no use your being anxious for her & my father & me. The doctors say now the limb will be quite useful again – The worst of the thing has been the confinement, which my mother has however borne admirably, (with the help – be it confessed – of some of the worst evangelical theology which she makes me read to her – and I'm obliged of course to make no disparaging remarks of an irritating character – You may conceive *my* state of mind after it!)

You shall have a lily next year – if I get over the water – It is a true lily about this size in the bell [sketch] pure white – and growing in clusters something like this [sketch], it is mingled in the pastures of the Varens with ranunculus or buttercup-leaved plant also growing in clusters, and like an anemone in the flower, very beautiful, and with I believe a true anemone; golden, and magnificent in size, single-flowered. If you look at my political economy of art, you will see what to do with your coalmerchant.² The price of coals is to be fixed by the guild of coalmerchants; the carriage to be paid like postage at a uniform rate – & coals of given quality delivered any where at one price, – for certain fixed periods – but I can't enter into details yet for a long while – till I've corrupted peoples minds more extensively.

So Sir Water likes iron haymakers. Well: we'll have it out some day: – I have'nt recovered my angelic temper yet, as having been

disturbed by seeing a steam engine devouring a wheat stack at Tunbridge wells, and hearing it growling over its prey a mile and a quarter down the valley.

My Father is pretty well – recovering from the shock which my mothers accident caused to him: and contemplating my Cornhill gambols with a terrified complacency which is quite touching.

I'm very poorly, philanthropy not agreeing with me – as you very properly say it should'nt. The other thing suits me much better.[3] I send this scratch merely to thank you for nice letter. I'll write more soon.

Ever affectionately

J Ruskin

[1] Ruskin had returned home at the beginning of September.

[2] During the Manchester Art Treasures Exhibition in July 1857 Ruskin had delivered two lectures on 'Political Economy of Art'. He was here referring to a passage in the second lecture in which he recommended a revival of the Trade Guilds.

[3] At about the same time he was writing to Miss Bell at Winnington School: 'I am very glad you like the other kind of writing better – so do I – much.' (*Winnington*, p. 275)

115

[? End of October 1860]

Dear lady Trevelyan

My mother bids me say with her love, that some collars or other vanities (which she and you suppose you have ever so many good & pious reasons for promoting) will "do" or "come at the right time" – or – something or other I don't know exactly what – in Two Calendar Months from this time: – that in fact if they come sooner she will not be able to wear them – or send them – or in whatever manner it may be – do for them as they should be done by. And that therefore you are not to hurry about said Collars or other Vanities.

I was so very glad to hear that dear crossgrained Peter was well: – I've always been afraid to ask for him lest I should make you cry – and I thought you were ever so much milder lately from not having been encouraged by him in a Captious disposition.

Talk of High Church principles & call your dog Peter: I wonder where you expect to go.

Mind you tell Hindhead Hill to send me his drawings.[1]

Love to Sir Walter

Yours affectionately

J Ruskin

[1] Unidentified, but just conceivably a joking name for the Hilliards' five-year-old son, Laurence (Lollie, Laurie), who showed an early aptitude for drawing and became a good artist. At Brantwood, Ruskin's future home, he learned to make and rig a sailing boat. It is just possible that this name for him derived from a child's delight in a memorial to a murdered seaman at Hindhead (a pleasant expedition from Cowley), while Hill was an abbreviation of his surname.

116

[23 November 1860][1]

Dear lady Trevelyan

So many thanks! My mother can hardly be said to gain, but the long confinement seems to lower her general health nearly as fast as the limb gains power, which it seems questionable if it will to any much greater extent. We have got her carried downstairs, and by help of back of chair she gets about the library[2] & sees the flowers, but she is perhaps more despondent in feeling: the imperceptible stages of progress lose themselves one in another; and she seems to herself as helpless as at first. My father bears it better than I expected; but he also is a good deal cast down by his clearer knowledge of the probable facts of the case. It is unlucky that I should have got into a black fit at the same time from entirely different causes; and that I am doing less to help therefore than I might have: It does help much to know that people care for one, only somehow I never *can* know it – or at least believe it. I think that people are kind & goodnatured – and (always excepting you) sometimes respectful – but I never believe they like me. I always feel as if I bored them. Then with you married ladies – the moment one gets up to anything like a comfortable or helpful state of things – one comes to the wire fences also – and then there are all sorts of complications – so you never can be of much use – except in giving advice and being impertinent – for any heart-ache or headache you have no medicine. And unmarried ladies are worse (always excepting my birds at Winnington who are very good – but I'm too stupid just now for play.) I got what

sounded like rather a good piece of advice from a married lady the other day: to "pick up a couple of children out of the street, boy & girl, and have my own way with them and see what I could make of them": I daresay I should, if I were living alone. Meantime I don't quite see my way to anything in particular, as the purpose of the downhill road of life. I should'nt care for an old wife – and a young would'nt care for me – or if she did, I should be always pitying her, and wondering what she would do with me when I got quite old.

Besides, though I'm out of heart just now, I fancy I've got some plans in my head rather too rough for a wife to help me in carrying out: and freedom is a grand thing – though a gloomy one.

It is at present wonderfully like the black slates of the Buet[3] – endless mud flaked with soppy snow. Still – one can go where one likes – on, or in it – as long as the knees carry one.

I'm so glad to hear of Peter – and of his approval of the politics of Dogs. It sounds absurd enough – but is'nt it true? We had lecture on geology the other day at the Work College and the lecturer told us that all theological opinions depended on stratification and the nature of the soil. High church sentiments were developed on oolite and primary limestones – clay lands had a tendency to produce dissent, presbyterianism is owing to the moral influence of whinstone; pliocene beds are episcopalian. I think there's a deal of truth in it. How polite the Bishop of Exeter is by the way to Dr Temple. These essayists have joined in the popular refrain of "Polly put the Kettle on" to some purpose, but I think we might have more cream with our Tea.[4]

Did you get a letter I wrote to you before you left town.[5] I forget what was in it but something I wanted to say. I've nothing more to say at present, that I know of. A nice letter from Mrs Browning arrives to day, I'll send it you if you would like to see it – as it speaks pleasantly of Italy, and kindly of me, and is nice too about her little boy.[6] (I'm thinking of learning to write some day soon, by the way.)

I was over at Carlyles the other night, meeting Froude there, and we agreed about things in general. C. said that Humboldt was no better than the pump in the Canongate with swelled leaden cheeks and a brass pipe in its mouth.[7] This mightily pleased me who always considered Kosmos the impudentest thing ever yet done by dull human brass.

All our kind regards to you & Sir Walter. My mother sends so many thanks. She was mightily pleased.

Ever affectionately Yours JR

¹ A reference to Mrs Browning at the end of the letter supplies the date.

² 'She walked from the drawing-room to the dining-room, leaning upon a chair which moved easily on castors as she pushed it before her.' *Memorials*, i, p. 252)

³ The Buet as described in *Modern Painters* iv was a 'waste of mountain ground . . . breaking continually into the black banks of shattered slate, all glistening and sodden with slow tricklings of clogged incapable streams' (R, 6, p. 159).

⁴ Dr Frederick Temple, in 1860 headmaster of Rugby School (later Archbishop of Canterbury), was a liberal educational reformer. After the recent publication of his paper 'The Education of the World' in *Essays & Reviews*, though in itself it was unexceptional, he was heavily attacked for refusing to disassociate himself from the other contributors (these included Dr Jowett and Mark Pattison), of whom two in particular denied certain doctrines of Anglican faith. However, Dr Henry Philpotts, Bishop of Exeter, a notorious High Church disciplinarian, was known to have raised no strong objection. The refrain of the eighteenth-century nursery rhyme 'Polly put the kettle on, we'll all have tea' implied a general willingness to countenance each other's views (even those bordering on the heretical).

⁵ Lady Trevelyan had been at Cowley with her sister and had now gone to the country to stay with the Ashburtons.

⁶ On 25 November Ruskin thanked Mrs Browning for her letter, which had reached him two days previously. He spoke of his and his mother's pleasure in having news of Pen, the Brownings' child (R, 36, p. 351).

⁷ Carlyle voted Humboldt a windbag. The pump is unidentified, though there were a number of well-heads in the Canongate until 1860 and two still remain, though neither retains any indication of decoration. Carlyle may have been thinking of St Margaret's Well, moved to Holyrood Park in 1856 (a mile distant from the Canongate), where the water was said probably to have issued from the mouth of 'a grotesque figure at the top of the central pier, but now it flows from a pipe fixed in a gargoyle's mouth'. J. A. Froude, the historian, was the friend and biographer of Carlyle.

117

1st January, [18]61

Dear lady Trevelyan

This is the first letter I write this year, – to thank you and Sir Walter for yours; & wish you many & many happy years – But I must send this round by Wallington for there is no address on either of your notes.¹ My mother scolds me for not having thanked you in her name for the parcel, which contained, she says, most beautiful things and leaves her five shillings in your debt, which I will be answerable for.

I am truly obliged to Sir Walter for enquiries about Nomenclatur and will cross-examine & further put to the Torture, Professor Owen,

who misled me.[2] I will call on Miss Swinburne to day; I am very sorry for her.[3] It was very naughty of you carrying off that frightful photograph with hanging lip. I won't scold Jeffreys however.[4] I cannot think what it is that has made me so very ugly; I suppose that the kind of instincts which enjoy colour & form are wholly sensual, and have the same effect on the features as mere love of eating or any other passion: –

– then I never have had any of my kindly feelings developed – (my best friends taking delight in Tormenting me – like some people I could name.) – and so they – the pretty feelings – have got all crushed into a shapeless – wide, comfortless, useless philanthropy which will not show in the face; – but the Savagery which you rightly say Richmond has left out[5] – though it is savagely against evil, is just as ugly as if it were savagery against good. The total want of wit and imagination lowers the forehead: there must however somewhere be evidence of some mathematical power; (for no one of my standing in my college knew his geometry as I did) but I don't know where it is; finally the irregular work of my life & its impulsive character have taken away what firmness there might have been in the mouth; and disappointment of all kinds – & dyspepsia – have destroyed any gleam of cheerfulness or colour that might have redeemed the shapelesness.

After all it is no wonder the photograph tells such a story. Am I better: No; I'm not better I'm in the profoundest sense of the words, "don't know what to do with myself". I hate the sight of everything I have done; and don't know what to do next. The only things I perceive any use in, are little sketches of towers that are fallen – & pictures that are soon to fade. I *think* I shall settle into a quite silent, slow, resolute, melancholy copyist of Turner & Veronese; etching and engraving as well as I can, but my work is so immeasurably feeble compared to what I want it to be, that, as yet, it makes me very miserable. If I can get to do it as indifferently & emotionlessly as a clerk copies a letter, as well as I can, caring nothing what comes of it – but doing it as a daily dead necessity, I may manage to do something useful; & though it will not make me happy, it will not make me wretched. But at present I feel almost too tired to work at all. I've done an eyebrow this morning – (Lady C. Grosvenor's, – from Monro's profile[6] – Eyebrow very nice – cheek a little blank & large –) – and feel tired by that, but nevertheless

Ever affectionately Yours J Ruskin

[1] On about the last day of 1860 a small fire broke out at Gambart's German Gallery in New Bond Street. Holman Hunt's painting *The Finding of the Saviour in the Temple*, exhibited there since the summer, seemed in some danger. Showing courage and resource a lady snatched an Indian shawl from her shoulders and threw it to a bystander who was thus able to smother the flames. When the fire was extinguished the unknown lady who had displayed such presence of mind was sought but she had left the Gallery immediately, and never came forward to claim any reward. When Holman Hunt came to publish his work on *Pre-Raphaelitism* in 1905, he noted that it was not until many years after the event that he learned that it was to the wife of Sir Walter Trevelyan that he owed a debt of thanks for the preservation of the picture. Another source gave the lady's name as 'Lady Seaton' (*Man of Two Worlds*, ed. D. Hudson, 1972, p. 92). There is plenty of room here for speculation, and no positive proof. The Trevelyans had left London for Seaton on 18 December, and there remained, so far as Sir Walter's diary records, for a month. It is possible, though unlikely, that Lady Trevelyan travelled to London at the end of the year without her husband, or that they came together and that Sir Walter omitted to chronicle the fact. It is also possible that Lady Seaton, wife of Field-Marshal Lord Seaton, herself the daughter of a clergyman as was Lady Trevelyan, had gone to the German Gallery that day to see Hunt's biblical picture. Holman Hunt was notably unreliable when in very old age he wrote his Pre-Raphaelite work. It seems also unlikely that Ruskin, writing to Lady Trevelyan on this New Year's Day, was unaware that she had been in London a day or two previously, unless the 'notes' referred to at the beginning of this letter gave him this information.

[2] This may be related to a reference in *Modern Painters* v to nomenclature in botany. Professor (Sir) Richard Owen, the distinguished naturalist, was Superintendent of the Natural History collections at the British Museum at the time. Ruskin had an opportunity for further investigation, for 'of all this long winter in London [he wrote to the Professor] there will remain few things to me so pleasant to remember as the walk in the park; the pleasant dinner . . .' and the examination together of fossils (R, 36, p. 363).

[3] Sir John Swinburne had died in September 1860.

[4] In about 1856 Jeffreys, a one-time pupil and later assistant art-teacher at the Working Men's College, had taken the photograph which Lady Trevelyan carried off with her after dining at Denmark Hill, and which is still preserved at Wallington. The 'hanging lip' had been occasioned by a bite from Lion the Newfoundland dog when Ruskin, at the age of five, had bent down to pat him while he was having his dinner.

[5] George Richmond executed three graceful portraits of Ruskin of which two, both made in about 1857, were chalk drawings of the head only (repr. R, 16, frontispiece; R, 36, pl. C). It was probably to one of these two that Ruskin was referring. At about this time W. M. Rossetti set down his impression of Ruskin as 'exceedingly thin . . . with a clear, bright complexion, very thick yellow hair . . . His nose was acute and prominent, his eyes blue and limpid, the impression of his face singularly keen' (*Some Reminiscences*, W. M. Rossetti, 1906, i, p. 177).

[6] A marble medallion executed by Alexander Munro. Exhibited at the Royal Academy, 1853, No 1460. Her husband was created first Duke of Westminster in 1874.

From JJR Denmark Hill
 27 March 1861

Dear Lady Trevelyan

Mrs Ruskin has received your kind Letter, the Six Collars which please her very much. They are so handsome that she is sure they must have cost more than the money sent 30/- & she hopes to remember this when you come to Town.

We thank you for your good wishes. Mrs Ruskin has by help of a self adjusting Chair got carried down Stairs for a month past remaining a few hours.[1] Her first Reception by Azlaeas in full dress seemed her first delight: it has been a weary time to us; yet has she never murmured. She has at present an access of Pain in the Limbs we suppose from Rheumatism.

John is in Cheshire since 18th March – I suppose endeavouring to compensate to his Mother who is at times uneasy at his frequent visits to Carlyle, by performing the part of Chaplain at Miss Bell's Winnington Hall in getting 30 or 40 young Ladies & Children through their Bible Lessons.[2]

Before he left home, he began emptying his cases of Turners & slightly pillaging the walls carrying off my property without scruple or remorse to present to his College & he has an equally felonious design on some Turners just bought, in favour of Cambridge.[3] Seriously however I am not sorry for this – I had indeed told him that his costly decorated Walls & large accumulation of undivided Luxury did not accord with his Doctrines. I am now paying for my Speech.

Our summer Prospects are far from bright but Lady Herbert Edwardes came & stayed with me all last week saying with a tender regard to Mrs Ruskin's quiet that she will go directly if I asked any body. Her Husband, a very Bayard, spent Sunday here & he is now at Eastbourne writing the Life of Sir Henry Laurence – a most delightful Book I can pronounce it to be before finished or reviewed.[4]

I owe Dr Brown much for his 2nd volume. I know nothing better than the child's answer to *Who made you* & the dry old Ladys *Less pith & mair to the purpose my man.*[5]

Mrs Ruskin joins in Kindest Regards to you & Sir Walter Trevelyan.

I am Dear Lady Trevelyan

Yrs very truly John James Ruskin

165

I expect my Son home about 6th April unless he goes into Wales. Dr Brown is strong in dedication to Man & Beast Peter & John & Chancellor.[6]

[1] The chair cost £21 (Bembridge).

[2] Both parents feared Carlyle's influence on Ruskin's religious and social thought and when G. P. Boyce, the water-colour painter, dined at Denmark Hill earlier in the year he noted that Ruskin's 'notion of things seems to be approximating to Carlyle's . . . Ruskin père didn't seem to like the direction of the conversation and broke it off.' (JJR had also given them sherry 'out of the same cask that Nelson drew his from before the Battle of Trafalgar. It was very strong.') (*Boyce Diaries*, p. 38)

[3] Ruskin sent forty-eight of his Turner water-colours to the Ashmolean Museum (Taylorian) on 12 March, and in May he made a further gift of twenty-five water-colours to the Fitzwilliam Museum, Cambridge.

[4] Lady Edwardes, stepdaughter of Dr Grant, JJR's physician, arrived at Denmark Hill on 20 March; Sir Herbert joined her on the 23rd and they left together on the 25th. Ruskin sent 'Love to Lady Edwardes' from Winnington. Her husband, the soldier-administrator, had gone to India as a cadet in 1841 and retired in 1865 as Major-General. At present he was midway through his three years' leave but returned to India the next year, where his career had already embraced civil as well as military appointments. He had been assistant to Sir Henry Lawrence at Lahore and the Indian Mutiny found him Commissioner at the Peshawar frontier. His life of Lawrence was completed by Herman Merival after his death in 1868 and was published in 1872. When Ruskin wrote *A Knight's Faith* in 1885, he incorporated into his study of Sir Herbert Edwardes much of Edwardes's own book, *A Year on the Punjab Frontier 1848-9*. In 1887 Ruskin presented 'The Edwardes Ruby' to the Natural History Museum in memory of the man he admired.

[5] 'Rab and His Friends', an essay by Dr Brown, had been included in the first of *Horae Subsecivas* (1858) and was reissued in 1861 under its own title. The two quotations are from other essays in the book, 'Marjorie Fleming' and 'Letter to John Cairns, D.D.' respectively.

[6] Ruskin was home on 8 April; there had been no visit to Wales but he had stayed with Lord and Lady Palmerston at Broadlands at the invitation of his friends the Hon. William and Mrs Cowper. Cowper was a son of Lady Palmerston and acted as her husband's secretary. 'Our Dogs', one of the essays in *Rab and His Friends* was dedicated 'To Sir Walter and Lady Trevelyan's glum and faithful "PETER", with much regard.' The volume itself carries a dedication to Thackeray, Dick, Gladstone (then Chancellor of the Exchequer), and John Ruskin.

119

From JJR Denmark Hill 4 July 1861

Dear Lady Trevelyan

Mrs Ruskin had very great pleasure in receiving your kind Letter

of 26 June with a quantity of Lace which always appears to exceed expectations – In Beauty too all the last arrived is remarkable & to you not to us the thanks are due.

I was greatly pleased with my hour at your Bazaar, I scarcely remember having been at one before having a sort of vague notion always in my head that a Bazaar was a place where you went with a Shilling & came home with Sixpence but Mrs Ruskin by coming to you seems to have benefited herself as much as she can have benefited others.[1]

Her recovery is very very slow. She gets a drive with Inconvenience & pain & she dare not attempt Tunbridge Wells. Having to leave the House for a fortnight I believe we shall only get to Queens Hotel Norwood a three to four mile change of Air.[2] John writes to me daily in a much more healthy tone. I think Cold & Langour & exhaustion are nearly gone & his mutterings are less churlish.

He is only on the French coast & I cannot persuade him to go farther away.[3]

Mrs. Ruskin unites in Kindest Regards to you & Sir Walter
I am Dear Lady Trevelyan
Yrs sincerely

John James Ruskin

[1] A bazaar was held for three days at the South Kensington Museum. On 14 June Sir Walter helped his wife array her stall, having energy enough left to see Fechter as Hamlet at the Princess's Theatre in the evening. On Saturday 15 June, the day of the opening, the Trevelyans were in position at 10.15 a.m. 'The Royal children came, Princess Alice bought Pauline's lace collar.' At noon the bazaar opened to the public. On the 18th Sir Walter found himself 'so gouty' that he did not go again; Lady Trevelyan was not home till the evening. She reported few sales that day except by raffle. The whole enterprise had been a shade costly for Sir Walter. He had spent £3 1s 6d at the bazaar; 15s 6d on 'cabs for Do.'; and 'Gown given to P, £1.11s.10½d', probably to wear when presiding at her lace stall. JJR had gone to the bazaar with instructions from his wife to buy lace; as the Trevelyans left London on 21 June, the order must have been dispatched from Wallington. His account book records £5 spent on lace. (In 1861 alone he gave over £1,000 in charity and gifts.)

[2] The Queens Hotel still commands an enviable position on a high ridge between Beulah Hill and the Crystal Palace with wide views of wooded country. Newly built in the Ruskins' day to accommodate visitors to the Crystal Palace, it has now been reconstructed, a servants' staircase alone surviving to give some indication of the loftiness of the original building. The house at Denmark Hill was having a spring cleaning and the servants their holiday.

[3] In the middle of June, still suffering from nervous depression, Ruskin chose

167

Boulogne for seven weeks' rest. He went mackerel fishing and saw 'the fish glitter and choke, and the sea foam by night', 'the whole sea phosphorescent in its foam, the boat running gunwale under, and currents of blue fire floating continually over the lower side of the deck' (R, 35, p. 534). He studied the formation of shells and walked on the sands and made friends with the fishermen and their children. Towards the end of July he received an invitation from the La Touche family to join them in Ireland in August.

120

From JJR

Denmark Hill
31 July 1861

Dear Lady Trevelyan

An hour ago there has arrived a Haunch of Venison perfectly beautiful to look upon for which I see we are indebted to Sir Walter's Kindness so many times shown to us. Mrs Ruskin joins me in returning best thanks. Our visitors at present are few & far between but we see a way of furnishing from this magnificent present a grand Repast to more than ourselves & still having our own Tables graced with an unwonted dish more than once – the remembrance of your Kindness coming but not departing with it.

My Son continues at Boulogne hesitating whether to direct his steps to Ireland or to Switzerland. His cold is gone & his health I hope returned but he has been saddened by the death of Mrs Browning. I could not take the liberty of asking you to write to him but I was wishing for him some such alleviation of sorrow as the possession of Letters from you. He is touched also by the Death of Mrs Wells a very gifted person & his dear American friend Norton writes in great distress of the Death of Mrs Longfellow.[1]

Mrs Ruskin & myself after some waiting, have got most pleasant apartments at the Queens Hotel Norwood.[2] Three & a half miles being the extent of our 1861 Summer Tour. Mrs H. Kemble Mr Hy Melvills Sister – resident near us has without being disabled by Broken Bones, been quite satisfied with the same Tour.

My Son complains of cold & boisterous Weather. Here the constant Westerly Winds are most agreeable though high.

Mrs Ruskin joins in Kindest Regards to Sir Wr Trevelyan & you

I am Dear Lady Trevelyan

Yours very truly

John James Ruskin

[1] Mrs Browning had died in Florence on 29 June, but 'one must not think of oneself when talking to her, it is all the Earth's loss', and later Ruskin wrote to Browning of 'the grave, enduring bitterness and completeness of regret – not the acute, consolable suffering of a little time, but the established sense of unredeemable, unparalleled loss, which will not pass away' (R, 36, p. 392). Joanna, wife of H. T. Wells R.A. and sister of G. P. Boyce, had died on 15 July soon after childbirth. An accomplished artist, she had exhibited at the Royal Academy. It seemed to D. G. Rossetti that there was 'no conjecturing what this wonderfully gifted woman would not have reached in her art, & in private life her greatness of goodness was no less rare' (letter to James Leathart). Ruskin 'counted upon her as a friend whom I could *make*, if only I had time'. Longfellow's second wife had died on 10 July.

[2] Within living memory apartments were still available at the hotel, in a separate wing. The Ruskins may have preferred those on the ground floor on account of Mrs Ruskin's disability. It is still possible to gauge the proportion of the rooms and the spectacular views from the windows.

121

From JJR

Queens Hotel, Norwood
23 Aug 1861

Dear Lady Trevelyan

I have the great pleasure of your letter of 10th Augt & in answer to your kind enquiries I think I may say Mrs Ruskin is the better of this *Mountain* Air but she cannot yet walk across the Room. My son paid us rather an unexpected visit of ten days – not entring London till he was about to leave us – He spent one Evening at Chelsea with Carlyle & Froude & is now at Llangollen[1] on his way (somewhat circuitous) to Harristown Ireland where he has been coaxed to go by Rose Latouche a spiritual little Creature of thirteen – I believe she figures with her sister Emily in last week's punch[2] – I will not answer however for his yet finding his way there as he seems a little in the Hamlet mood. His native hue of resolution is sicklied oe'r with the pale cast of Thought.[3] He is much better nevertheless of his sojurn at Boulogne with Pilots Mussels & Fisherman's Children – Salt water Rowing & Sea side walking. He will go (DV) from Ireland direct to Switzerland.

About Pine Cream unfortunately for our Cook's Reputation – the Creams Jellies & at times the Soups are the exception to the article made at home, a very Sensible Man Cook by name Self in Camberwell has for 36 years made Creams for us & I asked him yesterday if

it were not depriving him of part of his stock in Trade for the Recipe. He said there was no secret in it. He always uses English, never Foreign grown Pines & *preserves* because there is more flavour got from the preserves & the best Cream – (we give him Cream but not always).[4]

Sir Walter's success with the Short Horn Bull is very interesting but seems only a part of the success which attends on most of his undertakings.[5]

I have read no obituary that has lately affected me more than your Letter containing Peter's Death[6] – during the last drive I had with John only last week our Conversation fell on the short Lives of Dogs proving one of the minor Trials of Life. This has been felt even at Denmark Hill where Dogs have never been admitted to any degree of Intimacy – much more their loss must be felt where they are more kindly cherished but John says he will not keep another, so much has he felt the Loss of one or two now gone.

You mention the perfection of the Flowers. They are quite a Glory this year or else Science & the growing Love for them among all classes are every year drawing forth more Colour. Walking through Hydepark from Piccadilly to Oxford Street is quite equal to Paris.

I did not get to private view but I went in to the Exh. Rooms Pallmall to see your Pictures which show power & knowledge & thought. I do not in all respect enjoy them but I found the longer they were looked at the more they pleased.[7]

A Letter this morning from John's best american friend Charles Eliot Norton (perused by permission), a Federalist, says "the defeat we met with we not only deserved but needed.[8] It has made our final success more sure. It is a war between the two principles of Liberty & Slavery & they are resolved that Liberty shall triumph. It is likely soon to become a war of Emancipation in some form. The Slave holding forces success the other day will be the point from which the freedom of Virginia will take its date. &c &c Too long continued prosperity has weakened our Moral sense & dulled our perception. We are gaining through trial clearer view of right & wrong & higher principles of action &c &c signed Chas Eliot Norton."
Mrs Ruskin joins in Kind Regards to you & Sir Wr Trevelyan
I am, Dear Lady Trevelyan
 Yours very truly
 John James Ruskin
Your enclosure went directly to John at Llangollen

[1] The Welsh mountains he found 'duller than the sea', and the 'moorland hills' made him 'melancholy, utterly'. To Carlyle he confided by letter that the heaviest depression he had ever gone through was upon him, 'the greatest questions about God and man have come on me in forms so strange and frightful' (R, 36, p. 382).

[2] The *Punch* issue of 17 August carried a cartoon of a group of people playing croquet. In the centre foreground a pretty girl is knocking a ball with her mallet while flirting with a handsome young man; a second girl looks on. The caption beneath indicates that, quite fortuitously, the girls' names were Rose and Emily.

[3] *Hamlet*, III, i.

[4] George Self, confectioner, lived at Camberwell Green. In their seven acres of ground at Denmark Hill the Ruskins had a small farm, kept cows, made their own butter, and were able to supply Mr Self with cream.

[5] A herd bred by Sir Walter for which he took many prizes.

[6] 'July 1st. Good old boy Peter was chloroformed out of this life.' (TD)

[7] The eight large pictures by Bell Scott painted for the central hall at Wallington were exhibited during August at the French Gallery.

[8] The American Civil War had broken out earlier in the year.

122

Holyhead, 26th August [18]61

Dear lady Trevelyan

My Father sends me from Norwood your note to him, but not the enclosed one,[1] for me for which I write to thank you before getting it. I should have written to you long ago if I had had any thing cheerful to tell you about myself – or anything worse about things in general. I am as sulky as I was: – a little less viciously and more weakly & sorrowfully so. I read natural history and Greek grammar patiently, not caring for either, because one must do something, and gather molluses, and disgust myself.[2] Finding philanthropy unwholesome, I have given it up, as well as pastry, but am no better, or very little. I can't draw – at least perceive it to be of no use. – I have toothache all day long, and never expect to be any better. It is a wet day. Holyhead is not a lively place to sit in an Inn in – I believe people who care about such things would admire the coast, gorse and heather being in bloom together. I don't. My Turner's will all fade – I've demonstrated that they can't exist many years longer – so I don't care about them any more. I'm sitting thinking whether I've anything more to say – and find I hav'nt except that I'm sorry for Peter.[3] I've let myself be teazed into going to see some people in Ireland and suppose Ireland can't be much more than twice as ugly

as Anglesea – can it? – If it's only no worse than Northumberland I shall survive it and then I intended going to Switzerland – but I change every day – and don't in the least know what is going to become of me.

If you have anything spiteful or disagreeable that you particularly want to say, you may write, for a week – care of John La Touche Esq

<div style="text-align:center">

Harristown

Newbridge

Ireland

</div>

– afterwards, I fancy

 Interlachen

 Remember me to Sir Walter &

believe me affectionately Yours

<div style="text-align:center">

J Ruskin

</div>

You may as well see his as well to which mine is the answer[5]

I was going to send you only this but it's really too aggravating – Read the enclosed which I could not be troubled to write all over again – and then post it – it will only be a day or so later – It is to the best friend I have, among men as you will see. Mind you don't speak at Denmark Hill about the *boating*[4]

[1] But see Letter 123.

[2] He was also hoping for 'some rougher sailing' at Holyhead before crossing to Ireland. Although Mr and Mrs Ruskin were uneasily aware of their son's obsessive love for Rose, JJR was of the impression that his son's trouble was 'as much a want of purpose as want of Health' (*Letters to C. E. Norton*, 1905, i, p. 115).

[3] In a letter to Dr Brown Ruskin wrote of the dedication in *Our Dogs* (Letter 118) to 'poor dear old Sulky Peter, *momentum aere*' (*Letters to Dr John Brown*, 1907, p. 294).

[4] The 'enclosed' was his answer to Norton (for which see R, 36, pp. 379–82), in which Ruskin described how at Boulogne he 'learned to sail a French lugger and a good pilot at last left me alone on deck at the helm in mid Channel'. He knew what alarm this episode would cause his parents; similarly a few months later when writing from Lucerne he was obliged to reassure his father that there was 'no danger whatsoever in boating on this lake'.

[5] C. E. Norton's letter now about to be sent to Lady Trevelyan had already been partly quoted to her by JJR (Letter 121).

Holyhead Wednesday, 28th Aug [1861]

Dear lady Trevelyan

I have to day your illegible note – for which many thanks. I shall have nothing particular to do on board the Dublin steamer and I daresay in the course of the four hours passage, I may be able by diligence to make it out. It has been to Dolgelly, and as it always rains in Wales, the leaves of it are stuck together, of course – and it looks like a beautiful firm impression of the coal formation – It is not a bit the less legible than originally however, I can see that.

There's something about Peter in it. It is a comfort to think that in his best days he was deaf, and could'nt hear the organ.[1]

What an awful gossip you are getting to be. Why should'nt heads of colleges marry whom they like? Frances Strong will write Greek beautifully. But I'm glad she's done with her drawing.[2]

You don't suppose I know all these Doctors and people do you? I'm sorry for the Spofforths' – very.[3] Glad the Ashburtons are all right (babywise at least) I'm more interested about a little two year old baby – a pilot's, at Boulogne than I am usually in such animals but they think its going to have water in the brain and the father who had lost two before, all he had, cried so about it, (into the mackerel tub) that I hope it will live.[4]

I had a nice sail here yesterday but the sea is all green eddies like snakes, and long nasty swells coming round corners, and gusts down the cliffs – and yet no good waves to go over after all – so I'm going back to Boulogne – or Deal. There's more difference that I believed between French and English sailors – and besides its not of much use knowing names of things in French.

– I'll write again if I can make out more of the letter

Love to Sir Walter

Ever your affectionate

JR

[1] A hand organ in the central hall at Wallington.

[2] Lady Trevelyan had possibly referred to the disparity in temperament and age between the gloomy, silent, and elderly scholar, Mark Pattison, Rector of Lincoln, and Francis Strong (whose name Ruskin mis-spells), whom he married on 10 September as she neared her twenty-first birthday. By Ruskin's advice she had been studying at the South Kensington School of Art and would have met Lady Trevelyan there or at Oxford (her home was nearby) through the kindly

intervention of Dr Acland. Her artistic tastes, her high spirits, and not least her strong tractarian inclinations, made her a welcome friend to Lady Trevelyan. On a later visit to Wallington she successfully painted a cluster of sunflowers on one of the hall pilasters. Ruskin found her too self-willed for his taste; a year earlier he had reprimanded her in connexion with her studies. 'Nothing can be *starker* nonsense than the idea of practice being needed for invention. All practice destroys invention by substituting Habit for it' (R, 36, p. 333). (See *Lady Dilke*, B. Askwith, 1969, for a better acquaintance with Francis Pattison and her relations with Ruskin.)

[3] Mrs Spofforth, a friend of Lady Trevelyan, had suffered a miscarriage.

[4] Ruskin was fond of the Huret family and Paul, the little boy 'with eyes as black as two cherries', lived to become his godson. When the pilot died of cholera at Folkestone a few years later Ruskin assisted his widow financially.

124

Harristown, 4th September [18]61.

Dear lady Trevelyan

I have your kind note, and am grateful for it. I knew you would be vexed by my account of myself, but believed you would rather have that, than none. I will look at Aquinas – when I read next anything of the kind, but no book – however good, can do me much good. It is the course of (so called) "Christianity" in the world which I am watching and from which I reason.[1] My *health* is however now gaining steadily; the first start being given by boating at Boulogne and the second seeming likely to be given by *wading* here, and scrambling; for the "little Rosie" – mentioned in my letter to Norton, being half squirrel half water-ouzel, I have enough of both.[2] You would have liked the picture she made the day before yesterday, standing beside an old Irish piper ordering tunes of him – he nearly an ideal of road-side musician – worn & pale, but full of sweet sensitiveness – though sixty five: sadly ragged like all the Irish – (but not dirty;)[3] and very happy in pleasing the child; and she listening with intense seriousness – all the deeper for squirreline faculties at rest – the pure wild-rose-colour of the face braided with its auburn hair (clear gold in sun-shine) and a background to both of waterfall & wild dark rock – a piece of glen in the Wicklow Hills.[4] We have had a nice evening to night – papa and mama going out to dinner. I wouldn't go; so they left Rose and her sister (Rosie's just 14 & Emily – wiser somewhat, – shortened to Missy & transmuted complimentarily to Wisie – nearly 17) and schoolboy Percy at home for Holidays – 15 – to take care of me. Rose ordered dinner – and we had all the house to ourselves

174

with only the old butler to wait – we turned ourselves into lords and ladies – Lady Emily & I were very grand at head & foot of table – Percy & Rose for quatrefoil – then, plenty of music – a game or two of chess (Rose and Percy in council against me) – and a canto of Scott's Marmion. I've just come upstairs at eleven – sorrowfully: but in good humour enough to be goodnatured & write to you.

I am specially pleased at one thing – to find that standing for an hour in the strong current of a mountain river in September & pulling stones from the bottom with bare arms, does me entire good, and leaves no cold nor aches – but only springier limb & stronger arm than I have had for some year or two back.

Switzerland will perhaps be a little duller than usual after this kind of thing – I hope however to leave London for it towards the 16th or 18th – a line home, any day next week would find me.

I don't think I shall get into quite so sulky a fit again, for some time at least – but don't think that the change of thought & belief has anything to do with temper. The manner of expressing it may be. The change itself is steady and progressive. Rose can always preach me, if she takes it into her little golden head, back into second-volume *temper* – but not into second-volume convictions.[5] Love to Sir Walter

Ever affectionately Yours

J Ruskin

[1] Perhaps to strengthen a weakened faith, Lady Trevelyan had suggested that he read *Summa contra gentiles*, in which Thomas Aquinas argued that reason and faith, coming from the One source, need not be conflicting.

[2] To another friend Ruskin wrote of 'the grand wading in the Liffey'.

[3] Ruskin wrote to his father of the 'glare in the eye' being very peculiar in the Irish face; the dirt, 'ale-housy, nasty, ignoble', preoccupied him also.

[4] 'Rosie is very bright, bare-headed in her Irish sunshine [he wrote to Mrs Simon] purest wild-rose colour, with threads of gold – literally if one had to paint her hair it would have to be done as Perugino used – with real gold here and there' (Rylands). He wrote to his father of the trees in the park at Harristown, of the 'peeps of Wicklow hills in the gaps', though Winnington was prettier and 'Wallington grander'.

[5] The mood of the second volume of *Modern Painters* is one of seriousness and calm, but the theme was the theory of the spiritual quality of beauty.

Bonneville Savoy
10th October [18]61

Dear lady Trevelyan

I hope you got a little note I wrote to you one evening from Ireland, or you must be thinking me worse than I am; and that is saying a great deal. I got away here about a fortnight ago[1] – and have been breaking stones and otherewise servilely employed – as I best could – ever since. The weather has been lovely. The vines and apple trees loaded with black and ruby – the mountains all manner of colours; the sky soft and clear.[2] I am getting very thorough rest – and don't mean to get anything else if I can help it, – for a long time. If you have anything to say to me, a line would find me at poste restante Altdorf – Canton Uri:[3] I mean to stay there as far into the winter as I can in order to try the climate, with view to house in Switzerland.

Perhaps I shall get a little drawing done – but I'm lazy beyond expression. Not but that the long nights are wearisome enough, too.[4] I like sleeping in the day time better.

 Sincere regards to Sir Walter
 Ever affectionately Yours

 J Ruskin

[1] He had spent the night of 17 September with his parents at 'the Crystal Palace Inn' and had paused at Boulogne, Paris, and Geneva on the way, reaching Bonneville on 22 September and remaining there until 14 October.

[2] 'The vines yet luxurious in leaf [he wrote to JJR] and loaded with purple clusters . . . the apples, amber, white, and ruby, more beautiful almost than the blossom . . . the clouds dewy and broken in loveliest swathes and wreaths about the rock-crests' (R, 17, p. xliii). On this same day he wrote to a friend in England of 'the litter of fruits grown in luxuriant confused, profused, pig's trough manner. Bad grapes – bad apples, Bad pumkins . . . mixed up with Bluets, Popies, Nettles, Marsh reeds and Bulrushes – the whole burning and blooming about in a sort of devil's Eden, full of idiots.' (*Winnington*, p. 335)

[3] He did not go to Altdorf until the end of November, preferring to stay at Lucerne sketching out of doors in the sunshine.

[4] Soon he was to be 'sleepless with toothache', and to the Carlyles he wrote of the nights being 'sadly long'.

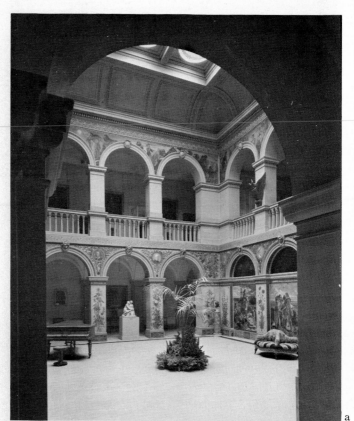

The central Hall at Wallington

Lady Trevelyan's poppies

Ruskin's unfinished pilaster

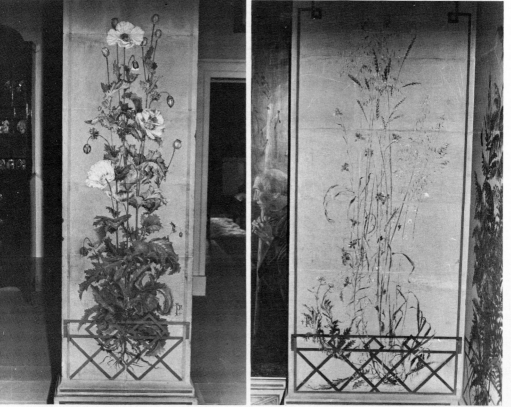

a

b

c

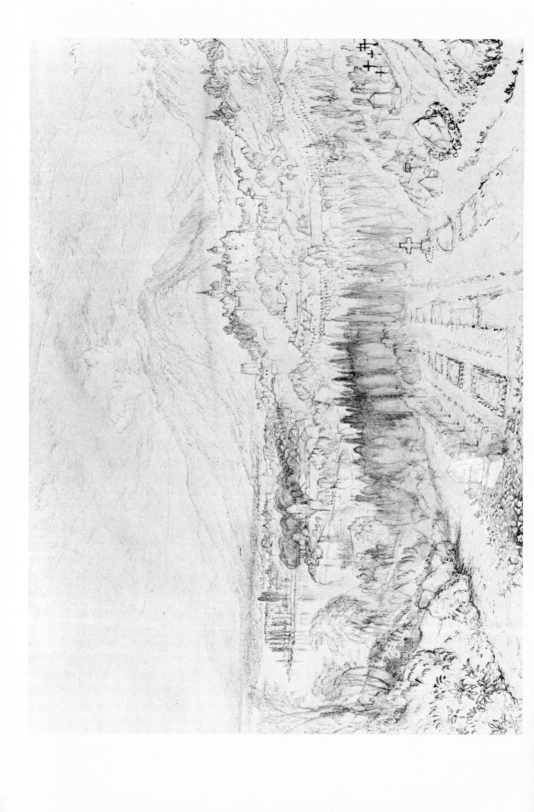

From JJR

Denmark Hill 2 Nov 1861

Dear Lady Trevelyan

When my Son left us 18 Septr for a second visit to the Continent he was apparently regretting the want of Letters from you. To my surprise & disappointment I find his last Letter from Lucerne expressing the same regret. He had written several letters I believe to Wallington & had not received one from you. Will you pardon the liberty of my bringing this subject before you. In the whole Circle of his Correspondents he would never perceive a blank equal to that created by the want of letters from you. I earnestly hope the silence is caused by absence & not by your being at all unwell.[1]

I wonder what Sir Walter Trevelyan in his good judgement expects to come of America. I think I sent you the substance or a sort of abridgement of Mr Norton's first Letter to my Son – an American of a higher grade & better tone of mind than can ever but very rarely be met with. I asked my Son to send you the entire Letters which are worth perusal.

I am sorry to say that Mrs Ruskin in nearly fifteen months from date of accident is only able to crawl across a Room with help of a Cane Chair. Frequent pain & little Sleep would have worn her to worse condition but for a good Constitution & contented disposition.

We unite in kind Regards to you & Sir Walter Trevelyan

I am Dear Lady Trevelyan

Yours very truly

John James Ruskin

a Letter this moment received leaves John very well & very happy studying Greek & Latin[2] with great Vigour & drawing so as to satisfy himself, on the Lake of Lucerne

Poste restante will find me for ever so long.

[1] Lady Trevelyan had been on the move, first to Co. Durham to pay a visit to Dr Howison who now practised at Darlington. She and Sir Walter had made an expedition to Croft and from there along the north bank of the Tees to 'Middleton-l-Row thence walked to Dinsdale, beautiful view of Tees'. From Darlington they had gone to Whitby and York, and by 6 November were back at Newcastle.

[2] Rose had agreed to follow Ruskin's suggestion and to study Greek. 'Writing out forms of G[reek] verb for Rose' (*Diaries*, 3 October, p. 553). This had given an impetus to Ruskin's own study.

Lucerne, 12th Nov. [1861]

Dear lady Trevelyan

I have your kind little note for which best thanks – What do you let your house be full of tiresome people for? I've turned every body out – am all the better for the change. There's a scratched bit of a letter on the other side of this, which was begun for Mr & Mrs Carlyle – but it was'nt nice, so I send it to you instead: – that it may'nt be lost[1] – but I could'nt write you any thing else just now for I come in tired with drawing or rowing. You had much better come to Lucerne – I never saw such a ruby sunset on Alps in my life as yesterday – and I never saw autumn before Fancy all the beechen groves – *tall* beeches – 80 – 100 ft high – in their now thin gold – with the sun shining intensely through them in multitudes – & backgrounds of purple mountain – dashed with filmy blue-greens of the indescribablest loveliness.

– I see what autumn was made for now,

– I could'nt make it out before a bit. Rosie says it's only peoples being hopeless that makes autumn wretched for them – It is enough to make one hopeful, to see what it can be – sometimes and in places meant for it.

I've promised Rosie she's to go & see you when you come to town next – mind you tell me when you're coming –

I don't mean to be in town ever any more – except when I'm forced – but she'll be there after the end of this month – if she don't kill herself with doing nothing first – for she's been ill, and the doctors say she must'nt do any thing.[2] I set her to cooking – and believe she's poisoned every body in the house with tough pastry by this time. How are your Irish lace people going on by the way. I think if you would set them to make decent clothes for each other – you would be wiser.

– Did I tell you I had seen poor Woodward's Dublin museum[3] – and that I thought it beautiful – and was very sorry I had'nt seen it before he went where the dead leaves go –

– it was very sad leaning over the parapet – and seeing all the leaves that would'nt die, all about.

I'm better than I was however. Grammar is very nice as see below

[in note 1] – but when I can't work I get miserable directly –
Love to Sir Walter
Ever your affectionate
J Ruskin

[1] 'Lucerne, 30th October, [18] 61. Dear Mr & Mrs Carlyle, The day before yesterday I wrote to my father an underlined charge to send me word forthwith how and where you both were. Today, he tells me of Mr Carlyles kind visit – and question why I do not write. Until the last week or two I have been in no heart to write – nothing seemed right and it was useless to tell you things were all wrong. I am now much better, by patience – quiet – fresh air – and Latin grammar –I find grammar the most soothing, at once, and exciting – of studies First – I never knew any; and the freshness of the idea of parts of speech is very grateful to me. Then one's pet words can't be spoiled – as one's pet pictures can be: there's no cruelty in cutting words to bits – as there is in so treating starfish or butterflies: one may hunt a word through all the kingdoms nations and languages until one is as wholesomely weary as in deerstalking, and a word at bay in the thickets of ages, is very grand in its own uncouth way. So I've been really for the first time in my life, learning a little Latin and Greek. I am painting a little every day, – and pleasing myself somewhat, and slowly, but I think steadily, recovering some peace of mind and health of body – which, I trust, will no more be risked, if regained, either by work or worry, but I see that I must give up all talking and writing – and live lambs life, if it may be – nothing but sucking and play – for years to come – not that I know well how to play, but hope to find out.' It was this letter, read by Lady Trevelyan and quoted to Dr Brown, which led Ruskin to observe in his letter to Brown of 3 December: 'You say you have heard from Lady Trevelyan – that I am busy and well. I suppose she knows. But I have been busier and better, and hope to be so again.' (R, 36, p. 396)

[2] Rose was subject to nervous complaints, but on this occasion Ruskin's parents were concerned lest her feelings for their son had precipitated an attack. Ruskin assured them that it had '*nothing* to do with any regard she may have for me'. He was probably aware of his parents' disquiet in regard to his relationship with Rose, whose own parents were also hardening in their opposition.

[3] Woodward, the architect of Trinity College Library (not Museum), Dublin, had died at Lyon in May.

128

From JJR
Denmark Hill [Thursday] 26 Decr 1861

My dear Lady Trevelyan
I should have sooner answered your very kind Letter from York of 5th Novr as you invited me to do but that the object of my late Letters was accomplished in your again being in correspondence with

my Son. When I found the Blank of his Existence occasioned by the want of your Letters was filled up I refrained from troubling you with any more Letters of mine.

I write however now to thank you most sincerely for your Letter of Xmas Eve enclosing another for my Son who will get it (D V) at Meurice's[1] at Paris on Saturday for I will not detain it even 48 hours for his arrival expected on Monday. I have sent him the Illustrated News with the picture of the young Frenchman spending his first Xmas away from his family. I doubt however if he is looking half so disconsolate.[2] He seems very well. In answer to your kind enquiries I can only say that Mrs Ruskin keeps up her health & spirits without any increase of power of motion. She keeps to her Chair or Bed – has much pain & little Sleep but looks as well as when going about without pain.

I wish I could send your last Letter so beautifully legible to one or two Lady Correspondents whose Letters I answer entirely by guess not being able to make out one word in five.

There is something almost sublime at the Nation's grief at the Loss of one virtuous man.[3] If his nation has shown us no love it may seem by our mourning over this Prince that we bear no resentment towards his country. This man's Life & Death may instruct Kings & Princes how they may by their own good conduct live in Safety & honour & die lamented.

I have not seen Capt [?Maurizz] letter but shall look for it – I have seen nothing on this disagreeable subject among the reams of paper covered with discussion, worth perusal except in Horsmuns [M.P.] speeches & the French State paper of Thouvenel.[4] There are two American Nations one composed of Gentlemen & another of the Mob. My Liking at present is entirely for the Gentlemen Slave owners.

You have had all the bad weather in the north. The autumn in the South has been lovely. John was tired of last winter's dark mornings & Evenings in London & this winter we have had the loveliest Sunrises & Sunsets I ever remember. In case John has not touched on the weather of Novr in Switzerland I enclose a little bit copied from one of his Letters to me.[5]

Mrs Ruskin joins in kind Regards to you & Sir Walter Trevelyan wishing you many happy years.

I am my dear Lady Trevelyan

Yrs very truly

John James Ruskin

A Book of Birds just come in from Mrs Blackburn,[6] what a singular or rather pre-Raphaelite gift this Talented Lady has in uglyfying everything. The staring Likeness of a Bird may be made as disagreeable as the staring Likeness of any Human Being.

[1] The hotel in the rue de Rivoli always patronised by Ruskin. He was not home until Tuesday 31 December.

[2] 'The First Christmas from Home' in the issue of 21 December illustrates an accompanying short story. It shows a young man seated in his lodgings wearing carpet slippers and gazing sadly into the fire while holding a letter from home which he has been reading over his solitary meal, the remains of which are seen under the subdued light of a gas lamp.

[3] The Prince Consort had died on 14 December.

[4] Edouard Antoine Thouvenal, French Minister for Foreign Affairs. Captain Maurizz is unidentified.

[5] 'Friday 22 November 1861. Dearest Father, it rained all yesterday steadily; all yesterday evening steadilier – at ten o'clock, when I said good night to the sky, as if the windows of Heaven had been opened: I woke at $\frac{1}{2}$ past five, the Stars were all like beacon-fires, so large, only more dazzling: presently up came the Moon over the ridge of peaks beyond the village where Tell was born. I couldn't think what was the matter with her – for I knew she ought to be crescent-shaped, and she came up in a long and broad bar of vague light, like a cloud; I thought I must be dreaming, for it could not be a halo, the stars were too clear: presently, as I was still in wonderment, – out flashed the point of her crescent – the vague light had been all from her dark side. And now, $\frac{1}{2}$ past nine, morning, there are no words for the radiance – all the high crests have new-fallen snow, but the rain has washed it all away from the russet meadows – I've seen much, – but nothing ever like this – the intense clearness, calm, and divine purity, – with the sadness of the red leaves. The Mountains look like the Gates of the City of God, – every several Gate was one pearl, and their foundations all of the Eleventh stone, Jacinth . . .' Ruskin has here adapted a passage from the Book of Revelations, XXI, vv 19-21: 'And the foundations of the wall of the city were garnished with all manner of precious stones. The first foundation was jasper . . . the eleventh a jacinth . . . And the twelve gates were twelve pearls; every several gate was of one pearl.'

[6] These large, carefully executed drawings were made from nature (so the author tells us in her Preface) and are therefore a more faithful rendering 'than the stuffed skin itself'. (*Birds Drawn from Nature*, Mrs Hugh Blackburn, Edinburgh 1862. JJR's must have been an advance copy.) 'The Common Heron' illustrated in Plate XXI, according to the note accompanying it, 'was caught alive during a hard frost in Stirlingshire, lived in a garret in the College of Glasgow where he fished with great success for small herrings in a foot-pail. He always stood on one leg on a chair without perceptible motion for at least an hour after meals.'

Paris, Saturday 28th Dec. [18] 61

Dear lady Trevelyan

Well you are very nice, to answer that horrid note of mine. This may perhaps be in time to thank you for yours & to wish Sir Walter & you a New Year just as you would like to have it, which will be good for others – they as well as yourselves.

(Such a straight – legible note as this of yours is, too! I read it down at the bottom of one of these Paris Wells, which I dropped into, tired, at ½ past five this morning, after seeing the sun set on Jura.[1] The early winter has been, they say, (in Alps) singularly beautiful; whether it has been singular I cannot say: but beautiful it has been beyond conception. Nothing that I ever saw in summer is comparable to the frosty days among the pines. Tuesday before Christmas day I was far up Pilate[2] – the entire mountain looking like one of these precious Benvenuto Cellini jewelleries in the Louvre – frosted Silver pines – purple shadows leagues long – and divine calm in the air. You wonder I stayed so long in Switzerland?

Well – even with all that you can generally allow for absurdities of mine – I suppose you can't fancy my having to stay there partly because I wanted a little too much to go home? At least – the little work that I'm now good for, goes on a good deal better by lake Lucerne than it would have done, if I had been within a walk of my little Wicklow blossom – What will she say to me now – that I'm half Heathen & half nothing, and can't talk about good things any more! However – I'll take care and not hurt her by letting her see why. Seriously – it is sorrowful work enough this, turning oneself upside down, like a cake on the hearth – when one is within seven years of fifty – Partly because it is worse confusion – and still more because it is hard to lose ones hopeful thoughts of death just when one is growing old.[3]

I'm not going to say anything for (if I live so long) seven or eight years at least – What a mercy, I hear you say. But if I *do* live – & get worse & worse – ? Such a dreadful book I could write, if I chose – – even now.

This is only to say I am on my way home & pretty well – & to thank you –
Ever your affectionate
J Ruskin

[1] Lady Trevelyan's note forwarded by JJR had reached its destination in time to catch Ruskin in Paris. His journey had been 'wretched with toothache . . . Arrive at 6' (*Diaries*, p. 559). Like most French hotels the Meurice was built round a court, the ground-floor rooms giving the impression of being at the bottom of a well.

[2] In his *Diaries* he called this a 'Day of Golden Pilate', and to Norton he wrote: 'All the pines of Pilate covered with hoar-frost – level golden sunbeams – purple shadows – and a mountain of virgin silver.' (R, 36, p. 403)

[3] On reading this passage Lady Trevelyan could have been left in no doubt of Ruskin's love for Rose.

130

[Early January 1862]

Dear lady Trevelyan

I did not answer your question about Americans.[1] I should like to beat them, if beating would do them good, & they had fair play, but they appear to me – the talking part of them, made of the bad sort of stuff which will neither beat nor melt into any shape – and which is simply best let alone – so long as one can keep clear of it. Of course in this business we have no choice – but it is to me just as if a dirty street boy had thrown mud at me – and it became necessary to thrash him, knowing that I should be all the dirtier and he all the more vicious, after the process.

I answer this question because all our English ideas about war and its legitimate causes are more like those of schoolboys than of men – and you should'nt encourage them in such.

I think all your heads are turned about the queen & her loss – Anything more disagreeable to the nation than that it should so much miss such a man, I never heard of – For the queen – I believe she will get on very well. There are some hundred-thousand widows who have been made by her german policy who miss their husbands more – I fancy.[2]

(Well, seriously, I think that lacemaking of yours *is* rather nice).

I never sent you those extracts – I only allowed the book to be made that I might know what to cancel if I ever publish any more editions – But I daresay I shall cancel the whole, only there may be a grain of sense here & there in what they've not "extracted".[3]

Ever affectionately Yours

JR.

183

¹ Ruskin took no interest in the American Civil War and mentioned it only with repugnance. He ascribed his ignorance to being 'too lazy to care anything about it'.

² He was referring to the Prince Consort's pro-Austrian sympathies in the Italian war of independence. Of Queen Victoria he had written to his father from Lucerne: 'The Queen by first accounts in paper, seems behaving well. Widowed Queens generally get on pretty well – if you look to history – it is odd how a woman seems to take to the notion of government.' (R, 36, p. 397)

³ The idea for the book of *Selections from the Writings of John Ruskin*, published the previous November, had originated with Ruskin's publishers, and it proved popular but Ruskin did not care for it greatly. 'It is a form of mince-pie which I have no fancy for,' he told his father. The selections were taken from *Seven Lamps of Architecture*, *Stones of Venice*, and from lectures and essays.

131

[Probably Monday 13 January 1862]¹

Dear lady Trevelyan

I have a dim recollection in reading your letter, of the sort of feeling that it used to be, to be ashamed of oneself,² in the days when one was – but its so long ago that perhaps I'm mistaken, after all, – because one used sometimes I suppose – to intend to do better, and I don't feel any particular symptoms of such intention just now. It is so comfortable always to feel that one can't do worse.

My Mother was in great contentment and gratitude about the lace – she says it was wholly pretty, and a great deal better than she wanted – and that if you'll send her anything you cant sell to any body else, it will always do, for her; – Also I shall be very glad to see Mr [Alfred] Trevelyan on Friday afternoon – thats what they call morning, in London – say two to four.

Mrs Carlyle is better. I'm going to see them both to night.

I don't know what I shall be about next spring, but I don't care about pretty places any more. They only make me sad – I've plenty to interest me here in my lawn – it's all over weeds; – and I'm getting as many as I can into the Orchard too, – but they're sulky about it this year. Somebody, – I forget who – was telling me I had spoiled them – they would be the better of some bad ground – I can't get over that bad habit of being kind & civil, even to the weeds – bless their little tiresome seedy hearts – and it does them no manner of good. But I don't care about pretty places – nor about big ones anymore – (not that I shall ever be able to endure Wallington – I

can't stand places so ostentatiously ugly as that – though I don't care for pretty ones as I used to do.)

– Well I'm glad you're better; so will the Carlyles be, mightily. Frederick is very fine, but too full of names;[3] my mother likes to hear bits read, but I've to put the names out of my mouth like fishbones, first, before I can get through a sentence – and skip not a little. After all one doesnt want *any* history, all through. One wants a few of the facts, & all the points, and a name, now and then, in a note.

Love to Sir Walter

<div style="text-align:center">Ever affectionately Yours JR</div>

[1] Mrs Carlyle had been very ill, but in a letter headed 'Sunday' (and dated 'about January 12th' on well argued grounds by the editor of *Winnington*, p. 344), Ruskin mentions her coming downstairs 'tomorrow' for the first time. In this present letter it will be seen that Ruskin was paying his visit to the Carlyles 'to night'.

[2] On receiving Ruskin's previous, ill-humoured, letter, Lady Trevelyan must have reprimanded him severely in her reply.

[3] The third volume of Carlyle's *Frederick the Great* was published early this year.

<div style="text-align:center">

132

[Probably April 1862][1]
</div>

Dear lady Trevelyan

Well, I wonder what you'll say next! I've been expecting you to write & amuse me, and forgiving you every day in the magnanimousest manner – thinking of course you were snowed up – & had got your fingers frozen[2] – and then you turn round upon me in this way, but its just like you – I've nothing to say – as I was – should have been worse – only I'm delighted to hear every body abusing the Exhibition building[3]

I'm being tried to be made a Catholic of, too, which is amusing.[4] A regular prescription of prayers, in the form of pills to be taken night & morning was sent me only yesterday.

– Yes – Rosie's here still[5] & getting horrid – wants one to keep two Sundays – her sister's quite bored with her – National gallery work not done yet – and no use when it is –

Weather smoky & cold – I hate the place – and don't know any place I like better – or worse – except perhaps some bits of Northumberland –

So no more at present from Your affectionate JR.

<div style="text-align:center">185</div>

[1] Dated on internal evidence, see notes 3 and 5.

[2] Lady Trevelyan had no doubt chided Ruskin for not writing, while he ascribed her silence to the effects of frostbite. The Trevelyans had come to London at the end of January and had dined at Denmark Hill on the 31st. Ruskin had shown them a number of Turner drawings, also sketches of his own made recently in Switzerland (TD). A few days later they met Ruskin at the National Gallery in company with Mr and Mrs La Touche and had been shown further Turner sketches. On 11 March they travelled north.

[3] The International Exhibition was to open on 1 May, though work was still being done until the hour of admission. Displaying two glass domes larger than that of St Peter's, there seemed to be no denying its monstrous appearance. The windows were said to be in the style of a Gothic Cathedral clerestory.

[4] In a letter to the Birds at Winnington of about this date Ruskin referred to a wish that he could be 'made a Roman Catholic of', on the grounds that Bellini, Orcagna and Fra Angelico 'were happier than I'm ever likely to be . . . in their old faith' (*Winnington*, p. 351).

[5] Rose La Touche had been in London since Christmas and remained until the latter half of April. There was a memorable occasion noted in *Diaries* (p. 560): 'Tea when they all three sat on the floor by me – her mother, Emily and she.' But he believed 'she is more harm than good'. In early April Ruskin took her and Mrs La Touche to the British Museum to hear a lecture by Dr Owen.

133

8th May [1862]

Dear lady Trevelyan

– I had no idea any human creature could be so horrid – leaving me all the while to be as dismal as its ones duty to be – and never saying a word to me. If you don't soon – I won't have it sent after me – I'm off on Thursday to Lucerne[1] –

There's Acland too has never come to see me once – and he comes to town continually for stupid Royal Society things – I'm sure there's no grace nor goodness left in people.

There's nobody but the La Touches who have any pity upon me – and they've been gone three weeks, nearly, & I've been fretting – So they thought what they could do for me – and they've offered me a pretty little cottage & garden & lawn – just between them and their village [at Harristown] – with a field walk past it, which Rosie passes by every day to her schoolchildren – Six miles off there are sufficient hills of *granite* – round & blue – and the country is rocky & full of Permian fossils – or older – perhaps – above the granite – and

there's a lovely brown mountain stream, which near the house is rowable upon – though full of stones – all the better. So I've accepted – & it will be a little rest for me to get away to when I want to be quiet and yet not quite alone – and I think its very nice of them – I don't mean they've given me the place – I shall rent it of them as long as I care to have it – and I'm going to have a nice little library & musical room fitted up while I'm in Switzerland – and I'm pleased – It will be too damp for me to stay long at – but the power of going whenever I please will be everything –

You're not to say anything about it however – for people will think it strange of me – and the L's know they'll have to bear with some disagreeable talk at first – but they're good & *will* bear it, to help me: only it need'nt begin yet.[2]

When once I've got over the worst of this despondent fit – I shall be able I doubt not to get on again well enough – but just now I needed some help. I shall see very little of them – only they'll be there if I've headache or toothache and can't work: – I may – it is even possible – learn to ride a little after a rural fashion[3] – which would be good for me – Meanwhile I'm off to the Alps with a little better heart, & a sense of rest that I have not had for many and many a year.

Love to Sir Walter
Ever affectionately Yours

J Ruskin

[1] Ruskin wrote to Norton at this time: 'I leave England for Switzerland; and whether I stay in Switzerland or elsewhere, to England I shall seldom return. I must find a home – or at least the Shadow of a Roof of my own, somewhere; certainly not here' (R, 36, p. 407). He left Folkestone on 15 May accompanied by Edward Burne Jones, the young artist, and his wife Georgiana. They were at Lucerne on 21 May, lingering there only a few days but sufficient to see Mont Pilate. Ruskin made his way slowly to Milan where he stayed until August.

[2] The offer had reached him the day before but owing to unfriendly gossip the invitation was not proceeded with. Writing to JJR in July, referring to his own reticence, Ruskin added: 'I often wish other people had been more reticent.' (R, 36, p. 410)

[3] In 1849 Ruskin wrote to his father: 'I never intend to mount a horse when I can help it – neither Effie nor anyone else shall ever make me.' As a child he had been given riding lessons but he had proved singularly inept; even a jog on a Shetland pony in the Norwood roads on a leading-string ended in disaster. His parents consoled themselves 'that my not being able to learn to ride was the sign of my being a singular genius'. (R, 35, p. 97)

Milan, 20th July [1862]

Dear lady Trevelyan

I have your nice rambling letter about everything – and answer
forthwith[1] – though I have nothing to say, for I do not know how I
am – nor what I am going to do, and I don't know anything about
anything.

You ask if I have been ill – I wish I knew. There are symptoms
about me which may be nothing or may be everything – but I am
better than I was, and when I can be quiet – it seems to me that some
strength is coming back – but the least bustle or worry puts me all
wrong again. I know my father is ill – but I cannot stay at home just
now, or should fall indubitably ill myself also, which would make
him worse. He has more pleasure if I am able to write him a cheerful
letter than generally when I'm there – for we disagree about all the
Universe, and it vexes him – and much more than vexes me. If he
loved me less – and believed in me more – we should get on – but
his whole life is bound up in me – and yet he thinks me a fool – that
is to say – he is mightily pleased if I write anything that has big words
and no sense in it – and would give half his fortune to make me a
member of parliament if he thought I would talk – provided only the
talk hurt nobody & was in all the papers.

This form of affection galls me like hot iron – and I am in a state
of subdued fury whenever I am at home which dries all the marrow
out of every bone in me. Then he hates all my friends – (except you)
– and I have had to keep them all out of the house – and have lost
all the best of Rossetti – and of his poor dead wife who was a creature
of ten thousand[2] – and such other – I must have a house of my own
somewhere. The Irish plan fell through in various – unspeakable –
somewhat sorrowful ways. – I've had a fine quarrel with Rosie ever
since – for not helping me enough.[3] Whom do you mean that my
father is glad I should be with – "if he thinks they do me good"?
Who does do me good in his present belief? I've had the Joneses
(you know them – do you not?) a good deal with me on this journey
– the hotel waiters much puzzled to make out whether *he* was my
son or Georgie my daughter. I really did'nt think I looked so old –
but nobody ever has thought she belonged to *me* –except the mate of
the Folkestone steamer – and that was only because I took care of her
when her husband could'nt. But they're very nice, both of them, and

he loves me very much. What a funny thing a mother is. She had left her baby at home in her sister's charge[4] – and she seemed to see everything through a mist of baby. I took them to see the best ravine in Mont Pilate – and nothing would serve her but her husband must draw her baby for her on the sand of the stream. I kept looking up massacres of the innocents, and anything else in that way that I could – to please her – He has made me some good sketches. I'm only doing St Catherine in water-colour – body white, thick, is very like fresco. The dress has come all very well – but I can't say as much for the face yet.[5]

Thanks for notice of Carlyle, lady Ashb[urton], Dr Brown &c – (Foolish letter of the Drs – that about exhibition.[6] He should write of nothing but dogs and [paper torn] and how to throw the one to the other)

By the way, have'nt you got a new dog yet? Peter used to write part of your letters for you I fancy – they've been a little stupider since he died. There are nice little ones about the streets here who take to the national institution of muzzle with the greatest spirit, and turn up their wired noses at unmuzzled dogs, like the American reporters.

Did you see the Times on the Church congress at Oxford – isn't it nice? I should like to see Henry Acland reading it, mightily.[7]

It is too hot to write any more to-day, the first really hot day we have had – though it has been blue and soft enough. It is no wonder Sir Walter has gout[8] – from what I hear of your weather in London. Come here. If you'll telegraph you're coming, I'll wait for you – there's no chance of my ever getting north of London – I hate cold – and moors – and nasty rivers all over green moss.

I'm getting quite fond of the Renaissance architecture, because it looks civilised & not like Northumberland. Come and see. Love to Sir Walter.

> Ever affectionately Yours
>
> J Ruskin

[1] The Trevelyans had been abroad during the summer and were now in town at 44 Drayton Grove, off the Old Brompton Road, between Thistle Grove and The Boltons.

[2] Elizabeth Siddal had married Rossetti in 1860; in February of this year she had died from an overdose of laudanum.

[3] To Mrs Simon Ruskin had written with regard to the house in Ireland: 'I've had an awful quarrel with Rose for not being more anxious about it and for

writing horrid prudent letters' (Rylands). But to Miss Bell he had been more explicit: 'Rosie's got too old to be made a pet of any more – her father & mother ... offered me a little cottage close to their park', but on further consideration 'they wrote saying it could not be – that their Irish neighbours would never understand it.' (*Winnington*, pp. 381–2)

⁴ Philip, the baby born to the Burne Joneses the previous October, had been left with his maternal grandparents in Manchester.

⁵ Burne Jones had spent some time in Venice making copies for Ruskin. Ruskin's own work was a whole-length copy of Luini's fresco of St Catherine (Monastero Maggiore, San Maurizio).

⁶ Dr Brown had presumably reported his views to Lady Trevelyan on a Scottish exhibition (see letter following note 2).

⁷ Held at the Sheldonian Theatre 8–10 July, presided over by Samuel Wilberforce, Bishop of Oxford, and attended by clergy and laymen. Its purpose was to discuss matters on which depended the work of the Church of England. Dr Acland read a paper on 'Hospital Work'.

⁸ Sir Walter was such a martyr to gout that once at Wallington he had had to climb the stairs on his knees.

135

From JJR

Queens Hotel Norwood
16 Aug 1862

Dear Lady Trevelyan

We have this afternoon had spread out before us the beautiful pieces of Lace sent to Mrs Ruskin who thanks you also for your kind Letters. To my liking these are the prettiest things yet to come in elegance of pattern & pure silvery effect. There must be some natural Refinement about the Cottages where these Laces are made: I had a project in my Head of getting some of this Lace in an appropriate [word omitted]. I hope to give to a Lady of Sixty originally Yorkshire but resident these forty years in France but Mrs Ruskin tells me that nothing so simple & so moderate in price would be appreciated in France.

We are much obliged by your mention of the Acland family & we value Dr Acland's kind intention of visiting us though he cannot realise it. You are good enough to enquire as to our Health. Mrs Ruskin was not injured by the fall but remains in some disabled State. I was getting a little better but my progress is arrested by our Son's change of plan. He got as far as Geneva from Milan on his way to pay some visits in Normandy & he will be with us on his Mother's

Birthday 2 Sepr but he has again over worked himself painting Frescoes & writing Political Economy & felt so unwell on reaching Geneva, that he has taken a House there for a month to rest himself & to try how he would like continued Residence there. He has intended having a house abroad for many a year but it has not the less taken us by surprise his stopping short now when we made sure of seeing him. His Man Allen at our Lodge is going to him[1] & he tells me his only wonder is, how he stood the pityless petting of London Artists male & female & Americans so long as he did.

Dr John Brown in place of coming to look at the Great Exhibition seems to be writing Criticism on Scotch Exhibitions: I do not feel as if his last little review & rejoinders were quite up to the Mark. He might have taken a Lesson from some other Criticism in same Paper on the French Pictures.[2]

To my regret I have only got once to this Fine Gallery of Pictures, though I aid the Funds by sending three four or five Foreigners very often from my House at Denmark Hill. I have told John that he makes an irreparable & Lifelong mistake in refraining from seeing this Inter Nl [National] Exhibition

Mrs Ruskin joins in kindest Regards to you & Sir Walter Trevelyan.

 I am
 Dear Lady Trevelyan
 Yours very truly
 John James Ruskin

I address my Son at present Hotel Des Bergues Geneva. I rather hurt his feelings by taking no interest in his Political Economy. It only hurts his Health & brings columns of abuse.

[1] JJR was being made ill with anxiety and disappointment by his son's behaviour. Ruskin had intended to be home at the beginning of September for his mother's birthday but an entry in *Diaries*, 7 August, signifies his change of plan: 'Geneva. An important day . . . Resolve to have some more Turners and if I live some of my own way at last. Stay here accordingly.' On the 11th and 12th he was 'looking for lodgings', and on the 16th, writing at Mornex, he was 'Established peacefully in my own parlour on the Salève slope'. On 22 August George Allen arrived bringing him letters from his mother. Ruskin was writing further papers on political economy for monthly publication, this time in *Fraser's Magazine* under the editorship of A. J. Froude. But, as with *Cornhill*, after four instalments (June, September, December, and April 1863) Froude was obliged to stop their publication. In 1872 the essays were reprinted as *Munera Pulveris*.

² This was a compliment intended for Lady Trevelyan, who had herself reviewed the French pictures in *The Scotsman*. Dr Brown received scant praise from JJR: 'Norwood, 5 Augt 1862 . . . I am extremely obliged by the Scotsman Critiques sent to me – I expected a graceful but hardly so Skilfull a Critic as Lady Trevelyan, who must surely be a practised writer for the public Eye – my Son indulges me with the sight of some of her Letters delightful always from their Touches of Naiveté & remarkable to me for their naturalness.'

136

Mornex, Savoy, 17th August [1862]

Dear lady Trevelyan

I do not know if you ever got a long letter I sent to your London (Brompton) address,¹ if not, it does not matter – there was nothing in it. I've lain down to take my rest at last, – having rented experimentally a month or two of house – preparatory to fastening down post and stake² – but except as I used to come abroad, I come home no more. For the present, I have a bit of garden, with espalier of vine, gourd – peach – fig – & convolvulus – shade of pine & sycamore – view over valley of Bonneville to the Savoy mountains – & Mont Blanc summit above me, like Malvern Hills, the rocky slopes of the Salève, in front, a dingle and rich wood of Spanish chestnut and pine, strewn with blocks of the tertiary glaciers – granite and gneiss, moss covered. I am within six miles of Geneva – (poste restante *there* the best address) the air is so soft that I can sit out all day, and as pure as 2000 ft above sea – and fair ground – (and no furnaces –) can make it – and if I don't get better here, it will be a shame – (but that's no reason why I should.). I've been out before breakfast weeding a little and looking at the convolvulus bells in the sunshine, & the morning clouds on the Mont du Reposoir – What a sad thing a *yesterday's* convolvulus bell is! When you pull it open. I feel *so* like one; and like a morning cloud – without the sunshine – yet better a little — even of a few days peace – but more still of the resolve to *have* peace, at any price – if it is to be had *on* any Mont du Reposoir – and not – only under the green little Mont du Reposoir, – or out of any "Saal" but that which is auf kurze Zeit geborgt – Der Glaubiger sind so viele.³ Have you ever looked at the second part of Faust? It is a perfect treasurehouse of strange knowledge & thought – inexhaustible – but it is too hard for me just now, I'm going dreamily back to my geology, and upside-down botany – and so on:

I'm very sorry for them at home as they will feel it at first – but no course was possible but this, whatever may come of it – I trust they will in the issue, be happier, they will, if things go right with me, and they won't see much less of me – only I shall be clearly there on visit – and master of my own house & ways here – which at only six years short of fifty – it is time to be.

The father has stood it very grandly, hitherto – I trust he will not break down. I could not go home. Every thing was failing me at once – brain – teeth – limbs – breath – and that definitely and rapidly – I painted a little at Milan, and would fain have gone on, but could not.

I'll write you soon again if I get better. love to Sir Walter

　　　Ever affectionately Yours

　　　　　J Ruskin

[1] See Letter 134, note 1.

[2] A few weeks later he rented a cottage as well, recently inhabited by the Empress Marie Alexandrovna of Russia, only a few hundred yards from the larger house where he worked during the day and breakfasted. He slept at the cottage and dressed on the balcony. Meanwhile he was searching for something permanent as a home.

[3] Ruskin is quoting from the burial scene of Goethe's *Faust*, II, v, implying that he preferred to find quiet this side of the grave while still alive, rather than after death. A month or two later he wrote to Miss Bell of the '*second* part of Faust – it is a treasure house of wisdom' (*Winnington*, p. 381).

137

From Lady Trevelyan

　　　　　　　　　Wallington

　　　　　　　　　21 August [1862]

Dear Mr Ruskin

　And have you really set up that dreadful house in Switzerland which I always used to hope would blow over? However it is no good even '*wishing*' for other people; everyone knows their own affairs best and I trust now you really are at peace you will get well, and I have such faith in your perverseness that I have no doubt when you don't live in England, and have nothing more to do with it, you'll begin to like the poor old country and think she was not so bad after all. And also that having satisfactorily got rid of all your friends, set up your hermitage, locked the door, & thrown the key down the

well, you will begin to think you like us, and that *we* are not so bad after all. That must be a delicious place you are in. I wish I could see your garden & the view & the convolvulus, though I know I've got as good convolvulus as you have.

I had a nice note yesterday from your Father, of course he is dreadfully disappointed at not seeing you, but if you get well, and seem cheerful, and come & see them pretty often, that will still be a great comfort to them, when they get over the great distress.

When you get tired of mountains and want somebody to quarrel with and abuse – you'll come and see me won't you? it would be a great relief to my mind to give you a hearty scolding, & I'm sure you'd be much the better of it. That's what you want.

Indeed it's very true I'm stupider a good deal since Peter died but I can't get another Peter. I have got a dog who is a great beauty – a thoroughbred Skye with lovely hair and a most amiable disposition, but he is a good gentle sort of dog, well behaved and not amusing. I want a quaint surly old fellow like Peter who takes his own views of things, and likes & dislikes people vigorously. Besides Peter was so like you.

Dr John Brown set up a new dog whom he named after Peter & fondly imagined he was like him – but he is just dead – poisoned as they think. Won't you have a dog in your house? I am sure it would be good for you. To be sure it will be dull for the dog, poor beast! but he might have an occasional holiday, and perhaps a treat of rats to hunt, and some rational person to speak to now & then.

Have you got Carlyle's 3d vol of Frederick? that's a refreshing book. Sir Walter is very well now, I am thankful to say – after a long fit of the gout, during which he would not do one single thing he ought to have done. However he got well, all the same, which isn't right – and so good bye. I hope you will write again *soon* & tell me how you are. With our kind love Ys affecly

P J Trevelyan

138

Mornex Dept. Haute Savoie France
26th Aug. [1862]

Dear lady Trevelyan

I have your nice letter.[1] This is only to say so – and to give you

address – You can't think how nice it is here – and how it softens one's heart to think with pity of the unfortunate creatures who have to live in England and see their raspberries blown off the bushes (how many, by the way, were ever on?) I really did'nt think I had so much compassion left in me –

The leaves here are just moving & no more – and I can just see the gleam of silver on the third summit of Mont Blanc, through them – and the grey morning sunshine; – and out of the other window a slope of rough limestone hillside (– some thing like an English down, I confess) – flat edged against the blue sky,

– I am a little better – and that is all – but it is something, in a fortnight, and I've good six or seven weeks of the warm days left yet – if the year is an average one – This house will not do for me – it is in a village – and there's no clear stream near – only a torrent in the valley, 400 feet below – and that in the molasse sandstone, which overlaps the Jura limestone just under the house – and the molasse streams are dirty. But the air here is exquisite, and I shall keep here till I find something to my mind.

Love to Sir Walter. Ever affectionately Yours

J Ruskin

¹ Which he then sent to his father with a covering note. 'Mornex, Tuesday 26th Aug 1862. I have a delightful letter from Lady Trevelyan which I have been answering. but only half – I will send it to you to morrow – and when you have read it and read it to Mama – please just put it in an envelope and address it to Mrs La Touche – (24, Norfolk St) – I've told her it is to come and that she's to send it back to you.' (Yale)

139

From Lady Trevelyan

Cowley Rectory Uxbridge
Oct 20 [1862]

My dear Mr Ruskin

You promised to write me a proper letter but you did not do it, of course, but please send me at least a few words to tell me how you are and whether you have got a different house yet? I hope, now the damp autumn days are coming, that you will get a nice dry healthy place, otherwise you might well be in England in all this rain & wind. There has been no summer here, & now winter is come. A few

fine autumn days are all we have had, so you may indulge to the full in the evil pleasure of knowing how much better off you are than me.

Sir Walter has been very unwell lately, and we have come south for him to see Doctors & get his Turkish Baths, which do him more good than anything. I wonder whether they would do you good? drive away the indigestion, and put Political economy out of your head. What a pity that the Aclands missed seeing you in Switzerland. Henry began a drawing four feet long – I think he said – and after the first day it rained all the rest of the time, & the poor drawing got no further. He was at Cambridge last week, looking very well.[1] I saw your Turners there, what beautiful ones some of them are – plenty of people to go and look at them, & they really take immense care of them. The School of art people there, who seem to consider themselves as part of your belongings, are getting on in a flourishing way and gaining medals. I can hear you say (from here) that you are sorry for it – or something equally perverse – however they [word illegible] you very much, and flatter themselves that you take a great interest in them.

Now do be good for once & write me a proper letter and tell me exactly how you are, and what you are doing with yourself in your hermitage, & when you are coming to England – it is so long since we heard of you & I am very anxious to know about you.

Sir Walter's love – Yours affecly

P J Trevelyan

[1] On their way south the Trevelyans had gone to Cambridge on 3 October and had spent a week there for the meeting of the British Association. They had stayed with Dr William Whewell at the Master's Lodge, Trinity College, where Ruskin had stayed in 1851, finding his host and (first) wife 'most kind, and delightfully easy to live with'. Lady Trevelyan had known him since girlhood and had commented on his *Inductive Sciences* (1837, 1849).

140

From JJR

Queens Hotel Norwood
22 Octr 1862

Dear Lady Trevelyan

I thank you very much for your kind Letter of yesterday & give you double thanks for the pleasure you enable me to convey to my

Son by your enclosure for him [previous letter] which was immediately dispatched to Mornex where he still is, a Geneva Doctor whom he much likes having persuaded him that the Air on the Salève & the climbing up into it are the best Remedies for weakness of either Head or Body.[1]

I was rather dismayed to hear of his busily searching for Houses & by no means sorry to find he has not yet suited himself though now in a Cottage not long since vacated by the Dowager Empress of Russia. It is a small well built House with a much better View than his first apartments had. He promises to be home about 10th or 12 Novr but only for two or three weeks which is nearly as bad as not coming at all. Our Xmas Holidays our Fogs & Darkness being equal abominations to him we have promised on our part not to ask him to prolong his stay, an hour beyond his own Wishes.

Our House at Denmark Hill has got workmen in it but we go home please God on Thursday week 30 October & either here before that or there after that day Mrs Ruskin would be delighted to see you.[2] She remains in the same state enduring frequent pain & unable to move but looking as if she could move & suffered no pain. I am much obliged by your & Sir Walter Trevelyan's enquiries. I am somewhat better & get to the City on fine days. We regret to hear of Sir Walter's complaints. These Turkish Baths are more & more spoken of for their unfailing efficacy.

Dr Brown sent us some very interesting Criticisms in the Scotsman which sent me a second time to the great Exhibition though I hurt myself by first visit I was moreover interested in No 74 French Gallery – "*A Young Girl embroidering*" – Mathilde Maison now the Baronne Mackau. To me a pleasing Portrait quiet & uneffected though Tom Taylor calls it Leathery & Teaboardy, not very elegant criticism of a young Lady. I parted with Scotsman Criticisms to send to John.[3]

With united kindest Regards to you and Sir Walter I am
 Dear Lady Trevelyan
 Yours very truly
 John James Ruskin

I am glad to see John quoted on page 290 of Replies to Essays & Reviews Modn Painters Vol 4 pp 83/89.[4] His political Economy is fearfully abused. I want him to keep it to himself till he makes out his case.

¹ Dr L. A. Gosse, his neighbour at Mornex. On 18 October Ruskin had had 'a long chat' with the Doctor, the result of which would have reached Denmark Hill by the date of this letter.

² The Trevelyans had come to London in the middle of the month and had spent three consecutive days at the International Exhibition.

³ JJR had visited the Exhibition on the 16th and 17th and made a note in his diary of Flandrin's *Young Girl Embroidering*, a portrait of Mathilde, lent by her father Comte Maison. It had a special significance for JJR as Diane, the eldest of the Domecq daughters, had married Comte Maison in 1836. Mathilde was married to a French politician, Baron Mackau, whose father had been Minister of Marine in the reign of Louis Philippe. Tom Taylor, at one time professor, barrister, dramatist, and later editor of *Punch*, was now art critic on *The Times*; there, as in *The Scotsman*, he criticised the picture unfavourably. JJR visited the Exhibition again the following week; this time he looked more closely at the British school and with magnanimity and good judgement pronounced 'Millais' Dove [*Return of the Dove to the Ark*] finer than Holman Hunt's Christ [in the Temple]'.

⁴ Two years after the uproar over the issue of *Essays and Reviews* (Letter 116, note 4), a volume was published, *Replies to 'Essays and Reviews'*, in which seven writers replied to the original essays. In his essay *The Creative Week*, the Rev. G. Rorison, incumbent of Peterhead in the diocese of Aberdeen, quoted (pp. 290–1) a passage from *Modern Painters* iv on the stages of creation in Genesis.

141

25th October [1862]

Dear lady Trevelyan

It's very nice of you to write to me, and though I'm sorry for Sir Walters rheumatism – it serves him right for not believing his Horace and being jolly:¹ and I shall be glad to have a glimpse of you in town. I am a little better, but not yet for much. I have two houses: breakfast and read in one – dine & sleep in another, having a noble view of Alps from my pillow on waking. To day I have been up 2000 ft – 2500 & odd – accurately), 4000 above sea – and all along the ridge of the Salève among golden moss and gentians – good five hours walk – so that I am pretty strong:² but have no life in me – hardly even any perversity – so I begin to think ill of myself. I'm getting a great deal too good for this world – and I don't see my way clear to any other. You'll have – by the time this letter reaches you – a nice pan of fat in the fire about Bishop Colenzo's book – and I've been worse than he, these three years.³

Thank you for telling me of Cambridge Turners. I feared they were neglecting them as I saw no single word of notice of them during

British Association. There are some beauties. The Storm at Venice – & Richmond with dog, one child;[4] I forget now what they were, my memory having failed lately. Yet I am learning Greek and Latin, slowly, & well, and as long as I can work – do well enough. I mean being at home by the 15th Nov & shall see you – shall not I? Acland's letter reached me at Milan two days too late to be answered before his day for leaving: but I should only have been a burden to him. The langour is however a little losing its hold on me: and if I could only find a house to my mind, it would amuse me to arrange things in it – but I have not yet been able: all the houses here abouts are on the molasse sandstone, which I have made a vow against – and I have not had energy to go to Annecy or look farther afield. Meantime I have room for my books & stones, and am content. the main healing thing to me is being able to look at the Mont du Reposoir, and think I have not got to leave it, but may look at it till I die.

My polit.econ. goes on too – slowly but nicely, and everything I am able to read is noted for future use in that – which if I live will become my main work.

I hope to get back here early in December, and begin some careful notes on Alpine geology of outward form. This can only be done well when there is fresh snow on the crag ledges. You'll have to learn that Polit.E. of mine at last so you had better make no more faces at it.

– Love to Sir Walter

Ever affectionately yours

J Ruskin

[1] The lines from Horace are unidentified but, taking the final paragraph of Lady Trevelyan's next letter (142) as a guide, one is emboldened to hope that they were from *Odes*, I, xxxvii, I: '*Nunc est bibendum* . . .' ('Now we must drink').

[2] 'Very busy and well,' he noted in his *Diaries*; and on the 27th: 'The best day I have had for years.' (p. 572)

[3] The Bishop of Natal's book, *The Pentateuch and the Book of Joshua Critically Examined*, Part I, was published on 29 October, but Ruskin had already seen passages copied out for him by Miss Bell, who was well acquainted with the Bishop and his family. The book, based on the argument that the Pentateuch was in part post-exile forgeries, caused a public outcry. Ruskin's own beliefs on doctrinal issues were not far behind the Bishop's. 'I stand with the Bishop and am at ease,' he wrote to a friend. In 1887 Ruskin presented the thirty-carat 'Colenso Diamond' to the British Museum in honour of the Bishop.

[4] *Venice, Storm at Sunset; Richmond, Yorkshire.*

From Lady Trevelyan to JJR

14 Michaels Place[1]
Brompton
Thursday morng. [30 October 1862]

Dear Mr Ruskin

I thank you very heartily for your great kindness in sending me the enclosed, it is a good account as far as it goes. I hope when he comes you will find him really better. I have got a nice letter from him this morning, with much the same account as yours really more cheerful & like himself than usual. I wish he had been going to pay his visit to you at a brighter time of year.

We were very sorry to miss you. I fancied Monday was a likely day to find you so I was disappointed but it was a pleasure to see Mrs Ruskin, & she said you were better than when last we met.[2]

I meant to have told you – what I wrote to John – that I found the Cambridge Turners well taken care of & constantly visited. We heard that while they were hung up people flocked to see them & now the man who had the care of them said he was showing them to parties of people continually. I really hope they are well bestowed.

Sir Walter is better – a good deal – since he has been here. I quite agree with you that he wd be better of more stimulants. His Doctors always tell him so – but he is obstinate, like the rest of your weak minded sex. With best love to dear Mrs Ruskin ys always very sincerely

P J Trevelyan

[1] Built in 1790 and running along what is now the south side of Brompton Road, Michael's Place extended from the top of Yeoman's Row to the junction of what was then Fulham Road (now the continuation of the Brompton Road). No.14 stood facing the carriage drive leading to Holy Trinity, Brompton. The letter is dated from internal evidence.

[2] The Trevelyans had paid their morning visit to the Queens Hotel on Monday 27 October.

Denmark Hill
14th Nov [1862]

Dear lady Trevelyan

I was in hopes you would have been in town. Between Somerset

St – and your coal hole – and Cavendish Sq. and Brompton – you are as difficult to catch as a trout.[1]

Can you coax people? or do anything else but be irritating and disagreeable? Because I am making up parcels for Savoy, and among the Turners which I want specially to work upon there (not, to my sorrow – all at Denmark Hill) is Miss Swinburne's Bonneville. Do you think *any* price could be made acceptable with her for it? Loan, even were she kind enough to think of it would not do. It is a principle with me now to avoid every form of anxiety great or small; if my own drawings were burned – there's an end of them – as there will be similarly – some day of me. But if any one else's were burned or spoiled in my hands, I should'nt like it. See therefore what you can do for me – in fair business.

How did you like Sir Alexr Hoods Turners – (once Sir *P.* Acland's – to their infinite damage.)?[2]

What a lark this jolly Bishop [Colenso] is! – What can the English church have done, that it should have the ill luck to get an honest man into it. They had all but kept him and his candle out of the [?Fraser's] Magazine – as it was. There will be a superb splash when the spars come down again[3] – I've been laughing all the way from Geneva, till my throat's sore –

Love to Sir Walter

Ever affectionately Yours

J Ruskin

[1] Ruskin had returned home on 12 November. The Trevelyans were to be found neither at Nettlecombe nor Wallington, nor at Holles Street near Cavendish Square, nor at Michael's Place, but at Felixstowe on the Suffolk coast where they had gone for a couple of weeks. Sir Walter had made the purchase of 'two woollen Vests' at 17s 6d as a precaution against the cold.

[2] See Letter 30, note 1. Sir Alexander Hood, Member of Parliament for West Somerset, was married to Sir Peregrine Acland's only daughter.

[3] Part II of the Bishop's book was to be published in January 1863.

144

[Before 21 November 1862][1]

Dear lady Trevelyan

Well – where will you be next? However I'm glad you're a little within reach, to redeem your character – for Mrs Carlyle was

saying all manner of civil things about you and how nice and how amiable you were and I don't know what nonsense besides, and I told her the truth of course – and that she ought to be ashamed of herself for not finding out how saucy and disagreeable you were – so please come and show true colours. – I can't bear people not to understand each other: You know its no use my showing Turners to Miss S [winburne] for she and I like the same things – I would only give Derwent water or some other drawing of middle time – and she would only take – if any – a late one – at least I fancy so[2] But I'm glad she's in town. Yes, Bp Cs book is'nt good for much – Would you like me to write something more Episcopal myself?

 Yours affectionately

<div align="center">JR</div>

[1] The Trevelyans returned to London on 21 November. They remained at 14 Hanover Street for a month, with expeditions to the Hilliards at Cowley. One evening at the end of the month Ruskin took Burne Jones to Cheyne Row to be introduced to the Carlyles. This was not a success, Carlyle caring nothing for painting. However the Trevelyans were there also and the evening passed agreeably. Carlyle described Lady Trevelyan as 'a kind of a wit, not unamiable, and with plenty of sense', while Sir Walter appeared to him a 'strangely silent placidly solemn old gentleman'.

[2] A reference to his last letter, in which Ruskin was anxious to secure Miss Swinburne's *Bonneville*; either she or Lady Trevelyan seems to have suggested an exchange. *Derwentwater* hung in the breakfast room at Denmark Hill. On 5 December when the Trevelyans called on Miss Swinburne they met Ruskin looking at her drawings.

<div align="center">**145**</div>

<div align="right">Paris, 16th Dec.[1] [1862]</div>

Dear Sir Walter

 I do not think I shall have occasion to trouble you in that matter of Mrs Booth.[2] I have got forty little bits of work for £400 – but agreed to pay it at once, on 1st January, and so have told my father to put the money into the bank: I have made one of the cheques payable to you – so you may have to put your name on it, & that will be all. Would you kindly send me Mrs Booth's address, accurately from that letter (I always forget it, the house having no visible number – and the row no visible title.)[3]

I got here very comfortably to day, and am going to morrow to enquire for lady Ashburton – I hardly dare say for Lord A. though (it is said) he still lives.[4] – to morrow evening I hope to be far on my way "home" – whence I will write to Lady Trevelyan. Always gratefully Yours

J Ruskin

[1] Ruskin left England on the 15th, spent this day in Paris and 'then travelled on through the night and came in the grey of dawn to the roots of the Alps'. Addressed to Wallington, the letter was redirected to Pakenham, Bury St Edmunds [Suffolk].

[2] Mrs Booth had been Turner's housekeeper at 119 Cheyne Walk, Chelsea. At Margate, where they had first met, he rented lodgings in her house.

[3] The following letter from Mrs Booth was sent by Ruskin to Sir Walter before leaving England. '2 Cremorn Road, Water side, Chelsea. November 30th [18]62. Dear Sir I write to inform you I am once more at home I returned on Wednesday last and should be really pleased to see you if you can spare time to come and see me I trust this will meet you all quite well I am thankful to say this leaves me much better but still very far from well am fearful I shall never be well again – but must have a good heart and hope for the best and all will be well in time with kind regards believe me to remain yours Sincerely E. C. Booth.' Ruskin had known Mrs Booth for some years and had corresponded with her from time to time. He appears to have seen her in the first half of December (there are no diary entries for the period) and to have bought from her Turner's early Margate sketch-book (see also Letter 146, note 3). JJR seems not to have known the details of the transaction. 'The reason I went to Sir Walter', Ruskin wrote to him on 20 December from Geneva, 'was that I wanted some respectable person to know what I was about.' (Yale)

[4] The Ashburtons had been on their way to the gentler climate of Nice, but were held up in Paris where Lord Ashburton was thought to be dying. On 'Christmas Evening (not Eve), [18]62', Ruskin wrote to the Carlyles from Geneva, 'I saw Lady Ashburton in Paris for a few moments, and promised to write to you, and did not – having no hope to give you, and thinking that you might as well be anxious as helpless' (R, 36, p. 427). Lord Ashburton survived and lived for another fifteen months.

146

Mornex 10th January [1863]

Dear lady Trevelyan

Quite seriously, I think you might write me some longer letters: and about something else than the weather. *I* can't write, because I'm sick of putting words together – and am out of heart; and because I want to read and paint whenever I can give a little energy to

anything, but I don't see why I should'nt be written to, and all the more. What do you want me to do when I come back in summer? – Paint those blue things?[1] Well, if I'm well I'll come and try, but I can't come for more than a day or two – for the father & mother will want all they can of me, and so will the Turners at the National gallery. And I'm not sure of being – sure in even the human degree of sureness – able to do anything but go fishing in the summer, and otherwise take more of my own way. I'm not very well again just now – the weather is colder than I like and there's too much darkness – though I've 40 minutes longer day than I should have at home. Tell Odin that if any of his cousins came here, the nasty ill bred Savoyard dogs would never give him a minutes peace.[2] I don't think one would venture near him, but they would bark him all to pieces. I got those drawings – sketches – from Mrs Booth – 3 mackerel! and two sunsets – and three or four seas – and some clouds, and scraps – inestimable in their way.[3] But I'm getting old – and there'll be no light to see them by where I'm going – firelight, perhaps you think: but I don't.

Ever affectionately yours, (till then) J Ruskin

[1] Ruskin's contribution of blue cornflowers to the Hall at Wallington still needed to be completed.

[2] Ruskin told his father on 5 January that in a letter from Lady Trevelyan of '3 days back' she had said that her dog Odin 'thinks you would be much better if you had one of his rough-haired cousins with you'. (Yale)

[3] Of some of these sketches he wrote: 'RAINBOW. Effect dashed down on the inside of the cover of sketch-book, all the paper being gone, his point being the gradation of light in the bow to the darkness of cloud; rare, therefore noted eagerly and energetically . . . I bought the whole book from his good Margate housekeeper, in whose house, at Chelsea, he died. HEAPED THUNDERCLOUD, over sea and land . . . Mighty work. A leaf out of the same book. FLYING SCUD OF THUNDERCLOUD . . . Noble. (Out of the same book.)' (R, 13, p. 470.)

147

Mornex 2nd Feb. 1863

Dear lady Trevelyan

I have your nice letter, and I am so sorry you have been ill.[1] I don't like you to be ill, though you are so tiresome. I can't write you much of a letter to night – for I've been out all day since eleven oclock and over the Mont Salève in the course of the day – and its

2500 feet up – besides being deep in snow half way; and I'm half asleep: But the spring has begun, here: I found a primrose yesterday: the dogwood buds are shooting fast and I found a shrub with a purple flower out, to day on the Salève. I've seen it often enough in my father's garden – but I never looked at it twice there. It is purple and has golden stamens – and is this shape [sketch] and two smaller leaves above the two larger, and it's a shame I did'nt look at it at home, for it's very pretty.[2]

Yes, I brought some nice things with me – Salisbury – and Heysham – and Scarborough and Farnley and Schaffhausen Turners – besides some of Mrs Booth's skies, and I should enjoy them a little – if Turner's spirit did'nt come crying to me always that there is'nt any good light to paint by under St Paul's floor, and I've so much here – three windows, & can't give it one.[3]

It is a great thing to have the extra hour of southern light.

I dine at 5 – by daylight and to day sate looking long into the twilight till Sirius came glittering over Mont Blanc – Orion's sword hardly visible above – his belt just countable – in the full warm moonlight It will soon be mild enough to let me draw a little each day – (I draw now, but only in tracing the Heysham & such like, having just finished another Fraser paper – the worst of all)[4] and there are such lovely pieces of cottage and crag landscape all round me – unspeakable & undone by any one yet. Turner could have done them in his early time – not afterwards.

– I've a great park of Spanish chestnut on the other side of my ravine, with granite blocks of the old glaciers cast here and there about their roots – so wonderfully mossed, and the turf so heaved about them – you can't think how lovely. The largest block but that's in the *pine* woods opposite is 37 feet long by 12 high and about 20 broad – (it slopes under the ground so; [sketch] so that I could'nt measure its breadth) but the average are from six to ten feet over. I've got a great piece of investigation to do on the Salève. It rises from Mornex nearly so [sketch] in a sweep of curved limestone – no, thats better [sketch] (for Mornex is just on the sandstone junction –) and falls in a great cliff to Geneva Now Saussure & Favre both call the beds at a. vertical *beds*. I don't believe it. I think they are cleavages, and that the structure is really this way [sketch] But in the elevation, all has been so torn & crushed and disturbed that I never saw anything in mountain form so unintelligible; yet so full of interest.

Please keep this note – because I told Picted the geologist at Geneva the other day that I did'nt believe they were beds: and as I'm going to work it out for the Royal Institution in June[5] – I don't care to have my little bit of a discovery snapped up by any body else. I get on well enough, as long as I can do anything – but if I tire of work, or lie awake at night – I get low – and I could make you so too – if I were to tell you what I see and know – – But I try to be blind – & to forget – If one did not – the world is too awful.– And yet – the long blindness & forgetfulness are the worst of it.

Yes, I should be nicely off, truly! – if I let those brats come in my way. I keep them all on the other side of the road – on pain of being made into pies, if they ever came across[6] –

Love to Sir Walter – Ever affectionately Yours J Ruskin

I'm sorry this is so utterly scrawled – but I could'nt have written at all to night unless this way

[1] Earlier in the day Ruskin had written to his father: 'I've got a nice long one from Lady Trevelyan which I must answer. She's been ill, and so has Sir Walter with the damp and cold. I wish I had them both on the Salève to day' (Yale). Sir Walter had been on a short visit to London, taking 'galvanic baths for Rheumatism'.

[2] 'February 1st. Found a primrose in wood; and blue of summer and summer cloud on the hills. February 2nd. Along base of Salève. Return over it by Cruseilles, 5 hours and a half. Found purple (mezereon?)'. (*Diaries*, p. 576. See Letters 150, 151.)

[3] Turner lies in the crypt of St Paul's Cathedral beside Sir Joshua Reynolds and Sir Thomas Lawrence.

[4] Though 'nervous and ill' he had begun the tracing on 25 January (*Diaries*) and, with the help of a printing press brought out from England by George Allen, hoped to print the plates, which Allen was to engrave from Ruskin's tracings. The 'Fraser paper', published in April, was to be the last, although, according to Ruskin, Froude, like Thackeray before him, had not 'wholly lost courage'.

[5] His lecture 'On the Forms of the Stratified Alps of Savoy' was delivered in London during the summer. Three weeks later he wrote on the same subject to his father: 'I have hardly any doubts the geologists have mistaken its fractures for its beds. They all state that it has vertical beds on its face. I believe they are merely rents, of extraordinary evenness and symmetry' (R, 36, p. 435). He spoke in this sense in his lecture, questioning whether it were not time that geologists revised earlier assumptions.

[6] George Allen's children. 'A parcel of white faced little animals [Ruskin wrote of them to JJR] whom I look upon in the same light as the pigs – except that I don't expect so much good of them – and am always afraid of their tumbling into my well and spoiling the water . . . I keep them out of my way on the other side of the road.' (*Winnington*, p. 398)

Mornex, 14th Feb. [1863]

Dear lady Trevelyan

I've been thinking that Sir Walter might be better of the dry air on this limestone, though it is cold when the North wind blows, and we are just at our very ugliest in Savoy, no green any where. But I could give you fair country houseroom – a room that don't smoke – and – not good dinners – , but as good as you can usually get among the Alps – Would you like to come and try whether the change would do him any good – You would'nt be in my way. I should just go on as if you were'nt here – having my own den at the other end of the garden – and you might come and teaze me sometimes in the afternoon and I should'nt mind.

Ever affectionately Yours

J Ruskin

149

From JJR

Denmark Hill 5th March 1863

Dear Lady Trevelyan

I thank you for your kind enquiries. Mrs Ruskin remains a fixture to Bed or Chair – in less pain but with less Sleep. cheerful nevertheless & thankful that it is no worse with her. The winter has been more agreeable than most Summers & we know nothing of Influenza. I am an Invalid I fear for Life but I get Intervals free from pain enough to let me Sleep. My Son writes he finds the cold so extremely disagreeable that I have some hopes of his postponing if not abandoning his Scheme of making Switzerland his home.

Here we have glorious Sunshine, smokeless & fogless even within four Miles of London. I had Mr Thompson with me today formerly Skinner & Thompson, Stockton [-on-Tees].[1] The Climate there as with you. I used to feel Durham very bitter in my Winter Visits but he describes it as gentle & genial this Winter. We are glad to hear of Sir Walter's improved health. Mrs Ruskin is forever wishing you would spend the winter in Naples where Rheumatism is unknown.[2] We met one person there who had after years of suffering been totally free of it but he could not go 70 miles North of Naples without twinges of the Complaint.

John's Letter just come in says "I was never in such troublesome snow crusted [word omitted] besides on Top with sharp Ice not always bearing – anything but Wind I shall be grateful for & anything that will let Grass & Flowers grow. J.R."

Now we have here with no attempt at a Garden Splendid Flowers prettily arranged by our now alas! old Lucy (I hate menservants). Lucy has a natural taste for arranging Flowers.[3]

I am sorry to hear you do not come to London. I don't know anything of the troubles & Labours of Lime Kilns[4] but I venerate & admire Sir Walter's disposition to labour for the benefit of our Race & even go with him in his views of waterdrinking though I have sold more Sherry last year than ever I did in my Life. I cannot help this – I would join in any crusade against Gin but that some of my best Correspondents have a wing of their Establishment devoted to the Sale of this Article. I am sickened at the sight of the Streets. Wretchedness caused by the sale of Spirits & go in heart with all attempt to arrest the evil Consequences of the Sale of this poison.

I send you morning Post of today 5 March containing a Letter sign ed Moderation against Railways in London. I sent it in a hurry yesterday & see a singular put for plural or the words *one of* – superfluous.[5]

Mrs Ruskin joins in kindest Regards to you & Sir Walter

I am My dear Lady Trevelyan

Yr very truly

John James Ruskin

I feel with my Son about Railways.

[1] A firm of solicitors in Finkle Street, in which John George Thompson was also empowered as commissioner for taking affidavits in courts. Finkle Street, one of the oldest in the town and still extant, contained a high proportion of business premises. JJR appears to assume that Lady Trevelyan knew of whom he was speaking; perhaps the Trevelyans had had occasion to make use of the firm's services.

[2] The Ruskin family had spent two months at Naples at the beginning of 1841.

[3] Lucy Tovey had already completed thirty-five years' service in the Ruskin household. After a further eleven years at Denmark Hill she and her sister were installed in a model tea-shop established by Ruskin in Paddington Street.

[4] Sir Walter's diary gives evidence of his activity: 'February 6th. Home past my works, lime kiln &c. February 7th. Walk along Railway to lime works.'

[5] JJR's letter concerning the invasion of the railway is headed: 'Destruction of London'; the offending sentence reads: 'If opposition be not quickly made, London in a few years' time will be one of the ugliest, the most dreary and desolate-looking city in Europe.'

[February or March 1863]

My dear lady Trevelyan

I hope you were not prevented from coming if you would have
liked it by my not very cordial invitation – I should have liked you
to come – but was not sure that the house would suit you – and was
ashamed of the grey frostbitten look of everything. (I did not say
either that I could have taken man & maid but that you would
understand). If I intended to stay in the village, I should *beg* you to
come & put me in some way of getting a little to rights: but I shall
only be here this spring; I must for permanence get more among the
hills – out of the north wind and above all – out of the way of Geneva
workmen and students – who get out here on the Sunday – As soon
as I am able to stir without needing fires at the inns, I'm going in
search of a better situation. If I find a habitable house, I think you
will really have to come and help me to set it to rights a little – and
put the garden in order – for I'm about as able to do it – as the
drowned baby in the Wansbeck[1] – and yet I like to see things tidy –
though you might'nt think it –

– And for geology – there's enough to amuse Sir Walter as long as he
will stay – the whole coal formation in Savoy is upside down to begin
with – and lies on the top of the lias – at least as often as at the bottom
of it. This mountain here is puzzling enough for a years work – but
I'm nearly sure of my cleavage now – My carpenter, Allen, is helping
me in a way I did not expect – his knowledge of wood-grain makes
his eye very keen to the run of fractures. I'm not so well off as you
suppose in mezereon – I only found one bush of it – The universal
Salève plant is the little Rosa Alpina – (not the rhododendron) but
true rose – and what I believe is the "rosa spinissima", at least its
stem is like this [sketch] and very nice to handle – and theres another
variety which runs about everywhere in long shoots like bramble,
very pretty when it's tall – and about as pleasant as St Catherine's
wheel. There are some pretty blue hepaticas out – and primroses –
nothing else yet.

– I'm not much better, I hate the cold so; but have had no cough
or cold, & hope to gain when the warm weather comes. I am so glad
about Lord Ashburton.[2] This is nice about Henry Acland too –

Love to Sir Walter

Ever affectionately Yours J Ruskin

¹ The meaning is obscure, but it is possible that Ruskin had in mind the plaster cast of a naked baby which still hangs at Wallington. Known as the 'Sleeping Babe', it represents a child lying helplessly entangled amongst ferns, seemingly asleep, but Ruskin may have given it his own interpretation, familiar to Lady Trevelyan. The river Wansbeck flows through the park at Wallington below the front of the house where the ground falls away from the South Terrace.

² Lord Ashburton's health was showing improvement.

151

24th March [1863]

Dear lady Trevelyan

You may put down that mezereon as native of Savoy. I find plenty now, wild in the woods and brushwood. The principal spring treasure is the two leaved squill, which grows rich like our wood-hyacinth.

I counted 26 heads in a square yard on a bit of bank by a brookside, mixed with primroses, the average was eight to twelve in square yard – for a quarter of a mile down the brook

I recollect making a hasty unscholarly mistake in my last letter writing spinissima for spinisissima I think the brambles deserve the title as much as the roses: and theres a horrible thing like gooseberry bushes – but with nothing to eat on it – which makes it next to impossible to get much about in the beechwood

I am quite satisfied the Salève beds are as I thought: the only question is whether the slopes above the cliffs are surfaces or shales, whether the beds are as at A. or B. [sketch] and this is very difficult to make out.

The cold worries me, and I'm as dead as the trees – perhaps I shall get some feeling, when they bud.

Love to Sir Walter

Yours affectionately JR

152

From JJR

Denmark Hill
4 April 1863

Dear Lady Trevelyan

I am very much obliged by your Letter of 2nd April. We are much pained to hear of good Dr Brown's troubles: I had hoped they were

lessening. One is afraid to express the thoughts that force themselves upon us in such cases else I should say Death would be a Blessing to the Sufferer & a relief to the survivors.[1] I once hoped there might be a pleasure in Madness, which none but Madmen know,[2] but I fear it is not so & think the suffering is frequently extreme.

Lord Ashburton must be a man of fine Character & I earnestly trust he will be spared to his friends & the world.

The Fraser of Smith Elder & Co was sent not by them but by me. I am fully paid by your Sympathy. I have been anxious about my Son getting on new ground, but his tread is already firmer, & this April paper if destined to be equally abused with those papers already out, is so good that I care nothing about any criticism. I am very glad you like it. Thackeray Editor then of Cornhill Mag was frightened at the threatening Letters he received from Manchester for publishing the first 4 Articles.

Froude the Historian Editor of Fraser is made of Sterner Stuff & says the two articles Septr & Decr 1862 have already done his Mag some Service. Mr Froude kindly wrote me hearing from Carlyle I was anxious, & these are his words 'I am happy to say it is in Type & in my opinion it is among the noblest & best pieces of writing which I have ever read.'

This is a great deal from Froude. The weekly Spectator called John *unbearable* on P. Economy but nevertheless quotes him as *splendid* on America.[3]

My Son writes well & rather amusingly on the Gluttons of Business in the City. What with his wife & his pictures & other things he has practiced a system of Depletion upon me entirely I presume for my Safety.[4]

Mrs Ruskin joins in kind Regards to you & Sir Walter Trevelyan.

John's Letter just come, seems very well.

I am my dear Lady Trevelyan

Yours very truly

John James Ruskin

[1] Dr Brown had much to bear in his wife's long and incurable illness.

[2] 'There is a pleasure sure,

In being mad, which none but madmen know!' (*The Spanish Friar*, John Dryden, II, i).

[3] 'Mr Ruskin is really unbearable on "Political Economy", the more so, for the occasional beauty and even wisdom of his thoughts.' Many years later when talking to his assistant, T. M. Rooke, Burne Jones related how it had seemed to

him that in ethics Ruskin had said things 'the like of which for insight, delicacy, and surpassing beauty and justice had never been imagined before'. (unpublished Diaries, T. M. Rooke). Of Ruskin's views on the American Civil War the *Spectator* (4 April 1863) believed 'It would be difficult to write in language more splendid.'

4 Much of the essay deals with the distribution of wealth and the morals of expenditure.

153

[7th April 1863][1]

Dear lady Trevelyan

What a nice letter. I am so glad to hear of some good coming out of that lace manufacture of yours at last. Young rooks in lace must be lovely, and how happy you've been making all your animals – its delightful to think of. I'm in a hurry to day, for a wonder – I've not been for three months – but I'm off to Annecy to look at two houses – in a warmer nook, as you say.[2] I want to settle things if possible, before coming home this time. I wrote yesterday to a lawyer, offering to buy, if I could get it – the entire top of a barren crag 5000 ft above sea, and the top of a pasture-ravine leveling down from it southwards & westwards, & build a chalet in a place I've long loved – & have watched this spring carefully to see how the snow lay – or rather did *not* lie, which was as I hoped.[3] Then you shall come and it won't be much warmer than Northumberland & I'll have everything made nice in the flower way for the Swiss beasts – I've such lots of owls where I am – and eagles – by the flight – I can see four or five together sometimes – there's a white one – I'm not sure he is'nt a vulture – has a nest in an isolated pinnacle of the Salève cliff – he must be 12 feet from wing to wing – he flies just like a railroad train – you never see a wing move –

How funny you are about Polt Econ. – as if I had'nt thought of all that!

You're just like a bad patient with his doctor –

Doctor – You must get up & walk before breakfast – at 7.

Pat. I can't – I never go to bed till four.

Doctor – You must go to bed at nine

Pat – I can't – I don't dine till eight

Doctor – You must dine at one –

Pat – I can't. I don't breakfast till 12.

– Don't you see that every bit of that work of mine points to a

radical change in the aims of human life – and in *every* custom of it
therefore! – As if precisely the worst and cursedest thing in coal-
mining was'nt that very fact – that people *like* it[4] –

<div align="center">Ever your affectly JR</div>

I'm very poorly, very.

[1] Dated from internal evidence.

[2] On 7 April, a day of rain, wind, and dust, Ruskin set out for Annecy (*Diaries*, p. 579). He remained there and at Talloires a month.

[3] By the end of May he was in treaty for two pieces of ground at Chamonix where over £700 was spent on rich pasture land under the Aiguille Blaitière; and on the Brezon, above Bonneville, the 'top of the barren crag'. There he hoped to build a small stone house for himself.

[4] This is probably what Lady Trevelyan herself propounded.

<div align="center">

154

[Denmark Hill] 17th June [1863]

</div>

Dear lady Trevelyan

I should like to know where you'll go next. From coals in North-
umberland to cinders in Auvergne, & pretending to enjoy them –
and thinking to take me in and make me believe it – If you were only
a little bit like her in amiability, I should always call you
Cinderella – How did you ever get up that Puy de Dome? it looks as
if one might as well try to get up the Dome of St Pauls a foot deep in
ashes. And *I* did'nt see any water in Auvergne – any more than in
other places where you pretend there is. I know there's a nasty spring
at Clermont that covers everything with mud. And for the nice
people – I remember nothing but sour and dirty faces[1] – I recollect
we could'nt eat the butter – it was all mottled like soup & full of
hairs. I could'nt call at Paris at 5 in the morning, I got there, from
Geneva – about that time – and breakfasted in a café with scarlet
and gold pillars and a sanded floor, and got to Boulogne at one
oclock.[2] I found my father & mother all the better for my absence
(N B. I could'nt see the least reason in that message of yours – and
was'nt going to give it – but my mother insisted there must be some-
thing for her – so I was obliged.)

The lecture went off very well only I had not time to say or read
half of what I had got to say, but I can always write or say it
afterwards.[3] – I'm not well – but perhaps a little better, and am

<div align="center">213</div>

going to stay here till end of July – then go down to Winnington & so to you – but you'll be here first and we can settle all that.

– I bought just before leaving Savoy about a square mile of Mont Blanc – 2000 feet above Chamouni – with quantities of weeds and stones upon it – and a torrent – (and I want to buy a glacier above) and I'm in treaty with the mayor and Common-Council-men of Bonneville for the whole top of the Brezon – which is a nice cliff about 1000 feet high, with nothing on the top of it but lichen. These purchases are in illustration of my political Economy. I wanted a big stone too, near Mornex but could'nt get it.

When you have had enough of that ash-hole, I hope to see you, & Sir Walter – I'm glad about the rheumatism: but he really deserves to get well too, for taking you to such places to please you.

Ever affectionately his & yours J Ruskin

¹ Auvergne was noted for its medicinal springs and Lady Trevelyan may have hoped to find the waters beneficial. Sir Walter was going for geological motives. Ruskin had been at Le Puy in October 1840 on his way to Italy with his parents. At the time he gave fine descriptions of the surrounding country in his *Diaries*. Amongst the people he found the 'nuns and women and children all ugly, decrepit, and diseased' (p. 86).

² Staying with the Ashburtons in Paris, Lady Trevelyan had hoped to catch a glimpse of Ruskin as he passed through on his way to England. He had left Geneva on 29 May, had reached Boulogne on the 30th, and was at Denmark Hill on 1 June.

³ His lecture on the 'Stratified Alps of Savoy' was delivered at the Royal Institution on 5 June.

155

[? End of July 1863]¹

Dear lady Trevelyan

I must be a day later than I hoped: the 5th instead of the 4th. But I don't think anything else can come in the way now, if I keep well.

Love to Sir Walter.

Yours ever affectionately J Ruskin

¹ The Trevelyans had dined at Denmark Hill on 16 July on their return from abroad. Ruskin had shown them a Turner sketch-book, possibly the Margate one bought of Mrs Booth, also Turner's working colour-box for travelling, a present from Mrs Booth. Ruskin's next visit to Wallington planned for 4 August must have been made at this time. The following letters refer to his change of plan.

[? End of July 1863]

Dear lady Trevelyan

Will it make any difference to you if I go to Winnington first for three days or so, and then come on to you – my very dear friend W. Kingsley (who lives at Kelvington, Thirsk) wants me to come & see him[1] – and if I go there as well as to you the Winnington girls will lose all patience for I promised them to come on the 7th before I knew of your meeting at Newcastle[2] I intended then to come to you on the 4th and go back to Winnington about the 12th which would'nt have mattered much – but now the Arundel people may want something which might keep me past the 5th[3] & I should like then to look in at Winnington in passing, unless you have made arrangements otherwise.

> Ever affectionately Yours
> J Ruskin

[1] An old friend of Ruskin, the Rev. William Kingsley was Rector of South Kilvington in the North Riding of Yorkshire. He owned several water-colour sketches by Turner.

[2] A meeting of the British Association, which the Trevelyans would attend, was to be held on 26 August.

[3] Probably concerned with Ruskin's report on the Luini frescoes in Milan.

[About 3 August 1863][1]

Dear lady Trevelyan

As I have a remnant of character still to lose at Winnington – and none at Wallington, I think it will be best to keep my word to the schoolgirls – who still believe it a little. But I want to see Dr Brown very much, and if you can get him to stay over Monday, I'll come to Wallington on Monday 10th after I've shown myself to time in Cheshire. I am so entirely weary and ill just now that you would be sorry to see me – after a little fresh air I may be better on Monday next. Read this sorrowful little letter from W. Hunt* & keep it for me.[2]
Love to Sir Walter

> Ever yours affectionately JR

*no use, not sent

¹ August 3rd was a Monday. In this letter Ruskin refers to 'Monday next', the 10th. Had this letter been written before 3 August he would have spoken of 'Monday fortnight'.

² Hunt had suffered deeply through the death the previous month of his old friend Mulready.

158

I've rather a notion if the trains
exist of coming by the Carlisle
line. I'll write you word on
Saturday [Thursday 6 August 1863]

Dear lady Trevelyan

I shall not fail on Monday unless I fall quite ill. I start at 10 to morrow – taking down Edward Jones and his little wife¹ – (She offered to run away with me – but I said it was'nt proper and he must come too – am not I getting correct!) – they'll make great pets of them at Winnington –

The Wansbeck is a nice honest little stream. I *will* say that for it, and does'nt want to look bigger than it is – Please make Dr Brown stay – I've been reading the Culverwell thing he sent me edited by his father.² Its great nonsense – but a nice enough nonsense book.

Ever yours affectionately

J Ruskin

¹ Ruskin travelled to Winnington with the Burne Joneses on Friday 7 August.

² Dr Brown's father, minister and theologian, was the author of many treatises and discourses. Nathanael Culverwel was a seventeenth-century divine and one of the Cambridge platonists.

159

[Winnington 8 August 1863]

Dear Lady Trevelyan

I cannot quite make out the train times – but I'll do the best, and earliest, I can on Monday and be with you I hope in time for dinner – though I had rather, as far as that great object of life is concerned, miss it than not

This place is very pretty just now in its perfect green – lovely park

and dingle foliage: and the girls are out of doors all day at some mischief or other – (what it is called a "School" for, I can't think) and looking mightily pretty glancing in & out among the trees by threes and fours – Here's Crawley comes in to say we can only get to *Morpeth* by ever so much past five – If you can send any orders to – no you can't – I daresay I shall find we can do better; never mind, and don't wait dinner. I'll come somehow sometime.[1]

Ever affectionately Yours

J Ruskin

[1] Ruskin did not arrive at Wallington until Tuesday the 11th, having spent the night at Newcastle, which, 'though ghastly and frightful', as he told his father, was 'very sublime & instructive – even enjoyable in its strangeness' (Yale). At Wallington he found his hostess 'in high spirits better than I have ever known her', and though the place seemed to him 'very wild and bleak after Savoy' (probably also after Winnington), he liked the 'nice oldfashioned roughness & largeness' of the house. The walls of his bedroom (now the Needlework Room) on the first floor facing east were inset with high panels of early eighteenth-century tapestry work 'with yellowish wainscot between carved in Louis 14 festoons – fruit &c . . . and the bed crimson damask with fluted pillars, it is very nice altogether' (Yale). Nevertheless, he was discontented for the wind was howling, and in contrast to the Alps he was taken for scrambles over the moors ('there's no exercise but in merely stumbling over moorland – and I hate it'). But worst of all: 'There are people in the house who bore me' (these were probably Bell Scott, and George Butler, Vice-Principal of Cheltenham College, husband of Josephine Butler), but 'no one can be kinder than they [the Trevelyans] always are'. He was glad to find Dr Brown and to make the acquaintance of Constance Hilliard, the eleven-year-old niece of Lady Trevelyan, to whom he became devoted. (See *Sublime & Instructive*, pp. 51–2, for an account of their meeting on the lawn.) Bell Scott, his star eclipsed by a brighter planet, left a few days later but with the following incident to relate, which lost nothing in the telling. 'The morning I left', he wrote to his friend Alice Boyd, 'I overheard something concocting for after breakfast, so I went up to Lady T's room by and bye, and there came upon a sweet scene. Lady T. & Dr Brown sitting in a wrapt almost devotional attention opposite a row of Turner drawings Ruskin carried about with him, displayed on chairs, the thin figure of the critic moving fitfully about seeing that they were properly exhibited and pointing out the "wondrous loveliness" of each. Of course I joined in and cried "oh, what a glorious treat!" ' (University of British Columbia). Turner's water-colour of *Schaffhausen* was amongst those Ruskin carried with him, and this he left with Lady Trevelyan for her to copy.

Coldstream[1]
Tuesday afternoon [18 August 1863]

Dear lady Trevelyan

Perhaps there might come a letter for me this morning: please let it go to

 Revd. W. Kingsley

 S. Kilvington; *Thirsk*

I never said goodbye to Mr Worcester, which plagues me. I've written to Kingsley to ask if he can come over with me to Wallington on Saturday but I fear there's no chance. I'll write you word on Thursday evening from Thirsk.

The tweed here is intensely lovely, and makes me utterly miserable; it sighs and mourns like a human creature and seems more senseless than Tiny: and it's as black as his nose. Everything is so small – and so dismal – and yet so pretty – that I can't bear it, and must get away as fast as I can to Thirsk. It all puts me so in mind of Turner in his sweet best days – and of myself when I was a boy – and of dead people – and of Sir Walter Scott[2] – and I wonder so where they all are – and where I shall be: and there's the water going on curdling and creeping and does'nt mind. I'm going to have some salmon for dinner – that's one comfort I get out of it – (out of the water, I mean). The streams of the Reuss, where I forded it below Lucerne was about twice as large as the Tweed is now[3] – but it flowed evenly – coming just out of a large lake while these Scotch streams get into pits and channels in the wickedest- wildest way – like demons digging long graves. The Reuss in *summer* is another kind of thing – running 12 feet deep at seven miles an hour, but it is never treacherous.

Theres a great castle opposite Norham which they are "doing up" – How they've spoiled Morpeth![4]

Love to Con – (rough hair & all.) – and the Con-trary to Tiny, and all sorts of things to everybody else – Ever affectionately Yours

 J Ruskin

[1] Ruskin was at the Collingwood Arms, Cornhill on Tweed, near Coldstream, having arrived earlier in the day after a week at Wallington. He stayed two nights at the inn in order to visit Lady Waterford at Ford Castle and see her fresco work in the village school.

[2] Scott had spent the greater part of his life in the Tweed valley and Turner's

sketchbooks of 'North of England' and 'Minstrelsy of the Scottish Border' were familiar to Ruskin, as were his many drawings of Norham Castle, just north of Cornhill. Ruskin had first crossed the Tweed at the age of seven.

[3] In November two years earlier Ruskin had walked through the Reuss half a mile below Lucerne, 'just for delight in its clear green water [he told Mrs Carlyle]. Not many people can say they've done that, for it is the fourth river of the Alps' (R, 36, p. 394). He had had to hold firmly to his pole for about twenty yards as the water was running like a mill-race and he was up to mid-thigh.

[4] There had been some building and restoration at Morpeth since Ruskin's last visit but the reference to Norham is obscure. Norham Castle was loved not only for Turner's sake, but also for Scott's, who celebrated it in *Marmion*, and Ruskin who had written about Turner's drawings of Norham Castle many years previously must have known it well. Restoration was undertaken in the mid-nineteenth century, but there appears to have been no other 'great castle' in the vicinity; the Trevelyans too must have been familiar with Norham Castle, so that Ruskin's allusion remains unexplained.

161

S. Kilvington Thursday afternoon
[20 August 1863]

Dear lady Trevelyan

You know, no human creature (masculine & so deceivable) – could stand such coaxing like that – and the sacrifice of the hair & all[1] so I'll come back on Saturday and stay over Sunday – and I hope to bring Kingsley with me – he says he should like so much to come if he can get any one to do his duty – but this is still doubtful – and as I don't like to leave you uncertain any longer – I'll make sure of myself – to my own great comfort.

The little picture is exquisitely funny – what power the child must have![2]

I'll tell you about Ford when I come – I was glad, for one thing, to see Flodden – I never knew before exactly where it was.[3]

Love to Con. I must read her the story of Rapunzel some day[4]

The above I wrote an hour ago – But Kingsley says he can find out whether he can come before I despatch my letter – so now it must be yes or no for both of us – for he is so much alone, I can't leave him if I *know* he can't come, so I just keep this out of the envelope – & will merely write, when he comes in – Yes – or No – for both – Ever affectionately Yours

J Ruskin

219

Thank Sir Walter so much for the pebble – it is so wonderful when I look at it long –

All kinds of devoirs to Miss Collingwood & Miss Ogle.[5]

Special antipathies to Tiny.

Yes. for both

[1] A reference to Bell Scott, who, as the result of an illness the previous year, had lost his hair and eyebrows and thereafter always wore a wig.

[2] Probably Connie's brother Lollie, who became an excellent draughtsman.

[3] Flodden Field, west of Ford and part of the estate, was the scene of the Battle between the English and the Scots in 1513. Unfortunately no record exists of Ruskin's account to Lady Trevelyan of his visit to Lady Waterford at Ford for it seems more than coincidence that these two women, Northumbrians by adoption, never met. Louisa, Marchioness of Waterford, came to live at Ford Castle at the end of 1859 as a widow of eight months. Her deep mourning was protracted by her sister's death in India and this was followed closely (in 1862) by that of her brother-in-law, Earl Canning. In a nicely defined society such as flourished in the nineteenth century, it was for the longer-established resident to pay the first call. Perhaps therein lay the stumbling-block. Lady Waterford was known to be very shy and retiring and after more than four years of mourning there may have been some hesitation on the part of the baronet's lady to make the first move of recognition. No doubt also there was some indefinable nuance of class distinction, for as one of the great ladies of the aristocracy Lady Waterford moved in Court and Society, while Lady Trevelyan, with her more radical views, was at home in the company of middle-class artists and writers. Whereas both women were earnestly religious, on Lady Waterford's part a tendency to High Church dogma had given place to the opposite extreme since her arrival in this Border country, and her letters to friends point to an evangelical piety which proved the support of a secluded life. While in a modest manner Lady Trevelyan fulfilled more nearly the role of patroness and sympathiser to artists, to Lady Waterford art, its study and execution, was the essence of her being. She seems never to have expressed a desire to be shown Bell Scott's work at Wallington and in some respects her own frescoes at Ford school are the more engaging, but in later years she stopped at Penkill Castle, Ayrshire, on her way north, to see his murals on the staircase wall. She rebuilt part of Ford Castle and laid out the gardens, and became a teetotaller. Also like Sir Walter, she was interested in building a model village and cared for the welfare of the villagers. Perhaps Ruskin, sensing that an acquaintanceship would not flourish, never urged a meeting. One reference is known to exist in a note from Lady Waterford after the death of Lady Trevelyan: 'I am grieved to hear of Lady Trevelyan's death (though I did not know her). I had heard much of her & knew she was one of the best of women & looked forward to knowing her in this solitude where there are *really literally* so few neighbours.'

[4] The fairy story of star-crossed lovers. Two strokes of the pen reach from the opening sentence of the letter to this point.

[5] Miss Collingwood, bearing a Northumbrian name, was most probably a

neighbour, as was Annie Ogle who, as Ashford Owen, was the author of *A Lost Love* (1864). Long after Lady Trevelyan's death her brother, Hugh Jermyn (Bishop of Brechin and Primate of the Church of Scotland) married as his second wife Annie Ogle's sister.

162

> Miss Bell's
> Winnington Hall[1]
> Northwich August 25th 1863

Dear lady Trevelyan

I had a fine day of jerking & jostling yesterday – out of one train into another, and always into a worse, till ten at night, when at last the lights of Winnington shone through the park trees, after (– between Manchester and Northwich) we had stopped at (I think) nine stations in twenty miles.

How beautiful that country must have been between Rochdale & Halifax! before its "iron mask" was put on. We had a pretty illustration of commercial manners – and temperance principles on the way – three sailors from Sunderland or Hull having tasted every thing in bottles at every refreshment room as far as Halifax junction two of them broke the last empty bottle over, & into – the other's head, in the last third class carriage – which produced a very pretty sensation scene at the junction. I'm half afraid my letters have been mis-sent again – and much ashamed of my stupidity if it be so; everything may come here, for the present

The key of boat is given to Crawley to be returned.

All kinds of devotion to Con.

Love to Sir Walter

> Ever affectionately Yours
> J Ruskin

Your kind letter just come[2]

I'm so glad you miss me a little – so do I you & Con – though I've some nice Lily's and Isabelles and May's here to tempt me to in-Constancy.[3] How nice it is that you've brought out Kingsley – he will be so happy with you.[4]

[1] Where Ruskin remained until 5 September.

[2] On the next day he wrote to his father: 'I've such a nice note from Lady

Trevelyan – you shall have it to morrow', but JJR found it hard to read and Ruskin wrote again: 'Lady Trevelyan's careless writing consoles me sometimes a little about mine but you would make out, I hope, what she said about Con.' (*Winnington*, pp. 416, 422)

[3] These were pupils at the school. Of Irish birth, Lily Armstrong was one of his favourites and reminded him of Rose. She remained a friend for many years and was the prototype for 'Lily' in *Ethics of the Dust*. Isabel Marshall was a studious and imaginative child for whose schooling Ruskin was prepared to pay. 'May' was probably one of the several Marys. (*Winnington*, p. 313)

[4] Kingsley stayed at Wallington until the 26th and was a pleasant guest. Sir Walter found his 'observations on Glaciers of Wales very interesting' (TD), and his knowledge of the works of Turner and Bewick truly remarkable. He had brought with him examples of both artists to show the Trevelyans.

163

Sunday morning [6 September 1863]

Dear Lady Trevelyan

I only got home last night and found your kind letter – best thanks for it and all its news of Con and Mr Kingsley and the dogs, and Newcastle – I promised Con a drawing of boats – I can't find any afloat, here are two aground in Dover Harbour rather well drawn, though I say it, but I wish they had been prettier in colour. I've had plenty of play at Winnington – (but it's all the duller afterwards;) there are more than forty girls there now – the school not having a vacancy left for some time to come – I got Edward Jones & his wife to come down and we had really a grand time of it. They actually forced me to dance Sir Roger de Coverley with them on the last evening.[1] I hope to get off for Savoy on Tuesday – & to get a little warm remnant of summer there – I will write you from Chamouni.

My Father & mother are wonderfully well. I can't say more to day

Ever with love to Sir Walter & Con affectionately Yours

J Ruskin

[1] Dancing 'in a quadrille or country dance' at Winnington, he 'looked very thin, scarcely more than a black line, as he moved about amongst the white girls in his evening dress.' (*Memorials*, i, p. 264)

Chamouni, 22nd Sept 1863[1]

Dear lady Trevelyan

I have – at last – your kind letter with coal mine sections.[2] It lay for a week at Geneva unforwarded, and now I am at a loss to know whether you have received a note I sent just before leaving London – with a little drawing of boats in it for Con: – It was on a stiffish bit of cardboard, perhaps some of the Post office people thought there was a sixpence in it & stole it. (What a shame it was of me to come away without completing any purchase of the cabbages!)

Paca is very like me, I think – and does'nt know what's good for him.[3] I am more disconsolate here than I used to be – somehow. I *can't* work – and vainly try to think the snow bright and the rocks entertaining. If I only could work, I should be alright.

Thank you always for the coalmine, but I knew of this "creeping" process and referred to it in my lecture – so that you need not copy any more for me – Have you done any of the Schaffhausen?[4]

– I told Rosie that Con would'nt write to me "for fear of the spelling", to which Rosie replies – "How funny of Con not to write! – Dear me, St C,[5] I don't think you would often hear from me if *that* was the reason *I* did'nt write – but I do truly think it is a great pity I can't spell" – Well – I would change my spelling for her *writing* any day – but these Irish girls seem none of them to take much to their books. There's a nice pretty one just come to Winnington – as gay as a squirrel – with the funniest name – Asenath – (daughter of Potipherah! –) I shortened it into "Egypt" and we got on nicely.[6] I told you about Isabella and her Latin, did'nt I?[7] – and that I had got the Jones's down to Winnington – all three – he – wife – & baby – who has a fine life of it among the girls – (But it really deserves a fine life – – I never saw so good a baby – It will always kiss me – and won't kiss above one in six of the girls – (I don't understand its principles of selection at all)) So they've been plotting to get me kept in England – and Jones is designing a piece of tapestry to go all round my study – (if I'll stay at home –) and twelve of the elder girls are to work it and the little ones are to work daisies and buttercups and mice and Pacas, and butterflies on the grass below.[8] But I've just paid to day for my grass *above* – and fresh snow has fallen – and I can't get up – to it – and I don't know what to do with it, now I've got it.[9]

Send me a line please – to poste restante Sallenche
Haute Savoie
– and tell me if you got the boats & about Schaffhausen. Love to Con.
Ever with kindest regards to Sir Walter
Affectionately Yours
J Ruskin

[1] After a short stay at Denmark Hill Ruskin was again at Chamonix, accompanied by Osborne Gordon, to complete the arrangements for the building ground, or to extricate himself from its purchase. In his *Diaries* Ruskin gives 23 September as the date of this letter.

[2] On 17 September Ruskin had written to his father: 'I cant think what has come of Lady Trevelyan's letter in which the bit about coal mines was – None comes from Geneva. Have you by any chance not sent it?' (Yale). JJR had his son's permission to open and read all letters that came for him before forwarding them, thus facilitating the exchange of news in their daily letters.

[3] Paca escaped by burrowing,' Sir Walter commented in his diary on 9 September. Perhaps some kind of pet rodent. Two years later Sir Walter offered Paca to the London Zoological Gardens.

[4] Turner's water-colour of *Schaffhausen* had been lent to Lady Trevelyan to copy. In his lecture on 'The Stratified Alps' of the previous June, Ruskin had likened the pressure of rock masses to the creep of the floor of coal-mines.

[5] 'St Crumpet' was Rose's name for Ruskin.

[6] Asenath Stevenson, the 'Egypt' of *The Ethics of the Dust.*

[7] Isabel (Letter 162, note 3), not yet ten, disliked eating meat. She had been eager to study Latin but Miss Bell, fearful of over-taxing her strength, refused to allow it until the child ate properly. Meat and Latin were soon being digested.

[8] The Burne Joneses had learned with dismay of Ruskin's plans to live in Switzerland and had suggested finding him a house in England instead, for which they would design a set of wall hangings representing passages from Chaucer, which the Winnington children would embroider.

[9] This was the pasture land and two chalets near Aiguille Blaitière. To the relief of his father and friends Ruskin decided 'to draw out of the Brezon business'.

165

Chamouni, 1st Oct. 1863[1]

Dear lady Trevelyan

I must certainly be getting sociable, for I was very glad of your letter and Con's to day: and here am I answering at once: but that's mainly because I tired myself yesterday & the day before, and I can't go out to day

– Well – yes – I think I am a little better: I've been working at nothing but quartz and coalslates, and it does'nt excite one – painfully: and it's full of the pleasantest endless puzzles, only the wind is

getting *cold* now at 6000 feet – so I shall have to give in

So it would be nice if I would stay among the people who want me?
But you can't think how frightened I am always lest they should tire
of me. I can't bear myself, – and hate everything I do and say – and
it seems to me as if everybody *must* tire of me in a little while; and if
ever I've let myself get the least bit fond of people, something always
goes wrong, and it hurts so: and yet, if people really did want me –
I'm sure they're welcome – if only they could be sure of themselves,
& promise not to tire – there are Ned Jones and his wife for instance
– You never saw such sweet letters as they write me – but the moment
I'm near them – I feel sure they're liking me less every minute, then
they see that, and have to tell me they are'nt tiring of me – and
that must tire them, you know. But I've told them and the Winning-
ton children, who really do cry a little, sometimes when I'm going
away, and whom I really do love very much – (fifteen or sixteen of
them at least, not all;) that they may do what they like with me –
only now I'm all at sea again & don't know what to do – with
myself – It must be very convenient to have some sense of ability – I
forget what it feels like – now, but it must be very steadying – I
like the bit of ground I've got here – only it bores one so to have to
think what to do with it.[2]

– On the whole, it seems to me best to go and have another look at
Venice, while some of it is still standing, and I've a dear old friend
there – Mr Rawdon Brown who will be so glad to see me – and so
will my old boatman, and I want to see the Paradise of Tintoret
once more[3] – in case I never see anybody else's Paradise – So send me
a line to Venice, please* – and tell Con I should like another letter
– only she need'nt tell me "Paca has become so very naughty" for I
know that, sympathetically – if I see any gentlemen in flowered
sashes at Venice I'll write and tell her about them. – Yes – you'll
miss her – I would'nt have kept her so long – if I had been you – I'm
glad you've got a nice young Lady Swinburne for a neighbour –
How are those nice, not old, but not young, ladies who live in the
house with the shepherdess portrait?[4] Remember me to Miss Colling-
wood, devotedly – and to Mr [Alfred] Trevelyan – & to Mr Scott.
– Love to Con, and to Sir Walter. Kindest regards to Mr Wooster –
Ever affectionately Yours

<div align="center">J Ruskin</div>

Or you may [send] one first to post restante Geneva – I'm not quite
sure yet if I go or not.

[1] In his *Diaries* Ruskin assigns this letter to 'October 2nd Friday. Wrote to Wallington'.

[2] Nothing was done with the ground, which was eventually sold.

[3] He had told his father that he would like to see Rawdon Brown to 'talk over bachelor life with him', and Panno the gondolier, to whom over a period of years Ruskin was generous in sending money. To Ruskin Tintoretto's *Paradiso* (Ducal Palace) was his masterpiece.

[4] Emily Elizabeth Broadhead had recently married the new Baronet, first cousin of Algernon Swinburne. The two middle-aged ladies are unidentified.

166

[Winnington, 30 November 1863][1]

Dear lady Trevelyan

I've been going to write to you day after day – I should'nt have written now – perhaps – though I was wanting to – very heartily – but I've just written the enclosed scrap for my father and afterwards changed my mind and thought it would scandalise my mother too much – & had better not go – but it may amuse you a little[2] – though it will only confirm you in your unfavourable impression of Miss Bell – for the present – but I'll get it out of you – for it is quite wrong. That letter you read of her's only seemed to flatter me so ungracefully because she knows how much at present I need the strongest expressions of praise to keep me merely alive – she knows how disgusted I am with my work, and myself – & how hopeless, and that I have not vitality enough to understand reserve, or care for it, – that I must be fed with fat and all sorts of unwholesome sweet things – merely to get me to feed at all – for a little while. I daresay she finds it terribly hard & disagreeable work[3] – I know she would not do it if I did not need it – but I get conceit enough when I come here to live by for another year or so – So the children are allowed to do anything in the world that will amuse me – she would not let them act before any body else except their parents – and among themselves.

– I have'nt time to write another word to day. I'm a little better – but fatally listless & heartless in this foggy England – not absolutely so gloomily depressed however as by myself.

Ever affectionately Yours

J Ruskin

[1] On leaving Chamonix Ruskin had spent a month sketching in northern

Switzerland. He was home on 14 November and at Winnington on the 23rd. During that week the Trevelyans were alternating between London and Cowley and there was probably a meeting.

² '[Winnington] Monday [30 November 1863] My dearest Father, I must be short to day. I shall have all the more to tell you when I come home. It is quite vain to try to keep up with things by letter. I enjoyed afternoon service yesterday in the chapel – the school being so full, the psalm chanting was as good as in a cathedral, & much more *meant*. What strange creatures girls are – I only wish I could have had Gainsborough to paint one of them on Friday & Sunday after-noons. – On Sunday in her plain printed dress – very intent – at least apparently so, (and I believe really so –) on her chant – looking as simple as our charity girl of Hunt's, and rather short of stature: and altogether inconspicuous – subdued – gentle – & childlike. On Friday, this same girl – not quite 16 played me the prin-cipal lady character in Molière's "Précieuses Ridicules" – with four or five of the other children for the other parts. It convinced me at once for one thing that the costume of Reynold's time – artificial as it may seem – is beyond all yet invented for giving dignity & brilliancy to women – even the plainest of the girls became striking in it: – The rest acted well, but I felt that they *were* acting, but this *one* peculiarly simple looking child, *became* actually a quite dazzling "Grande Dame" – her fan – her hoop – her towering hair, all managed as lady Waterford would have managed them – and her character assumed with absolute mastery – or mistress-hood, & ease, and good taste, no french actress could have been more piquante – no French princess more graceful. Miss Bell is a good deal frightened for her, as this peculiar gift of external bearing is a terrible power & temptation if it is not associated with very sterling inner qualities – and it will be very difficult to give this child due balance within for her without. But Miss Bell has long known practically the truth of my great educational principle – that whatever a child's gifts may be – you cannot educate by repressing – but by guiding their exercise – nor can you change them for others.

Dearest love to my mother.
Ever my dearest Father
 Your most affe Son
 J Ruskin.'

³ Though admirable in many ways, not least in the manner in which she managed Ruskin's life at Winnington, Miss Bell was aware of the expedience of retaining his patronage.

167

[? January 1864]¹

Dear lady Trevelyan

Thank you – the face-ache is better, all my ailings are summed in one – languour – or death-defused. – "Mortification" literally – always doubling on itself from vexation & sorrow at itself.

I do nothing except a little mischief I suppose here & there – Yes, I

was quite spoiled at Cowley[2] – I never saw anything approaching the child's [Lollie] work, except Turner's in perfectness of manner – if he lives, which it's no use saying God grant (for if it pleases God I suppose he will and if it doesn't he won't) I look for such pleasure in my old age as I had in my youth – (the hope only wanting –) but the pleasure of his work to me will be a renewal of the old feeling. The *letter* was very beautiful.

Yes – those chalk streams are wonderful – no Alpine water purer. I should have liked the fish in the clear water. That *is* the natural state, and that they should come to be fed like chickens. The *un*natural state is to have the streams made drains of – and the fish driven to skulk in the holes. . . [Letter incomplete]

[1] Ruskin returned home on 19 December. The Trevelyans were at Seaton where they remained until the spring.

[2] Ruskin appears to have gone to Cowley and seen the Hilliard children; a report of his health was sent to Lady Trevelyan.

168

[Probably January or February 1864][1]

Dear lady Trevelyan

Thank you so much for sending me that letter. It made me laugh, loudly too, and it was something to do that – for I had just heard that we shall never have any more grapes nor plums – nor hawthorn boughs – come spring when it may.

No. I don't think Con is jealous of Laurie – is it not nice his saying she "would be in such a rage" at the suspicion.

– What a difference there is between noble & ignoble people in the matter of their anger. Do you know – I was not quite pleased with Con's own look – in health. When I was down there she seemed so much more languid than in Northumberland.

I am not well, of course – never well now. Life brings such heaps of things one can't do – or be – or know – My father & mother have both been sharply ill, both are better.

I wish You would bring up that fisherman's book with you. It would really do me good I think – to put it in some order myself & I've hardly any doubt but that [George] Smith [Elder & Co.] would publish it & be delighted. Think of the best way of managing it – in treatment and tell me. I began writing down the lecture on geology

I gave them at Winnington but the abysses of things half known just now – and yet in the half – are million fold more than one's old whole-knowledges – swallow one quite up – & I can't go on –

 Ever affectionately Sir Walter's & yours

<div align="center">J Ruskin</div>

<div align="center">see over</div>

Mrs Carlyle has been all this while lying ill – getting weaker & weaker.[2]

I go over & see him sometimes he is very sad & worn.

– Everything is too sad – nothing is nice but being wicked.

[1] Date suggested from internal evidence. At the beginning of the year Ruskin had written to Froude: 'We've all been very ill, and I am still'; cf. Ruskin's reference to his parents' health in this letter.

[2] Mrs Carlyle had fallen in the road and had severely injured her hip; this together with further complications caused her so much pain that she feared for her reason.

<div align="center">

169

</div>

<div align="right">[Probably 1 or 2 March 1864]</div>

Dear lady Trevelyan

 I should have answered about the smuggler before, but have not yet been able to examine the papers – my father has been very ill and continues so – I fear mortally.[1]

 I will write again soon if there is any change, my mother understands the danger and is bearing up wonderfully as yet, but she can't & does not allow herself to – realize the thing & the grief will be horrible when it comes. I am pretty well able for helping her all I can.

I'll write soon.

 Ever affectionately Yrs

<div align="center">J Ruskin</div>

[1] JJR died on the morning of Thursday 3 March after an illness of four days. This letter was probably written on 2 March, for when writing to Acland Ruskin believed that his father had 'died on Thursday morning – *expired*, that is: he died, I should say, some time on the Tuesday night'. This would make intelligible 'I could have given you darker words even' of his next letter to Lady Trevelyan. The 'smuggler' is unexplained.

[Probably 5 March 1864][1]

Dear lady Trevelyan

I knew well enough how you would feel. I could have given you darker words, even, when I wrote that former note but wanted to soften the shock to you a little. My mother has borne it hitherto – by unspeakable sweetness and strength of heart – I think she is now, for the time, safe –

I will write to you again on Monday [7 March]

Ever affectionately Yours

J Ruskin

He was taken ill on Sunday, died at ½ past 11. Thursday

[1] The black mourning border to the writing-paper measures quarter of an inch in width.

171

12th March [1864]

Dear lady Trevelyan

I am provoked with myself for not having written before. I fully thought I had, but there has been much to do, and I am little used to doing.

My mother is entirely herself – that is to say – brave – calm – & even sometimes cheerful: I trust that the closing years of her life may in some ways be yet capable of very great happiness – much is in my power in this respect.

I am as well as I usually am – so far as I feel or know. I liked the children's letters much – & am sorry for you, & glad for Mr Carlyle & Lord Ashburton[1] and ever affectionately Yours

John Ruskin

[1] On the same day Ruskin wrote to Carlyle: 'To day I have a note from Lady Trevelyan saying Mrs Carlyle is much better' (R, 36, p. 472). The reference to Lord Ashburton is puzzling as his health was declining and he was within ten days of his death. Mourning border to paper quarter of an inch.

[Probably about 12 April 1864][1]

Dear lady Trevelyan

We are getting on pretty well. I should be very well if I could work
– but after I've pulled a flower to pieces, and one or two things up
by the roots to see how they grow, I can't do any more, for that day:[2]
and then I mope, afterwards – but I'm not worse than I was last
year. My mother is quite herself. I think if I were to get rid of all my
Turners I should be better – they torment me so because I can't get
any more. I've done nothing at your sailors book yet – but it is safe:
Rosie's so ill – you can't think – her mother sent me two photographs
yesterday – and she's so wasted away not that there was ever much
of her to waste – but there's less, now – & the face full of pain – and
she looks about thirty five[3] – and she can't eat anything but children's
meat – and she can't write me a word. Everybody's dying – I think
– at least – they would be – if one were sure one had ever been alive
– How long are you going to stay at Seaton? You could'nt come –
could you – and look after the house and the gardeners for a day or
two, while I go to give a lecture at Bradford? – No – it wouldn't do –
my mother would bore you – or feel as if she did – which is the
[? same thing. Letter incomplete.]

[1] Dated from internal evidence. At the end of this letter (mourning border 1/8
inch) Ruskin suggested that Lady Trevelyan might come and keep house while
he was away. On 9 April he had written to Bradford asking that a date might be
fixed for his lecture there. It was probably then, or on receiving a reply from
Bradford, that this letter was written. (The lecture on 'Traffic' was held on 21
April) On 19 April Joan Agnew, a young cousin ('a good cheerful girl') came to
stay for a week as a companion for Mrs Ruskin, remained till she died, and there-
after was almost constantly with Ruskin until his death.

[2] At about the same time Ruskin wrote to Mrs Cowper: 'I have been laying
down turf . . . and I've been paving a bit of gravel walk with new pebbles . . . I've
got into *a* course of investigation of Currant blossom . . . and I don't care about
the next world if there are no currants' (*Letters of John Ruskin to Lord and Lady
Mount Temple*, J. L. Bradley, Ohio State University Press, 1964, pp. 33–4). 'Work
at Currant Blossom' was Ruskin's diary entry for 14 April.

[3] Rose was then fifteen years old.

[May or June 1864][1]

Dear lady Trevelyan

Here is this mother of mine saying she wants Four Collars! – and Four Cuffs! – pairs of cuffs – I suppose! and that she does'nt mean to pay more than Five Pounds for them – Why – if they were Dog-Collars – and Hand-Cuffs – she would'nt get them for that! – However – she will have it put down in black and white.[2] – If you have profited by my last chapter – you will appreciate the "modesty" of this application – but here it is, and I can't help it.

Tell Sir Walter I'm getting my minerals into lovely order – bettering and rejecting as I can – I'm getting superb things up from Cornwall – what a good style of crystallization the rocks have got there! there's nothing like it except Andreasberg and one or two other Hartz-Goblin places.[3]

Ever affectly Yours JR.

[1] Date suggested from internal evidence. 'My last chapter' (below) referred to Ruskin's last paper for *Fraser's Magazine*, April 1864.

[2] The Trevelyans were at Nettlecombe, where Lady Trevelyan was preparing for the 'Grand Fete and Bazaar' at the South Kensington Museum in aid of the Female School of Art when she would again exhibit and sell Honiton lace made by the women of Bere. Mrs Ruskin, unable to attend, wished to place an order.

[3] The next year Ruskin made an important purchase of over a thousand mineral specimens from Cornwall. St Andreasberg was one of the chief mining centres of the German Harz Mountains.

174

22nd June [1864][1]

Dear lady Trevelyan

There's no hurry about the lace for mama – anytime within six weeks will do she says – (or said – about a fortnight ago –) Any time before September – she meant

I've had this letter about the smuggler by me ever so long – please tell me what you think of it?[2]

The idea of my coming down among the peewits and snipes again! I go to the Brit Museum every other day, & live with the (Egyptian) Gods.[3] Have you seen a clever book of rude caricatures of English travelling on the Nile?[4] the ideas are excellent – A dream of one of

the sportsmen, of the Hawkheaded & Parrotheaded (– wrong by
the way – they ought to have been Ibisheaded & Hawk headed –
there are no Parrot headed) Gods, catching hold of him & stuffing
him, is immensely nice.

 Love to Sir Walter
 Ever affectly Yours

<div align="center">JR.</div>

[1] Mourning border to paper measures 1/8 inch. The Trevelyans had arrived in
London on the 18th, and on the 22nd Lady Trevelyan was occupied in unpacking
and arranging her lace stall. She was awarded first prize for 'the best Pockethand-
kerchief of good workmanship', which she had designed herself. The opening day
was the 23rd: the Trevelyans took an early stroll in Kensington Gardens and after
breakfast repaired to South Kensington in company with Ellen Heaton, Ruskin's
friend from Leeds. The bazaar was attended by the Prince and Princess of Wales,
and Sir Walter's expenses amounted to £1 8s.

[2] The story of the smuggler of Letter 169 remains unexplained.

[3] Lady Trevelyan appears to have asked Ruskin to come to Wallington that
summer; she and Sir Walter left for the north at the end of the month. At about
this time Ruskin wrote to Lady Waterford that he had 'had a fit of mythology'
and was studying Egyptian antiquities.

[4] Unidentified.

<div align="center">

175

</div>

<div align="right">[? July or August 1864][1]</div>

Dear lady Trevelyan

Mama has got a notion that you are making some fine new
patterns & beautiful out of the waynesses for her collars: and she
wants me to say – she don't mean it and only wants what you have
by you – or what is quite commonly made. And she wants the money
sent at once – so here it is and I'm ever yours affectionately

<div align="center">J R</div>

[1] Mourning border to paper 1/16 inch.

<div align="center">

176

</div>

<div align="right">[September 1864]</div>

Dear lady Trevelyan

I knew you were very spiteful – but I really had no notion what

<div align="center">233</div>

you were capable of – till I read the sentence about the three nice girls,[1] that were – and are not.

I wouldn't have answered a word, but I'm ordered to say the lace has come, and is appreciated – which means much, and I'm to ask what my mother really ought to pay for it, because it is all nonsense that it is only worth five pounds. Also, (with your vicious letter in my pocket) – I walked up to the Crystal palace yesterday – and the third person I met was Miss Con – papa & mama being the two first. I was pleased, but Con is not growing properly – I like Mr Hilliard more & more, and your sister – for a woman, is well enough –

Thats all I shall tell you to day Love to Sir Walter – (What a life he must lead with such a wife – it makes me shudder to think of it.)

Ever affectionately Yours

J Ruskin

[1] Writing to Alice Boyd in September, W. B. Scott referred to the three girls at Wallington as Pauline Power, aged twenty (niece of Lady Trevelyan); Alice Trevelyan, 'a charming unaffected jolly girl'; and Constance Hawdon, aged fifteen.

177

[September 1864]

Dear lady Trevelyan

Are there any more nice girls to play with me down in that square well of yours?[1] I always think of it now as a dry old well – all full of nettles and weeds at the bottom.

You never answered my question about – (no, my mother's question I mean – for *I* don't expect any answers to anything –) the five pounds, but here they are and if you have over worked your poor butterfly makers for it) – it's a shame –

– I shall have some funny things to show you when you come up again – I've been drawing Egyptian beasts and such like – I'm a little better. My mother is well – and sends her love.

Love to Sir Walter

Ever affectionately Yours

J Ruskin

[1] The central hall at Wallington (mourning border to paper 1/8 inch).

[October or November 1864][1]

Dear lady Trevelyan,

I've just heard from Con that you are ill – so please write when you are well again, that I may know.

This cold weather plagues me dreadfully. I hate it and think it so unkind.

Ever affectionately Yours JR.

[1] Mourning border to paper 1/8 inch. At the end of September Lady Trevelyan fell ill and her condition became so grave that a fortnight later two doctors were summoned to Wallington at 2 o'clock in the morning. A slight improvement followed but by the middle of October she was weaker and doctors were again telegraphed for. They were able to give Sir Walter 'hopes which God may grant'. Progress was slow, but by the end of November the patient was able to use her invalid chair in the gallery above the hall.

179

[Winnington, 5 December 1864][1]

Dear lady Trevelyan

You see I know your address[2] and how naughty and like yourself you've got to be – and so I'm going to write every day again – unless you answer something impertinent – and as you can't answer civilly, I know, you had just better hold your tongue.

– I've been having such a game at blind-mans-buff – (at which *I'm always* blinded – because they say the game is blindmans; not blind-girls-) – in the schoolroom – and they laugh at me so because I never can remember, if I try ever so – who it is that has "got on" what. Then the ones that have their hair tight let it loose – and the ones that have it loose tie it into knots – and they put on each other's brooches and bracelets – and they plague me out of my poor little halfwits.

All my lecture is in a fine way – as you may think – and I've got to give it to morrow, and I can't read two words of it straight. I've got to pin it together this afternoon – and that's all I can tell you – except that I've such a nice letter from James Forbes, thanking me for the glacier letters[3] – but I'll tell you about that when you're better.

Ever affectionately Yours

J Ruskin

¹ Ruskin was to give two lectures at Manchester (6 and 14 December) and an address at the Manchester Grammar School (7 December). During this period he was at Winnington, within easy distance, except for the three lecture nights when he stayed at Halliwell Lane, High Broughton, Manchester, with Professor A. J. Scott (*Winnington*, p. 534, note 3).

² By the beginning of December Lady Trevelyan had sufficiently recovered to go to Darlington again to consult Howison. The Trevelyans stayed three weeks and made some pleasant expeditions along the banks of the Tees.

³ Correspondence in the *Reader* had begun in the middle of November with a letter from Ruskin on the conformation of the Alps; this he followed up with a further three letters. James Forbes, a friend of the Trevelyans, had published his theory on the motion of glaciers in 1843. He wrote to Ruskin on 2 December from St Andrews.

180

[Manchester, 6 December 1864]¹

Dear lady Trevelyan,

I've been saying every thing likely to be beneficial to society in general in my lecture – and don't feel as if I had any didactic remnant in me for you – not that any thing would do you any good – of course, but its too provoking to lose a day's lecturing of you when you can't answer. I think I've settled some impertinent people who write with initials in the Reader, too² – so I'm having it all my own way, for the first time in my life – & you can't think what a nice feeling it is – (what nonsense I'm writing *but I mean* – that you women – who always have your own way – can't possibly conceive what it is to any of us unfortunates to get the least bit of it. – Not that I've had too much – now I think of it, even to day, for Lily and Isabelle have been rolling me round the room on the floor, and pulling my hair over my eyes, and curling it afterwards – and pinching a great deal out.

Shall I *never* have the chance of writing a nice long letter – and telling you all I think about you – and having it out. Tomorrow will be worse than to day, but I'll let you know whether the Manchester people appeared properly impressed –
Ever affectionately Yours

J Ruskin

¹ Mourning border to paper 1/16 inch. Written after Ruskin had delivered his lecture. The early part of the day had been spent at Winnington.

² Two letters concerning alpine forms had been signed with the initials 'M.A.C.'

and 'G.M.' Ruskin replied on 5 December, adding that in future he would take no notice of letters signed in that manner. 'There can be no need of initials on scientific discussion, except to shield incompetence or licence discourtesy' (R, 26, p. 558).

181

Manchester, Wednesday [7 December 1864]

Dear lady Trevelyan

I think I gave them a tolerable piece of talk last night – some bits strong enough even – perhaps – to have done *you* a little good – if you had been there to hear them – if anything could in the least amend you –

– Perhaps – if you had been there – the sense of intractability might have been too much for me – I had some of my schoolgirls there – they sat very quiet & made no faces at me – was'nt it good of them – but that's all I can say

– I'm pretty well in voice, I find, and I had a nice shy at the Bishops, which makes me lick my lips to think of, this morning.[1]

Ever affectionately Yours

J Ruskin

[1] His lecture 'Of Kings' Treasuries' had been held at the Rusholme Town Hall, near Manchester. Though seemingly lost to the Church (though in effect its influence was lasting), Ruskin could never resist a provocative thrust at it; here his argument on episcopal power was based on a passage from Milton's *Lycidas*.

182

[Winnington, 8 December 1864]

Dear lady Trevelyan

I've had more to do than I thought to day, & must just say – that if you venture to say another syllable – I won't write for a week[1] – nor tell you any of the mischief I'm getting into – I went and made the boys a speech at the Grammarschool of Manchester yesterday and they ran after the carriage shaking hands in at the window – if Henry Acland had been there he *would* have enjoyed it so.

– But I'm just off to give my lecture on girls behaviour[2] – thats all I can say Ever affectionately Yours

J Ruskin

[1] Returning to Winnington after his lectures, Ruskin had received a letter from Lady Trevelyan. Her handwriting was probably evidence of her weakness.

[2] Having given his 'Address to Boys' the previous day Ruskin was about to read aloud to the Birds his lecture 'On Queens' Gardens' before delivering it the following week. He 'got on quite well last night [he told his mother the next day] but the room was too small, so that I could not give full force to the reading.' (*Winnington*, p. 530)

183

[Winnington, 9 December 1864]

Dear lady Trevelyan

I'm so glad you are better[1] – I'm just going to write an essay on patience – which I could never have done without understanding what it was to be plagued by provoking people – the little return of the infliction just now will be very good & helpful for me –

I've no time to day, nor patience either – but you may read the enclosed note and slip of paper (and don't give it to Tiny nor wrap his cutlets in it)[2] – and mind you put it up again nicely and seal it prettily with a forget me not or something – and post it.

Ever affectionately Yours JR

[1] Referring to the letter received yesterday. He was also able to reassure his mother: 'I have a pencil note from Lady Trevelyan herself, much better' (*Winnington*, p. 530). (Mourning border to paper 1/8 inch.)

[2] There was a long-standing joke that Tiny did a trick of unwrapping bones.

184

[Winnington, evening, 9 December 1864]

Dear lady Trevelyan

I am provoked at your getting that wretched Guardian report[1] – I assure you – if you had got a good one, it would have made you so angry, you would have thrown the bolster at Dr Howison – or thrown your breakfast out of the window – I hope next Wednesday to be nearly as mischievous – I've nothing to tell you to day: – it's school packing day: and I keep out of the way – and am dull: I hate the sound of packing now – as much as I used to rejoice in it in the days of postchaise and pair – and roadside Inns – and afternoon walks in strange places, after a long days journey of forty miles. How one used

to triumph in the thought of being forty miles north of London –
forty miles nearer Skiddaw – nearer the Tweed, nearer the blessed-
ness of moors and torrents – Now – I want to get away home to read
Egyptian mythology.

Can you read now – and what will you read when you can – The
last book of collected travellers sketches has a pleasant account of life
on Mount Sinai in it:[2]

How stupid I am – this afternoon. I've been having a violent romp,
and am giddy – how strong schoolgirls are! or at least are here –
where they spend more time in playing cricket than anything else.[3]

Ever affectionately Yours

J Ruskin

[1] The rather meagre report of Ruskin's lecture appeared in the *Manchester
Guardian* on 7 December. Mrs Ruskin also complained of it.

[2] Unidentified, but possibly *Forty Days in the Desert on the Track of the Israelites*,
or a *Journey from Cairo by Wady Feiran to Mount Sinai*, advertised in the *Athenaeum*,
14 January 1865.

[3] Miss Bell was a great believer in physical exercise and the girls were among
the first to play cricket. Ruskin later referred to her 'intense though often erring
energy'.

185

[Winnington, 10 December 1864]

Dear lady Trevelyan

I do not know how it is, but Newspapers in reporting any address
of mine, always put down little ridiculous bye sentences – of no more
weight than a cough or a "hem" – and miss out the whole gist –
often the whole body – of my most intendedly laboured pieces – I
can't send you the reports of these lectures. They shall be printed
directly in full.[1] I have made acquaintance with the pianist Hallé
and his family – So nice they are all, – his wife just like Mrs Browning
– Fancy his playing quadrille-music here one evening – for us to
dance to! After we could dance no more, he played "Home Sweet
H." with variations: I heard Thalberg play it last year – sitting close
to him and watching his hands, and I am quite certain Hallé's was
the finer rendering I never heard such a variation in my life – but
he was sadly vexed at my being so pleased – for he had been playing
Mozart sonatas to me in the afternoon[2] – and had liked my liking

them, and the praise of H.S.H. was to him (– I know the feeling so well) just what it is to me when anybody to whom I've been showing Turner looks up to a Copley Fielding and says – Oh – how pretty *that* is. Ever affectionately Yours

J Ruskin

[1] The two lectures were published in one volume in June 1865 under the title *Sesame and Lilies*, and cost 3s 6d.

[2] Ruskin had invited Charles Hallé, the Manchester pianist, to come to Winnington and play to the school but he had committed a blunder by preferring the pianist's rendering of 'Home Sweet Home' to the carefully chosen and skilfully executed selections of classical music performed for him. Writing to apologise, for Hallé had been indignant at such lack of taste, Ruskin referred to himself as a 'musically illiterate person', but went on to explain that though he did not care for the tune of the song and was prepared to agree to its being 'sickly and shallow', yet he cared 'about hearing a million of low notes in perfect cadence and succession of sweetness. I never recognised before so many notes in a given brevity of moment, all sweet and helpful. I have often heard glorious harmonies and inventive and noble succession of harmonies, but I never in my life heard a variation like that. Also, I had not before been close enough to see your hands, and the invisible velocity was wonderful to me quite unspeakably, merely as a human power.' Of the rendering of the same song by Thalberg (the Austrian musician) Ruskin had been 'entirely disappointed . . . your variation therefore took me with greater and singular surprise' (*Winnington*, p. 528). Mrs Hallé's resemblance to Elizabeth Barret Browning must have been most marked for in writing to his mother from Winnington Ruskin referred to her being 'liker Mrs Browning in face – and liker to her and me, in feeling – than any woman I've known since she died' (*Winnington*, p. 530). In their younger daughter Ruskin detected a look of Adèle Domecq.

186

[Winnington, 11 December 1864]

Dear lady Trevelyan

Do you recollect that for a long time I used to wonder why it was that every body who knew anything of writing used always to put me with De Quincey.

– I've found out now why it is – for there is a singularly parallel temper and far more scholarly and varied use of language in his work. I'm going to read his Joan of Arc to the children to night.[1] I think you would have liked to see the pleasure of the little Puritan girl of about 14. who was "very good" when she came to school four years ago, and whom I've been trying to take the goodness out of, ever since – She came into the gallery to day all aflush – she had written

to her father and mother to come to Manchester to take her to my Wednesdays lecture – and they've promised to come, to please her – and she's in a great state. And I've some other nice little pets, one Irish dark-eyed Lily – very precious in her own way – but nothing any of them like my old pet [Rosie] – and she's still ill – and cares only for her horse and dogs

– I hope there will be a better report of this lecture, but please don't trust to it Ever affectionately Yrs

<div style="text-align:center">

J Ruskin

</div>

[1] *Joan of Arc* originally appeared in the March and August 1847 issues of *Tait's Magazine*. Reprinted by De Quincey in *Collected Writings*, 1854, iii.

<div style="text-align:center">

187

[Winnington] Monday [12 December 1864]

</div>

Dear lady Trevelyan

I had a pleasant Sunday evening yesterday, reading first to the Children, de Quinceys Joan of Arc and then making them sing to me mass music. They have a fairly good organ, and they found a Jubilate of Mendelsohns which I had never heard, and found lovely – and they made all kinds of nice standing groups beside the organ as they sang.

– There now – heres been a nice pretty Northumberland girl come to say goodbye – and I don't know how I'm to get over it. She has the nicest little preRaphaelite pointed chin – and arched eyebrows – and hair that curls more gracefully than any in the school – in the quaintest little opposing waves that keep passing across each other over her shoulders – She lives half way between Morpeth and Alnwick – and her pony is called Rattles.

– I shall have to give my Wednesday lecture at Manchester without any schoolgirls – and shall feel quite outcast – Next day I am to take tea with Hallé and go to his concert with him.[1]

– I'm very stupid – and have nothing to say – Is'nt this letter like a schoolboy's? If I had been well – I should have enjoyed that talk to the schoolboys at Manchester – but I was quite tired before I got there. My mother writes to me every day! and is well – and always so thankful to hear of *you*.

<div style="text-align:center">

Ever affectionately Yours J Ruskin

</div>

I have never answered about Mrs Carlyle. She is nearly well again –
though very weak. I took tea with *both* about a month ago – He
called at Denmark Hill last week – both are pretty well.

¹ Hallé gave his concert at the Manchester Free Trade Hall on 15 December.

188

Wednesday Manchester [14 December 1864]¹

My dear lady Trevelyan

I hav'nt a minute – I've had so many goodbyes at school today,
and the girls are so pleased with my lecture on girls that they've
kissed me all to pieces – the prettiest of them make their lips into
little round Os for me whenever I like – as if they were three years
old –

– Well – I hope I shall give my lecture all the better to night – I
couldn't write yesterday.

Ever affectionately Yours

J Ruskin

¹ Mourning border to paper 1/8 inch. Ruskin had now left Winnington for
Manchester where he delivered his last lecture.

189

Manchester Thursday [15 December 1864]

Dear lady Trevelyan

I got on very well last night – speaking with good loud voice for an
hour & quarter – or a little more – reading I should say – for I can't
speak but when I am excited – I gave them *one* extempore bit about
Circasian Exodus¹ – which seemed to hit them a little as far as
Manchester people *can* be hit. But in general I find my talk flies over
peoples heads – like bad firing. I shall be glad to get back to my
quiet study and my minerals & casts of coins. These last I find very
valuable and precious, and when you come to see me again I've
quantities of things to show you – perhaps even I shall have some
flowers to amuse you – for I'm getting all the *old* ones that will grow
under our glass – and I daresay you'll find some forgotten ones,
prettier than present favourites.

242

I've given the gardener carte-blanche in ixias – amaryllis's – gladiolus's – and the lily & flag tribes generally – every thing that he can get and grow, he's to have – and *wild* roses in masses all round the garden and I've planted twenty peach and almond trees alternately – down the walk where they'll catch the spring sunsets – and I'm going to lay on a constant rivulet of water and have watercresses and frogs and efts and things; I daresay I can get as much water as that driblet of yours down the park – for twenty pounds a year, or so: and if I were as Littery as you and as fond of weeds, *I'd* have clock-leaves and everything in a mess, too – but *my* stream will be tidy.

– If I want any nettles in the dry places, you can spare me some, I daresay – I never saw any so fine as yours – anywhere.

Ever affectionately Yours J Ruskin

I find nettles always wither quickly when they can't sting any body – mind how you pack them – please (you ought to know just now how ill they feel when they're helpless.)

¹ A reference to the subjugation of the Circassians by the Russians after the Crimean War, and now their emigration from the Caucasus. (Mourning border to paper 1/16 inch.)

190

[Manchester 16 December 1864]

Dear lady Trevelyan
– I shall not perhaps be able to send a line to morrow – I may hardly get home in time for post. – would you just send me a pencil word on Sunday to Denmark Hill saying whether I must still write to Dr Howison – However – I'm getting tired of teazing you in your fallen fortunes – and I won't abuse my advantage much longer –

Ever affectionately Yours

J Ruskin

191

To Sir Walter Trevelyan
[Probably end of December 1864]¹
Unluckily I've not only promised my next presentation² but promised

it to two people, and expect to get into a fine scrape, with whichever of them has the latest promise (– I hadn't been drinking – I assure you [Paper mutilated]
With my mothers sincere regards I am ever faithfully Yours
J Ruskin

Sir Walter C. Trevelyan Bart.

[1] Mrs Ruskin's name alone appears towards the end of the letter, the implication being that it was written after her husband's death. The writing paper is without a mourning border but this has no direct significance as Ruskin was irregular in its use and by the end of the year had very nearly discontinued it altogether.

[2] The presentation was probably to Christ's Hospital (the Blue Coat school), of which Ruskin was a governor. This enabled him to make a nomination to the school at regular intervals. In January 1860 he had written to F. T. Palgrave regretting having 'just given away my presentation. I shall not have another for five years' (R, 36, p. 332). Similarly, in April 1860 he told Anna Blunden: 'I haven't a presentation till 1864 – or 65' (*Sublime & Instructive*, p. 126). Consequently, with the period for nomination approaching Ruskin found himself to have been over-prodigal with his assurances. In April 1866 Ruskin was again active in this respect and a week before his journey abroad with the Trevelyans wrote to Augustus Howell, his then secretary, inquiring how he stood with regard to his presentation to Marlborough College (R, 37, p. 667), but the above letter to Sir Walter is more likely to refer to the earlier date (1864) since in April 1866 Sir Walter would have been unlikely to have made the request by letter when within a week he and his wife were to be Ruskin's travelling companions.

192

5th Jan. 1865

Dear lady Trevelyan

That is indeed all nice news[1] – your letter came pleasantly to day, a diamond among a wheelbarrow full of gravel delivered by the postman in form of begging letters – bills, – (not the less provoking to open when they're addressed like letters, because they're little ones – one knows of the larger – but the lovely little thirty shillings worth come by surprise) – good wishes – particularly useless – (I hope the bad ones are, too) – and perfumery advertisements – I really am very glad to hear lady A[shburton] has built a house near you[2] – and that the little girl is nice and naughty and well – mind she don't take cold with that clay game of hers – I can't write much

to day being in arrears of letters – and I've several things on hand which you shall see soon

– I was down at Panshanger in early part of this week – and unspeakably disgusted by their nasty Salvators – but there's a Vandyck worth a kings ransom and a Rembrandt the finest in the world, I suppose – & some good Andrea del Sartos – and two fair Raphaels – it was like breakfasting in the Louvre one always expected the public to turn one out.[3] I told lady Cowper the public ought to.[4]

– Sir R. Murchison was there and I was glad to renew old acquaintance and we agreed about glaciers – Goodbye

Ever affectionately Yours

J Ruskin

[1] The Trevelyans were in London over Christmas and had most probably seen Ruskin. On 24 December they had looked at the outside of the newly built Charing Cross Hotel, and on the 27th had gone shopping at Heal's to 'look through stocks of furniture' for their house at Seaton. By the end of the year they were in Devon and remained there until May. (Mourning border to paper 1/16 inch.)

[2] Loo's house, Seaforth Lodge, was on a larger scale than the Trevelyans' but was completed first.

[3] On 29 December 1864 Ruskin had gone to Panshanger ('this ugly place'), the home of the seventh Earl Cowper, and had stayed two days. The visit had been arranged by William Cowper, uncle of the earl, so that Ruskin might see the fine collection of pictures. Of the several Vandycks it is not known which he preferred. There were three Rembrandts and it was probably the fine equestrian portrait (sitter unknown; National Gallery) which he singled out. Both Raphaels were of Madonna and Child (National Gallery of Art, Washington D.C.; Elkins Park, Philadelphia).

[4] Lady Cowper, daughter of Earl de Grey, was the widowed mother of Lord Cowper. She was a great talker and had a lively wit. (Lord Cowper did not marry until 1870.)

193

[March 1865]

Dear lady Trevelyan

You know it is always the old story. People will not draw and work in light and shade. The colour of these things is very brilliant & beautiful – could hardly be better, but he cannot draw a single form – knows nothing of perspective – cannot lay anything flat down – or set it right up.[1]

– I've just cut this nasturtium out of one of my note books – he ought to draw every flower in the garden so, in all sorts of positions, before he touches colour again – and then to work a light and shade drawing every day, as well as the bit of colour. – I must have my nasturtium back – because it fits into a place – What have you been doing with my Schaffhausen all the while – before you were ill I mean? Nothing? I want it back now, when you can "ketch hold on it"!!

I'm so glad to hear Mr Carlyle is enjoying himself but you ought'nt to be larking at this rate with every body, after being so ill.[2]

I'm up to all sorts of mischief – though not strong, by any means – but I think I shall make my lectures generally "unpleasant". Love to Sir Walter. Sincere remembrance to Lady Ashburton

Ever affectionately Yours

J Ruskin

[1] Probably a reference to a drawing by Laurence Hilliard. (Mourning border to paper 1/16 inch.)

[2] In early March the Carlyles went to Seaton to stay with Loo and as the Trevelyans were also guests there were many joint excursions.

194

[March or April 1865]

Dear lady Trevelyan

It is very nice to have so long a letter. Do not send the Turner, bring it with you when you come to town – or keep it longer if you would still like to work on it – I only thought of it the other day, & then it occurred to me that perhaps Tiny had got hold of it – so I asked –

Thank you for nice long account of house.[1] But I think I shall live now pretty nearly at the British Museum – I don't care about country any more – except to sketch – & that must be by wandering – But I am glad to know such places *are* to be had, if one wanted; (& I enjoyed the long letter) [Letter mutilated and incomplete.]

[1] When completed in 1866 Calverley Lodge, the Trevelyans' house at Seaton, presented an astonishing appearance, though not without a singular charm (repd. *Country Life*, 26 May 1977, p. 1398). It would be pleasant to have Lady Trevelyan's description of its black and white chequer-board exterior contrasting with the

tall trefoil windows which lent an incongruous ecclesiastical appearance to the seaside villa. Much care and thought had gone to the interior, all of which would have been recounted to Ruskin. A laconic entry in Sir Walter's accounts records the purchase of a tin hip-bath for £1 5s. (Mourning border to paper 1/16 inch.)

195

Denmark Hill.S.[1] [End of May 1865]

Dear lady Trevelyan

Ah – it's all very fine – but next time I'm in the north I shall go and live at Cambo and never go near Wallington – this is the third or fourth time you serve me so – but never mind – I've got cold and could not have seen you if you had wanted to come[2] –

Crawley will take care of the Schaffhausen, if you can give it him – but have you finished your copy of it? – Read enclosed from an Oxford friend – it is nice on both sides in different ways. Of course I say No.[3]

 Ever with love to Sir Walter
 Yours affectionately J Ruskin

[1] Ruskin makes use of his writing-paper with the new letter-heading, the address and postal district being engraved in scarlet. This was in use from May 1865 to 1868 (*Facets of Ruskin*, J. S. Dearden, 1970, p. 147).

[2] The Trevelyans came to town on 19 May and for the next ten days journeyed to and fro between London and Cowley without seeing Ruskin. They left for France at the end of the month. Ruskin had a bad cold, which prevented him taking the two or three Winnington girls who were staying at Denmark Hill with Mrs Ruskin, to see the London sights.

[3] This seems to have been an invitation to Oxford to lecture on poetry. (See following letter.)

196

Denmark Hill, S. [End of May 1865]

Dear lady Trevelyan

Yes of course its of course I've got my quiet room & a few Turners and minerals[1] and I'm 46. What should I go plaguing myself to talk to people for – Let me have a little pleasure & peace, before I die, and read a book or two – without feeling that "I must cut out that bit for next lecture". – I hate Oxford – and I don't know anything

about poetry. I only know political economy. I've got a big book to write on that, and I want to turn botany upside down – its so stupid as it is. – And I'm nearly always half asleep – I am – now.

– How sorry I am about Mrs Carlyle – I had no idea there was anything much the matter with her now[2]

– But you're both of you much too mischievous to be in any danger. I've had a horrid cold, and can't take my schoolgirls any where, – but they do well enough at home.

Love to Constance & Ethel & Lolly, & papa & mama Yes . . it is very nice of them letting you run off with her.[3]

[1] Ruskin sold four of his drawings (*Derwentwater, Warwick Castle, Harlech, St Catherine's Hill*) to pay for the collection of minerals. (See Letter 173, note 3.)

[2] Mrs Carlyle was suffering acutely from neuralgia in the arms and wrists.

[3] Ethel was a younger sister of Constance. The Trevelyans were taking Mrs Hilliard abroad with them.

197

Denmark Hill. S. [Summer 1865]

Dear lady Trevelyan

Can you tell me if this is a variety of Golden rod, or what I can't find it in Sowerby. Baxter says the stem of G.R. is angular. This is round and the leaves are jagged – not smooth edged in his drawing & Sowerbys.[1]

Ever your affectly JR

[1] In August Ruskin was keeping his garden weeded and wrote in the same month to C. E. Norton that he was 'at work on some botany of weeds'. The Trevelyans were at Wallington until October. James Sowerby was the author of *English Botany* (1790–1814) in thirty-six volumes. William Baxter, curator of Oxford Botanic Garden, was the author of *British Phaenogamous Botany* (1834–43) in six volumes.

198

Denmark Hill 8th Dec. [1865]

Dear lady Trevelyan

Are you still at Seaton I want to send you a book, in a week from this. We're all pretty well, but I was too busy to answer when you wrote.[1]

– I went to see Swinburne yesterday and heard some of the wicked-
est and splendidest verses ever written by a human creature. He
drank three bottles of porter while I was there–I don't know what to
do with him or for him – but he must'nt publish these things.[2] He
speaks with immense gratitude of you[3] – please tell him he must not
[letter incomplete.]

[1] *The Ethics of the Dust*, published in December 1865 (dated 1866) was a col-
lection of lectures on the elements of crystallisation, prepared for the pupils at
Winnington School. The Trevelyans had been at Seaton since the end of October
and remained there until March. Ruskin was a poor correspondent during the last
half of this year. In July he had told Mrs Carlyle that he had heard from Lady
Trevelyan from abroad but had not answered her letter.

[2] Lord Houghton had urged Swinburne to submit his manuscript of *Poems and
Ballads* to various influential friends for heir opinion before publication as the
lyrics seemed likely to prove offensive on moral grounds. Ruskin was one of those
friends selected to pass judgement. Lady Trevelyan had written to Swinburne on
6 December begging him to 'be wise in which of your lyrics you publish. Do let
it be a book that can be really loved and read . . . and become part and parcel
of the English language . . . You have sailed near enough to the wind in all
conscience . . . do mind what you say for the sake of all to whom your fame is dear,
and who are looking forward to your career with hope and interest.' Swinburne's
account of Ruskin's visit to 22A Dorset Street is contained in a letter to Lady
Trevelyan written on 10 December. 'Ruskin called on me and stayed for a long
evening, during which he heard a great part of my forthcoming volume of poems
. . . It was impossible to have a fairer judge . . . I can only say that I was sincerely
surprised by the enjoyment he seemed to derive from my work, and the frankness
with which he accepted it' (*The Swinburne Letters*, ed. C. Lang, Yale University
Press, 1859, i, pp. 139–40, 141). The date of Ruskin's visit differs in the view of
the participants; heading his present letter '8th Dec' Ruskin referred to its having
taken place 'yesterday'. In his letter to Lady Trevelyan of 'December 10th',
Swinburne speaks of the visit 'two days ago'. Ruskin's is probably the correct
version, though starting on the 7th the 'long evening' was probably extended into
the 8th. With the publication of *Poems and Ballads* in 1866 public abuse was so
great that the book was withdrawn. Ruskin, 'not usually averse from reading
moral lectures', stood by his opinion. 'He is infinitely above me in all knowledge
and power and I should no more think of advising him or criticising him than of
venturing to do it to Turner if he were alive again . . . In power of imagination
and understanding he simply sweeps me away before him as a torrent does a
pebble. I'm *righter* than he is – so are the lambs and the swallows, but they're
not his match.' (R, 36, p. xlix)

[3] Swinburne had cause to be grateful to Lady Trevelyan. When he was a
schoolboy she had detected in him the elements of genius and this, together with
her affection, had enabled him to confide in her and count on her sympathy. She
may also have effected his first introduction to Lord Houghton. On the day of her
death one of her last thoughts was for him. 'Lady Trevelyan was asking me about

him at half past one of the day on which she died in the twilight,' Ruskin wrote to Dr Brown (Yale), and after her death Swinburne never mentioned her name without emotion.

<center>

199

</center>

<center>

Denmark Hill. S. [Probably about
12 December 1865]

</center>

Dear lady Trevelyan

Thank you for the long talk about Swinburne.[1] I shall take sharp and energetic means with both him and Rossetti. I have some right to speak to the whole set of them in a deeper tone than any one else can.

My mother is very glad to hear that you are well – and she bids me enclose five pounds, and to say she wants, first, a veil – and then, any little thing that nobody else is likely to buy.

I am promised – some time ago however, my book, on Friday & you ought to have it by Saturday's post.

Such a lovely Providential occurrence has taken place among my friends – yesterday; a nice wife,[2] intensely loved, and very clever – and first rate manager, and everything that was nice, (only too fond of metaphysics) – having three pretty little small troublesome children, dies in bearing a fourth – Isn't it pretty? The husband is put in the push of beginning a new business of promise too – after having been very poor till now – so it is in the very nick of time –

<div style="text-align:center">Ever affectionately Yours –</div>

<center>

J Ruskin

</center>

[1] By now Lady Trevelyan had received three long letters from Swinburne, 4, 5 and 10 December (*Swinburne Letters*, i, pp. 137–142) and no doubt she now imparted the substance of them to Ruskin.

[2] Unidentified.

<center>

200

</center>

<center>

Denmark Hill. S. [Christmas-time 1865]

</center>

Dear lady Trevelyan

Would you please send me that old (not so very old neither) lady's name properly[1] I should like to send her one of these new books – she

<center>

250

</center>

might perhaps sink a little lower in your good opinion under the influence of it.

A happy Christmas to you. Rosie is in London.[2] I had such a trimming up of the garden for her to see it – She stole two crystals from the bottom of my primrose pool, – for which her mother says she has "no conscience". She is nearly well again; only must be in open air nearly all day – or bad symptoms return.

<div style="text-align:center">Ever yours affecte</div>

<div style="text-align:center">J Ruskin</div>

[1] Miss Macdonald (see following letter), but otherwise unidentified.

[2] On 10 December Ruskin had seen Rose for the first time for three years; on the 16th he saw her again at the British Museum. On 21 December Rose went to Denmark Hill, but her presence was emotionally disturbing. 'Rose is in town [he told Miss Bell] which puts me out, variously.' (*Winnington*, p. 577)

<div style="text-align:center">**201**</div>

<div style="text-align:center">Denmark Hill. S. [End of December 1865]</div>

Dear lady Trevelyan

The book is off to day to Miss Macdonald: it is very nice to think one can give pleasure that way. I never *can* believe it, somehow, but trying to believe it is pleasant.

I fancied you did'nt care about Rosie or I should have told you of her sometimes. She is very terrible just now – for at least she has *lost* nothing in the face, except spoiling her lips a little with winter and rough weather. (for she's out all day long:) and she's tall, and the kind of figure I like best in girls – and the dressmakers make the dresses so dreadfully pretty for girls just now. . so that the end of it is that I dare not go west end way – (above all not near Rotten row –)[1] above once in a fortnight or so – only I had a peep at her yesterday; and she was out here last Thursday and stole some stones out of my brook and loosed Lion whether I would or no, and petted the calf in the stable till she drove me wild: and I'm to have her to take down to dinner on her birthday next week[2] – and then I must take to my stones again, hard.

I've got some wonderful carbonates of lime lately, tell Sir Walter – I had no idea the Cornish minerals were so lovely – and I'm putting tickets on them and describing them one by one in a book, and finding out funny things.

It is a great shame of Sir Walter – not to improve by that book –
I could'nt have believed it of him

 Ever affectionately Yours
 J Ruskin

[1] Where Rose might be riding in Hyde Park.
[2] Rose would be eighteen on 3 January.

202

 Denmark Hill. S. 25th February [1866]

I am very glad to have a little note again, and the more as it tells me
such nice things of Con. I look forward with great delight to having
her;[1] only – for once like my mother, I feel it a weighty *trust* and shall
be always a little nervous lest anything should hurt her. But the
drawing is so beautiful that I know I can be of great use to her now,
so I venture the responsibility –

 I have not seen Algernon again. I was hopeless about him in his
present phase, but mean to have another try soon.[2]

I've just finished – and given a talk to the soldiers at Woolwich –
They liked it, and want to publish it in their own proceedings – but
I'm going to do it like Sesame & Lilies – it ought to be out in two
months at latest.[3]

Ned Jones is doing a drawing of me,[4] and that takes time but other-
wise I'm now free for the Spring and am trying to make out some
more of your nasty botanical scientific names, that I may upset them
all.

And I'm going on with my minerals & the like, and am pretty well,
and ever

 Yours affectionately
 J Ruskin

[1] Mrs Hilliard was going to Seaton to care for her sister who was ill, and it was
arranged that Con should come and stay at Denmark Hill.

[2] Swinburne's eccentricities and bouts of drinking were becoming uncontroll-
able. There are no accounts of further visits.

[3] On 16 February Ruskin had given his lecture on 'War' at the Royal Military
Academy, Woolwich. This was published with two further lectures in *The Crown
of Wild Olives*, 1866.

[4] C. E. Norton had sent £50 for a portrait. Ruskin sat to Burne Jones several
times in January, but by the end of March the portrait had been 'a little checked,

but is going on well' (R, 36, p. 504). Writing again at the end of the year there was a different story to tell. 'I did hope to have sent you some account of the portrait, but both Jones and I have been ill . . . and no portrait seems finishable for the present, so I have cancelled your cheque.' (R, 36, p. 521)

203

Denmark Hill. S. [About mid-March 1866]

Dear lady Trevelyan

You never send me a word now: and I can't write somehow – not knowing if you are ill or well – But Con's here and I think you will like to know how good she is, and that she is happy; and it is altogether nice. Only I wish she would begin to grow a little – and I think she wants change – and I've got a plan which is a little for her – & a great deal for myself. For I want a little change too now – and I'm so horrid that I can't bear myself alone any more – and I would'nt go, alone anywhere: but I just want to run to Venice & back in about six weeks, to look at a Titian or two – and Con's got to be very fond of my cousin Joan – and I should like to have them both with me: and if Mrs Hilliard could come too: it would be approximately proper – would'nt it! as far as running away with a clergymans wife can be proper – Do you think it could be managed? Con says that her mother wishes her to go abroad a little – but that she would'nt go herself "even when auntie asked her" – so I thought it best to consult you about it. I should like it so much – Mrs Hilliard is so nice – and the two girls would be very happy, I think – and I would take really very fair care of them all – at the inns; only they would have to mind I did'nt leave them behind – somewhere. I want to get away about the 20th or 25th of April, for May and early June. Will you please think & tell me about it

Love to Sir Walter

Ever affectionately

J Ruskin

[A blot on paper] I beg pardon – I did not see this

Denmark Hill. S. [Perhaps 21 March 1866]

Dear lady Trevelyan

How good of you to write me such a nice long letter – only I hope it won't hurt you.

I do not know any thing in which I feel the insufficiency of life and its wrongness and out of the wayness so much as in the impossibilities of saying all that one wants to say – and knowing what one ought to know, about ones friends. I have twenty letters in my pocket this morning – all of which I *should* – it seems to me answer with some care – and two or three with tender & difficult care – and I'm tired and my head will not do it – and my heart is sorry – and it seems so wrong. However the first thing is to thank *you* and say how glorious it will be if we can all go at least as far as Paris together[1] – You will be amused by my cousin, who is wonderfully capable of all. childish enjoyment – and brings out Con, in the character of Duenna and Chaperone – which is exquisite, & then to see Con herself – the first time in France! She *is* a dear little thing. I write today to Mrs Hilliard – that is to be the second letter.

I hope we *shall* be able to manage it somehow: for though I get on pretty well, I can't take any exercise here – and I believe I need change more than I know: and besides, Rosie's going away on 2nd April – and I'm afraid I shall be very bad, – so manage it for me if you can, or I shall be moping about deserted Grosvenor Street[2] – which would'nt be so healthy as Venice – Rosie is getting quite well, gradually – I'm going to have her with me at the Christie minstrels to day – and at Elijah!! next week – The Irish side of her comes to day – but the Elijah is her liking – and I hate it; but she is resolved to make me like something in it, near the end – I don't know what; and has ordered me to come, accordingly.[3] My mother has a sadly severe cold to day, but desires her love to you always – Would desire it I mean – only I have not told her of our plan yet – If we can't manage it – its no use teazing her.

Love to Sir Walter

Ever your affectionate

J Ruskin

[1] Lady Trevelyan was particularly unwell but she was resolved to go abroad and see what a change of air and surroundings might do for her. She and Sir Walter had decided to cross the Channel with Ruskin and the two girls.

² Rose La Touche was at 4 Upper Grosvenor Street with her parents. Ruskin, who had asked her to marry him at the beginning of February and had been told to wait three years for an answer, was in a state nearly bordering on mental disorder. Little of this is apparent in his letters to Lady Trevelyan whom he probably rightly conjectured was not in complete sympathy with this hopeless and tormenting passion for Rose.

³ At the beginning of March Ruskin was to have accompanied Rose to a performance of the *Elijah* but this was abandoned when she fell ill. After a visit to Northumberland she was back in London by the middle of the month. The Christy Minstrels, a troupe made up to look like niggers, had been performing every night at St James's Hall for several months; this season they had a 'peerless tenor' to render the popular ballads 'Would I were a bird' and 'I'll meet you in the lane'. On 21 March there was a 'Grand Illuminated Day Performance' at 3 p.m., which was perhaps the one attended by Rose and Ruskin. He loved the Minstrels and his *Diaries* record attendances with Lucy and Jessie Tovey, the maids at Denmark Hill; with Lily Armstrong and Joan Agnew; and Burne Jones remembered how in later years he was carried off to St James's Hall where they sat in the front row. 'The burnt-cork people anticked and shouted' while Burne Jones longed to get up and go and Ruskin sat there laughing and enjoying it (R, 29, xx). 'An afternoon to him of oblivion to the cares of life'; perhaps also a recollection of a few hours spent there with Rose in the past. The performance of *Elijah* was given at Exeter Hall on 27 March, the Tuesday of Holy week. Ruskin's dislike of Mendelssohn's oratorio stemmed principally from its association with Effie (Letter 28, note 4). Bearing in mind that Rose had asked him to wait three years before asking her again to marry him, perhaps she particularly wished him to mark the passage: 'O rest in the Lord, wait patiently for Him, and he shall give thee thy heart's desire', followed by the Chorus 'He that shall endure to the end . . .'.

205

Denmark Hill. S. [Towards end of March 1866]

Dear lady Trevelyan

It is immensely kind of Sir Walter – and I do truly hope that Baveno and Lugano, with Monza, & Luini everywhere – (one of my chief objects in going at all being to see the crucifixion at Lugano)¹ – will be more health giving than the ashes of Auvergne. Coming *down* on the Italian lakes is delicious. As for the sorrowful little fear, I hope it will disappear in a day. *I* am nearly as much unable for things as you – I like short slow days above all things – I am wholly free and at your service – to stay or go on – at any moment. I think you will find Joan [Agnew] a helpful – (not handy) – but willing and loving nurse, if ever you have to lie by for a day or two.

Neither she nor Con at all believe in these things coming to pass, yet. When they do! – I am thinking of shutting them up in some of the storeroom cupboards, till the effervescence is over.

Will you please tell me, as soon as may be, what time about you wish to leave, as I have several matters to settle. What do you want to quarrel with me for? I am quite, quite, down – and shall not be up to quarrelling till you've brought me home again – and then – you wait –

<div align="center">

Ever gratefully Yours

J Ruskin

</div>

¹ Sir Walter had now suggested that the whole party should proceed from Paris to the Italian Lakes where at Maggiore the Trevelyans would join Loo. Of Luini's picture Ruskin wrote to Norton in the summer of 1869 from Lugano: 'Observe, in passing, that the *Crucifixion* fails in colour, all its blues having changed; nor was it ever high in that quality, Luini having in it too many instruments to manage (great musician as he was) . . . Also, observe – Luini can't do *violent* passion. As deep as you like but not stormy; so he is put out by his business here, and not quite up to himself because he is trying to be more than himself. But with all these drawbacks, and failing most where it tries most, it is, as far as I know, the greatest rendering of the Catholic conception of the Passion.' But he warned Norton to first study Luini, or else the *Crucifixion* with 'its faults would be too painful to you – deficiences, I mean, for Luini has no "faults", at least, no sins, for "fault" *is* deficiency.' (R, 36, pp. 578–9, 587)

<div align="center">

206

</div>

<div align="center">

Denmark Hill. S. Good Friday [30 March 1866]

</div>

Dear lady Trevelyan

Nothing could be better for me than 23rd April, or thereabouts – I could not be ready much before, and to enjoy any spring, we should not be much later. We'll arrange a perfect system of journeying before we start. Between Paris and Dijon there's always Sens and Mont Bard, for good stopping places – and the Neuchatel line from Dijon gives command of either Simplon or St Gothard at our pleasure.

Con has been so exquisitely sweet and amusing – there's no end to her charmingness. Ever affectionately Yours

<div align="center">

J Ruskin

</div>

Love to Sir Walter

Denmark Hill. S. [Probably the end of
first week in April 1866]

Dear lady Trevelyan

I've been thinking over this plan, now that I'm getting back my
senses a little[1] – and you know, we shall have a good deal – all of us
thats nice in it – and a good deal to put up with. *I* in particular shall
have a great deal to put up with, I'm sure, and I'm not going to put
up with it, neither, if I can help it.

First of all, I'm not going to drink nasty French River water to please
Sir Walter – so he need'nt think it – and he's not to make faces at me
at dinner. I shan't be abroad after now – and I mean to be comfort-
able. – Perhaps I shall even take a hamper of old Sherry with me.

Secondly (and this is an inconvenience on your side and his) – I am
of course liable to be called home at any moment if my mother got
ill for want of me – and then I should have to leave those brats
behind for Sir Walter & you to do the best you could with. I don't
think this will happen – but its of course on the cards.

Then – and this is the main article of treaty we've got to sign – you
know – as long as I can stay (– and all the while, therefore, I hope) –
the said brats belong to me and not to you – and I'm to have them
when I want them, and you're not – and I'm to be their papa in all
respects – just as if we were travelling alone.

And accordingly, I mean to have my own set of rooms comfortably
and you and Sir Walter are not to bother me to come to table d'hote
and the like. I hate talking at all times, but chiefly when I'm eating,
because I can't chew. And I hate meeting people whom one half
knows – again & again, and I hate whole-knowing them, worse. So
there my rooms will be – and I'll have them big enough – and tidy,
and if you & Sir Walter like to come and dine with us & sit with us
& be sociable – its all right and if you won't – you'd better say so at
once and I won't go. And you shall pay for your own dinners, and
we for ours – and you shall pay for your own bedrooms and we for
ours; but I mean to have the sitting room under my own control,
that there may be no worry about it anyhow – and if I get one with
too many windows in it – for I love windows – you shall draw the
curtains when there: too much light.

My cousin went off to Ireland with Rosie on Tuesday – but I can
get her back whenever we want her. Are you likely really to keep

your time? I don't know which is nicest, of those nephews & nieces
of yours – I've *such* a letter from Con to day – only I can't send it by
post – because one never knows what might happen
– Love to Sir Walter
Ever affecty Yours

J Ruskin

[1] Rosie had probably left London on Tuesday 3 April.

208

[Neuchâtel] Thursday morning [10 May 1866][1]

Dear Sir Walter

I would have come myself to day but I thought I should only
worry you and not be of so much use as Crawley – and Emma is
not in the least wanted here and shall be with you by the afternoon
train – and perhaps I too, if I have telegram not favourable – pray
tell me exactly what you would like – and don't think of us but as
only able to be happy if we can be of some use to you in this time of
trouble.[2] You see there is absolutely no need of hurry of any sort, for
Venice is in a state of siege, and we are really as well at this lovely
place as we could be any where, – but that is a cold place for lady
Trevelyan to be ill in so that if she *could* get down, we would nurse
her here finely, and it is very quiet & bright and all that is nice for
her accessible – even doctors, I should think from Lausanne, in two
hours. I have a very dear friend at Veytaux, the widow of A. J.
Scott, who will know all about this.[3] So many thanks for the flowers,
thought upon through all your trouble.
Ever affectionately Yours

J Ruskin

[1] This was the last letter before Lady Trevelyan's death, which occurred at
Neuchâtel on the night of Sunday, 13 May. '10.45 pm (Berne time)', Sir Walter
inscribed punctiliously in his diary. (See Appendix VI.)

[2] Lady Trevelyan had been taken seriously ill during the third day in Paris.
The party, consisting of Ruskin, the Trevelyans, Joan and Con, Crawley, and
Emma the maid brought to look after the girls, had met at Charing Cross station
on 24 April, the Trevelyans having passed the night at the Craven Hotel close by
(the bill amounting to £2 1s 6d). In Paris Ruskin took the girls sightseeing; he
also accompanied Sir Walter to the rue de la Paix to see photographs of paintings
at the Prado Museum in Madrid, but being saddened by the recent death of Mrs

Carlyle and in low spirits he noted that 'The Continent is quite ghastly in unspeakable degradation and ill-omenedness of ignoble vice, everywhere' (Bembridge). After Sens to Dijon and a noisy hotel in a nearby village, and from there Ruskin took his party to the Hotel Bellevue at Neuchâtel on 7 May, while the Trevelyans decided to proceed by easy stages, stopping at the Hotel de la Poste at Pontarlier. From there news reached Ruskin of Lady Trevelyan's critical condition and on May 9 Crawley went from Neuchâtel to inquire, returning that evening with a message from Sir Walter asking that Emma might be sent to give assistance. Crawley accompanied her and took this note with him. Ruskin followed on the 11th, having risen at 4.30 to sketch the dawn, and, with Lady Trevelyan suffering great pain, they managed to bring her to Neuchâtel that day. On the 13th Ruskin wrote to Howell: 'I am entirely occupied to day by the too probably mortal-illness of one of the friends I am travelling with – but I may be yet more painfully so to morrow.' (Bembridge)

[3] Veytaux, near Montreux on the Lake of Geneva. The Rev. A. J. Scott who had died earlier in the year was first Principal of Owens College, Manchester, and had been instrumental in starting the Manchester Working Men's College.

209

Thun, 22nd May [1866]

Dear Sir Walter

I enclose you a letter just received – and in doing so – I would very earnestly repeat my assurance to you of the pleasure it would give us if we could be of any help to you when you leave Neuchâtel.[1] – It is very lovely among these hills; the flowers so wonderful that you could not but be interested in them – the sense of peace and beauty continual and heavenly. I cannot but feel strongly that it would be better for you to be here* with us and the hills than engaging in business detail at home.

Please come.

Our sincere regards to Sir Charles,[2]

Ever affectionately Yours

J Ruskin

Sir Walter C. Trevelyan

* We go to Interlachen to day, & *stay* there, I believe

[1] Lady Trevelyan was buried in the cemetery commanding a wide view of lake and mountains, at 8 a.m. on 16 May. Besides Sir Walter and Ruskin, the hotel proprietor and Dr Regnier were present, also the Rev. J. S. B. Monsell, Vicar of Egham, Surrey, who, since there was no English church at Neuchâtel, must have been there for a holiday and not doing a locum. (English church services were not

held at the hotel until the 1870s.) Mr Hilliard had been telegraphed for but did not arrive until breakfast was being taken. Upon his arrival, Sir Walter took Con to the cemetery where her father read the Church of England burial service beside the grave. The funeral expenses, including the gravestone and eight shillings for Mr Monsell, amounted to £31 14s 6d. On 19 May Ruskin took the girls to Thun. Having written this present note they set off for Interlaken where Sir Walter joined them for a few days. On the 28th Ruskin was up at 4.15 and 'bade Sir Walter goodbye'. Since leaving the Craven Hotel Sir Walter's 'Expenses of tour' had been £95; he was back in England by 4 June. A hurried line went off to Howell on 8 June from Ruskin: 'Whenever you get any letters with postmark "Harristown" forward them immediately without waiting.' (Bembridge)

[2] Sir Charles Trevelyan, married to Hannah Macaulay and recently returned from India, had come out to Switzerland to be with his cousin.

Interlachen 11th June [1866]

Dear Sir Walter

I have just received your letter, and I will take care to do all you wish at Neuchatel. My plans are now fixed day by day, and unless some accident should interfere, I hope to get home by the 5th or 6th of July; and I will soon send Mrs Hilliard a list of each days halting places, that she may fancy where we are.

I intend making a careful little outline sketch for you of that view;[1] which will be both truer and fuller than the little engraving from the photograph but I will get some real photographs also properly taken, if I find (as I little doubt) anybody able to do it: and ten of the one you have, if gettable. Yes, the cooperative system will do much good – but no final good will be done till all society is cooperative. Company against company will bring about nearly as much distress (though not as much disorder) as man against man.

We have not had good weather: but many very beautiful mornings – though we could never count upon the day – for long excursions. I have not again found so much as a blossom of the Dryas but I found Astrantia major the other day at the Giesbach, which delighted me under the lens more than anything I have examined. In the meadows of the valley of Hasli I found the common blue milkwort in luxuriance as the characteristic flower – mixed with blue and violet (two real varieties) salvia. I have stopped the wine – for the present entirely – as I wanted to make some experiments on myself also. I find myself better & more comfortable in feeling – but not nearly so

able for walking; this may be partly however from warmer weather. The children cant walk, any how; but they are both better I think in general health.

I have heard some awful things about the habit of drinking in the Oberland, from two nice Swiss girls at the Giesbach. – I would willingly join a total abstinence society *there*. The children send their dear love, and I am ever affectionately Yours J Ruskin

You may like to look at enclosed line from lady Waterford.[2] My love to Mr and Mrs Hilliard always. I hope to write soon to Mrs Hilliard now but fine weather has come – and I'm out all day – Not thinking less of her, however. Constance is *very* well and happy this morning 12th June – the Jungfrau is pure in cloudless light. We shall dine at one – and go up – as we should – pure waterdrinkers – to the valley of *Lauterbrunnen* – to tea. It's a pity (I think) even to put tealeaves into those springs

[1] Ruskin returned to Neuchâtel for the day on 30 June to make a pen and ink sketch of Lady Trevelyan's grave (at Bembridge). He used this as a guide for the smaller drawing touched with blue wash, the convolvulus in the foreground being executed in careful detail. This drawing (at Wallington) he completed in England later in the summer.

[2] Partly quoted in Letter 161, note 3.

211

Denmark Hill, S. 4th August 1866

My dear Sir Walter

You must be surprised that you have not yet received your drawing but I have been very far from well since I came home, and when I am languid or anxious I cannot draw with the least power, and so delayed setting to work, but I am a little better now, and have begun the drawing to day, and you shall soon have it.[1] It is only an outline sketch – that has careful detail in it, and will I hope be more interesting to you than the photographs which are not taken precisely from the spot. The ground was still much in weedy disorder about the stone, so that it will not be well to take the photographic views yet: – I liked it better so however – because the wild convolvulus of the Jura had turned itself all round the foot of the stone.

My mother has been making me anxious lately and is confined to

bed to day by bleeding at the nose, but she has had this before and it is perhaps better it should be so than that the blood should over-charge the vessels of the head.[2]

I fell in the other day with the ten first volumes of the "Flora Danica" I never saw such lovely flower drawing, nor anything near it – do you know the book?[3]

Ever affectionately Yours J Ruskin

[1] Ruskin was home on 12 July. On 2 August he started on the drawing of the grave, but was not pleased with it. On the 14th he was 'drawing for Sir W. Trevelyan; and moping variously', and on the 19th 'working on Sir Wr drawing'.

[2] On 5 August, while Ruskin was entertaining Carlyle and Thomas Richmond to dinner, Mrs Ruskin was in bed and unwell. The next day she was up.

[3] *Icones Florae Danicae*, a series of engravings of flowers from Scandinavia, published in numerous volumes the first of which appeared in 1794. Ruskin had bought his at Quaritch on 23 July.

212

Denmark Hill. S. 3rd Sept. 1866

My dear Sir Walter

Thank you for your letter. Your drawing has been done this week, but I could not find a frame to suit it, and had to have one made – I hope it will be fairly sent off tomorrow.

I saw the Hilliards on Friday – they had horrible weather in Scot-land. I am glad to have them back again here, within a drive of me. I have no one now who cares for me so much, since that day of May at Neuchatel.[1] Can you remember anything of your friend the pro-fessor of botany who edited that book – Either he, or his subordinates, indeed in a measure both – *must* have been extraordinary people[2] – I never saw anything at all approaching the book, for unobtrusive perfectness.

I hope the drawing will reach you safely – the few people who have seen it seem to think it pretty.

I wish I could have done you a coloured one – but I can only paint slowly and on the spot.

Ever affectionately Yours

J Ruskin

Sir W Trevelyan Bart.

I forget how you felt about the Jamaica business.[3] Carlyle is nearly

alone on the defence committee just now – with me for his henchman – I cannot, by any effort at this moment recollect what you thought – if you *could* join us, we should be grateful.

[1] Ruskin became very fond of Mrs Hilliard. In 1872, writing nostalgically to Dr John Brown of the days at Wallington which he looked back to 'with more and more thankfulness for them', he declared that 'I could not say she [Mrs Hilliard] was less than Lady Trevelyan in anything, – certainly not in kindness, for she is now my chief comfort, and helps me in all sorts of ways . . . and scolds me when I am wrong, and laughs at me when I am foolish, and is still her sister to me, though no one can ever be her sister to me.' (Yale)

[2] There were many editors for the many volumes of the *Florae Danicae*.

[3] In late 1865 the Governor of Jamaica, E. J. Eyre, had approved the sentence of death on a coloured man thought to have been guilty of inciting a negro insurrection. At home the 'Jamaica case' gave rise to tremendous controversy. When Eyre was threatened with dismissal an 'Eyre Defence and Aid Fund' was raised in England and was joined by Carlyle, Dickens, Charles Kingsley, Tennyson, and Ruskin, who donated £100. On 3 and 5 September he noted in his *Diaries* i. 'Up early, thinking for Governor Eyre.' 'Doing my duty as well as I can for Governor Eyre.' These entries referred to a speech he made to the Fund's committee on 7 September. Sir Walter Trevelyan ranged himself with the 'Jamaica Committee' on the other side in company with J. S. Mill and Huxley.

213

Denmark Hill. S. 10th Sept. 66

Dear Sir Walter

Sincere thanks for your kind note – The botany I meant was not Sowerbys but the Florae Danicae and the professor I wanted to know was the Swedish or Norway one, but I am glad of your account of Sowerby too.[1] It is to me a very wonderful – very pathetic fact as bearing on party-feeling in England that an English gentleman of your rank and character should be able to suspect another English gentleman, of Eyre's antecedents[2] – of hanging a man with greater haste, or satisfaction, because he was his political opponent.

The question is not at all whether Eyre was, or was not – "the last man who *should* have done it". The question is, whether he was not the *only* man who *could* do it – and whether or not it had to be done.

Ever affectionately Yours

J Ruskin

[1] For Sowerby's great work see Letter 197, note. Sir J. E. Smith wrote almost

all the descriptive texts for the 2,500 colour plates. Sir Walter must have had a particular interest in Sowerby who came from an old border family, for not only was he a naturalist like himself, but was interested in mineralogy and fossils.

[2] Eyre, son of a Yorkshire clergyman, had emigrated to South Australia, where he aided and protected the aborigines. Later he became Lieutenant-Governor of New Zealand.

214

Denmark Hill. S. [10 October 1866]

Dear Sir Walter

Can you kindly tell me the name of this flower. It is so lovely when fresh and bright. Its seeds come with some of Nigella Hispanica. Connie is here for a few days and sends her dear love – Joan's too.

Ever affectionately Yours

J Ruskin

[1] The letter is endorsed (probably in Mr Wooster's hand): 'Leptosiphon [word illegible] – California'.

215

Corpus Christi College, Oxford [? 1872][1]

Dear Sir Walter

I am here, as the Duke says (when he gets shot) in the Duke's motto[2] – and little able to go elsewhere, but am glad that you think of me. I would fain come & see you. But old things are past away and all things – for both of us become new – and we must be content I'm afraid with thinking kindly of each other.[3]

Ever affectionately Yours

J Ruskin

Sir W. Trevelyan Bart.

[1] Following upon his appointment as Slade Professor at Oxford in 1869, Ruskin was elected to an honorary fellowship at Corpus Christi and had been given rooms in the college in 1871, though he did not make use of them until February 1872.

[2] *The Duke's Motto* was a melodrama adapted from the French by John Brougham, in which the Duke of Nevers, being shot in an ambush, reiterated his motto: 'I am here'. The play had been first produced at the Lyceum in January

1863 with Fechter in the lead, and had been revived in 1867, when Ruskin attended a performance on 30 March. It is not known whether he or the Trevelyans had seen it in 1863 but Ruskin was seemingly aware that Sir Walter was familiar with the play.

³ They never met again, but Ruskin's memory of Lady Trevelyan remained undimmed. 'That loving, bright, faithful friend . . .'.

APPENDICES

Appendix I

(Letter from Lady Trevelyan to Dr John Brown
October 7th [? 1852])

I have seen Turner several times – & have been in that wonderful old house – where the old woman with her head wrapped up in dirty flannel used to open the door, & when she vanished at last, another old woman with the same dirty flannel about her head, replaced her and where on faded walls hardly weather tight – and among bits of old furniture thick with dust like a place that has been forsaken for years, were those brilliant pictures all glowing with sunshine and color – glittering lagunes of Venice foaming English seas and fairy sunsets, all shining out of the dirt and neglect, and standing in rows one behind another as if they were endless – the great Carthage at one end of the room – and the glorious old Temeraire lighting up another corner – & Turner himself careless & kind and queer to look upon – with a certain pathos under his humour, that one could hardly miss. The Man & the place were so strange and so touching no one cd forget it all who had ever seen & felt it. The first time I saw him I remember it was not long after Wilkie's death, and I cannot forget the tone of feeling with which he alluded to it.

Appendix II

My dear Acland

You have probably expected my promised letter with anxiety. I have been resting a little – after a period of much trouble – and keeping my mind as far as possible on other subjects – but I cannot delay longer telling you what you must wish to know.

I married because I felt myself in need of a companion – during a period when I was overworked & getting despondent – I found Effie's society [could] refresh me & make me happy. I thought she loved me – and that I could make of her all that I wanted a wife to be. I was very foolish in thinking so – but I knew little of the world – and was unpracticed in judging of the expression of faces, except on canvas. I was especially deceived in the characters of her parents, whom I thought straightforward & plain kind of people, but who were in reality mean, and designing. A fortnight before our marriage – her father told me he was a ruined man, – having lost all he possessed by railroads, and being some thousands of pounds in debt. I never expected any fortune with Effie – but I was surprised to hear this; and the fortnight spent in Edinburgh and at her fathers house before marriage was one of much suffering and anxiety – for *her* especially – who saw her father in the greatest misery about his future prospects, and was about to leave him, with a man for whom as it has since appeared, she in reality had no affection. I did what I could to support them all; but Effie appeared sadly broken by this distress, and I had no thought in taking her away but of nursing her – I never attempted to make her my wife the first night – and afterwards we talked together – and agreed that we would not, for some time consummate marriage; as we both wanted to travel freely – and I particularly wanted my wife to be able to climb Alps with me, and had heard many fearful things of the consequences of bridal tours.

But, before three months had passed – I began to discover that I had been deceived in Effies character. I will not attempt to analyse it for you – it is not necessary for you to know it – nor is it easy for me

to distinguish between what was definitely wrong in her – and what was disease – for I cannot but attribute much of her conduct to literal nervous affection of the brain – brought on chiefly I believe by mortification at finding that she could not entirely bend me to all her purposes. From the first moment when we married, she never ceased to try to withdraw me from the influence of my father & mother – and to get me to live either in Scotland – or in Italy – or any where but near *them* – and being doubtless encouraged in this by her parents & finding herself totally incapable of accomplishing this set purpose, mortification gradually induced hatred of my parents, and, at last, of me, to an extent which finally became altogether ungovernable, and which is now leading her into I know not what extremes.

I do not think that many husbands could look back to their married life with more security of having done all they could for the sake of their wives than I. Most men, I suppose, find their wives a comfort, – & a help. I found mine perpetually in need of comfort – & in need of help, and as far as was in my power, I gave her both. I found however that the more I gave, the less I was thanked – and I would not allow the main work of my life to be interfered with. I would not spend my days in leaving cards, nor my nights in leaning against the walls of drawing rooms. Effie found my society not enough for her happiness – and was angry with me for not being entertaining, when I came to her to find rest. Gradually the worst part of her character gained ground – more especially a self-will quite as dominant as my own – and – I may say it certainly without immodesty – less rational. I found with astonishment & sorrow, that she could endure my anger without distress – and from that moment gave up the hope of ever finding in marriage the happiness I had hoped. Still until very lately I thought something might happen to make her if not happy in her lot – at least patient in it; I thought her too proud, and too clever, to sacrifice her position in any way, and was content to allow her to find what enjoyment she could with the acquaintances or friends who were willing to take her society without mine; or with those whom she chose to invite to the house – so long as my own room was left quite to me. The disappointment was no sudden shock – but a gradual diminution of affection on both sides – soon leaving on her's, none, – on mine, nothing but a patient determination to fulfil my duty to her & to be as kind to her as I could – We still, at intervals, had some happy times

– and when Effie was with people whom she liked, she made herself agreeable – so that the world thought we got on pretty well. I was desirous it *should* think so – if possible – and would have borne – and have borne much, in order to prevent Effie from exposing herself – but all in vain.

– The loss of my wife – for such – indeed it was, did not tell upon me as it would upon another man. I married because I wanted amusement, not support: I was prepared to protect & cherish my wife but I never leaned on her – the staff proved rottenness without staggering me – My real sorrows were of another kind. Turner's death – and the destruction of such & such buildings of the 13th century, were worse to me, a hundredfold, than any domestic calamity. I am afraid there is something wrong in this – but so it is; I felt, and feel – that I have work to do which cannot be much helped by any other hand, and which no domestic vexation ought to interrupt. – & I have always had the power of turning my mind to its main work & throwing off the grievousness of the hour. But one thing tormented me much: The more I saw of my wife – the more I dreaded the idea of having children by her, and yet I felt it my duty to consummate the marriage whenever she wished. I straitly charged her to tell me if she thought her health suffered by the way in which we lived: – but it fortunately happened that at first she dreaded rather than desired consummation – and at last, seemed to have no feeling for me but that of hatred. For my own part I had no difficulty in living as we did, for her person – so far from being attractive, like her face, was in several respects displeasing to me.

During the last year, however, the evil came to its head. Provoked beyond measure at finding that she could not change me – mortified at the passing away of her first beauty – and incapable of finding any enjoyment in the life she was compelled to lead, her passions seem entirely to have conquered her reason, and a fixed mania to have taken possession of her – a resolution to get quit of me some way or another – and to revenge herself upon me at the same time – for all the suffering which her own self-will had caused her. I hardly could have believed in the existence of ingratitude so absolute – so unconscious of itself – so utterly shameless and horrible. I said I would not analyse her character to you. But it is perhaps right that you should know the impression which it has left on my own mind – Have you ever read Miss Edgeworths Leonora? – Effie was, as far as I could judge – the "Lady Olivia" of that novel – (with less

272

refinement) – mingled with the Goneril in King Lear: – (always excepting *actual* criminality – of which I do not in the least suspect her). False herself – she could not in the least understand my character, and mistook my generosity for simplicity, and my frankness for cunning. Casting about for some means of obtaining her liberty, she seems to have fancied that my offers to consummate marriage were mere hypocrisies – and that I was incapable of fulfilling the duties of a husband. She never informed me of this suspicion – but having arranged with me to pass this summer in Scotland with her father & mother, told me the evening before she left that "she had laid her plans, and was too clever to be beaten by *me*." – I never condescended to enquire into her plans; but saw her to the railroad the next morning. That afternoon, I received a citation to the ecclesiastical court in her name, on a charge of impotence. – and discovered that her father & mother had been in London for some time, arranging the plan with her. She sent back her marriage ring to my mother the same afternoon.

I at first intended simply to state these facts in court; but I have on reflection come to a different conclusion – I have given you my entire confidence – you are at a liberty to tell Mrs Acland if you wish, But *no* one else – excepting Sir Walter Trevelyan – from whom also I have no secrets. But as respects the courts – I mean to make no answer and see what they can do. If Effie *can* escape with some fragment of honour – let her; – so that I am not forced to speak, I will not expose her; But I do not know what the issue may be. The one thing which is of course decided is that I receive her no more. I believe she is informing every one who will believe her that I am a villain – so at least I hear from Scotch friends. Let her do her worst. I shall go on with my work – whether people speak ill or well of me – and time will do the rest.

I am writing in the Hotel d Angleterre at Rouen. Tomorrow I hope to be at work at ½ past six, drawing the cathedral south transept. I am going on to Switzerland; I hope to be in England early in the autumn. Meantime – when you have time to send me a line, I shall be grateful.

Her father – as you may perhaps know – is a lawyer – and she has probably given him such accounts of herself and of me as may have led him to hope to get large damages – which would be very useful to him. I am sorry to have even to occupy your thoughts with these mean and miserable things – but whatever pain it may give you to

hear them – do not vex yourself about *me*. It is well for me to have seen this side of human nature. It has not made me less trustful of other kinds of human nature – nor I hope, has it lowered my own habits of feeling. On the contrary, I see now that many things which I was disposed before to look upon as innocent are in reality dangerous or criminal, and I hope I have gained from the last six years of my life, knowledge which will be useful for me till its close.

One thing you ought to know – I need not caution you respecting the necessity of silence respecting it – but I think half confidences are no confidences. I have, myself, no doubt that Effies sudden increase of impatience and anger – and the whole of her present wild proceeding is in consequence of her having conceived a passion for a person whom, if she could obtain a divorce from me, she thinks she might marry. It is this which has led her to run all risks, and encounter all opprobrium. If you write to me, direct to 7 Billiter St. it will be forwarded.

My sincerest regards to Mrs Acland. Believe me always affectionately yours,

<div align="center">J Ruskin</div>

[On the envelope] I have omitted to say that Effie had no excuse, such as some daughters in law might have had – in the conduct of my parents to her. They exercised the most admirable kindness & forbearance towards her throughout aiming only at making her happy & good – if possible, and restraining her in nothing that it was in their power to grant her. I am going to write to Sir Walter Trevelyan but I want to give him just the information I have given you – It would save me the trouble & pain of writing another letter like this to him if you would send this to him at *Wallington*, Morpeth, for him to read.

Appendix III

Newcastle 12 May 1856

My dear Sir

I am going to begin a work in which you will, I hope, be somewhat interested. Lady Trevelyan has proposed that I should write you about it. I have undertaken to paint the Hall at Wallington. Enclosed is a memorandum of a compartment of the wall, and on looking at it and reading this, will you please, give us any suggestions or advices that may suggest themselves to you.

You probably recollect that the lower parts of the two sides of the Hall are pannelled, the two ends are open arcades like the upper portion all round. These pannels are to be occupied by pictures, the lunettes above them by landscapes. The pictures are to be four historical (Northumbrian) subjects and four Northumberland Heroes exhibited in some event of their lives. The landscapes to have relation to the histories.

Between the pannels are pilasters, on which I propose an upright native plant full size as the foxglove the bulrush corn of different kinds, &c a sufficient number of which may easily suggest themselves. In the spandrils above the pilasters the spreading leaves of a native tree will enter every part leaving only a medallion in the centre for the head of a lesser Northumbrian worthy. The long course under the bannisters to be occupied by ivy, & other running creatures. (The trees mentioned above by the bye to be oak, mountain ash, beech, elm, &c) The upper pilasters to be merely pannelled, but the second tier of spandrils to be filled, although less densely either with foliage like those below or arabesques.[1] The propriety of the arabesque taking the place of natural foliage as we approach the roof appears very great to me, as the stuccoed Roman mouldings and pateras are all that I would recommend to be strongly painted on the soffit and overhead, thus the arabesque would harmonize the upper and give value to the lower parts of the work. However the upper spandrils might be filled with natural forms and the arabesques confined to elsewhere. Sir Walter & Lady Trevelyan seem to incline to nature

275

entirely to the exclusion of the arabesques. This is one subject of question the propriety of landscapes is another.

Having given you the rough sketch of the plan perhaps you will think over it a little and do us good. Of course any question about particular treatment of parts is for after thought. Although it is to be the work of time, meanwhile in the first enthusiasm of opening the scheme we wish to have a fixed idea. Lady Trevelyan desires me to say she has so long expected a letter from you, she has given it up as useless. Yours very Faithfully W. B. Scott.

¹ The decoration of the central hall followed closely the proposed scheme, except for the second tier of spandrils. Here during the years 1864–7 Bell Scott painted scenes from Chevy Chase, but they were not in place until 1868, two years after Lady Trevelyan's death.

<div align="right">

Bath Hotel Tynemouth
Thursday [May] 22nd [1856]
</div>

My dear Mr Scott

The enclosed came yesterday. Mr Ruskin was at Amiens when he wrote, on his way to Geneva. He was quite knocked up, so is obliged to be absolutely idle for some time. He says in his letter to me that even if he were well he does not think he could help us. He says he likes the plan very much . . .

 With kindest regards
 Yrs very sincerely P. J. Trevelyan

<div align="right">

[Amiens, presumably 17 May 1856]
</div>

Dear Mr Scott

I am quite *vowed* to idleness for a couple of months at least and cannot think over the plan you send – for I am as much in a fix as you are about interior decoration – but incline to the *All Nature* in the present case – if but for the experiment. The worst of Nature is, that when she is chipped or dirty, she looks so *very* uncomfortable, which Arabesques don't. Mind – you must make her uncommonly *stiff*. I shall most likely come down & have a look when I come back in October.

– So get on – that I may have plenty to find fault with – for that I believe, is all I can do. Help you I can't – but am always truly Yours
 J Ruskin

Appendix IV

Our address is
Seaton near Axminster Nov 12 1857

My dear Mr. Scott

. . . About the Union frescos[1] – as soon as I got well of my cold I went there every day for it was most delicious to see them going on – They will be very fine and striking, *I hope they will last*. They are very high up – at the top of a lofty room – first there is a pretty high range of bookcases – then a gallery on a level with the upstairs rooms. Above that another range of bookcases – then the frescos – & then the highpitched roof which Mr. Morris is painting in *dark* colors & with that sort of northern grotesque of twining serpents &c – very ugly – unnecessarily ugly I think, but some of the frescos are most noble things – and I do beg, and insist that you give yourself two or three days at Xtmas to come and see them – I am sure it would be worth your while, and put you into spirits. The figures are much larger than life – They are painted on a very thin coat of whitish plaster (hardly more than whitewash) over the rough brick & mortar wall – some are almost on the brick – *that* & the room being lighted with gas – makes one wonder how long they will last.[2] Of course they are very rough bold work. Rossettis is a most glorious piece of color, & very beautiful besides. It is where Sir Launcelot comes in sight of the Holy Grael,[3] but cannot reach to it, by reason of his love for Guenever & falls asleep, & sees Guenever under an appletree –In one corner Launcelot is sitting fast asleep – and the Queen & her appletree occupy the middle of the picture, in the other corner the Holy maiden of the Grael is kneeling, & there are a circle of the most lovely Angels heads round her. I don't think anyone ever invented more divine ones, & angels below are pulling the bell (as in the Tennyson). The grand Queen, & the holy maiden, & the angels are really splendid, & the color is like flowers or fresh fruit with the bloom on. Next to it is Mr Princep's[4] (that youth who has lived with Watts so much), the knight who is leaving the faithless Lady for the Lady of the lake – (or vice versa, for I am not up in the old Morte d

Arthur). The figure of the lady who is being left is full of touching entreaty. The knight's head is fine & manly the rest of him wasn't painted. There are several others not so good & too many to describe. You would be amused at Palamon [Tristram] in his garden of sunflowers[5] – & the fair Iseult so hideously ugly that even the PRBs themselves can't stand her, & say she must be done over again – but Mr Jones has a most beautiful figure of an enchantress with a lute, enticing Merlin into a wood[6] where there is a little well and rushes &c – very nice – the lady is really very fine, something in her reminds me of yr etching of Fair Rosamund, & yet she is not very like.

Hughes has painted Arthur conveyed away in the boat, over the moonlight lake, & Sir Bevedere throwing Excaliber back into the water.[7] I like it very much, but Mr. Ruskin does not[8] he thinks it is not decorative enough and that a moonlight & an effect of light was not suitable, which perhaps is true, but it seems needful to complete the story, & the quiet of it seems to me pleasant & reposeful among all the blue skies, red haired ladies, and sunflowers. Several of the mourning ladies are very pathetic.

I am afraid I have told you very little that you want to know about the whole thing, but you really must run down & see it, for it is so fresh and unlike other things, and so characteristic, and so queer – that it excites and delights one immensely. Of course it affords an unlimited field for criticisms – and has plenty of shortcomings, but it is eminently delightful and I know you'll consider the time well spent to come & see it. You can easily get to Oxford in a day from Newcastle . . . How I long to see *Bede*[8] – I don't think that anything at the Union suggests anything to us about spandrils – or otherwise.

[1] These were scenes from Mallory's *Morte d'Arthur* begun in the summer of 1857 and painted on to the upper walls of the Debating Hall of the new Union building. D. G. Rossetti was the prime mover in the scheme, and his six artist companions were William Morris, Edward (Burne) Jones, Arthur Hughes, Valentine Prinsep, Spencer Stanhope, J. Hungerford Pollen.

[2] The rough brick walls and the wet mortar had only a thin coating of white-wash. The artists were inexperienced in mural painting and by June of the following year Scott found them already 'much defaced' by dust, dirt, and gas smoke.

[3] *Sir Launcelot's Vision of the Sanc Grael.*

[4] *Sir Pelleas and the Lady Etarde.*

[5] *Sir Tristram and La Belle Yseult,* by William Morris.

[6] *The Death of Merlin.*

[7] *The Death of Arthur.*

[8] Scott was at work on the third large painting for the hall: *The Death of the Venerable Bede.*

Appendix V

(From a brown notebook measuring 2 × 3 inches.)
April 12th 1859

Mr Ruskin said the other night: 'If you wish to write a good novel you must accumulate material by studies from nature and then set the imagination to work at it just as you would as a subject for a picture. Go and live a year in any village, gossip with every body, be every bodys confidant, be here and there, every where &c. Throw yourself completely into other peoples interests, so as to understand them – & at the end of the day write down exactly what you have heard & seen & in peoples own words as closely as you possibly can – give up your time & memory to it entirely and at the end of the year you will have material for half a dozen volumes – then comes the task of the imagination, to handle it, play with it, mould it to a work of art. In some such way as that a good novel must be written.'

Now I do not know how far any occupation & my sometimes moving from home may allow of this but I mean to try at least something of the sort in the way of collecting material & if I get nothing but the amusement and the exercise of observation & memory for my pains, it is something. I often long to see a real story of real life not melodramatized in any way, but a real true story and I think one must write "A year of my life".

Appendix VI

Neuchatel 14th May 1866

My dearest Mother

It is all past, and our good lady Trevelyan rests here, until she is called to a more perfect – it can hardly be a more heavenly, rest. I was with her and Sir Walter to the last: he would not have me leave the room – From eight to ½ past ten, last night her *apparent* suffering was terrific; and more and more so every moment to the close, but I am quite sure these signs were unconscious – There were no words spoken of any importance.

I am attending to Sir Walter, and helping him in the too painful business. I slept in the room with him last night, and left him only at dawn. I'm going out now to walk with him.

Neuchatel Tuesday
15th May 1866

My dearest Mother

I do not yet write any details, for there is so much horror and melancholy in all I have to do that I spare myself everything I can. I have had a line to-day to write to Mrs Hilliard. We have a telegram saying that *Mr* Hilliard is coming, which is an immense comfort to poor little Con. We had the body examined to-day, and the organic disease would have rendered it wholly impossible for her to live much longer. We think a slight jar on the railroad must have been the immediate cause of accelerated death.

Before she lost consciousness, Sir Walter and I were beside her, he holding her left hand and I her right. I said to Sir Walter that I was grateful to him for wanting me to stay: "I did not think he had cared for me so much." "Oh" he said, "we both always esteemed you above any one else". Lady Trevelyan made an effort, and said "He knows that." Those were the last conscious words *I* heard her speak: then I quitted her hand, and went to the foot of the bed and she and her husband said a word or two to each other – low; very few. Then

there was a pause – in a few minutes she raised herself, the face wild and vacant, and said twice, eagerly (using the curious nickname she had for Sir Walter of "Puzzy") "That will do, Puzzy, that will do." And so fell back – slightly shuddering – a moment afterwards she said "Give me some water". He took the glass and I raised her; as I did for all her medicine; – she drank a little, but had scarcely swallowed it when violent spasm came in her throat, and her husband caught her as I laid her back on the pillow; and then the last struggle began – I went to the foot of the bed and knelt down, and he held her: the spasm passed through every form of suffocating change, and lasted for upwards of an hour, each new form of it getting fainter, but all unconscious, though terrible in sound – he saying softly to her sometimes, "Ah, my dear" – I rose in a little while, thinking it must be too dreadful to him, to assure him it was unconscious – He said, Yes, I know it. Then I went back to the foot of the bed, and stayed, till the last sobs grew fainter – and fainter – and ceased, dimly and uncertainly – one could not tell quite when. At last he raised the chin which had fallen; and laid her head back; and took the candle and called me to look at her.

And so it ended.

We are all fairly well.

Geneva. 5th July [1866]

My dear Acland . . . Sir Walter stayed a week with me at Interlachen after all things were done at Neuchatel which needed his seeing to. I thought it would have been good for him to stay longer – and prayed him to do so – but he would go home . . . After all – you doctors are not worth much! – We had a good one at Paris – who found out a good deal about her – and told us her liver was wrong – (among other wrongnesses) – And then the Neuchatel doctor said there was nothing the matter with it – (and was right as it turned out – at least by his report). [Autopsy] Nearly the last words she said to me before the last spasms came on, were 'It will be a bore if we have to eat humble pie to that little doctor, after all.' I should think you *did* feel 'bereft by her death' – unless you know a great many more nice people than I do – but it is likely you do – only not many like her, I should think –

Index

daguerreotypes 12, 23, 41n; destruction and restoration 11, 83, 113, 272; dogs 76, 96, 164n, 170, 251; etches 17n, 111, 140, 142, 144; friends 47n, 50n, 52n, 138, 168, 220, 225, 250; on geology, minerals, etc 74, 100, 111, 114, 127, 153, 161, 195, 199, 205, 206, 209, 210, 223, 232, 247, 251; love for Rose 150n, 154n, 172n, 179, 182, 251, 254; marriage 1n, 2n, 4, and annulment 78; opinion of Effie 36, 52, 81 ff.; 270 ff.; his plans 1n, 88–9, 101, 113, 161, 163, 253, 255, 256, 257; political economy 110n, 150, 158, 191, 196, 197, 199, 211, 212, 214, 248; portraits of 51, 52, 56, 84n, 92n, 97n, 118n, 252; religion, loss of faith 68n, 141, 150n, 171n, 175n, 182, 198; on religious denominations 37, 59n, 134n, 185; seeks PT's help 40, 42n, 43, 53, 62, 65, 90, 95, 107, 109, 110; studies Greek 171, 177, 178, 179, 199; works at DH 104, 105, 123, 124n, 140–1, in London 30, 32, 129n, 131, Venice 19, 21, 22–3

Advice sought on: church glass 76; novel-writing 136n, 279; photography 98; tiles 71, 74–5, 80

Comments on: Alps 84, 89, 178, 181, 235; Civil War 183, 211; illuminated M.S.S. 69, 76, 88, 94n, 98, 128, 130, 153; pictures 88, 89, 106n, 127n, 129n, 136n, 137–8, 174n; Pre-Raphaelitism 37, 68n, 72n, 85, 88, 95, 146n; W. B. Scott 105, 106, 127n; solar halo 16–17, 18; vegetation 53, 54, 63, 90, 107, 141, 152–3, 158, 184, 205, 209, 210, 242–3, 248, 260, 264; Wallington 124, 128, 129n, 204, 217n

Illnesses: 9, 57, 174, 175, 179, 193, bilious 155, colds and coughs 8, 10, 15, 100, 111, 247, feverish 110, languor 167, 199, 226, 227, 261, toothache 124n, 171, 176n, 183n

Relationship with: Effie 3, 6n, 76, 77, 82, parents 150n, 188, 191, 193, 194, 226, PT 7, 15, 16, 38n, 44, 45n, 141, 160, 177, 180, 184, 186, 202, 209, 217, 263, 265n

Travels to: Amiens 112, Boulogne 167, 168, 169, 172, 173, 174, 213, Canterbury 7, Chamonix 19, 84, 105, 113, Dover 6, 78, 103n, 113, 136, 147, Durham 69, 127, 128n, Germany 136n, 137, 138, Ireland 174, Ligurian coast 31, Milan 19, 188, Montélimart 29, Monza 21, Normandy 11, 12, 80, 272, Panshanger 245, Paris 31, 87, 113, 182, 203, 213, 258n, Salisbury 8, 10, Scotland

2 ff., 44 ff., (Glenfinlas) 48 ff., 65, 68, 100, 126n, 127, Shropshire 32, Switzerland 20, 21n, 26, 36, 39, 79, 81, 88, 89, 96, 113, 114, 131–2, 133, 136n, 147, 149, 150, 152, 172n, 176, 178, 189, 223, 258 ff., Tunbridge Wells 100, 159, Turin 132–3, 135, 139, Venice 21 ff., 26 ff., 36 ff., Wales 32, 169, 170, 171, 173

Artists mentioned by 17, 47, 48n, 88, 89, 98, 113, 114, 125n, 130, 136n, 143, 146n, 168, 175, 186, 225, 245, 255

Books and papers mentioned by 9n, 82, 85, 87, 90, 98, 99n, 105, 109, 113, 119n, 130, 174, 181n, 198, 216, 228, 232–3, 236, 238, 239, 240, 241, 248, 249, 262, 263, 264

Drawings by: Aiguilles de Blaitière 86n, 95, Alps with fir trees 85, 95, Christ Church Cathedral 85, copies from Claude 56n, 63n, Turner 56n, 63n, 76, 163, Falaise Castle 12, Fribourg 85, Gneiss study 57, Neuchâtel 259n, 260, 261, 262, Rouen 12, St Catherine 189, St Wulfram 12, San Ambroggio 21, studies 134n, 138, Swiss sketches 133n, 186n, vignettes 83, Visconti palace 21

Lectures by: Decorative colour 92, Edinburgh 51, 54, 58, 59n, 63n, 65n, 66n, 67, 72n, Ethics of the Dust 222n, 223, 248, Forms of the Stratified Alps of the Savoy 206, 213, Of Kings' Treasuries, On Queens' Gardens 237, Traffic 231, War 252

Works by: *A Knight's Faith* 166n, *Academy Notes* (1855) 101, 124n, (1856) 112n, (1857) 125, (1858) 146n, (1859) 136n, *Elementary Organic Structures* (*The Laws of Fesole*) 72n, *Elements of Drawing* 124n, *Elements of Perspective* 142n, *Giotto and his works at Padua*, 76, *Harbours of England* 87n, 103n, *Modern Painters* i, 13n, 124n, ii 13n, 46n, 59n, 124n, iii 39, 57, 69, 76, 77n, 98, 104, 105, 107, 112n, 124n, 175, iv 55n, 96n, 111, 162n, 197, v 129n, 134n, 139n, 141, 142n, 145, 147, 148, 151, 153, 156, 164n, *Mulnera Pulveris* 191n, *Notes on the Construction of Sheepfolds* 34, 36, *Opening of the Crystal Palace* 86, *The Oxford Museum* 136, 152n, *Praeterita* 2n, *Pre-Raphaelitism* 37, *Proserpine* 54n, *Selections* 183, *Sesame and Lilies* 239, *Seven Lamps of Architecture* 13n, 15, 16n, 17n, 185n, *The Stones of Venice* i 25n, 32, 34, 67, ii 34, 35n, 39, 58, 60, 63, 67, 93n, iii 35n, 42n, 48n, 58, 59n, 67, 77n, Turner *Catalogue* 118n, *Two Paths* 137n, *Unto this Last* 150

285